DISPLAY

Appearance, posture and behaviour in the animal kingdom

DISPLAY

Appearance, posture and behaviour in the animal kingdom

STEVE PARKER

IVY PRESS

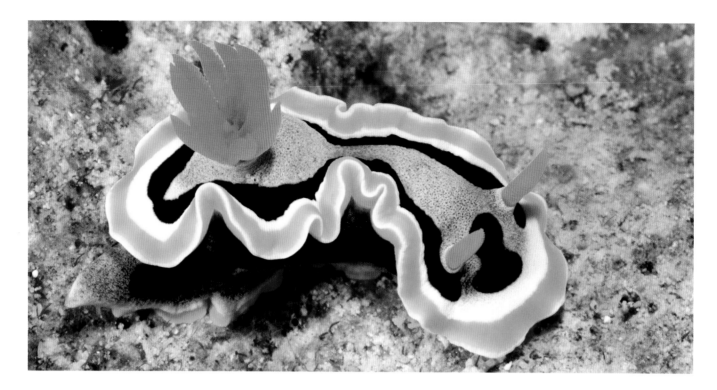

Brimming with creative inspiration, how-to projects, and useful information to enrich your everyday life, quarto.com is a favourite destination for those pursuing their interests and passions.

First published in the UK in 2022 by
Ivy Press
An imprint of The Quarto Group
The Old Brewery, 6 Blundell Street
London N7 9BH, United Kingdom
T (0)20 7700 6700
www.Quarto.com

British Library Cataloguing-in-Publication Data
A catalogue record for this book is available from the British Library.

ISBN: 978-0-7112-7852-3
E-book ISBN: 978-0-7112-7853-0

Printed in China

10 9 8 7 6 5 4 3 2 1

MIX
Paper from responsible sources
FSC® C016973

PICTURE CAPTIONS
Page 1: Eastern grey kangaroos (*Macropus giganteus*)
Page 2: Pondichéry fan-throated lizard (*Sitana ponticeriana*)
Page 4 above: Seaslug (*Chromodoris annae*)

Contents

Introduction

Nature's struggle for survival means many creatures spend much of their lives trying not to be noticed as they avoid a multitude of threats and dangers. They secrete themselves in dens, burrows, thick undergrowth and other hiding places. Some animals are disguised or camouflaged, so that even out in the open, they merge into their surroundings. So why do other creatures do the opposite? They make every effort to be noticed and to stand out from the crowd. They put themselves on display using a wide range of gaudy colours, garish patterns, startling shapes, striking scents, song-and-dance routines, and other conspicuous behaviours. They are the flamboyant show-offs, exhibitionists and poseurs of the natural world.

Animal displays have varied purposes. One of the most vital is self defence against predators and other enemies. Important for some species is defending a territory with its resources of food, shelter, and nesting places or other reproductive needs. Further motives are gaining high status or dominance in a group, intimidating rivals at breeding time, and courting and showing off to members of the opposite sex in order to mate. In some instances, displays fulfil all these aims.

COLOUR AND PATTERN

Some display trends are represented across a huge range of species. Warning coloration is one form of aposematic mechanism (the word has Greek roots: *apo* 'away from', *sēma* 'sign'). Creatures as varied as the mountain katydid, postman butterfly, leopard sea cucumber, strawberry seaslug, blue-ringed octopus, mandarin fish, fire-bellied toad and poison dart frog have bright, bold, usually contrasting patterns. These say: 'Stay away!', because the displayers are venomous, have sharp claws or teeth or spines, or their skin and flesh are distasteful, even toxic.

Red and black, yellow, orange and black, and similar clear-cut combinations are common warning colours. If a predator survives its encounter, it learns to avoid creatures that display a similar look.

Even if the attacked victim dies, others gain because the predator subsequently avoids the aposematic coloration. So the mechanism works within a species and also across a range of species with similar appearance – that is, they copy or mimic each other. This mutual protection effect is known as Müllerian mimicry.

The startle or deimatic (from the Ancient Greek verb *deimatóō* 'to frighten') display occurs when an innocuous-looking creature facing peril suddenly reveals vivid

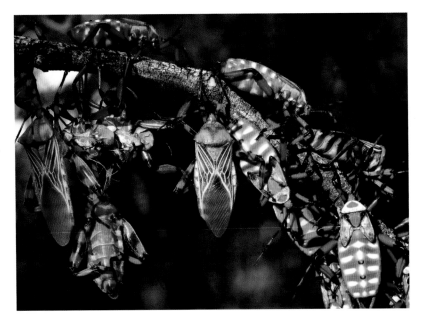

▼ A blaze of red, orange, yellow, black and white warning colours advertise these giant mesquite bug nymphs (young forms), *Thasus neocalifornicus*, have toxic flesh and a corrosive spray. Winged adults can be seen centre and far left.

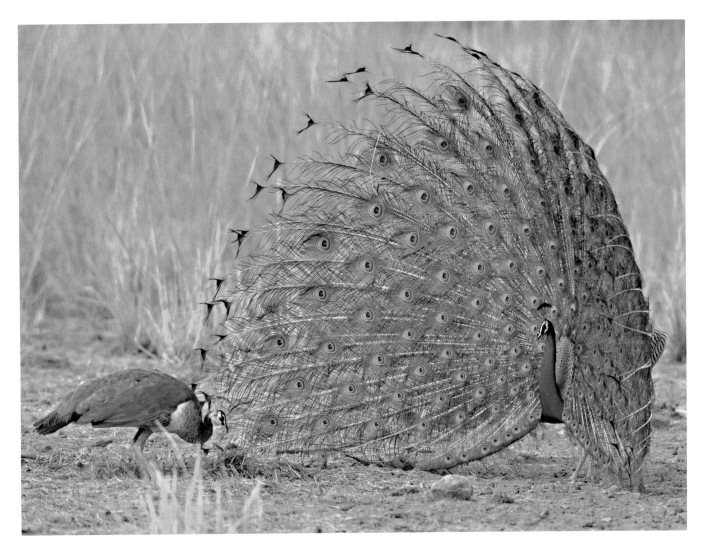

contrasting colours and bold designs. The devil's flower mantis spreads its leg flaps, the postman butterfly opens its wings, and the frilled lizard extends its neck ruff. Common deimatic designs are eyespots, or ocelli, and similar rounded shapes. One biological explanation is that the eyespots look like eyes of a larger predatory creature such as an owl, hawk or cat, thereby surprising and scaring away the aggressor.

COURTSHIP AND MATING

Displays take centre stage during the breeding season. Colours and patterns are joined by jumps, bows and other forms of 'dancing', also vocalizations ranging from simple clicks and pops to lengthy, complex bird song, the orangutan's remarkable 'long call', and the incredibly complicated

compositions of great whales. The vast majority are enacted by males, to attract females for mating. This is especially familiar in birds. Males moult or shed their relatively dowdy, non-breeding feathers for bright, colourful breeding or nuptial plumage. Meanwhile most females remain plain and camouflaged, since in many species, they alone raise the young.

In some animals, females choose males based on a particular anatomical or behavioural feature, such as a betta fish's flamboyant fins, a deer's elaborate antlers, or a stalk-eyed fly's amazing eyes-on-stalks. In group displays, males perform near each other and compete for female attention at a traditional breeding display site called a lek. These are often used for generations, as in grouse and great argus pheasant. In clear

▲ The peacock, *Pavo cristatus*, has become symbolic of the incredible courting displays performed by so many male creatures. Dozens of animals have 'peacock' in their name, from worms and spiders to flounder fish and monitor lizards.

view, competing males strut, pose, parade, vocalize, throw off scents and perhaps engage in physical tussles.

Attending females assess and compare the males for breeding potential. And, for example, if they choose males with long, showy tails, over many generations those tails may become even longer and showier. This is part of the general evolutionary driver of natural selection known as sexual selection. Well-known examples are peacocks and birds of paradise. However, the extra-long tail may become so heavy, unwieldy and cumbersome that it threatens the male's survival. In this way, sexual selection self-limits.

RITUALS AND GROUP ORDER

Courtship and rivalry displays may include ritualized elements. Animal rituals are stereotyped sequences repeated in much the same order each time. The behaviours are often based on actions that the animal does for other reasons, such as self defence or feeding. However, as in the sand lizard's head-bobbing, the great crested grebe's gift of weed, and the gorilla's chest-beating, these actions have become detached from their original survival purpose and incorporated into the ritual.

Ritualized displays can establish dominance or supremacy in a group with an organized hierarchy, such as a wolf pack, tamarin monkey troop or 'pecking order' bird flock. Rivals for status deploy a habitual series of actions and signals. For example, a dominant coyote bares its teeth and growls, while a submissive individual crouches in appeasement. The display avoids serious confrontation and injury, reinforces group order, and is usually over in a couple of seconds. But inevitably there comes a time when the group's alpha 'boss' individual, perhaps ageing, injured or diseased, must face a real challenge.

Animal territories come in many sizes and have diverse functions. They may be the occupier's entire survival locality, with food, shelter and breeding sites. Or they can be a small token of the individual's status and fitness to reproduce, as with a position at the centre of a lek for wire-tailed manakins and blue wildebeest. The incumbent is proclaiming to breeding partners that he is fit, healthy, better than the rest, and ready for successful progeny.

ULTIMATE DISPLAY

Perhaps the most immediate and essential display is for self defence and survival against danger, especially a predator. Many threatened animals retaliate by appearing bigger, fiercer, noisier and generally more intimidating. Cats and other mammals raise their fur, birds like the New Zealand bellbird fluff out their feathers, reptiles

▼ A blue-spotted mudskipper, *Boleophthalmus boddarti*, raises its dorsal (back) fin at a rival to declare: 'This patch of mud is MY territory!' The area provides food, hiding places, and confers high status to attract a mate.

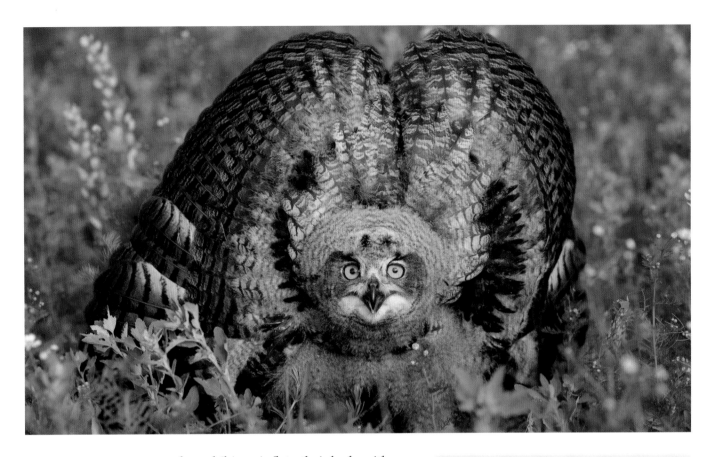

▲ One of the largest owls, the Eurasian eagle owl, *Bubo bubo*, puts on an angry defensive display with head lowered, bill open, body feathers ruffled, wings spread and tail fanned, to appear as big and fierce as possible.

and amphibians inflate their body with air. Weapons are put on display, such as the gelada baboon's bared teeth, the snow leopard's unsheathed claws, the African porcupine's spines and the porcupine fish's thorny prickles. The king cobra spreads its hood. Muscles tense, ready for action. An audible part of this display, employed by a great variety of species across the animal spectrum, is the hiss. Mammals such as cats and possums, geese and other birds, reptiles such as alligators, snakes and lizards, amphibians like frogs and toads, and even some insects, all hiss in aggressive self defence.

This book showcases a range of incredible displays by a variety of creatures, from tiny flies to great whales, living across the continents, seas, oceans and islands of the world. Unknown to the displaying animals, there is one more role their performances fulfil. They provide us human onlookers with some of the most spectacular, amazing and memorable experiences that the natural world can offer.

IUCN CONSERVATION STATUS

The Conservation Status included in the information panel for each animal is taken from the International Union for the Conservation of Nature (IUCN) Red List of Threatened Species.

- **NOT EVALUATED, DATA DEFICIENT**
 No suitable, or not enough, information to assess

- **LEAST CONCERN (also LOWER RISK)**
 'Doing alright', unlikely to be at risk in the near future

- **NEAR THREATENED**
 Increasing threat levels, possible extinction in the medium-near future

- **VULNERABLE**
 At risk of extinction soon, human support required

- **ENDANGERED**
 High risk of extinction, urgent human help vital

- **CRITICALLY ENDANGERED**
 Extinction is extremely likely, even with immediate human intervention

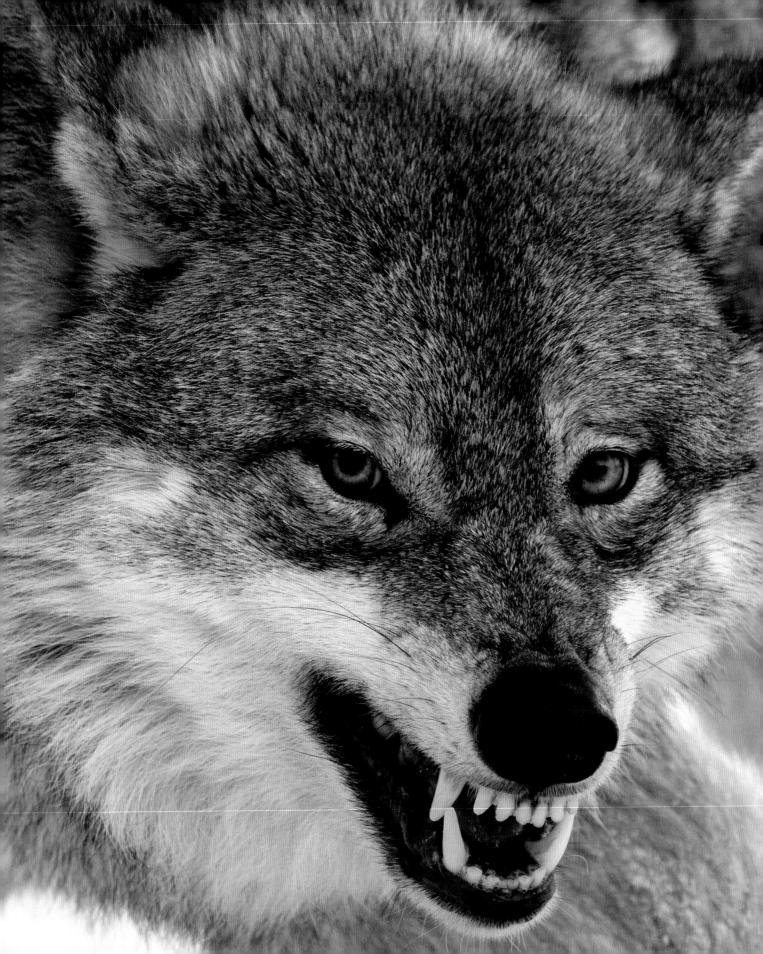

1
North America

Spicebush swallowtail butterfly

COURTSHIP BY FLIGHT AND SIGHT

The large family of butterflies known as swallowtails, or Papilionidae, has more than 500 species – and plenty of these are large, visually showy, and profusely active. The spicebush swallowtail of southern and eastern North America has darker background colours overall than many of its relatives, but this serves to accentuate the rows of bright, spot-like scales on both the upper and lower wing surfaces, and along the plump body.

The spicebush swallowtail's upper and lower wing surfaces are markedly different. The top side has a mostly black forewing with small cream or ivory spots along the rear edge. On the upper hindwing these spots are larger, with a 'frosted' band that is blue in females and blue-green in males. At the outer front corner of the hindwing there is also a vivid orange spot.

The lower wing surfaces broadly follow this design, but each row of spots is doubled. The spots are orange on the hindwing, with dusty blue, blue-green or grey tinges to the rear of the front row, especially for the female, all on a chocolate brown background.

FLASHING DARK AND LIGHT
As the spicebush swallowtail flutters, the whole effect of its complex coloration is a startling series of flashing dim backdrop and bright spot patches passing by. The male cruises to and fro along flyways, usually on a ridge near the adults' food plants. He scans for females, and when a possible partner is located, he hovers nearby. However, when males encounter each other, they may briefly approach but then fly away in opposite directions.

- LOCAL COMMON NAMES
Green-clouded butterfly

- SCIENTIFIC NAME
Papilio troilus

- SIZE
Wingspan 8–12cm (3–4 ¾ in)

- HABITATS
Caterpillar: woods, swamps, bush
Adult: open shrubland, wood edges, parks and gardens

- DIET
Caterpillar: trees and bushes of the laurel family, especially spicebush, redbay and sassafras, also magnolias
Adult: nectar from a wide range of plants including honeysuckle and impatiens

- CONSERVATION STATUS
IUCN Not evaluated
(see key, page 9)

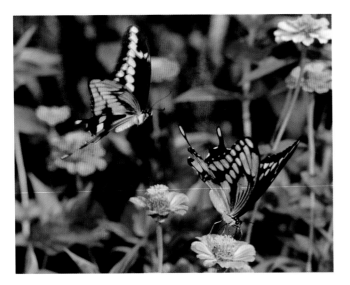

POTENTIAL DANGER

Laurel wilt fungus, *Raffaelea lauricola*, has become widespread in eastern and south-eastern North America. Transmitted by the introduced redbay ambrosia beetle, it affects many kinds of laurels, especially redbay and sassafras – common foods for spicebush swallowtail caterpillars. This could threaten some populations of the butterfly, as well as other laurel-dependent wildlife. Commercially more serious are the effects on Florida's avocado-growing business, since the fungus attacks avocado trees.

◀ Many swallowtail species have similar fluttering courtship routines. This is a pair of giant swallowtails, *Papilio cresphontes*.

▶ A male spicebush swallowtail (below) approaches a female perched on swamp milkweed. His beating wings display flashes of colourful spots as the pair scrutinize each other visually.

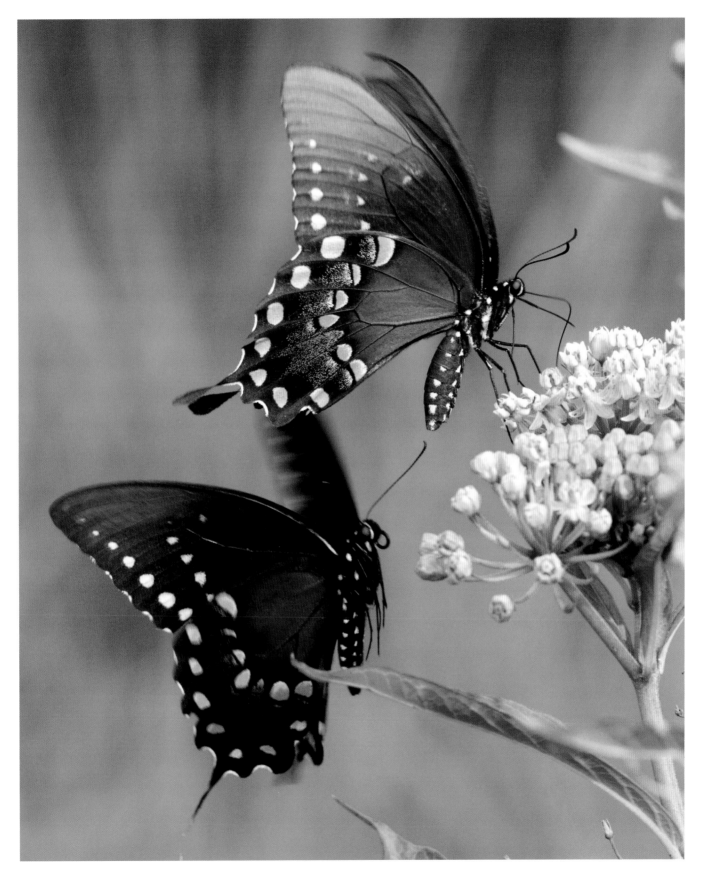

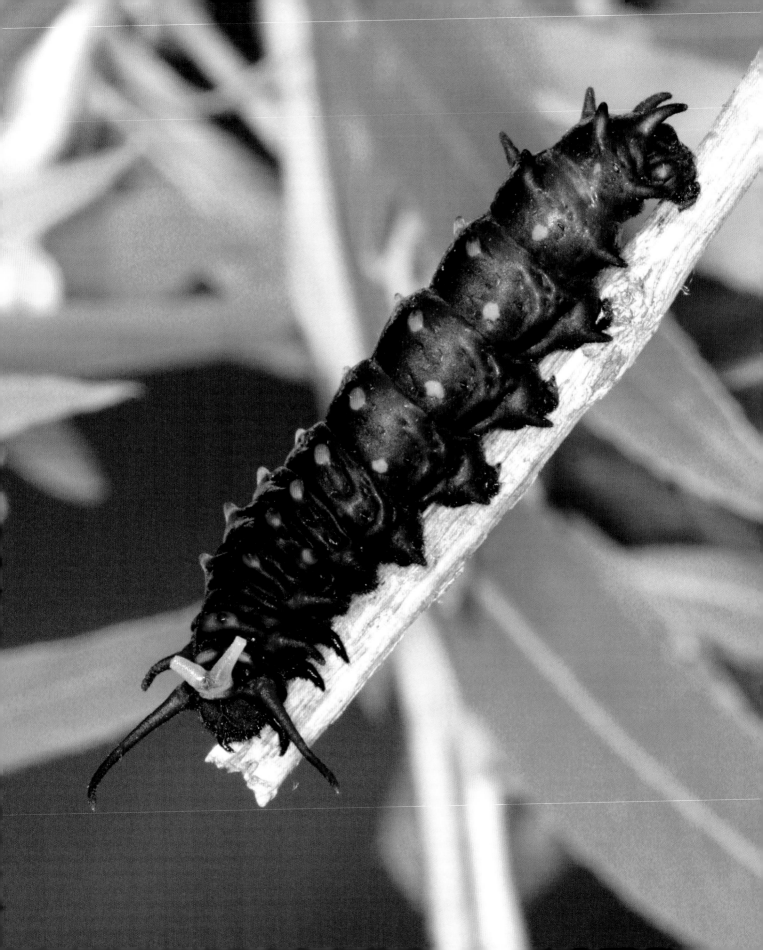

Pipevine Swallowtail Caterpillar

STICKING OUT ITS 'TONGUE'

The caterpillars, or larvae, of butterflies and moths are staple food for so many predators, ranging from fellow insects like beetles, ants and wasps, to spiders, frogs, reptiles, and all kinds of small birds and mammals. Very few types of caterpillar are able to defend themselves physically in the sense of fighting back. But some have surprises waiting. Swallowtail caterpillars possess a flexible, usually hidden organ, the osmeterium. The caterpillar can suddenly protrude it to display, wave, and expose its noxious secretions.

The swallowtail butterfly family, Papilionidae (see previous page), is a huge group with members on every continent except Antarctica.
Many of the caterpillars and also the adults are brightly decorated with contrasting colours such as yellow and black, and red and black. These are common examples of aposematic or warning coloration, also sported by wasps, salamanders and frogs (see page 6).

SUDDEN APPEARANCE
Warning colours are a first line of visual defence that advertises something distasteful, poisonous, noxious or dangerous. If an attacker ignores the caterpillar's black and red pattern, the second line of defence is its osmeterium. It is a Y-shaped, flexible organ usually stored behind the head, under the first of the three body segments (sections). It can be pumped up rapidly by muscle actions moving body fluids, to pop out like twin prongs or horns and wave around. It also has contrasting colours to the rest of the caterpillar for added startle value – orange-yellow, in the case of this species. And it secretes an irritant, bitter, foul-smelling slime that a predator must surmount if it wishes to devour the caterpillar.

DISTRIBUTION MAP

- LOCAL COMMON NAMES
 Blue swallowtail
- SCIENTIFIC NAME
 Battus philenor
- SIZE
 Caterpillar length up to 50mm (2in); adult wingspan 75–125mm (3–5in)
- HABITATS
 Varied, especially woods, forests, parks, gardens
- DIET
 Caterpillars eat chiefly pipevines *Aristolochia*; adults feed on nectar
- CONSERVATION STATUS
 IUCN Least concern
 (see key, page 9)

◄ A bright yellow osmeterium is displayed by this last-instar pipevine caterpillar. Last instar means its next life stage will be the adult butterfly.

▶ A caterpillar of the black swallowtail, *Papilio polyxenes*, rears up at the front end and everts its osmeterium in response to an approaching threat. Most swallowtail larvae have this form of defence display.

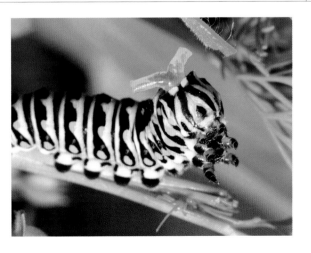

SWALLOW'S TAILS
Swallowtail butterflies received their common name from the birds. Each of the butterfly's hind wings has a trailing, tapering tail. Together these form a forked V or U shape, similar to tails of swallows, swifts and martins. The swallowtail butterfly's family name, Papilionidae, was chosen by Carl Linnaeus, who founded the modern system of naming living things in the eighteenth century, after the Latin for 'butterfly', *Papilio*.

Regal Jumper

LEGS AND FANGS TO THE FORE

The great majority of spiders have a similar display when faced with threat or danger – and that is a great number, since there are more than 45,000 different kinds, or species, in the spider group Araneae (see also pages 80, 183). They swivel to face the menace, rear up at the front end, thrust forward their venomous fangs, and spread out their front legs and their 'feelers' or pedipalps. The regal jumper has the added advantage, as its name suggests, of suddenly leaping away from the situation – so fast that it seems to disappear.

Jumping spiders, or salticids, number more than 6,000 kinds. They have eight thick, strong legs with powerful muscles, and the ability to spring up without warning and travel a surprising distance. They also have large eyes, again eight in number, and excellent vision. They can plan a lengthy leap, several times their body length, and land with remarkable precision – for example, when crossing a gap between two twigs.

DASH OF COLOUR

Regal jumpers quickly adopt the typical spider display. They spread their long first pair of legs outwards and upwards, and poke forward their pedipalps or 'feelers'. These resemble short legs on either side of the head. They are used mainly for sensing scents, tastes and movements, and also by the male when mating, but they add to the spider's array of possible defence weapons. Also visible are the regal jumper's fangs or 'jaws', known as chelicerae, ready to jab venom. In this species the fangs are a striking and unusual shade of gleaming, almost metallic blue-green, violet or blue-pink. They are raised forwards to be clearly visible.

- LOCAL COMMON NAMES
 Regal jumping spider, Royal jumping spider

- SCIENTIFIC NAME
 Phidippus regius

- SIZE
 Female body length up to 20mm (4/5in), male up to 15mm (3/5in)

- HABITATS
 Fields, shrub, bush, scattered woods and similar open habitats

- DIET
 Smaller insects, spiders, worms and other invertebrates

- CONSERVATION STATUS
 IUCN Not evaluated
 (see key, page 9)

EASY TO DISTINGUISH

Regal jumpers exhibit sexual dimorphism. This means the two sexes have different appearances. The female's base colour is grey, brown or even orange, with lighter bands and patches on the abdomen (main body) and sometimes on the legs. The male is smaller and usually very dark grey, brown or black, and the pale leg bands show up more clearly. The regal jumper's appearance and habits have made it a popular exotic pet.

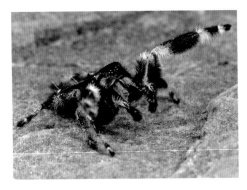

◀ A female regal jumper projects her front legs in two possible situations. One is defence. The other is a sign to a possible mate at breeding time. If he does the same, the two begin their courtship sequence. This includes more defence-type postures, but in a less intimidating, more intimate style.

▶ A male regal jumper extends its front pair of legs, the shorter hairy pedipalps next to them, and its iridescent violet chelicerae or fangs. Its large eyes watch for any sign of danger, and if this appears, the regal is suddenly gone.

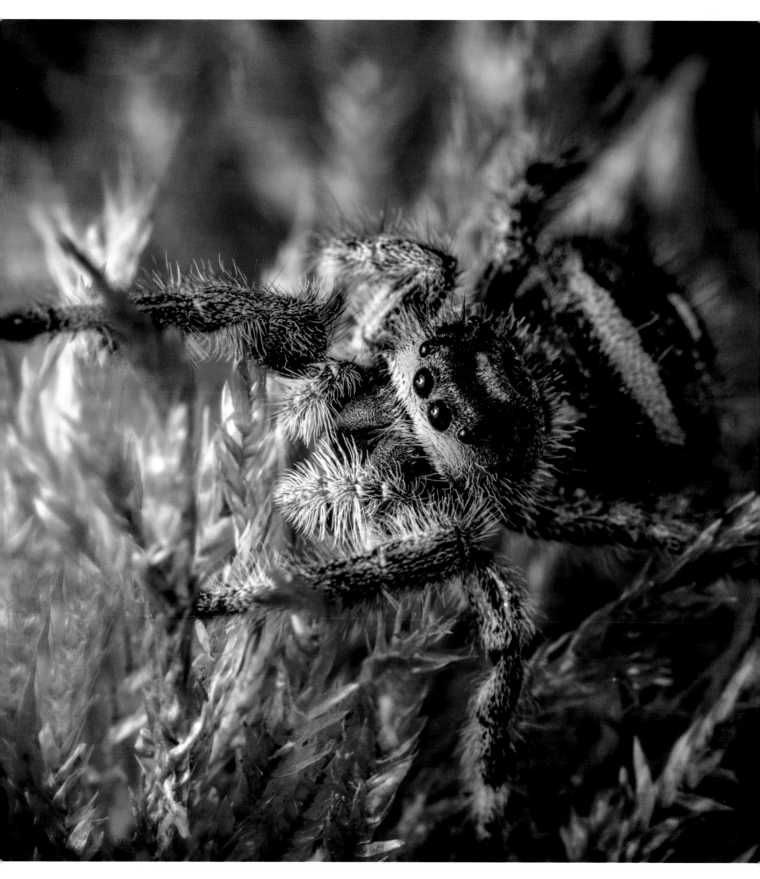

Sarcastic fringehead

SMALLISH FISH, BIG MOUTH, BIGGER ATTITUDE

The strangely named sarcastic fringehead is a shallow-water fish from California and Baja California coasts that is famed for its feisty temperament. Its main displays concern territory. What appears to be 'kissing' between rivals is in fact mouth-wrestling, as they gape their hugely wide, stretched mouths with glaring colours inside, and show their rows of teeth, ready to do battle over a favoured shelter and patch of sea floor.

The sarcastic fringehead is a type of blenny, a large group with about 900 species of mainly bottom-dwelling marine fish. It bases itself in a shelter or lair, such as a rocky crevice, coral overhang, old crab burrow or large seashell. In recent times, items of human debris are also favoured, like bottles, cans and plastic containers. From this retreat, the fish makes forays to eat various snacks, such as fish eggs, worms and shrimps.

VALUABLE REAL ESTATE
The usual breeding strategy among fringeheads, and many other blennies, is for the female to lay eggs inside the male's retreat. Here he fertilizes and guards them. The retreat is therefore a valuable possession for which males compete with astonishing zeal. They face up, open and sway their enormously wide mouths, showing off the bright interiors to each other. Sometimes their mouths touch as if gently kissing but the intent is much more serious. Usually the biggest mouth wins and the loser swims off. The evolutionary driver producing such an extraordinary wide-mouthed feature is sexual selection (see page 8).

(see page 8)

DISTRIBUTION MAP

- LOCAL COMMON NAMES
 Big-mouth blenny; Tubícola chusco (Spanish)
- SCIENTIFIC NAME
 Neoclinus blanchardi
- SIZE
 Length up to 30cm (12in)
- HABITATS
 Shallow coasts, depths 3–60m (10–200ft)
- DIET
 Varied, mostly small invertebrates, eggs, edible debris
- CONSERVATION STATUS
 IUCN Least concern (see key, page 9)

STRANGELY NAMED
This fish's common name 'sarcastic' derives not from any hint of an ironic or cynical disposition, but from its rows of small but sharp teeth that can easily tear flesh – *sarco*- meaning 'flesh', as in sarcophagus. 'Fringehead' refers to the hair-like fringes above the eyes and on the head, in the manner of long, exotic eyelashes.

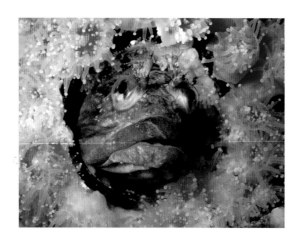

◄ Off duty, the fringehead spends much time in its shelter, here among corals. The elastic tissues of the mouth retract and fold into what look like wide lips.

► Rearing up from its seabed retreat, the male sarcastic fringehead's yawn-like territorial display involves its mouth distending (seemingly impossibly) to four times its usual width. Inside are bright, almost Day-Glo colorations and small but efficiently sharp teeth. Females usually choose the male with the biggest mouth.

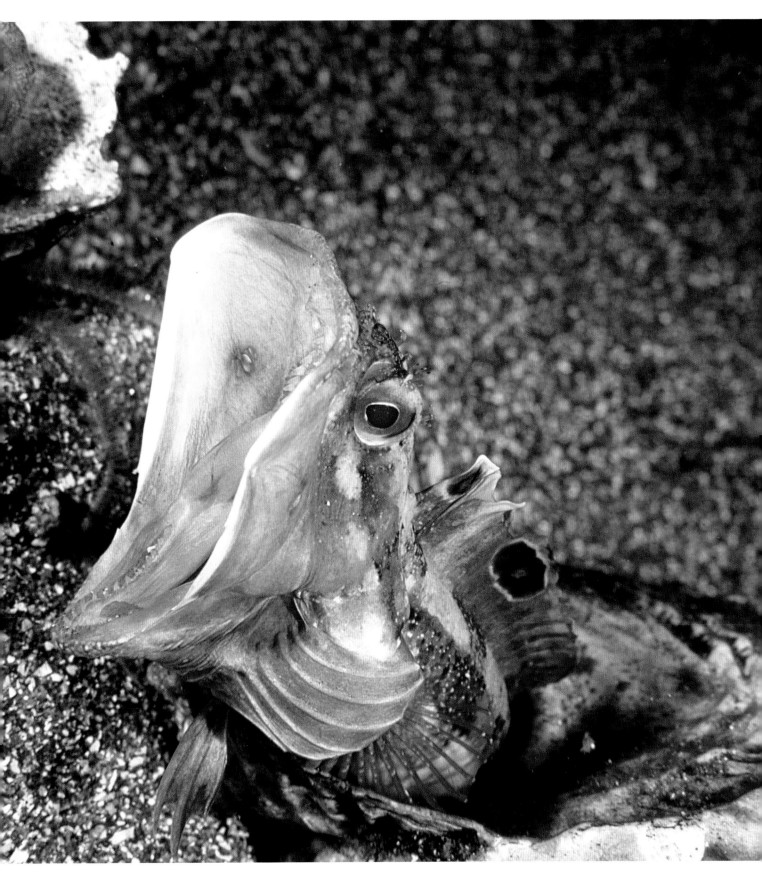

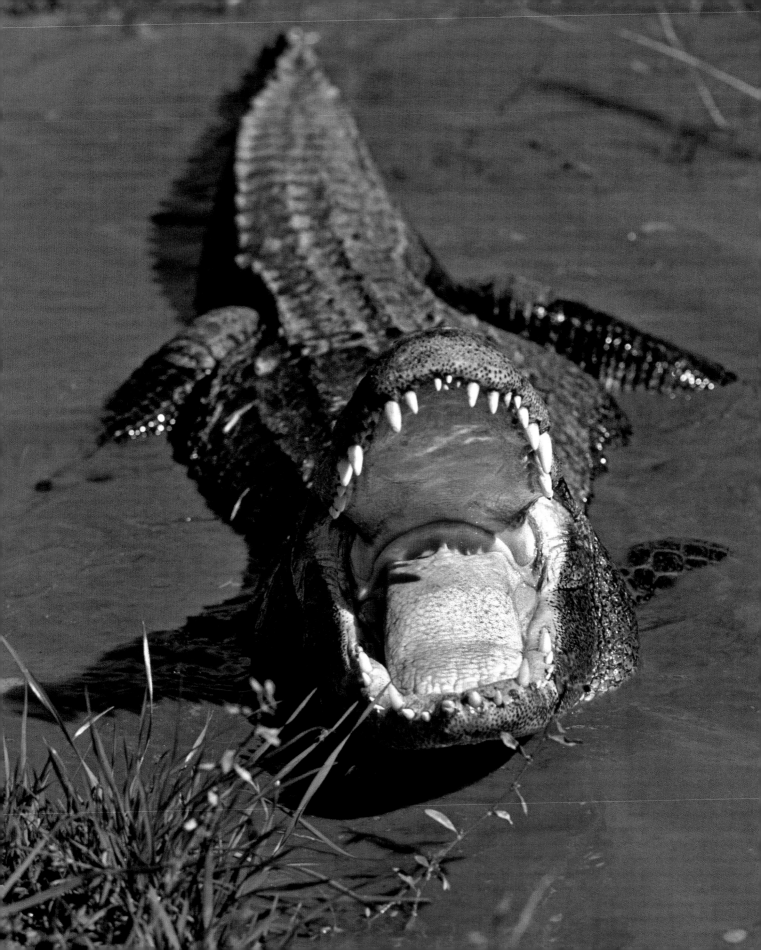

American alligator

YAWNING A WARNING

Biologists and naturalists have long puzzled over why alligators and crocodiles 'yawn' or 'gape' with their mouths. Usually the mouth opens quite widely and stays there while the reptile does little else. Sometimes the behaviour occurs during very hot weather, presumably as a cooling mechanism. It is also a multipurpose display at times of mating, claiming territory, self defence or defending young. Despite extensive scientific research into the matter, the 'gator's open mouth sometimes seems to be for no reason that we can discern.

Mouth-gaping or yawning is a feature of all twenty-seven species of crocodilians – that is, crocodiles, alligators, caimans and gharials (gavials). They aim to keep their body temperature in a favoured range – for most species about 30–33°C (86–91°F) – by behavioural means. For example, they sunbathe to gain heat when too cool, or seek breezy shade when too hot.

A common assumption is that gaping exposes the mouth lining, richly supplied with blood vessels, to passing air, which allows evaporation and carries away body heat. This process is called thermoregulation. But scientific studies measuring factors such as temperatures of the air, the water, and the 'gator's head and body, do not always support the idea.

A FLEXIBLE BEHAVIOUR

Gaping occurs at night when it is much cooler, and when it's raining. It seems to happen as a threat display, when two alligators confront each other, perhaps over a large prey item. A mother with eggs or hatchlings may gape at danger in their defence. For the alligator, opening wide seems to be a complicated and flexible behaviour trait.

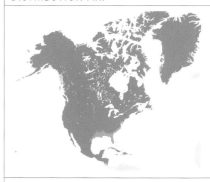

- **LOCAL COMMON NAMES**
'Gator, Florida alligator, Louisiana alligator, Mississippi alligator; Alligator americano (Spanish)

- **SCIENTIFIC NAME**
Alligator mississippiensis

- **SIZE**
Subject to much exaggeration in local folklore; in general, fully grown female length 2.5–3m (8ft 2in–9ft 10in) and 100–150kg (220–330lb), male 3.5–4m (11ft 6in–13ft 2in) and 200–250kg (440–550lb)

- **HABITATS**
Rivers, lakes, estuaries, bayous, canals, ditches, swamps and similar wetlands

- **DIET**
Any animal that can be overpowered, on land or aquatic, from small fish and frogs to the size of boar, deer, occasionally fruits

- **CONSERVATION STATUS**
IUCN Least concern (see key, page 9)

◀ An alligator in full threat mode displays its formidable rows of teeth, up to 80 in total. It may also emit deep guttural bellows and hisses, and thrash its tail. It is one of nature's most fearsome spectacles.

▶ A resting alligator with jaws only slightly ajar may well be thermoregulating. The hotter it gets, the wide the gape. Also, the 'gator may adopt a particular angle to the sun, so that its mouth and head become cooler – very important for the temperature-sensitive brain – while the body conversely gains warmth.

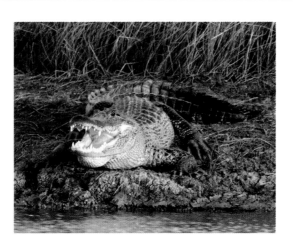

OFF THE DANGER LIST
During the nineteenth century, hunting reduced the American alligator's populations at dangerous rates. Humans were seeking meat, skins, trophy teeth and jaws, or carrying out persecution and revenge for attacks on people, pets and farm animals. Also, suitable habitats were drained for agriculture and leisure activities. Gradually the reptile's plight was recognized and conservation began. By the 1980s the species was off the danger list.

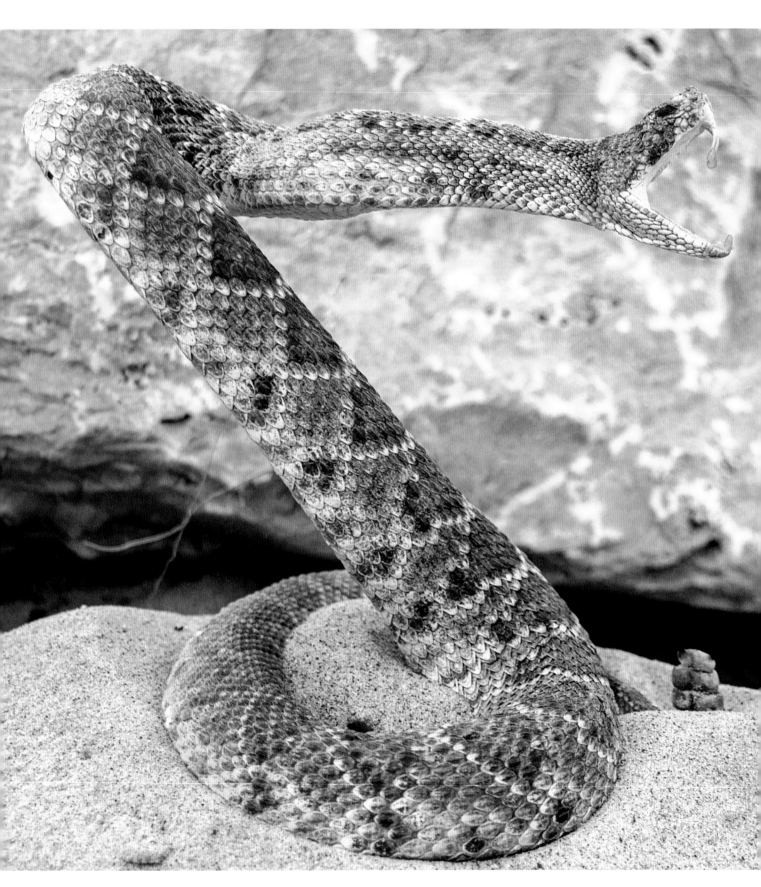

Prairie rattler

SINISTER SOUND AND OMINOUS VISION

A disquieting sound in the American West is the subdued clatter or rasp that could indicate a rattlesnake. The prairie rattlesnake's excellent camouflage means that the rattle is often heard before the snake is seen. The sound warns: Stay away. Compared to other rattlers, which may slither away from confrontation, or deliver a 'dry' bite – one without venom – the prairie rattler may well hold its ground and strike with plentiful venom.

DISTRIBUTION MAP

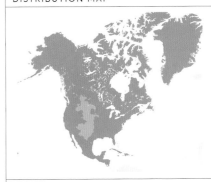

The rattlesnake group, *Crotalus*, has about forty-five species that live only in the Americas. The group name comes from the Greek *krótalon*, 'castanet' or 'rattle'. The snake vibrates the muscles in its tail base to shake the series of hollow, empty, bulb-shaped scales at the tail's end, which tilt and knock against each other.

RAISING THREAT LEVEL

The prairie rattler, one of the larger rattlesnakes, first produces a quiet, slow rattle. Then it raises its head and front body, increases the rattle's volume and speed, and faces the threat, which it first detects by the tiny vibrations of approaching footsteps or similar. The rattler flicks out its tongue to 'taste the air', transferring airborne odour and taste particles to a sense organ in the roof of its mouth.

Rattlers, being in the pit viper group, have another sensory system. A bowl-shaped depression or 'pit' between each eye and the mouth detects infrared or heat radiation, to show direction and size of nearby warm objects. This is how the snake hunts small mammals and birds, and also how it assesses whether to strike at an intruder.

- LOCAL COMMON NAMES
Prairie rattlesnake, Great plains rattler/rattlesnake, Western rattlesnake, Black rattler, Confluent rattlesnake, Missouri rattlesnake, Spotted rattlesnake, Western Pacific rattlesnake; Crotale des prairies (French); Víbora-cascabel occidental (Spanish)

- SCIENTIFIC NAME
Crotalus viridis

- SIZE
Average adult length 110–130cm (43–51in), weight 250–350g (9–12oz)

- HABITATS
Wide range from rocky scree, dry prairies and sandy basins to chaparral, bush, woods, hills and mountains, farmland

- DIET
Small prey such as voles, mice, gophers, squirrels, birds, eggs

- CONSERVATION STATUS
IUCN Least concern (population stable) (see key, page 9)

◄ With head and foreparts raised, a prairie rattlesnake first looks, listens, feels, scents, tastes and heat-senses the scene. It may then open wide to expose its venom-exuding fangs as a final warning.

►► The terminal scales of the rattler's tail vibrate with a clattering sound, as an audible warning that most local creatures recognize. The rounded 'spot' between the eye and tongue is the heat-sensing pit.

SHAKE THAT RATTLE

The tail rattle is derived from former tail-end scales, or buttons. Unlike the rest of the scaly skin, these do not fall off when the snake sheds its covering. The buttons have constrictions to hold them in a loose interlocked chain, and another is added each time the snake moults. Shedding can occur up to four times yearly, and in theory, the number of rattle segments should increase by one each time. However, wear and slackening mean they regularly fall off, so eight to twelve is a common maximum number.

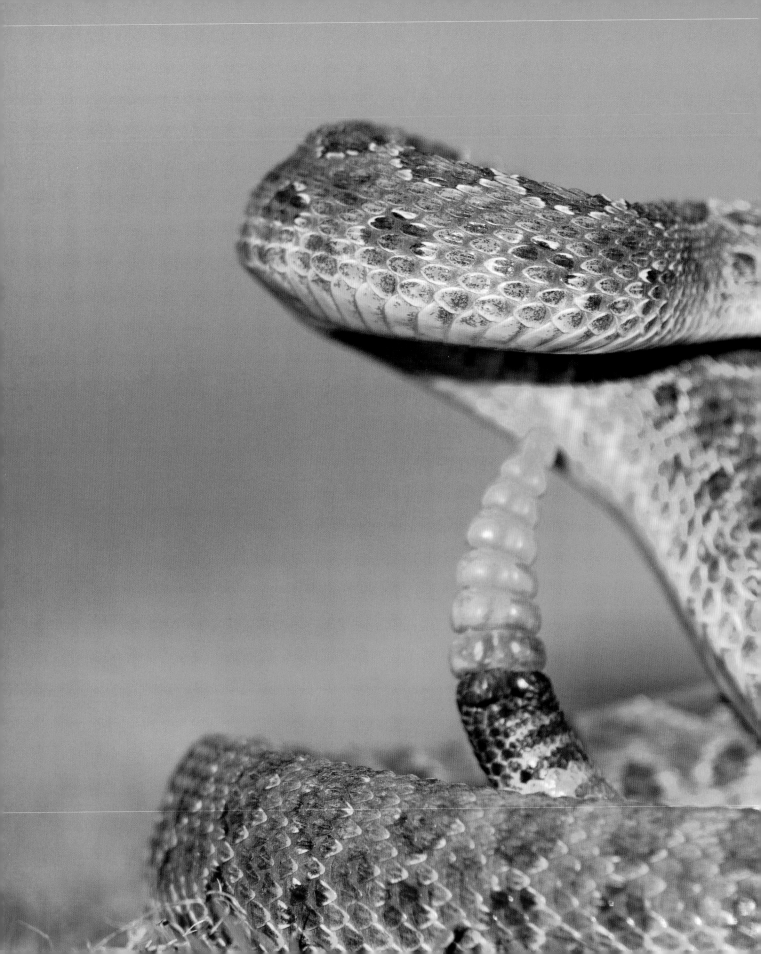

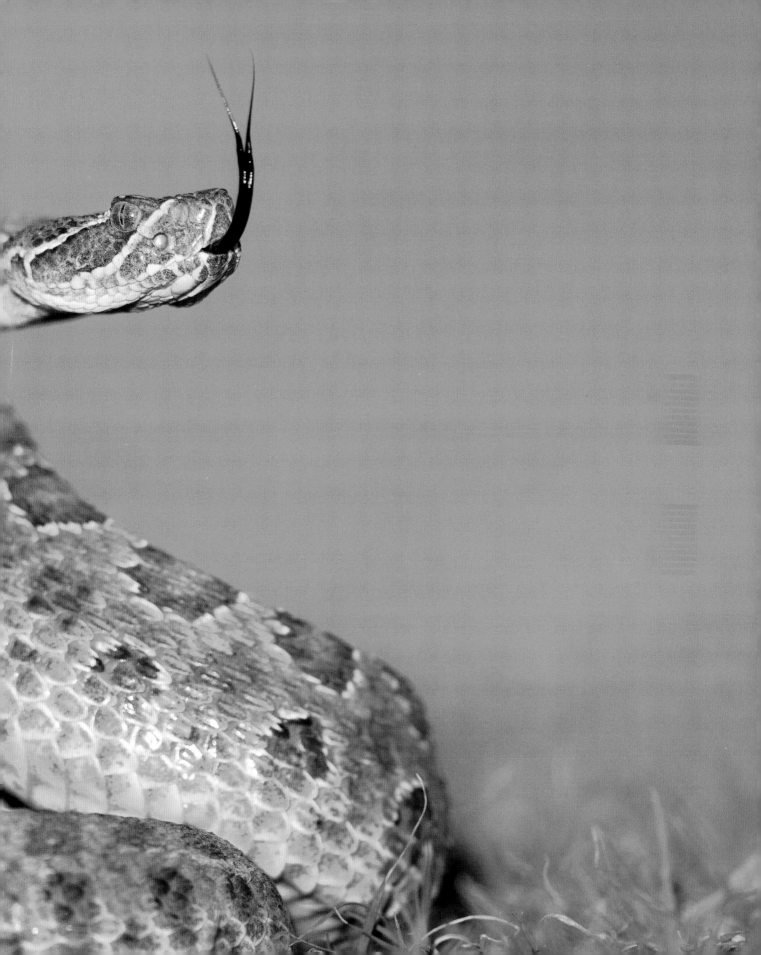

Wild Turkey

STRUT, GOBBLE, SPIT, DRUM

The wild turkey is a considerable bird in size, with the male larger than the female. Breeding time arrives with the fading of winter, starting in late January in the southern parts of the turkey's range, and four to six weeks later farther north. This is when the males, or toms, begin their gobbling and strutting. As with so many courtship and breeding displays, the aim is to show off the individual's fitness and readiness to mate.

A turkey tom in full display is an energetic spectacle. He fans his tail feathers, struts and marches along with jerky steps. Standing erect, his head is held up and back to show off its red-, white- and blue-coloured skin. He plumps up his chest and back feathers and also lowers his wings so the tips drag on the ground. As well as the familiar clattering, rapid-fire gobble, now and then he makes a deep 'chu', 'huff' or 'chump' spitting sound, shakes his tail feathers briskly, and emits a low-pitched drumming 'huumm' or 'boom'.

PECKING ORDER
The strut-and-gobble courtship display is designed to show off the male's breeding fitness to females, or hens. It is also used in other contexts. For example, a male may strut to show dominance over other males in a group, as part of the 'pecking order', or to display to females outside the breeding season in order to remind them of his presence. Females also strut, although in a less flamboyant way, to dominate other females or to defend their nest, eggs or young.

- LOCAL COMMON NAMES
 Guajolote norteño, Guajolote gallipavo (Spanish); Dindon sauvage (French); Perú-bravo (Portuguese)

- SCIENTIFIC NAME
 Meleagris gallopavo

- SIZE
 Male typical head-tail length 100–120cm (39–47in) and weight 7–10 kg (15–22lb), female 75–95cm (29–37in) and 4–5 kg (9–11lb)

- HABITATS
 Generally woods and forests, both mixed deciduous-evergreen and deciduous, especially with open areas such as fields, meadows, orchards and wetlands, other habitats vary from semi-deserts to swamps

- DIET
 Mainly plant matter such as seeds, fruits, nuts, buds, leaves, roots, occasionally small animals such as insects, frogs, lizards

- CONSERVATION STATUS
 IUCN Least concern
 (see key, page 9)

TALKING TURKEY

There are two species of turkeys, the American wild as described here, and the ocellated turkey, *Meleagris ocellata*, with a much smaller range in the Yucatan region of north-east Mexico. The American wild turkey has about six varieties or subspecies, such as the Osceola wild turkey, *M. g. osceola*, in Florida, and the Merriam's wild turkey, *M. g. merriami*, of the Midwest, Rocky Mountains and south-west. Our familiar farm turkeys are descended from the wild turkey.

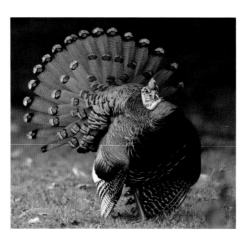

◀ The ocellated turkey is named after eyespots, ocelli, at the end of its tail feathers.

▶ Tail up and fanned, wingtip primary feathers lowered, a male wild turkey struts his stuff at breeding time. Prominent is the snood, a long fleshy flap at the base of the bill that here covers the bill, and the wattle of bumpy skin hanging on the neck. These parts become much brighter for the breeding display.

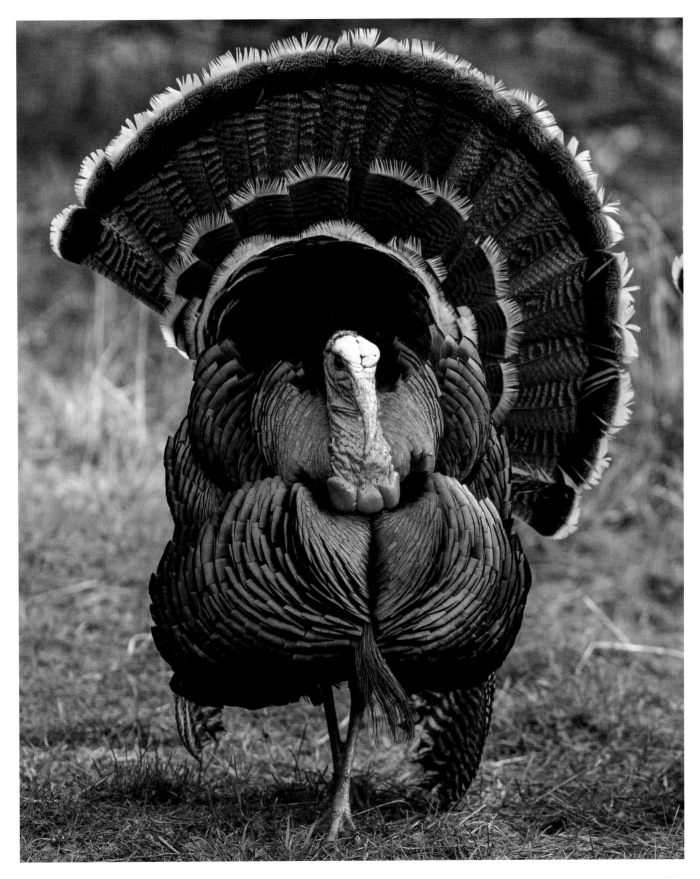

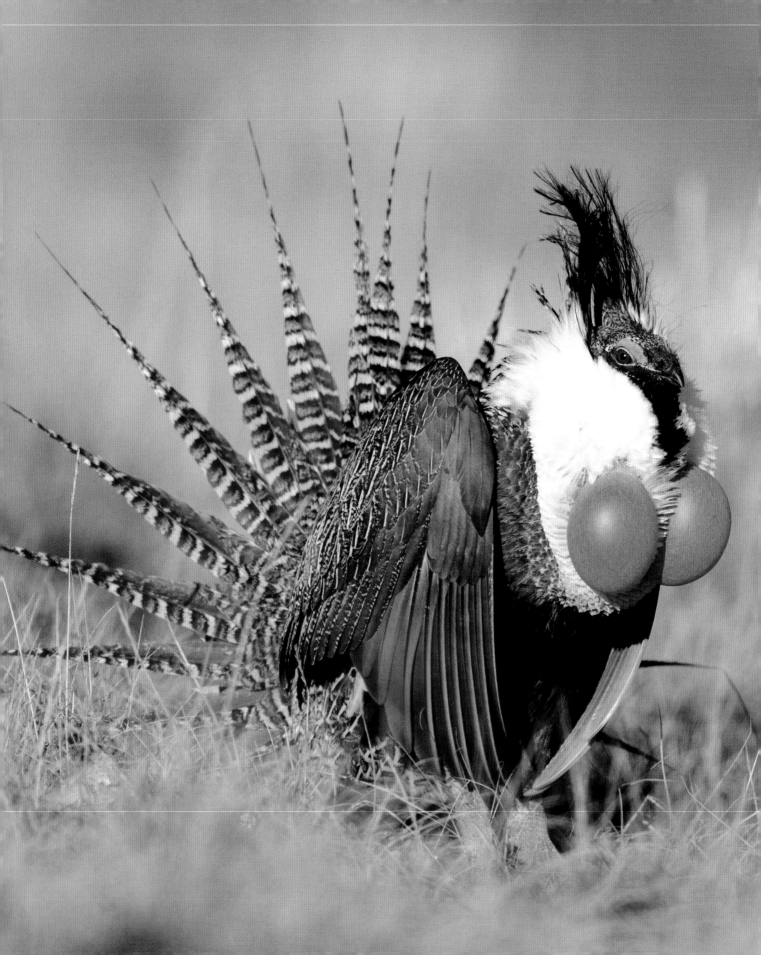

Gunnison sage grouse

LIFE AT THE LEK

The Gunnison or lesser sage grouse is a slightly smaller cousin of the more widespread greater sage grouse. Like many members of the grouse and gamebird family, it has an energetic, showy, eye-catching display. In spring, males gather at a traditional site called a lek. Here they prance, strut and call to watching females.

DISTRIBUTION MAP

Gunnison sage grouse

Grouse mating systems are known as polygynous, which means numerous females mate with one male. Many males congregate to show off at an open arena known as a lek, used by the local grouse for decades, even centuries. Each lek is usually on a relatively bare patch of open ground with clear visibility.

PRANCING AND POPPING
From about mid-March, male Gunnison collect at their local lek and practise their performances. They fan tails, prance and strut, vocalize their mating calls, and lean or lunge forwards to make popping and gurgling noises with their inflatable air sacs. These flexible chambers of skin on the throat and chest, called gular pouches, belch or burp out the sounds. This preliminary action, before females arrive, decides which males occupy which of the small territorial areas at the lek.

The central zones are most closely monitored by females and the biggest, best-performing males claim these. During the main lekking period, March and April, the males' displays can continue for hours, mainly morning and evening. But most displaying males are disappointed. Of twenty or perhaps thirty, only the two or three individuals towards the centre of the lek become fathers.

- **LOCAL COMMON NAMES**
 Gunnison sage grouse, Lesser sage grouse, Gunnison or lesser sage-hen or sage-chicken; Tétras du Gunnison (French)

- **SCIENTIFIC NAME**
 Centrocercus minimus

- **SIZE**
 Male length 65–75cm (25–29in) and weight 1.5–2.5kg (56–88oz), female 45–55cm (18–21in) and 1–2kg (34–71oz)

- **HABITATS**
 Open country dominated by sagebrush, *Artemisia*, grasses and low shrubs

- **DIET**
 Soft plant matter such as leaves, fruits, chiefly of sagebrush, also insects and other small creatures

- **CONSERVATION STATUS**
 IUCN Endangered, populations decreasing
 (see key, page 9)

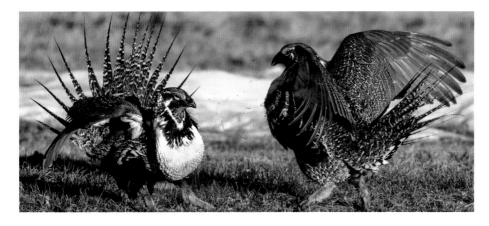

◄ A male Gunnison postures with tail filoplumes (narrow feathers) spread, wings hunched and tips angled to the ground, and gular skin pouches inflated to make their characteristic popping or cracking noises.

▲ Two males confront to out-impress each other and gain the best display site. In the background is the flat, open scene of the communal display area, the lek.

ALREADY AT RISK
The Gunnison sage grouse is named from the Gunnison Basin, south-west Colorado. This is the species' stronghold, with smaller populations in other parts of Colorado and south-east Utah. It was formerly included with the greater sage grouse species, *C. urophasianus*. However bird experts noticed the Gunnison's smaller size and slightly different plumage, calls and behaviours. In 2000 it was classified as a species in its own right.

Yellow-crowned night heron

TOGETHER FOR THE SEASON

Exactly how and when yellow-crowned night herons indulge in courtship and form a pair bond is something of a mystery. The breeding season usually begins in March in North America. In a particular area, some individuals are already present as residents, while others arrive on migration. Generally, the farther north, the greater the proportion of migrants to residents. However, some birds have already paired and show a strong bond, while others have yet to start their courtship displays.

In some areas, yellow-crowned night herons are known as crab herons or crab-eaters. Crabs, crayfish and similar crustaceans are their dietary mainstay. The birds' migrations and breeding are largely based on their food, when increasing numbers of crabs and crayfish provide the birds with plentiful nutrition to raise their families. In turn, crab reproduction varies with temperature, being earlier in more tropical/subtropical parts of the herons' range, and later further north or south.

GREETINGS, PARTNER
Yellow-crowned night herons have several courtship and bonding displays. Some take place in flight, as the pair chase each other, flap wings in an extravagant manner, and circle each other as they swoop and dive.

On the ground, the 'stretch behaviour' is when the bird flexes its neck up and down, but the head stays level. After a temporary absence, for example, foraging for food, the pair greet by raising and fanning out their wing and tail feathers rearwards, as the male erects his head crest and shoulder or scapulae feathers. Vocalizations include a quiet 'yup-yup', also a throaty 'huh' and a high whoop from the male.

- **LOCAL COMMON NAMES**
 Crab heron, crab-eater heron; Bihoreau violacé (French); Pedrete corona clara (Spanish)

- **SCIENTIFIC NAME**
 Nyctanassa violacea

- **SIZE**
 Height 55–65cm (21–25in), wingspan 105–115cm (41–45in), weight 650–800g (22–28oz)

- **HABITATS**
 Freshwater wetlands and saltwater coasts, including wooded marshes, rivers, lakes, floodplains, tidal lagoons, mangrove forests, rocky coasts and cliffs

- **DIET**
 Aquatic and land creatures from little worms, snails, shrimps and the mainstay of crabs and crayfish, to lizards, snakes, small birds and their eggs, and small mammals such as mice

- **CONSERVATION STATUS**
 IUCN Least concern
 (see key, page 9)

PROBLEM INTRODUCTION
After humans came to the Caribbean island of Bermuda, they and their introduced animals gradually exterminated the local Bermuda night heron, *Nyctanassa carcinocatactes*, a close relative of the yellow-crowned. This species specialized on crabs as food, controlling their numbers. With the Bermuda night heron gone, gradually the crabs became a plague. In the 1970s, yellow-crowned night herons were introduced to control the crabs. However their more varied diet means they too have spread at the expense of the local wildlife.

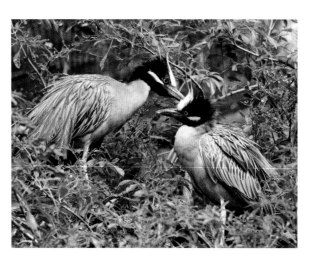

◄ A pair of yellow-crowned night herons affirm their pairing with close perching and soft 'yup-yup' calls.

► Wings and tail raised and fanned, a yellow-crowned night heron displays during courtship. The front row of shorter, slimmer, more widely spaced plumes are scapular feathers which usually cover where the wing base joins to the body.

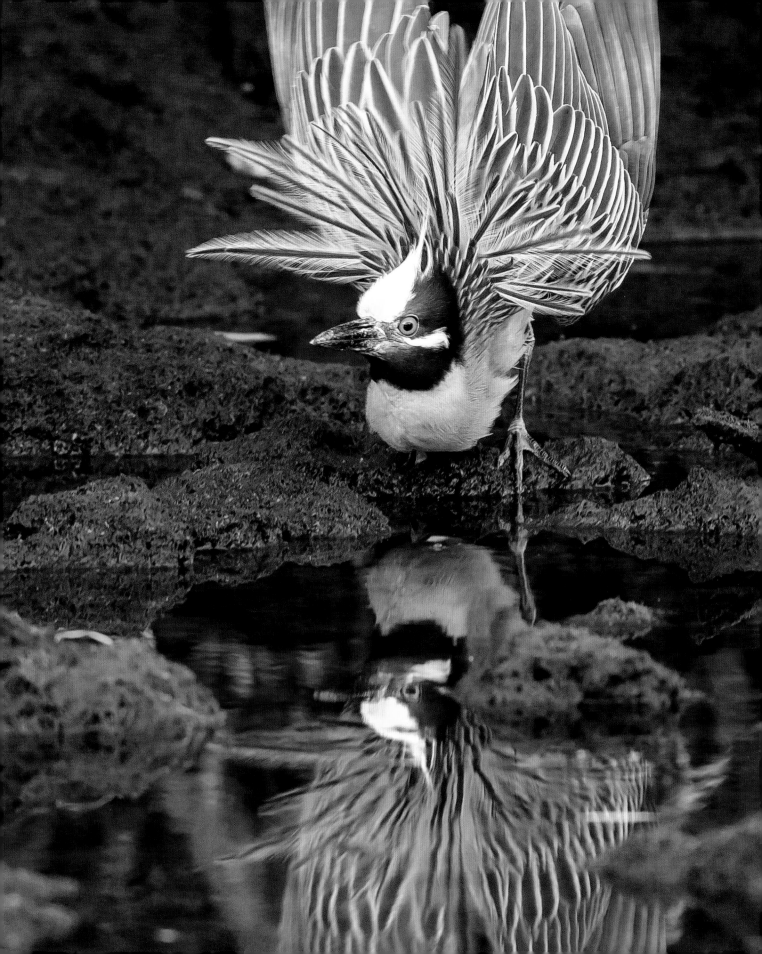

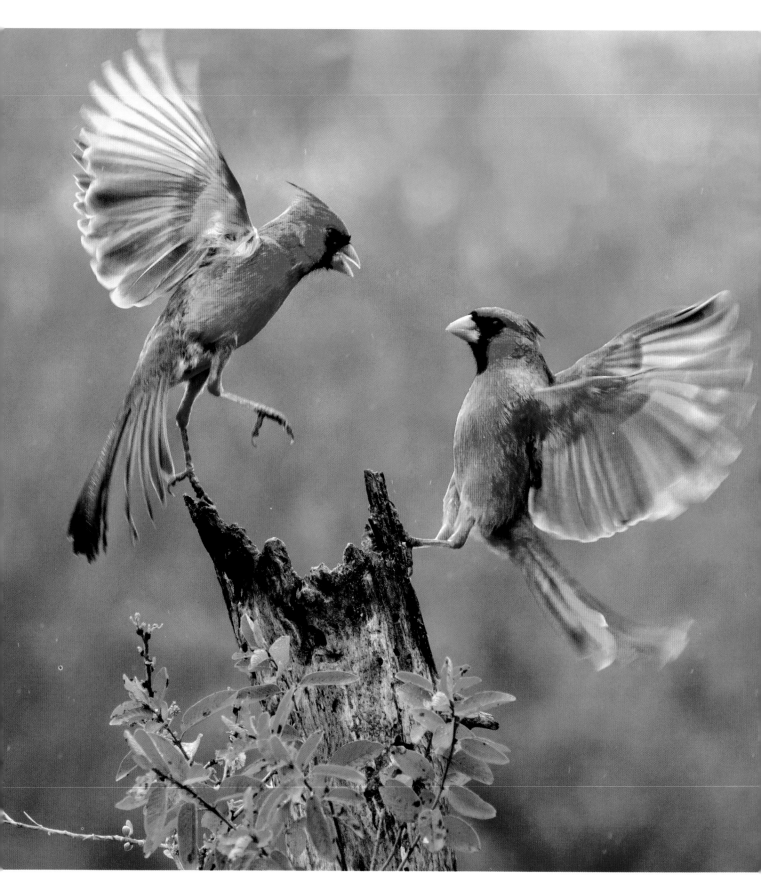

Northern cardinal

DOGGED DEFENDER OF TERRITORY

As spring approaches the male northern cardinal becomes very aggressive in defence of his territory. He flies, flaps, sings, kicks, perhaps pecks, and generally harasses male intruders of his own species, and sometimes other birds as well. However his behaviour to his female partner could not be more different. When courting and pair bonding they perch together, sing together, feed each other, and the male brings food to the female on the nest, through the whole breeding season, and perhaps for following years.

To avoid engaging in a physical encounter, which could be costly in terms of injury, the male northern cardinal marks out his territory with song. He patrols the borders, perching in various high and prominent sites, and sings loudly and clearly. He has a wide repertoire of whistle-like phases, often repeated and segueing into each other, such as 'chairy-dote, chairy-dote', 'wach-eer, wach-eer', 'weet, weet', 'wot-wot-wot' and 'hoo-it, hoo-it'.

SELF-DEFENCE, SELF-ATTACK

If this clear and carrying audible defence of territory does not work, a rival male may approach. The two eye each other, then engage in a blur of flapping and general combat. Usually the contest is soon over – with the stronger, fitter male the winner.

However, the modern world holds a danger for the male northern cardinal. Sometimes he sees his reflection in a window, car mirror, hubcap, shiny garden pot or similar. He threatens and attacks – and, puzzlingly for him, the opponent does precisely the same. The battle can continue for minutes, even on and off for hours, and some males even injure themselves.

DISTRIBUTION MAP

- **LOCAL COMMON NAMES**
 Cardinal, Common cardinal, Red cardinal, Cardinal grosbeak, Red-bird, Virginia nightingale, Virginia red-bird, Crested red-bird, Top-knot redbird; Cardenal rojo (Spanish); Cardinal rouge (French)

- **SCIENTIFIC NAME**
 Cardinalis cardinalis

- **SIZE**
 Length 20–25cm (8–10in), wingspan 28–32cm (9–11in), weight 40–50g (1.4–1.8oz)

- **HABITATS**
 Woods, shrubland, wetland, mixed farmland, parks, gardens

- **DIET**
 Seeds especially of grains and other grasses, fruits, flowers and other plant parts, also small insects, snails and similar invertebrates

- **CONSERVATION STATUS**
 IUCN Least concern (see key, page 9)

◄ Two male northern cardinals engage in a flurry of flapping and feathers. Such encounters only occur if, after listening to and watching the resident male, the intruder considers he can take over the territory.

SPECIES CONFUSION

Sexual dimorphism, when female and male differ in appearance, might have been invented for the northern cardinal. The male is almost impossibly red, crimson or scarlet, with a black 'mask' around the base of the bill and chin. The female, slightly smaller, is light brown, fawn or brownish-green, with a dark but less demarcated 'mask', and hints of red on the wings and tail. Early European settlers in North America thought these were two very different species.

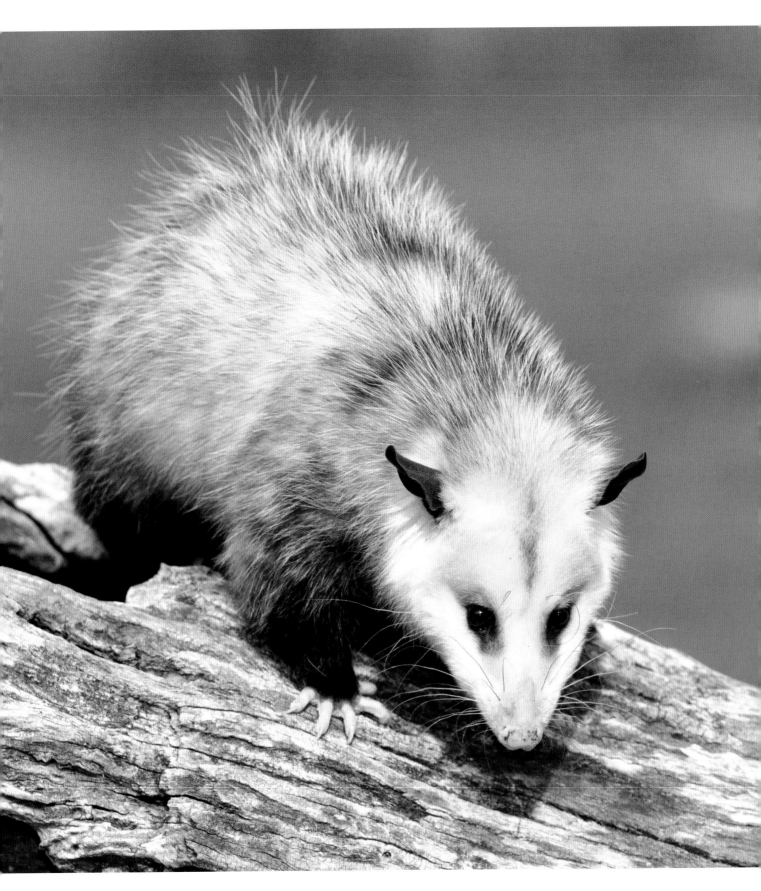

Virginia opossum

FATAL DISTRACTION

The term 'playing possum' has passed into everyday English. The Virginia opossum or 'possum' provides one of the clearest displays of feigning death. It pretends to be deceased, comatose, apparently dead. This anti-predator tactic is found in various animal groups: insects; fish; amphibians such as certain frogs; reptiles like snakes (see page 90); birds; and mammals other than the possum. It has several technical names, including thanatosis and tonic immobility.

A possum under threat at first confronts the attacker, snarls, hisses, bares its teeth, and fluffs out its fur, all to look bigger and fiercer. If this fails, the animal may suddenly fall over and lie still, curled, eyes open, mouth open, lips drawn back, and dribbling with tongue out, but motionless. It may also expel a foul-smelling liquid from its anal glands, and perhaps urinate and defecate as well. This presents the assailant, especially one that usually hunts prey which fight back, with a confusing and disagreeable situation.

AN UNAPPETIZING MEAL
Playing dead may work in several ways. Many possum predators – and there are many – generally follow a behavioural sequence of attacking and killing a victim, and consuming it while still alive or only just dead. The motionless possum, with heart and breathing so slow as to be barely detectable, disrupts this sequence. There is no active prey to tackle. The possum could have died from parasitic infestation, microbial infection or other disease, and its putrid anal liquid and rigor-mortis-like muscles all add to the impression of decaying, rotting flesh. Many carnivores, unless specialized carrion-eaters, instinctively and actively avoid these food sources due to the risk of poisoning themselves.

- **LOCAL COMMON NAMES**
 Possum, Virginia possum, North American opossum/possum; Tlacuache norteño (Spanish); Opossum d'Amérique (French); Wapathemwa (Algonquian Native American)

- **SCIENTIFIC NAME**
 Didelphis virginiana

- **SIZE**
 Very variable, usually larger in the north, and males bigger than females: head-body length 40–70cm (16–27in), tail length, 25–45 cm (10–18in), weight 0.5–5kg (1.1–11lb)

- **HABITATS**
 Varied and adaptable, from woods, scrub and farmland to parks, gardens and urban centres, usually near water

- **DIET**
 Extremely varied and opportunistic, from plant matter, insects, frogs, birds, mice and many other small animals, to eggs, carrion and all kinds of edible human garbage

- **CONSERVATION STATUS**
 IUCN Least concern (see key, page 9)

◄ Virginia opossums are active, agile and opportunistic. They take advantage of many human habitats such as towns and cities, especially eating our unwanted food.

► A possum in classic tonic immobility display is unresponsive to physical contact. Its natural reflexes, such as blinking or pulling away a touched part, are suspended.

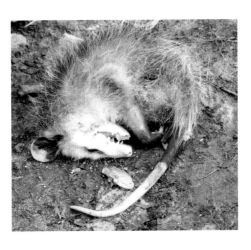

REAL OR MAKE-BELIEVE?
Does a playing-dead possum go into a kind of deep sleep or trance, or is it still awake and aware? Their brain electrical activity, monitored by the medical device called an electroencephalogram (EEG), shows little difference between normal consciousness and the tonic immobility state. However it seems that the possum needs a period of quiet and not being stimulated or touched, before it 'wakes up'.

American black bear

SLOW TO CONFRONT, READY TO STAND UP

Around the world, bears are regarded by people with a time-honoured mix of wonder, awe, respect, caution and fear. Their mainly solitary nature, bulk, power, and formidable weaponry are viewed with caution. If treated knowledgeably by humans, bears prefer non-confrontation. The American black bear, in particular, prefers to turn away roam elsewhere. However, among its own kind, it occasionally needs to stand up for itself, both figuratively and literally.

Experienced bear-watchers recognize dozens of social signals. A bear with mouth slightly open may be taking a long yawn, or using its excellent senses of smell and taste, or showing slight signs of nervousness (especially if the head is held low), or approaching a possible breeding partner. Or – and especially between males – it may be assessing a rival before a challenge.

BEAR NECESSITIES

Apart from mating and maternal defence of cubs, the usual reason for two bears challenging – generally males – is to establish dominance.

This is a central part of gaining access to food, females, perhaps a winter den, and similar requisites.

Usually the contenders circle each other on all fours, mouths open, grimacing to expose teeth. They may come together, rear up on hind legs to look intimidating, and mouth each other with open jaws. If they are well-matched, they try to bite the other's face and neck, tussle, push and swipe with their front paws. Such battles rarely result in serious injury, as the vanquished individual slumps down onto all fours and ambles away. Occasionally, however, there are long-lasting wounds and scars.

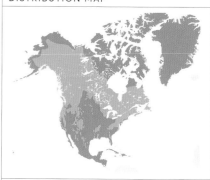
IMPORTANCE OF SMELL

Bears have an excellent sense of smell due partly to their well-developed vomeronasal (Jacobson's) organ. This is a patch of smell-sensitive tissue towards the rear floor of the nasal cavity. A bear licks its muzzle or protrudes its tongue to gather scent particles, then distributes these into the mouth and nose for detection. It is important when searching for a mate, foraging, and for assessing a challenge. The organ is well developed in certain other mammals (although not humans), also in lizards and snakes (see page 144).

▶ Battling or even courting black bears look alarming, but in most cases, much of the action is symbolic or ritual rather than aimed at serious damage. Usually the contest concludes in a mutually agreed way and the subordinate retreats.

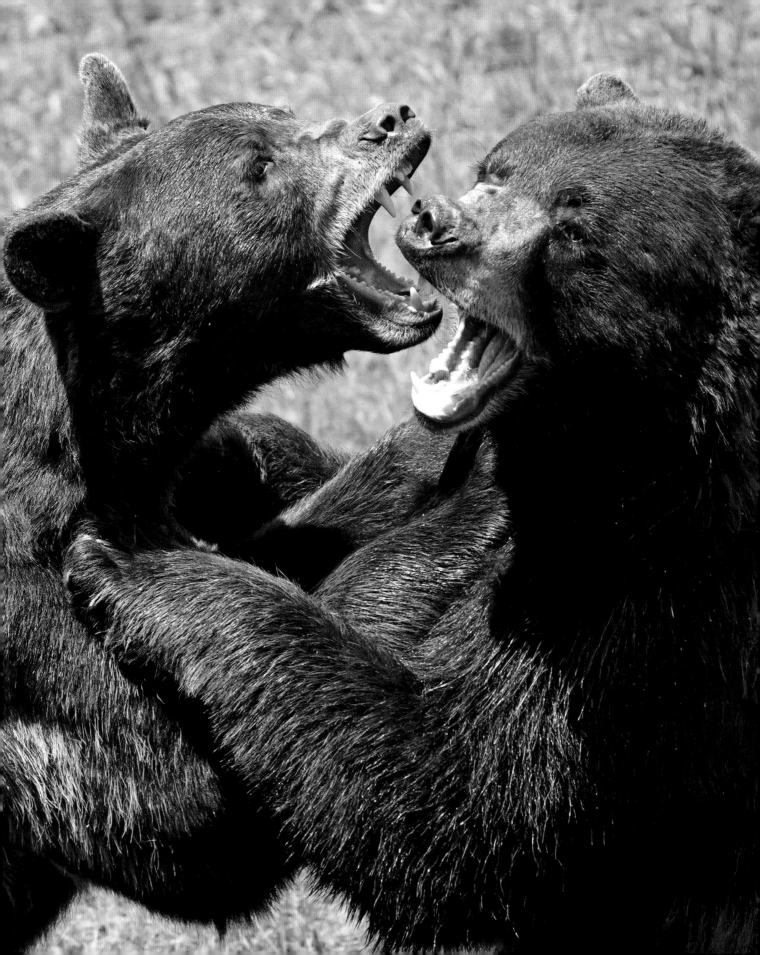

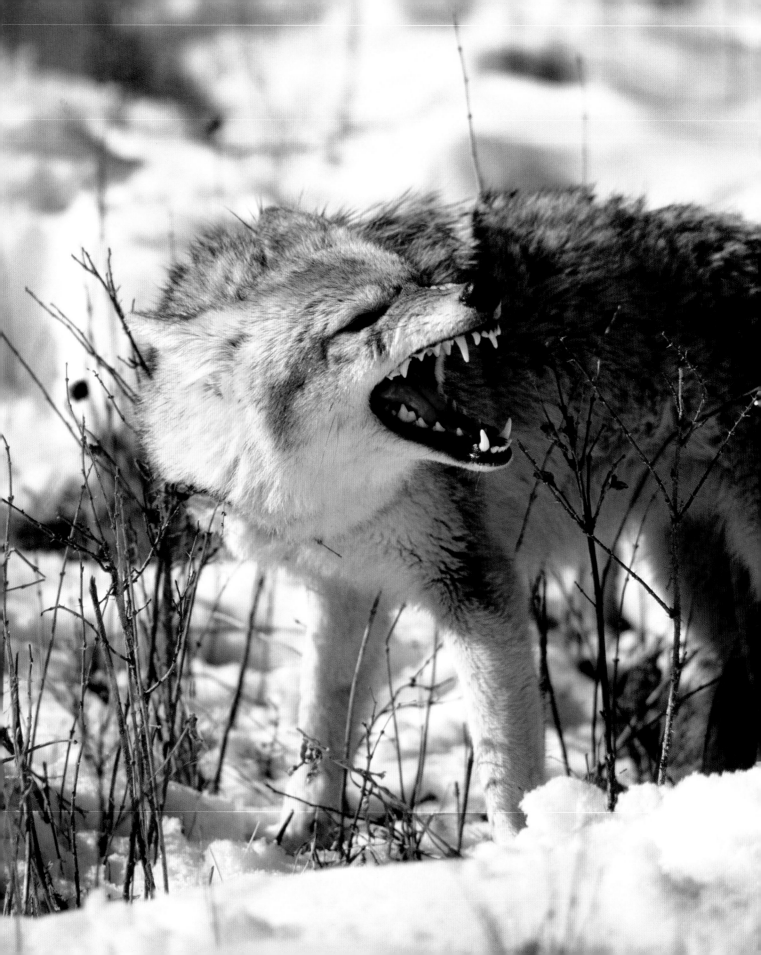

Coyote

ORDER IN THE GROUP

Long thought to be lonesome wanderers, howling forlornly in the dark American wilderness, recent studies show that coyotes are relatively social. During these social interactions, as well as at breeding time, they show various threat, defensive, aggressive and appeasement displays. Many elements of the coyote's behaviour are recognizable from those of our 'best friend', the closely related domestic dog, and in the ancestor of both coyotes and dogs, the grey wolf, *C. lupus*.

Coyotes display with almost every part of their body, as well as by sounds. The chief signals are being aggressive or submissive to other members of the 'pack', although this social system is rather looser, more informal, and less organized and long-lived than in wolves. Subordinates show their rank by crouching or lying, ears flattened, and opening their mouths, but with less intent to attack or bite. Dominant individuals stand more erect with ears upright and jaws thrust forward.

A WORKING HIERARCHY
The main coyote group consists of a senior mating pair, their offspring of the year, and sometimes juveniles from the previous year. Like wolves and feral dogs, they arrange their dominance hierarchy around the chief female. Coyote groups hunt together and occupy a territory at breeding time that they defend, mainly against wandering males. Any member of the group can warn of an advancing intruder: then other active members gather around for displays of aggression and repulsion.

If a receptive female arrives, non-mating males in the group may readily leave to follow her and set up their own groups. During the pupping season they must also carve out their own territories.

DISTRIBUTION MAP

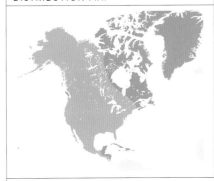

- LOCAL COMMON NAMES
Little wolf, prairie wolf, brush wolf, American jackal; Perro de monte (Spanish); also very many indigenous American language and dialect names

- SCIENTIFIC NAME
Canis latrans

- SIZE
Varies according to geographic region, being larger further north; in general head-body length 100–130cm (39–51in), tail length 35–45cm (14–18in), weight 10–20kg (22–44lb)

- HABITATS
Exceptionally adaptable, almost any habitat, from subpolar forests to arid plains to subtropical swamps, including around human habitation

- DIET
Mainly carnivorous, any animal prey from insects and crayfish to deer and sheep, occasionally plant matter, also carrion and edible garbage

- CONSERVATION STATUS
IUCN Least concern
(see key, page 9)

◀ Fur on end, ears flat back, eyes narrowed, jaws agape, lips retracted, fangs bared – compare this display to the bobcat on the next page.

▶ A dominant coyote group displays seniority by standing over a more submissive member, who lies in appeasement. Usually the breeding female and her current partner occupy dominant positions, but the hierarchy is not so clear or sustained as in wolf packs.

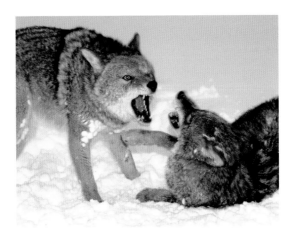

MANY-NAMED DOG
Partly because of its vast range of habitats and foods, and its role in tradition and folklore, the coyote has more local names than almost any other North American creature. The main English term 'coyote' is probably from *coyōtl*, a Nahuatl/Aztec/Mexicano expression. Similar names include *cayjotte* and *cocyotie*. Some Navajo peoples use *ma'ii*, referring to the coyote's place as a god-like dog spirit. In the Hopi group of languages it is *iisaw*. Many others are sadly now forgotten.

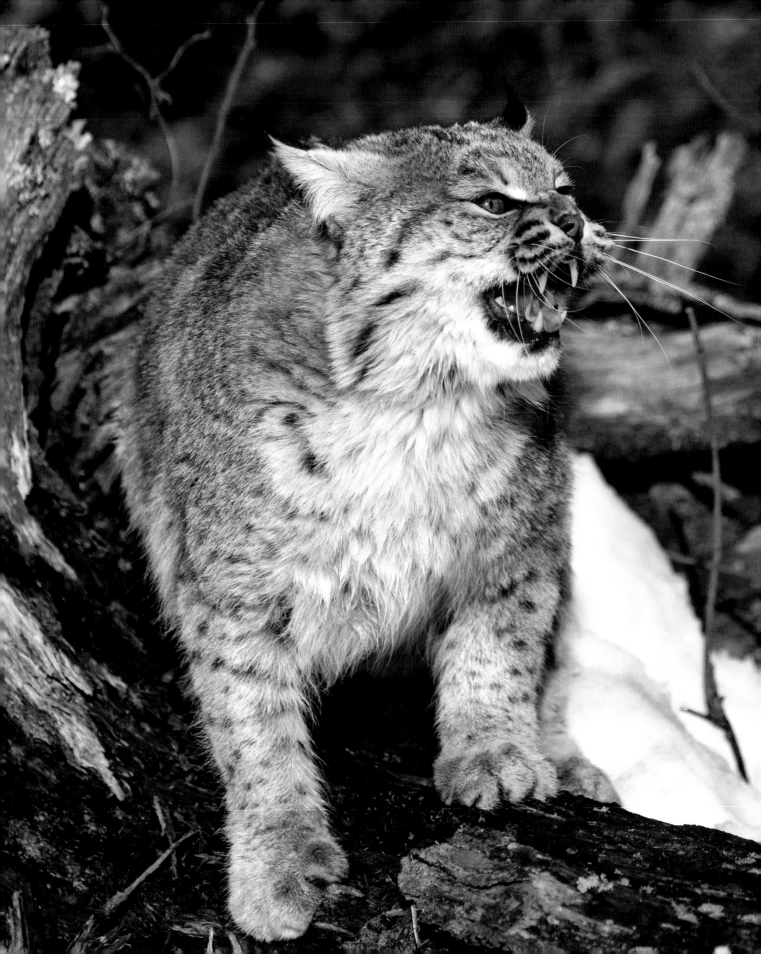

Bobcat

TEETH AND CLAWS AND SNARLS

From the smallest wild cats to the biggest lions and tigers, cats show a familiar response to threat. The body crouches ready to pounce or spring or flee, the tail swishes from side to side, the fur fluffs up on end, ears lay back, eyes narrow to slits, the nose wrinkles, and the mouth opens with lips curled back to expose the awesome sharp teeth. Audible are hisses, growls and perhaps spitting. All this can happen within a second.

Pets like our cats, and also dogs (see previous page), teach us much about wild animal behaviour. Our domestic cats, *Felis catus*, were part-tamed as long as 10,000 years ago, from wildcats *Felis silvestris* in West Asia and North Africa. However they still show many of their ancestors' behavioural traits, and one of the most striking is reaction to a threat. The bobcats' defensive/aggressive display very similar.

As they hunt, bobcats mark their territories with urine, faeces and claw marks. If a male, especially, encounters an intruder male in his territory, there may be cat-to-cat aggression. A male who detects a female in his area is less likely to initiate an encounter, since a male's area usually overlaps those of several females. In addition, amicable relationships with females are valuable when the breeding season arrives.

AN OCCASIONAL PREY

Bobcats not especially large. They themselves are sometimes hunted by wolves, bears, larger cats like cougars (pumas) and Canada lynx, also eagles, crocodiles and alligators. At these times the bobcat's defence display comes into full force, and it is known as a fierce and tenacious adversary.

- LOCAL COMMON NAMES
 Red lynx, Bay lynx; Lince americano (Spanish); Lynx roux (French); many names in indigenous American languages, such as Dukuvits, Sehe tukuvits (Shoshone)

- SCIENTIFIC NAME
 Lynx rufus

- SIZE
 Head-body length 50–100cm (19–39in), 'bobbed' tail 10–20cm (4–8in), weight 5–15kg (11–33lb), males 25–40% larger than females.

- HABITATS
 Versatile, from rocky mountains to lowland swamps, dry plains to thick forest, suburban and even urban areas

- DIET
 Opportunistic, preferably small-medium mammals and birds such as rats, rabbits, hares, raccoons, ducks, but also any creatures from insects, small fish and frogs to sheep and deer

- CONSERVATION STATUS
 IUCN Least concern
 (see key, page 9)

◄ A bobcat demonstrates more than a dozen elements of behaviour that characterize a cat's aggressive-defensive presentation. The claws are partly extended to grip the ground, ready to leap in whichever way the bobcat decides, and perhaps to swipe at or sink into the adversary.

► With snow on the ground, bobcats face off in a chilly stream. Shortage of food in winter may be the cause of this scuffle for a valuable prey item.

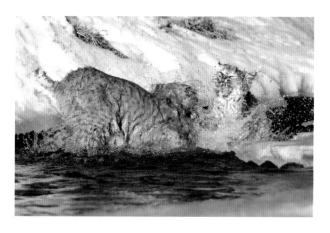

CLOSE COUSINS

The bobcat is one of four *Lynx*. From largest to smallest, these are the Eurasian lynx (*L. lynx*), the Iberian lynx (*L. pardinus*, a rare species from Europe's Iberian peninsula), Canada lynx (*L. canadensis*, from northern North America), and the bobcat. They are all closely related and have very similar behaviours, including their defence-aggression displays. Interbreeding is known between the bobcat and Canada lynx.

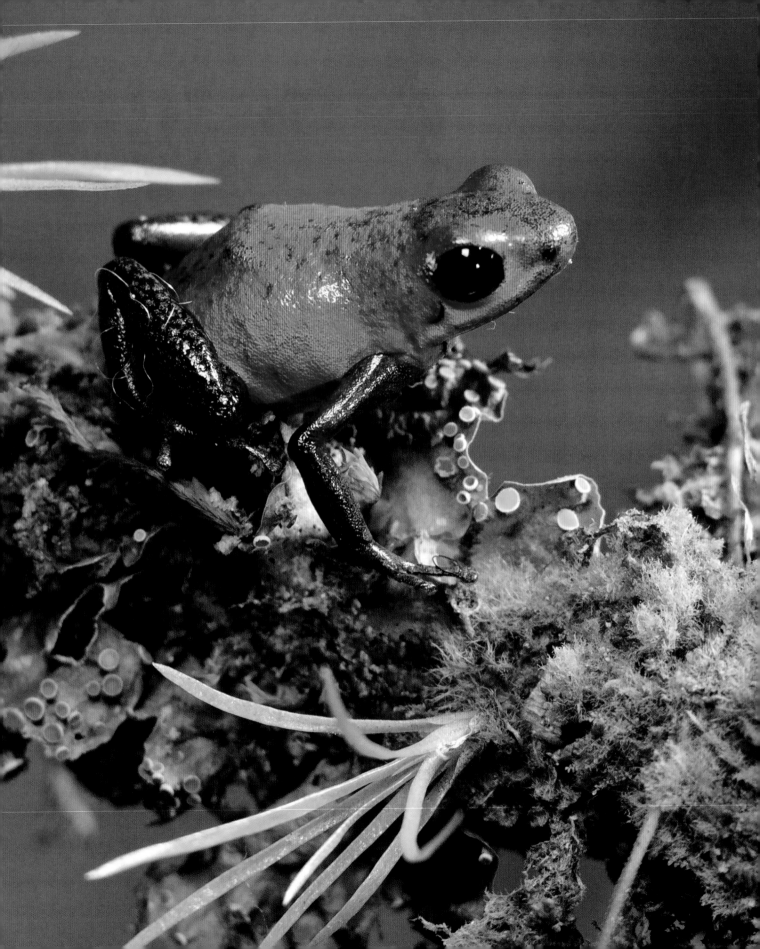

Central and South America

Postman butterfly

PLAYING THE MATING TUNE

Tropical butterflies are a complicated topic in biology. For example, what was believed to be one individual kind, or species, with members able to breed together but not with other species, may turn out to be several species. Or the reverse. The postman butterfly of Central and South America fits both these categories. However the butterflies themselves seem to cope. They put on visual mating displays and send out airborne scent signals, called pheromones, to select mates.

Like many of their kind, male postman butterflies flap and display to watching females. But before this visual contact, the females themselves have sent out natural body chemicals called pheromones, which waft in the breeze around the local area, perhaps for hundreds of metres. The males detect the pheromones using their feathery antennae, or feelers. By flying in a zig-zag pattern, the males sense the strongest pheromone trail and its direction, using its difference in level between the left and right antennae. In this way they gradually narrow it down to approach the scent-sending female.

VITAL WING PATTERNS

Postman butterflies exist in a dazzlingly wide variety of colours and patterns, known as morphs. As a male approaches a female, they scrutinize each other visually. One of the chief factors is whether a potential pair recognize each other's morph. The postman's eyes have acute vision and they can see ultraviolet light, which is emitted by the patterns on the wings, especially as these move and flap. If pheromones and wing patterns coincide, the pair are set to come into contact and make a final physical check before mating.

DISTRIBUTION MAP

- LOCAL COMMON NAMES
 Piano-key butterfly, Passionflower or Passionvine butterfly

- SCIENTIFIC NAME
 Heliconius melpomene

- SIZE
 Wingspan 35–40mm (1.4–1.6in)

- HABITATS
 Mainly open areas, especially along waterways, also edges of farm cultivation and urban locations

- DIET
 Caterpillar: various parts of passionflower plants, *Passiflora*, such as granadillas and related species
 Adult: pollen and nectar

- CONSERVATION STATUS
 IUCN Not evaluated
 (see key, page 9)

SAFETY IN COLOURS

In Müllerian mimicry (see page 6), certain combinations of the same warning (aposematic) colours in widely varied species indicate they are poisonous, harmful, distasteful or dangerous. Common permutations include black with red or yellow or orange, seen for example in frogs (see page 49), salamanders, wasps, bees, ladybirds – and butterflies. Predators who survive an encounter come to recognize and avoid these colours, so all the mimics benefit. All of these colour combinations are used by various forms of postman butterflies.

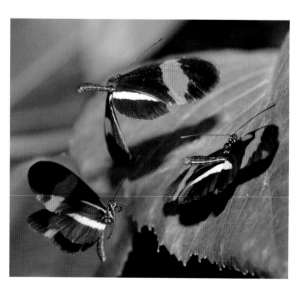

◄ Postmen of *Heliconius melpomene rosina* gather on leaves to assess each other. The combination of black, red and white warns predators about their bad-tasting flesh.

► Courtship dancing and positioning to mate are displayed by the form of postman called the piano-key butterfly. The black and white 'piano keys' may occupy more than half of each rear wing, or only a narrow edging.

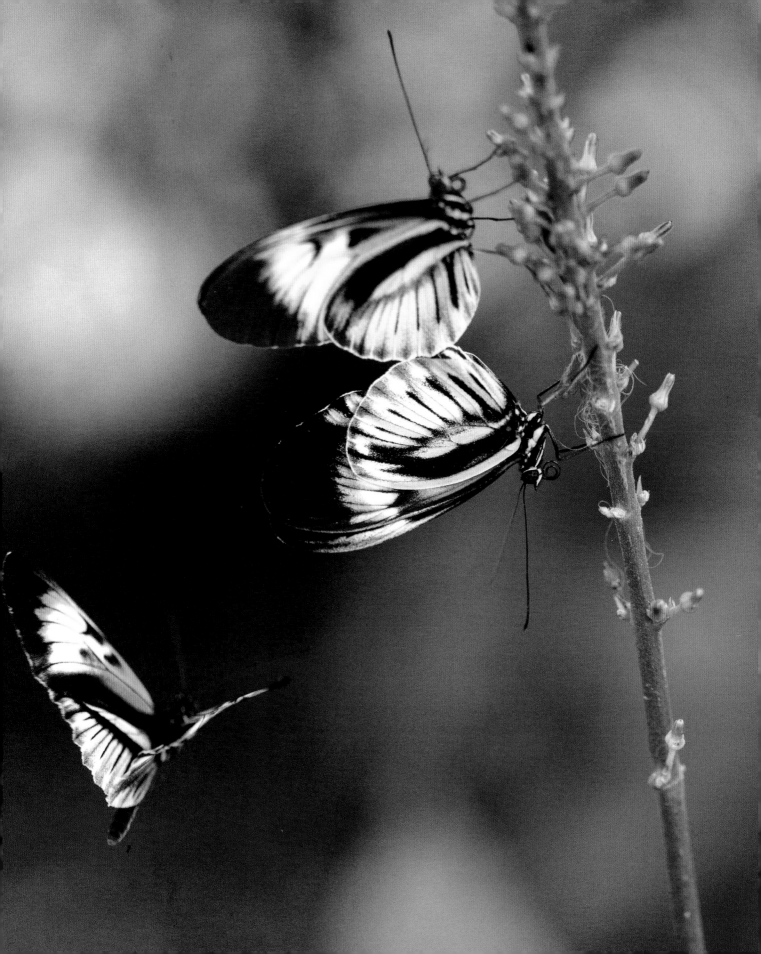

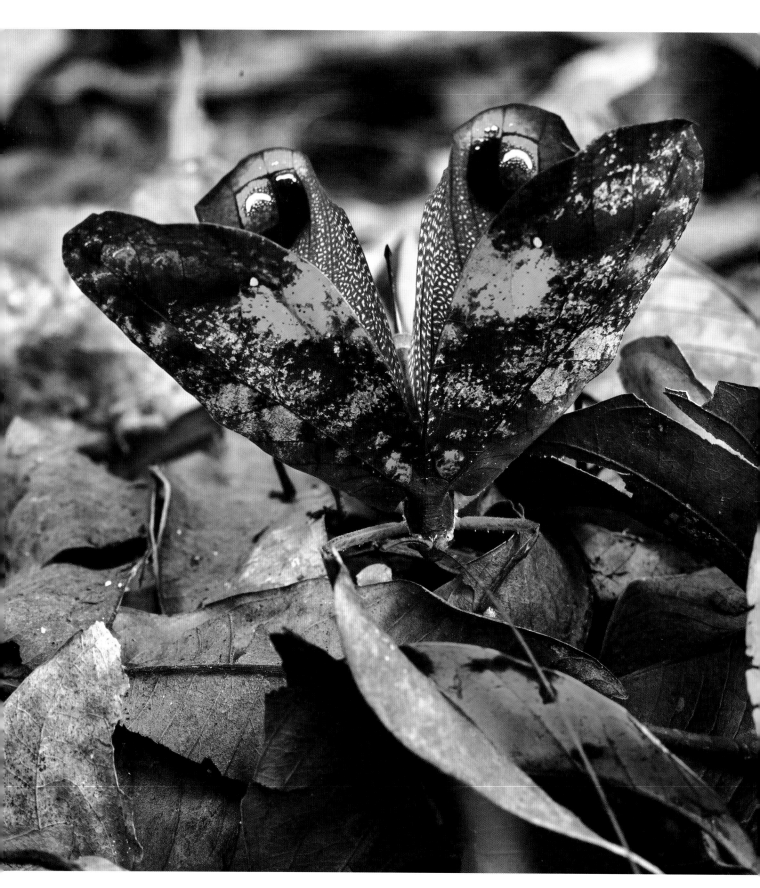

Peacock katydid

FROM DEAD LEAF TO SCARY EYES

Deep in the rainforest of northern South America, a monkey picks through twigs, leaf litter and other debris, searching for fallen fruits and seeds. Prodding what looks exactly like a dead leaf, the monkey is startled when two large scary eyes suddenly stare back. The display is enough to make the monkey retreat in haste. Meanwhile the peacock katydid folds its wings and resumes its own feeding, munching leaves and other plant matter.

Naturalists have observed this actual behaviour between monkeys and peacock katydids. Eyespots are among the most displayed items for self defence, shock or alarm. The traditional reason is that a pair of these big, round eyes, with their circular contrasting colours staring out from a plain background, mimic the eyes of powerful predators such as cats, owls and hawks. Many creatures use eyespot displays for various reasons – especially male peacock birds, after which the katydid is named.

NOT QUITE SO SIMPLE
However, recent research has queried this belief. Experimenters displayed various designs of circular eyespots, and also other shapes like squares and lines, printed onto pretend paper moths, to birds whose reactions were recorded. It seemed that not only resemblance to predator eyes was important. Making the eyespots smaller, bigger, of different colours, different shapes, or even more numerous, could sometimes bring about startle reactions in the birds. The researchers concluded that eyespots looking like predator eyes represent just a single factor in this defensive display. Other aspects include various contrasting and conspicuous shapes and patterns on a plain background.

DISTRIBUTION MAP

- LOCAL COMMON NAMES
 Dead-leaf katydid, Peacock grasshopper, Peacock cricket

- SCIENTIFIC NAME
 Pterochroza ocellata

- SIZE
 Body length 50–65mm (2–2.5in), wingspan 100–125mm (4–5in)

- HABITATS
 Tropical rainforests

- DIET
 Leaves and other plant matter, general forest floor debris

- CONSERVATION STATUS
 IUCN Not evaluated
 (see key, page 9)

◄ With its cryptically coloured or camouflaged front wings spread out, the peacock katydid's contrasting patterned rear wings show 'eyespots'. However these do not have an especially close resemblance to glaring predator eyes like those of an owl or cat. Biological research suggests they work using a generally conspicuous, contrasting design.

EYESPOTS EVERYWHERE
Katydids are members of the grasshopper, cricket and locust group, known as orthopterans, meaning 'straight winged'. Several species have eyespots or ocelli on the rear wings that can be suddenly revealed by moving aside the front wings, the latter usually coloured and patterned for camouflage. Eyespots are widely displayed in many parts of the animal kingdom, from butterflies, moths and mantises to spiders, molluscs (cuttlefish), fish, reptiles and birds.

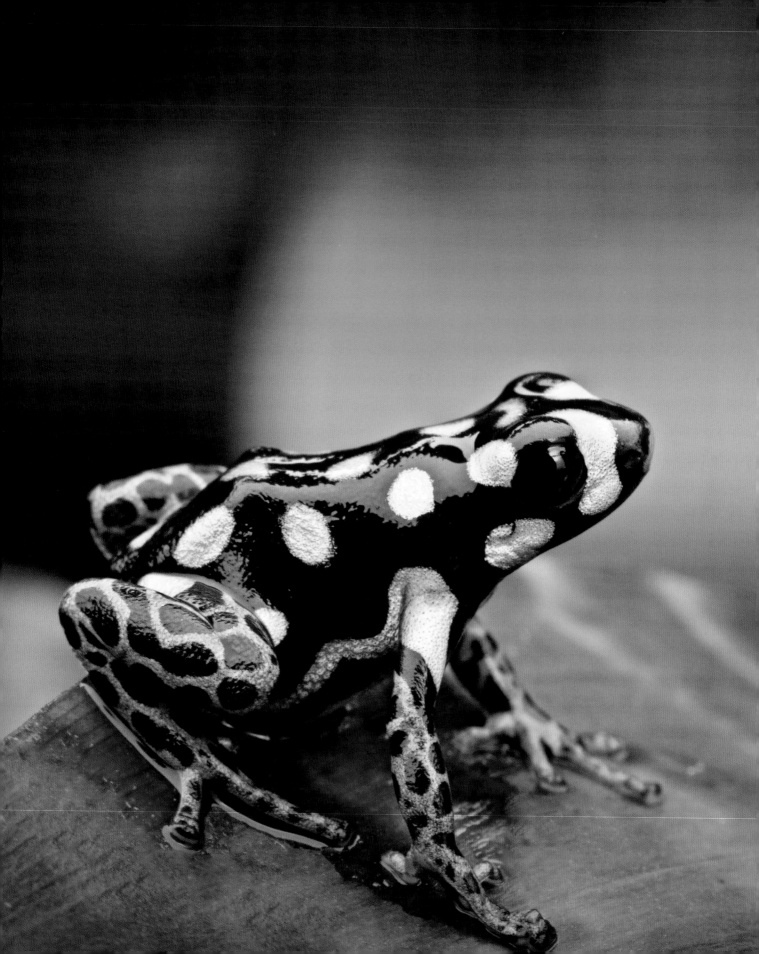

Spotted poison frog

BEWARE BRIGHT COLOURS

Many frogs are dull green, brown or similar, for camouflage. The spotted poison frog is the opposite. Its bright patterns are highly visible, because the frog is extremely poisonous. Its skin bears toxins known as alkaloids that, if eaten or even touched by another animal, affect that animal's nerves and the way they control muscles and heartbeat. Most creatures that mouth or molest a poison frog, if they survive, learn a serious lesson. They associate the colours with the very unpleasant experience, and avoid in future.

The spotted poison frog's head and body look like they belong to a different species from the limbs. The body pattern of black background with yellow rounded or elongated spots, occasionally yellow-cream or yellow-orange, is a combination known as aposematic or warning coloration (see page 6). It forewarns potential predators of the frog's dangerously powerful skin poison. The legs also have a black or dark background, with a web- or mesh-like pattern of blue lines.

A DANGEROUS FAMILY
Gaudy coloration occurs in many of the spotted frog's relatives in the poison frog group, dendrobatids. Most of the 170 or so species live in damp tropical forests of Central and South America. The appearance is a continuous visual anti-predator display, simply because of the coloration. Under threat, the frog may rear up or extend limbs to emphasize the colours and toxicity. It was thought the toxic substances were manufactured in the frog's skin glands. Recent research indicates the toxins are probably recycled from the frog's food of mites, ants and similar very small prey. In the frog's body they are concentrated, known as bioamplification.

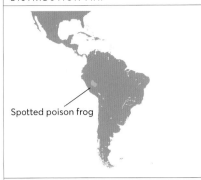
◀ The spotted poison frog is almost small enough to place on a thumbnail, though that could be dangerous because of the skin toxins. Sadly, collecting from the wild as exotic pets is making some poison frogs very scarce, even in danger of extinction.

▶ The harlequin poison frog has a glaring array of distinct colour forms, or morphs. Background colours range from black to blue, red, yellow or orange, while the contrasting patterns vary from web-like to giraffe-type patches, bars or even simply a few spots.

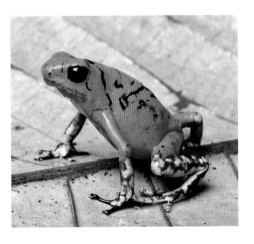

DARTS AND ARROWS
Dendrobatids are sometimes known as poison-dart or poison-arrow frogs. This name refers to local people who smear the frog's skin secretions onto the tips of their blowpipe darts or bow arrows when hunting monkeys, birds and similar animals as food. On piercing a victim, these toxin-covered weapons cause convulsions, paralysis and similar effects, making the hunt more successful.

Spectacled caiman

LEAPS OF REMARKABLE POWER

Caimans basking on riverbanks may appear unconcerned. However the body language and behaviour of the croc-and-'gator group are complex and intricate. They are capable of sudden, explosive action with formidable power. An example is the caiman's vertical leap or jump from water. This is usually for two reasons. One is hunger, to grab prey from a low branch overhanging the surface. The other reason is a dominance display to fellow caimans, usually when competing for food, mates or territory.

Caimans are close cousins of alligators (see page 21), within the overall group known as crocodilians. Of the six kinds of caiman, all native to the Americas, the spectacled caiman is the most widespread and the most adaptable in terms of habitat and prey.

BATTLE FOR DOMINANCE
The breeding season generally begins in April or May, when males, especially, become more aggressive and competitive. They interact using various gestures and movements, such as mouth-gaping or yawning, swishing the tail, and leaping from the water. When floating at the surface, leaps are achieved by tilting upright so just the head is above the surface, then thrusting downwards against the water's resistance with the rear feet while thrashing the rear body and tail to gain upward momentum. In shallow water, pushing against the bottom makes the leap even higher.

This action probably originated as a hunting technique to grab food just above the surface, such as a bird or monkey on overhanging vegetation. It has become adapted or 'repurposed' to express dominance, in animal behaviour known as ritualization (see page 8). The biggest, best-jumping males gain mating entitlements.

DISTRIBUTION MAP

- LOCAL COMMON NAMES
Speckled caiman, Common caiman, White caiman, Brown caiman; Caimán pululo (Spanish); wide variety of regional dialect names such as Baba, Babilla (Venezuela, Colombia), Yacaré tinga (Brazil), Kaaiman (Suriname), Lagarto (Central America), Yacaré cascarudo, Yacaré ju (Argentina, Paraguay)

- SCIENTIFIC NAME
Caiman crocodilus

- SIZE
Length 1.5–2.5m (5–8ft), weight 20–40kg (44–88lb); males are larger

- HABITATS
Mainly freshwater wetlands, slow rivers, lakes, floodplains, ditches, canals, also some brackish and saltwater areas

- DIET
Varied, from snails, shrimps and crabs to fish, frogs, ducks and other waterbirds, small- and medium-sized mammals

- CONSERVATION STATUS
IUCN Least concern
(see key, page 9)

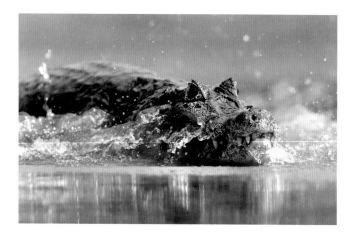

LOCAL FAME
Spectacled caimans are relatively common in many kinds of wetland and also in drier areas near water. They have numerous local names, such as caimán pululo in Spanish – meaning an alligator that swarms or teems, and is therefore common in many places. In English, the term 'spectacled' comes from a sideways ridge on the upper face, between the eyes, which is likened to the cross-bridge over the nose of a pair of spectacles.

◄ Display behaviour also includes splashing, surging and thrashing to intimidate rivals.

► Younger, smaller, lighter caimans tend to thrust more of their bodies out of the water. The leaps to grab food and to demonstrate authority have many similarities.

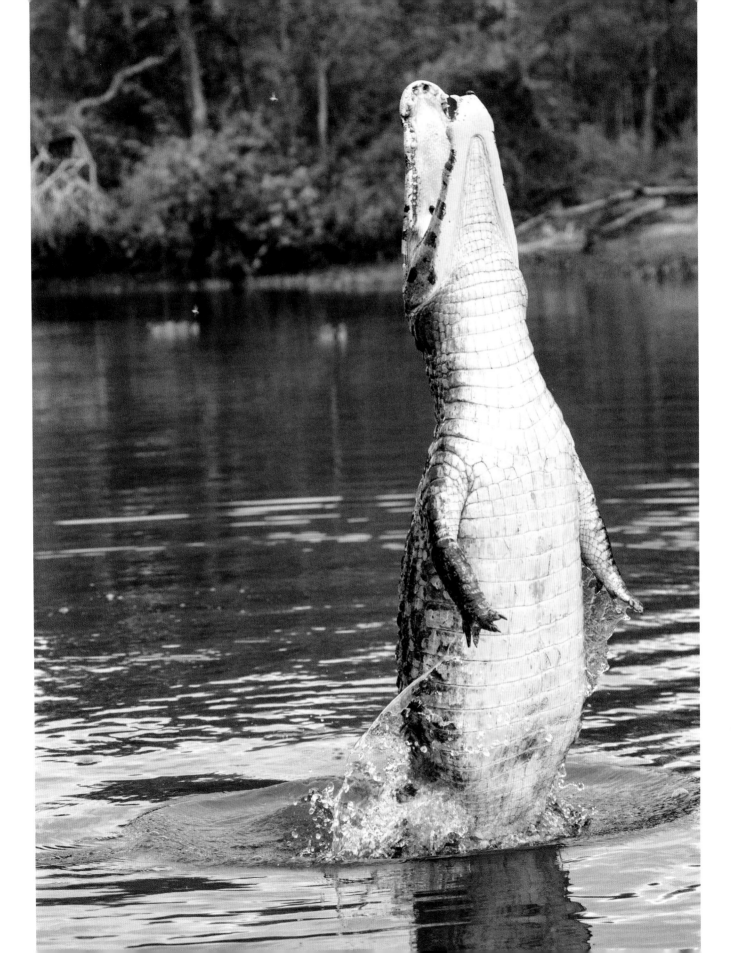

Brown anole

UNFURLING THE FLAG FOR FEMALES

Few animal displays are more striking and impressive than a colourful 'flag' unfurled and folded in rapid succession, to grab attention. The male anole lizard's 'flag' is a flap of skin known as the dewlap, attached to the lower throat and chest. It is usually bright red, orange or yellow-orange, and makes a visual 'splash' compared to the rest of the lizard's brown or grey-brown hues. He displays it to warn other male anoles off his territory and advertise himself as a fit future father to females.

A common, adaptable and widespread lizard, the brown anole has spread from its original distribution on Cuba, the Bahamas and nearby Caribbean islands, to mainland south-eastern North America and Mexico, and then to Jamaica and even the Hawaiian Islands.

A male brown anole uses his dewlap to warn other males away from his territory, where he feeds and which is also a prized possession that attracts females. Different anole species may look very similar at a glance, but their dewlaps do not. In areas with several similar kinds of anoles, the dewlap colour helps a female to select a male of her own species to ensure successful reproduction.

FLASH, NOD, PUSH-UP

At breeding time, the male brown anole sits on a low branch, fence or similar visible perch near the middle of his territory, and monitors other males. He is ready to flash his dewlap, nod his head, and do push-ups with his front legs. Unheeded, he may physically confront the rival. Females tend to choose males who are larger, possess bigger and more food-rich territories, and have a display perch higher than their rivals.

DISTRIBUTION MAP

— Brown anole

- LOCAL COMMON NAMES
 Cuban anole, Cuban brown anole, Bahaman brown anole, Sagra's anole, De la Sagra's anole, Rámon's anole; variety of Spanish, Portuguese and local dialect names such as Anolis marrón, Anolis café, Anolis pardo, Abaniquillo costero Maya, Lagartija chipojo

- SCIENTIFIC NAME
 Anolis sagrei

- SIZE
 Total length males 15–25cm (6–10in), females 10–15cm (4–6in)

- HABITATS
 Adaptable, mainly ground-living among shrubs, bushes, grass, scrub, farmland, parks, gardens

- DIET
 Any prey that fits into the mouth, from worms, snails, insects and spiders, to fish, small frogs, other lizards, eggs of any kind

- CONSERVATION STATUS
 IUCN Least concern
 (see key, page 9)

A FAMILY FEATURE

The anoles, or dactyloids, is a large lizard family related to iguanas and chameleons. They live mainly in the warmer New World, with strongholds on Caribbean islands. They are chiefly dull brown, green and grey – useful for camouflage but not for eye-catching display. Males in most of the 400-plus species have a distinctively colourful dewlap, which can extend and retract using muscles to pull forward and down the throat bones, ceratohyoids.

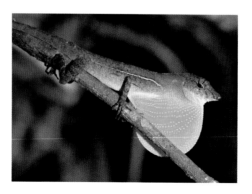

◀ Anolis polylepis, the many-scaled anole or Golfo-Dulce anole, is a lizard endemic to the Gulf of Dulce area of Costa Rica.

▶ The male brown anole's conspicuous dewlap is stretched using stiff, skeletal, rod-like bony projections along its front edge. The naturally elastic skin retracts as the rods move back towards the neck.

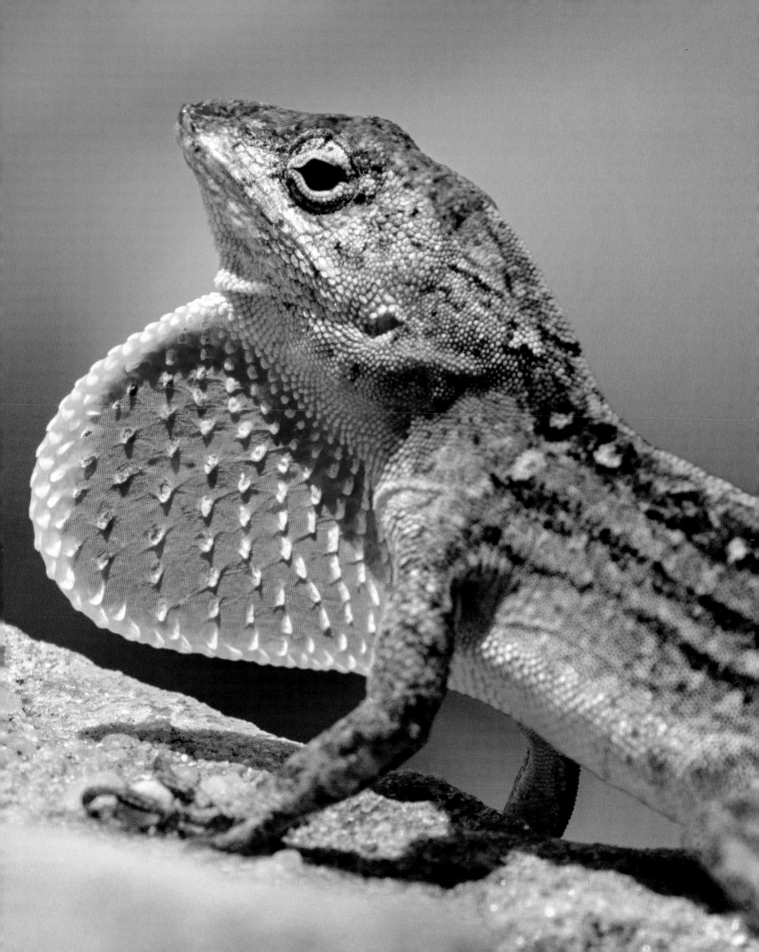

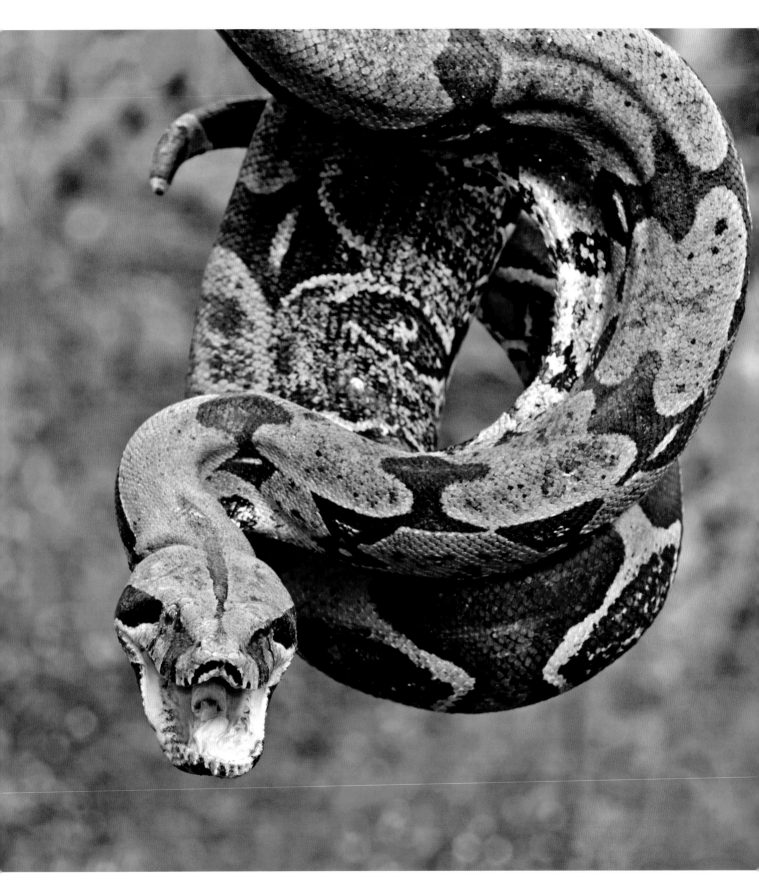

Boa constrictor

SSSSSSSSSSS...STRIKE!

Boa snakes are mostly medium-to-large, powerful, and non-venomous; the majority of the fifty species live in the Americas. The boa constrictor or red-tailed boa – 'the' boa – is the most widespread, occupying varied habitats in most of South America. Like many snakes, its main form of display is for self defence, and involves opening the jaws to display the teeth, hissing or 'ssshhhing', and tensing and perhaps curving back the neck and front body. This gives the impression of being ready to strike with its curving, rear-pointing fangs.

Older adult boa constrictors are formidable creatures. Very few predators tackle them, apart perhaps from jaguars and caimans. However when newly born they are only 40–50 centimetres (16–20 inches) long and spend much time among branches. Their defensive behaviour is needed against varied hunters ranging from owls, eagles and hawks, to wild cats and dogs, foxes, otters, large bats and similar carnivores.

AN AGONIZING END
Despite this species' common name and also scientific name being boa constrictor, nearly all types of boas constrict. They deliver a very fast bite while wrapping their muscular coils around the prey, and tightening or squeezing. As the prey, such as a medium-sized mammal or bird, breathes out, its lungs shrink. The snake tightens further. The victim is less able to expand its lungs to breathe in. This may repeat several times and can be a slow process. The effects are eventual suffocation or asphyxiation through lack of air, and physical pressure restricting blood flow to the victim's brain and heart, leading to unconsciousness and heart stoppage.

DISTRIBUTION MAP

- LOCAL COMMON NAMES
 Red-tailed boa, Common boa, True boa; local dialect names include Jibóia, Macajuel

- SCIENTIFIC NAME
 Boa constrictor

- SIZE
 Length up to 4m (13ft), weight up to 40kg (88lb); females are generally larger

- HABITATS
 Varied, from forests and woods to scrub, dry bush, farmland, around human habitation

- DIET
 Mostly small- and medium-sized mammals and birds, occasionally fish, crabs, frogs

- CONSERVATION STATUS
 IUCN Least concern (see key, page 9)

◀ A boa constrictor faces its threat, gapes its mouth to display its teeth, and makes a hiss. The hiss is a common defence or threat sound for many animals, including other snakes and reptiles, amphibians like toads, cats and similar mammals, even some fish and insects.

BABY BOAS
Boas are unusual among members of the overall snake group in that the female gives birth to live young, rather than laying eggs as in most other snake species. The boa group includes the anacondas, so these are also live-bearers. However, there are eggs involved. These develop in the mother and she keeps them protected and nourished within her body until they hatch there. Then the young emerge, small but fully formed. This type of reproduction is known as ovoviviparity.

Roseate spoonbill

DEDICATED COUPLE'S TEAM EFFORT

Spoonbills are named, probably obviously, from their spatulate or spoon-ended beaks, or bills. The roseate species is named, again self-evidently, from its rosy pink coloration. 'Rosies' are among the thousands of bird species who pair for the breeding season. A female and male strike up a relationship and continue to stay near each other, feed in proximity, and mate together during the season – unless one of them goes missing. The end of the pair bond can be for any number of reasons: disease, predation, old age, accidental demise, and sadly in modern times, trapping, shooting or otherwise being hunted.

Roseate spoonbills are social birds. Often they dwell in groups or colonies with similar tall, wading avians such as storks, herons and ibises (see next page). The spoon-ended bill is adapted to slice or scythe, part-open, through shallow water, silt and soft mud. The instant a small creature is felt by sensitive nerves along the bill, it snaps and clamps onto the food, then the bird jerks back its bill and head to swallow the food.

STRENGTHEN THE BOND
Bird bills have many other functions, such as preening oneself or a partner, and being presented as a defensive weapon in the face of danger. Roseates also employ their bills for several types of behaviour in the initial courtship and then in regular pair-bonding displays throughout the breeding season. One action is to pick up a stick, twig or stem with the bill and present it to the partner, either as a symbolic gift or to use in nest building. Another is mutual bill-slapping or bill-clattering, when the bill is slightly opened and snapped shut many times in quick succession. The two also raise and spread their wings, flap these slowly, cross bills and align them parallel. They preen in front of each other, and also preen each other, in a regular stereotypical method, along the wing and around the neck.

- **LOCAL COMMON NAMES**
 Espátula rosada (Spanish); Becplaner rosat (Catalan); Spatule rosée (French); Colhereiro (Portuguese)

- **SCIENTIFIC NAME**
 Platalea (Agaia) ajaja

- **SIZE**
 Height 75–85cm (29–33in), weight 1–1.5kg (35–48oz)

- **HABITATS**
 Wetlands such as swamps, marshes, ponds, lakesides, riverbanks, estuaries and tidal lagoons

- **DIET**
 Small shrimps, crabs, fish, snails, worms, insects, amphibians and similar aquatic creatures

- **CONSERVATION STATUS**
 IUCN Least concern (see key, page 9)

ROSY DIET

Being tall and pink, from a distance roseate spoonbills are sometimes confused with flamingos. It is believed that both have the same source for their plumage colour. Common dietary items are small shrimps, which have eaten algae: algae manufacture red and yellow pigments, called carotenoids, as part of their method of capturing sunlight for energy (photosynthesis). The more shrimp and algae that are eaten, the pinker the bird. Captive flamingos that do not receive this dietary source gradually fade to pale and even white.

▶ A roseate spoonbill pair affirm and strengthen their pair bond by holding heads and bills parallel and slowly raising their wings. The couple work together to build the nest, sit on or incubate the eggs, and feed the chicks – a true team effort.

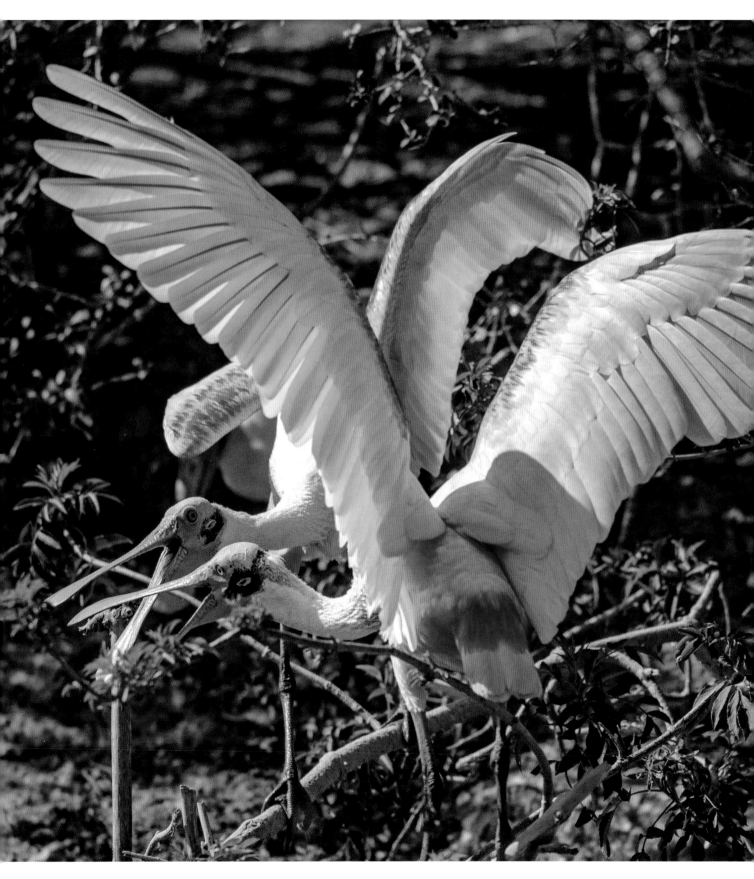

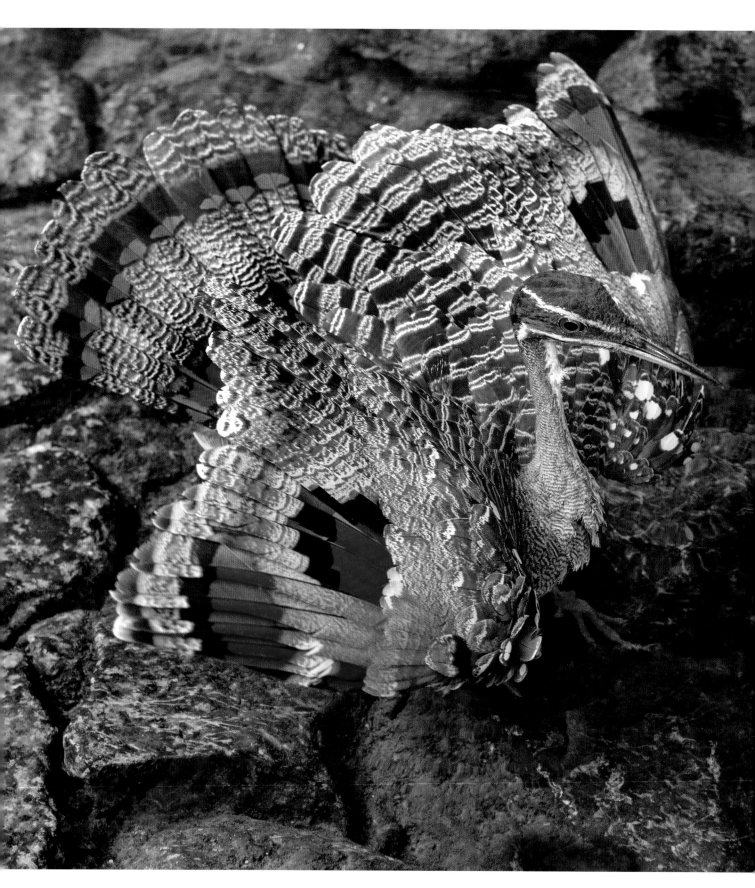

Sunbittern

LET THE SUNS SHINE

Few birds show such a contrast between normality and full-on display as the sunbittern. The former has mainly fine stripes on the head and delicate bars and speckles on the wings and body, in shades of brown, blue-grey, grey and cream. These blend with undergrowth, earth, old leaves and general forest floor debris. But when aroused, the bird spreads and tilts its wings to reveal amazing, dazzling patterns of yellow, gold, red, chestnut and black, akin to a low sun's glow, along with fanned, red- and black-barred tail.

The sunbittern is a long-legged, long-necked, slender bird with the general shape of waders such as herons and storks, although not closely related. Its long, pointed, dagger-like bill, the lower mandible being yellow or orange, is designed to spear and grab fish, frogs, crayfish and similar, in water and on land. The sunbittern has quiet habits and generally lives a solitary, mainly ground-dwelling life, or perhaps forms a pair, in plentiful vegetation along creek banks or lakeshores.

FRONTAL PERFORMANCE

All this changes when the sunbittern performs its frontal defence display. It suddenly and alarmingly spreads and fans its wing feathers, and tilts the fronts of the wings downwards, to reveal remarkable multicoloured patches, likened to a setting or rising sun, or perhaps to enormous eyes. The tail also bears contrasting bright colours. In addition the bird emits hissing, sizzling, rattling or knocking sounds, nods or darts forward with its head, sometimes bows its front body, and patters its feet, all in an animated fashion. Even while displaying, the sunbittern keenly watches the threat and is ready to swoop away into vegetation cover at any moment.

- LOCAL COMMON NAMES
Tigana (Spanish); Pavãozinho-do-pará (Portuguese); Caurale soleil (French); also many Spanish-based local dialect names such as Garza del sol, Garceta sol

- SCIENTIFIC NAME
Eurypyga helias

- SIZE
Bill-tail length 40¬-50cm (14–18in), wingspan 50cm (20in)

- HABITATS
Wetlands and vegetated areas near water, including swamps, woods, forests

- DIET
Both terrestrial and aquatic small creatures such as worms, insects, spiders, shrimps, fish, amphibians

- CONSERVATION STATUS
IUCN Least concern but decreasing (see key, page 9)

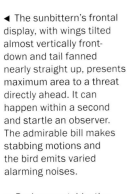

◄ The sunbittern's frontal display, with wings tilted almost vertically front-down and tail fanned nearly straight up, presents maximum area to a threat directly ahead. It can happen within a second and startle an observer. The admirable bill makes stabbing motions and the bird emits varied alarming noises.

► During courtship, the male sunbittern presents a less excited display to its partner, with wings held more horizontally.

PUZZLING RELATIONSHIPS

The sunbittern is not a close relative of other bitterns, the latter being part of the heron and egret family, Ardeidae. Neither is it in the cranes family, Gruidae. Recent research into the make-up of its bodily genes, proteins and other substances suggest its only close cousin is the kagu, a rare species of the New Caledonia islands in the West Pacific. Both species are probably remnants of a once more widespread group. The next nearest relatives are tropicbirds.

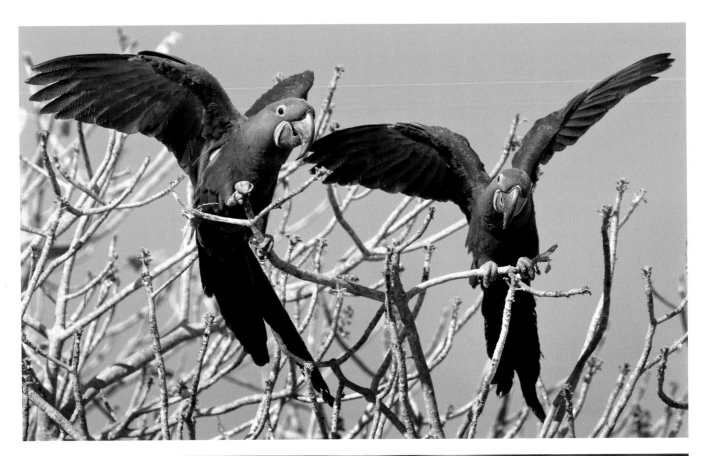

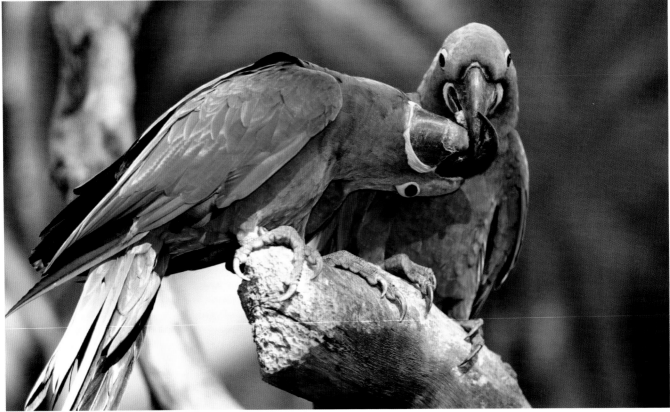

Hyacinth macaw

'GENTLE GIANT' WITH FAITHFUL HABITS

Parrots and macaws are famed for complex behaviour, learning, and what we humans call general intelligence. Hyacinth macaws are among the largest of their family, with gentle dispositions and regular habits. And they pair and mate for life, preen each other's feathers, stay close together, and remain faithful until one dies or disappears. Most humans find all of these traits very endearing. These behaviours are reflected in the hyacinth macaw's intimate displays of affection, often observed in the wild and as a species popular in captivity.

Compared to many birds, hyacinth macaws have long lives. Estimated wild lifespans are thirty to forty years, and fifty-plus in captivity. This makes their partnerships and breeding a long-term commitment.

Apart from this macaw's forceful blue colouring, and the yellow around the eyes and base of the bill, there are few colour patterns and contrasts to display. Coupled with the bird's size, and the dauntingly hooked bill, both of which deter many predators, most of the hyacinth's behaviours appear to us to be subdued and relaxed. However, if provoked it can flap and snap with sudden power.

TAKING TIME

Away from feeding and breeding, one of the main hyacinth activities is preening. Essential for all birds, to clean, comb, de-pest, waterproof and arrange their feathers, preening in these macaws is something of an art form. They self-preen in view of each other, usually beginning with the head and neck, moving to the body and wings. They preen each other too, in an approximately similar way and order, but they also pay attention to the other's lower body parts, including the combined waste and reproductive opening, the cloaca. Flapping and soft, low chirps reinforce the bond.

DISTRIBUTION MAP

- LOCAL COMMON NAMES
 Hyacinthine macaw, Blue macaw, Cobalt macaw or parrot; local Spanish-Portuguese-native names include Aara preta, Arara una

- SCIENTIFIC NAME
 Anodorhynchus hyacinthinus

- SIZE
 Bill-tail length 100cm (40in), wingspan 120–130cm (47–51in)

- HABITATS
 Open forests, scattered woodlands, plantations, orchards, shrubby wetlands

- DIET
 Nuts, especially of palms; seeds, fruits, blossom and other plant matter; occasionally small animals like snails, beetles

- CONSERVATION STATUS
 IUCN Vulnerable
 (see key, page 9)

◄◄ One of the hyacinth macaw's pair-reinforcement actions is mutual flapping and head-bobbing. This helps each partner to monitor the other's health and suitability as a parent.

◄ Each partner develops its own sequence of mutual feather care, or allopreening. Usually this begins with the other's head, including the bill and mouth interior. It tends to finish at the other end with the genital opening area.

STAYING TOGETHER

Hyacinth macaws are very pair-orientated. When young, before sexual maturity at six to ten years of age, they rove noisily in mixed flocks between food sites and safe roosts. Then begins the process of courtship and establishing a partner relationship. In most of their range they continue these displays and activities all year round, with courtship, bonding, simulated mating or pseudo-copulation, and actual mating on a continuing basis.

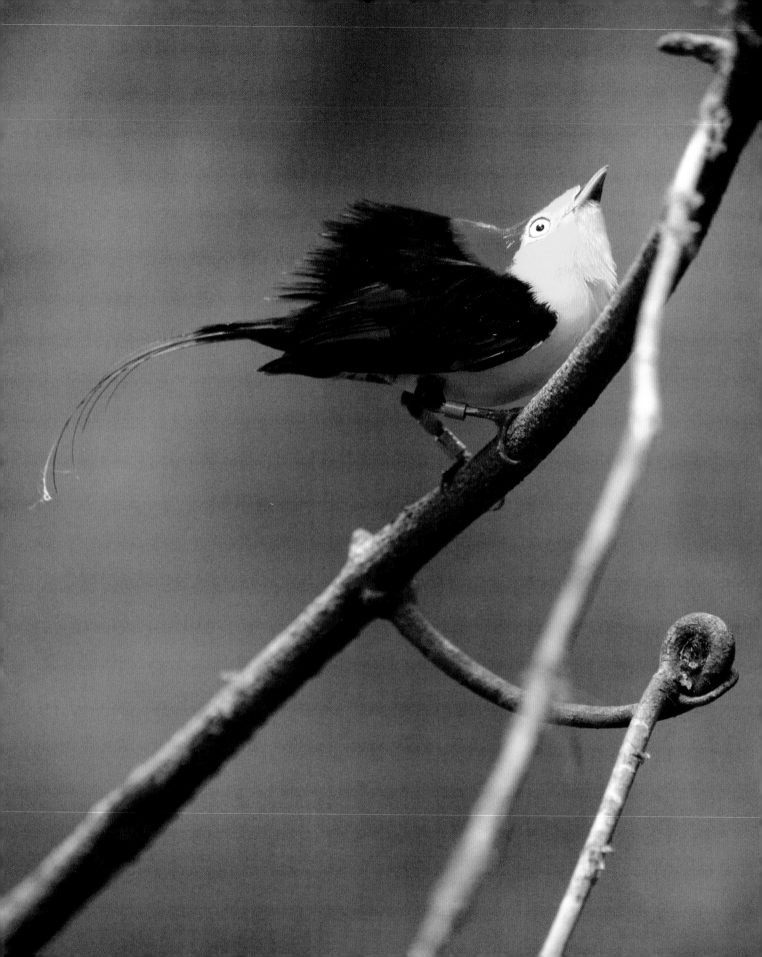

Wire-tailed manakin

SHOWING OFF ONSTAGE

Wire-tailed manakins are a lekking species. Leks are places where individuals, usually male, from a species gather communally for breeding purposes (see page 7). They put on a vision-and-sound display so that the females can judge who will be the best breeding partner to pass on the 'fittest' genes and give their young the best chance of survival. Competing males rarely interact physically, so the risk of inflicting physical damage is low. This means both victor and vanquished live to display another time.

Wire-tails are named from their long, slim, central tail plumes. These may seem a hindrance in everyday life and general survival. But they come into their own at breeding time. Both males and females possess them, although they are longer in males. However, a bird actually still having them when courtship starts is a sign that the individual is healthy and has avoided losing them: for instance, during a sudden near-miss with a predator.

TAKING TURNS
The manakins' communal display arena or lek is a small collection of branches and twigs in a clearing, generally at a height of one to two metres (three to seven feet). Here females can assess the performing males. Rather than all males exhibiting at the same time, often one male displays and perhaps calls, although quietly (to avoid attracting predators), while the others look on. He flits, hops and jumps along a branch or two, to show his prowess. Then another male takes over, and so on. Often the efforts of most males are in vain and the best exhibitor gains all mating rights.

DISTRIBUTION MAP

- LOCAL COMMON NAMES
 Long-tailed manakin, Thin-tailed manakin; Rabo-de-arame (Portuguese/Spanish); Saltarín uirapuru (mainly Spanish)

- SCIENTIFIC NAME
 Pipra filicauda

- SIZE
 Head-body length 10–12cm (4–5in), males similar but with extended tail feathers that add up to 5–7cm (2–3in)

- HABITATS
 Tropical and subtropical forests, woods, swamps, plantations and orchards, especially where the edges open to clearer areas

- DIET
 Chiefly plant material such as fruits, berries, soft seeds, occasionally small soft-bodied invertebrates

- CONSERVATION STATUS
 IUCN Least concern
 (see key, page 9)

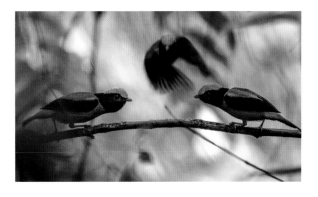

◀ A male wire-tailed manakin displays on his favourite perch at the communal site, the lek. He has graphic coloration of yellow face, chest and underside, red crown and back, and is otherwise black, with distinctive filament-like tail plumes. Females are much more drab olives, green and yellows.

▶ Blue manakins, *Chiroxiphia caudata*, eye each other at the lek. They co-operate to clear the view of leaves, mosses, lichens and similar visual obstructions.

DIFFICULT TO DISTINGUISH
There are three kinds of species of *Pipra* manakins – probably. They include the wire-tailed, the crimson-hooded (*P. aureola*) and the band-tailed (*P. fasciicauda*), all from northern and equatorial South America. They may be a superspecies – when species are so similar and closely related that biologists have trouble separating them. It usually means that one species is in the process of evolving into two or more in different geographic regions.

Guanaco

TUSSLE FOR TERRITORY

Guanaco adult males are usually busy, either feeding, or patrolling their territory to repel other males – often with fierce battles that involve wounds and other damage. A resident male and a challenger stand sideways to each other for mutual assessment, then approach with threatening moves such as neck-bending, stamping and tail wagging. If neither backs down they may spit at each other from distances of up to two metres (seven feet). Should the confrontation escalate, close-quarter hostility ensues.

Male-male guanaco battles have many elements. They wrestle with heads and necks, push or ram chests together, and in particular, aim nips and bites at each other's legs, rumps and rear ends, and necks. The male's long canine teeth can inflict deep wounds. At some stage one competitor may have second thoughts and turn to retreat, while the other chases and bites; then the two suddenly swap, and the fleeing individual turns aggressor. At last there is a resolution, but also bloody injuries. These battles are about territory. Occupying one gives the male and his social group or 'family' – females and young, numbering about five to fifteen – a place to feed at ease, with little intrusion from other guanacos.

A PLACE TO FEED AND BREED
The 'family' females are not necessarily related but come and go according to the individual male they choose, and whose breeding success is strongly linked to territory possession. This all happens during the breeding season, spring and summer. In winter, guanacos often roam in mixed groups numbering perhaps hundreds.

DISTRIBUTION MAP

- LOCAL COMMON NAMES
Various Portuguese and Spanish terms taken from native dialects, such as Guanaca, Huanaco, Luan, Wanaku

- SCIENTIFIC NAME
Lama guanicoe

- SIZE
Head-body length 1.9–2.2m (6–7ft), shoulder height 1–1.2m (3–4ft), weight 100–130kg (220–280lb)

- HABITATS
Varied and often harsh, from windswept uplands to grassy plains, scrub, bush and semi-desert

- DIET
Almost any plants, from soft leaves and flowers to spiky cacti and thornbushes, also fungi

- CONSERVATION STATUS
IUCN Least concern
(see key, page 9)

SOUTH AMERICAN CAMELIDS

The camel-and-llama group, Camelidae, includes three Old World camel species and four more in South America. These are: the guanaco, which is wild; its domesticated descendant, the llama; also the vicuna, again wild; and its domesticated version, the alpaca. Llamas were probably domesticated from about 5,000–6,000 years ago to carry loads, and for their milk, meat, wool, hides and other body parts. Alpaca domestication had a similar timescale.

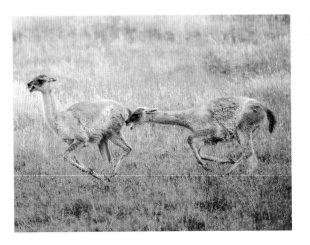

◀ A resident male guanaco spends much time patrolling his area to deter rival males. He chases them away with darting lunges to bite at the rear end, flanks and legs.

▶ Juvenile guanacos appease an adult male with a submissive display of lowered neck, bent knees and raised tail – which mimics the posture of a suckling youngster. As the males reach three to four years old, they practise their various combat moves, such as neck-wrestling as shown here.

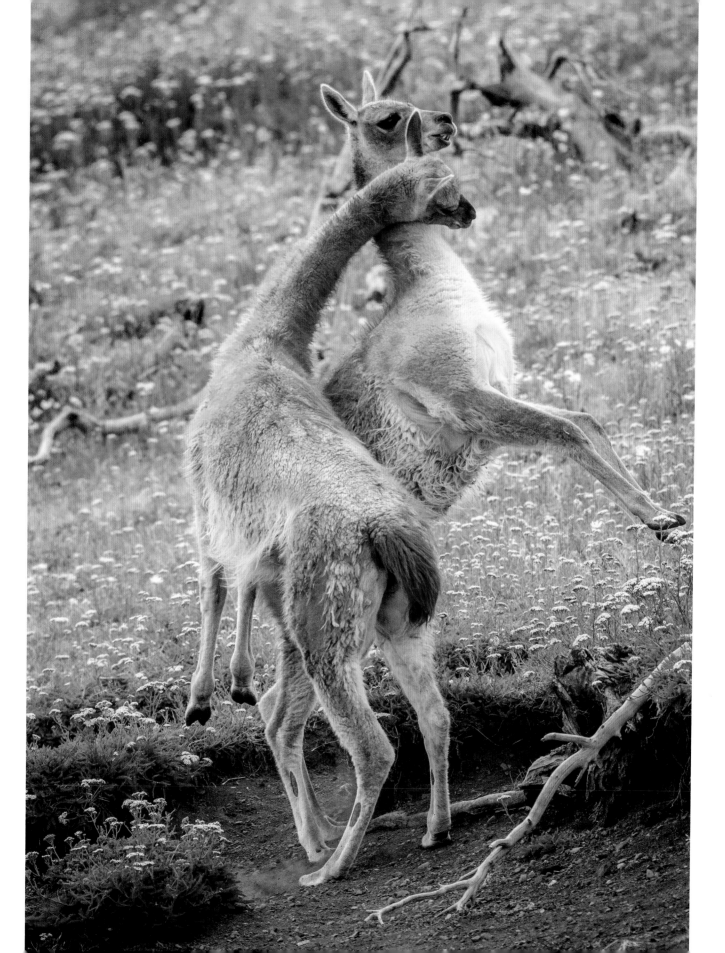

Collared peccary

BOLD AND BRASH IN NUMBERS

One of the collared peccary's many local names is javelina. This may well describe its tusks: four sharp, pointed canine teeth, each like the tip of a spear or javelin (however, see below). Two in the upper jaw aim straight down, and two in the lower jaw are directed upwards. As the peccary bites, these teeth rub together and keep each other sharp. They are the focus of the peccary's main visual display, revealed by a wide 'yawn' for both defence, aggression and territorial conflict.

Although generally peaceful, a peccary does not hesitate to use its mini 'javelins' when cornered or under any threat. A wide range of predators is ready to make a meal of an old, weak or injured adult peccary, or snack on a youngster or 'red'. These enemies include jaguars, pumas (cougars), bobcats, coyotes and foxes.

Collared peccaries form mobile groups from five or six, to fifteen or twenty. Each group has a relatively settled membership and is dominated by an alpha male who fathers most offspring. The others are mixed adults and young of both sexes. The adults co-operate to mark their feeding territories by rubbing rear-end oily scent secretions onto objects like tree trunks and boulders.

READY TO CHARGE

Predators or rival peccaries might trigger display. The peccary stands head-on and then sideways, lays its ears flat, opens wide, then clatters and snaps its tusks together. Aggressive when roused, a peccary has few qualms about charging an adversary, with growls, barks, fierce biting and tusk slashing to the head, neck and flanks, also kicking out with its rear hooves.

- LOCAL COMMON NAMES
Mexican hog, Musk hog; numerous mixed Spanish, Portuguese, Carib and other native dialect terms, such as Tajaçu, Báquir, Báquiro, Quenk, Saíno, Sajino, Pecari, Pakiro, Jabali, Queixava, Porco do mato

- SCIENTIFIC NAME
Dicotyles tajacu, also referred to as *Pecari tajacu* and formerly *Tayassu tajacu*

- SIZE
Head-body length 100–150cm (40–60in), shoulder height 40–60cm (18–24in), weight 15–25kg (33–55lb); males may be slightly larger

- HABITATS
Adaptable, from tropical forests and swamps to sparse woodlands, also drier grassland and scrub, farmland, around human habitation and even within towns and city suburbs

- DIET
Plants including cacti, fruits, berries, roots, leaves and stems, also small animals, carrion, eggs, edible leftovers from garbage

- CONSERVATION STATUS
IUCN Least concern
(see key, page 9)

◄ A collared peccary displays its canine tusks, ready to use them if the threat continues.

▶ A dominant peccary in its herd stands over a submissive individual. The latter still displays an open mouth but has a crouched body position and laid-back ears.

WHAT'S IN THE NAME?

The peccary's tusks may well resemble the front end of a javelin or similar spear-like weapon. A more likely name origin is terms for boar or wild boar used by European settlers in the Americas: jabali in Spanish and javali in Portuguese. These refer to the striking resemblance of New World peccaries to Old World wild pigs and boars. Despite their similarities, peccaries (Tayassuidae) and boars and pigs (Suidae) probably separated from a common ancestor 25-30 million years ago.

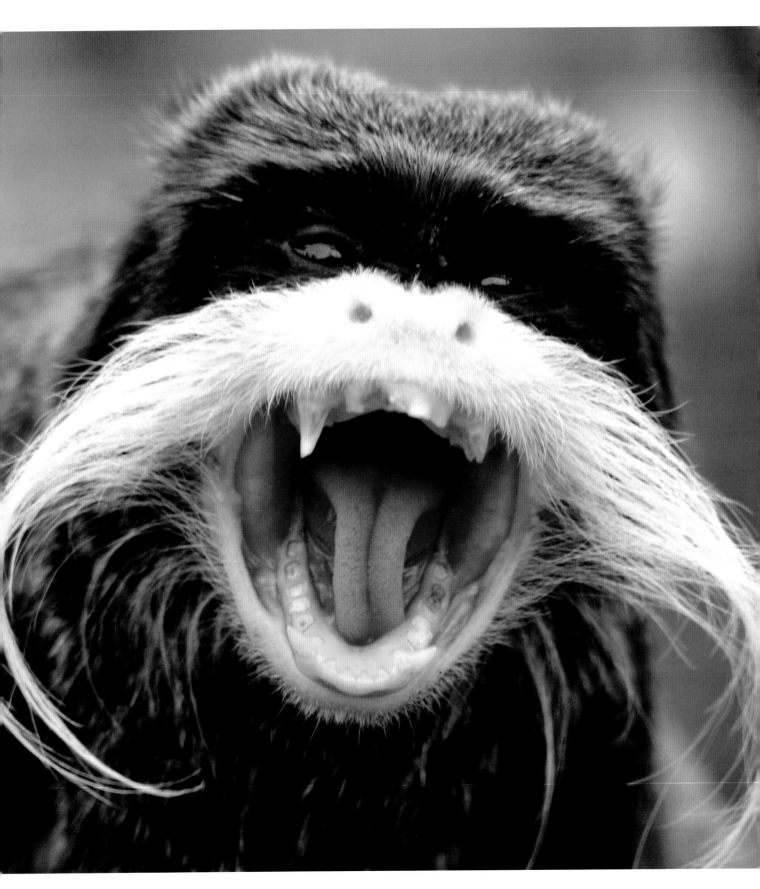

Emperor tamarin

RULER OF ITS TREETOP TERRITORY

To humans, the small monkeys called emperor tamarins look petite, cute and likeable. The enormous white moustache is especially distinctive. They also have sociable dispositions and lifestyles, in the wild and captivity. However, when threatened among the branches by a predator such as a snake, hawk or wild cat, being friendly and cuddly is not an option. Within a second or two the tamarin becomes a grimacing, snarling, hissing, scratching, kicking, biting, and generally ferocious adversary.

Of the twenty-two tamarin species from Central and South America, emperors are among the most social and demonstrative. Their defence display is certainly fierce and off-putting. Behavioural elements or components from this defensive-aggressive display are also used within the monkeys' social group, which usually numbers from five to about fifteen.

Generally an emperor tamarin group is dominated by an older female and male, who are the breeding pair. There are also their offspring and perhaps siblings. Other individuals occasionally join or leave but the overall group composition is relatively stable.

ORDER WITHIN THE GROUP

Within the group, a dominant emperor's behaviours include opening its mouth to display teeth, flicking out the tongue, holding another individual in an embrace usually from behind, and adopting a breeding position by mounting but not actual mating, known as pseudo-copulation. The subordinate accepts these actions, perhaps displaying its rear end, or facing the dominant individual but without eye contact. Such actions maintain group hierarchy – until a senior member dies. Then a challenge may come from a new, young, powerful individual, within or perhaps outside the group.

◄ An emperor tamarin leaves no doubt about its intentions with a frontal jaws-open show of its dental weaponry. Accompanying sounds include hisses, clicks and chirps.

► Golden lion tamarins, *Leontopithecus rosalia*, have a social hierarchy, breeding system and range of displays similar to emperors. However they are much rarer, classed as endangered, and the subject of vigorous conservation.

FAMOUS EMPERORS

The name 'emperor' is apparently derived from German–Prussian Kaiser or Emperor Wilhelm II, who ruled from 1888 to 1918. He too had a distinctive moustache. The account goes that the monkey received its title during a casual, light-hearted comment about the comparison between the two, and the name then stuck. Alternative accounts focus on historical emperors of China, whose moustaches resembled the tamarin's much more closely.

Howler monkey

DEFINITIVE SOUND OF THE AMAZON FOREST

Among the most famous sounds in the animal kingdom are the whoops, howls, hollers and roars of howler monkeys. These astonishing auditory displays echo through South American forests sometimes for several kilometres. In a visually limited habitat of dense branches, leaves, blossoms and fruits, such resonant, reverberating audio messages are an effective way of proclaiming a howler's location, age, status, territory ownership and breeding condition.

Most of the fifteen or so howler species have a similar social organization. They dwell in groups of about five to fifteen, usually one or two males plus several females and their combined offspring. Unlike many other monkeys, groups are relatively fluid, with individuals coming and going.

A howler's calls originate – like our own speech – from its voice-box or larynx. The main structure is the hyoid bone. Compared to most mammals, the howler's hyoid is enlarged and bowl-shaped, with an air space within it, known as skeletal pneumatization. Air space and bone work together as a resonating chamber. Also the howler's vocal cords and laryngeal muscles are proportionally large and robust, and the deep lower jaw provides extra reverberation.

ROARS, GRUNTS AND SCREAMS
As well as 'howling', sounds involve roars, grunts, growls, barks, whoops, hoots and screams. Males, especially, call loudly at dawn and dusk to tell neighbouring groups that their patch of forest – their territory – is occupied. Members within a group call to communicate location and to inform about possible threats, such as a predator or an intruding howler.

- LOCAL COMMON NAMES
 Mono aullador (Spanish); Macaco barulhento (Portuguese); many other names according to species

- SCIENTIFIC NAME
 About 15 species of *Alouatta* including *A. belzebul* (Red-handed howler), *A. palliata* (Mantled howler), *A. guariba* (Brown howler), *A. caraya* (Black or Black-and-gold howler), *A. nigerrima* (Amazon black howler), *A. ululata* (Maranhão red-handed howler)

- SIZE
 Most species head-body length 50–90cm (20–35in), tail of similar length or greater, weight 3–10kg (6–22lb)

- HABITATS
 Forests and woodlands

- DIET
 Mostly fruits, leaves, shoots, buds, flowers and other plant matter, occasional animal food such as insects, eggs, small bird

- CONSERVATION STATUS
 IUCN Species range from Least concern (*A. nigerrima*) to Vulnerable (*A. belzebul*) to Endangered (*A. ululata*) (see key, page 9)

THREATS GALORE
Howler monkeys are often used to symbolize the rampant dangers facing so much wildlife in Central and South American forests. Direct habitat destruction uses vary from agriculture, timber extraction and mining to transport, industry and housing. Indirect habitat harm comes from pollution and of course climate change. Hunting for bushmeat and, sadly, to seize youngsters as pets still occurs. Numbers of almost every howler species are decreasing.

▶ Group howling usually warns of intruding howlers from other groups or a menace such as a predator. Individuals spaced around the group's territory pass on the calls and vocalize in relays so that a predator realizes the whole area is alerted.

▶▶ The deep lower jaw and expanded front neck area contribute to a howler's vocalized volume and power.

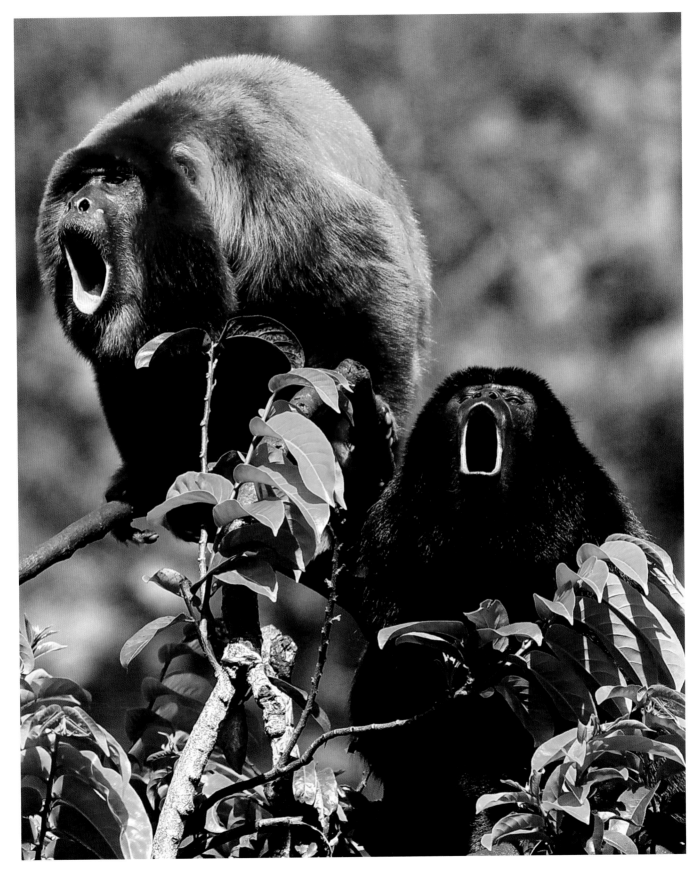

Jaguarundi

UN-CAT-LIKE CATCALLS

Not counting the domesticated pet, the Americas have about thirteen to fourteen species of wild cats, felids. The jaguarundi is a smallish example. But in many respects it is not especially cat-like. It is diurnal, or day-active. It displays visual postures and expressions that are generally rare among cats. It also has a strange range of calls and 'songs' that bring to mind dogs, squirrels and birds. But its main defensive and aggressive displays of snarls, hisses and spits are typically cat-like.

The adaptable jaguarundi occupies varied habitats. Despite hunting mainly in daylight, rather than the usual cat darkness, it is seldom observed since it is so secretive, alert and shy.

Degrees of mouth opening indicate the jaguarundi's mood, from a slight gape signifying displeasure or unease, to wide-open mouth with the prominent canines in full view, ready for anything. It also flattens its ears, but this is less noticeable than in other cats since the ears themselves are relatively small and rounded. The jaguarundi erects its fur too, but again, its coat is short and dense, so this too is less conspicuous than in other cats.

SOUNDS AND SIGNALS

The jaguarundi's calls and other vocalizations are very un-cat-like. A mating pair exchange soft chirps and tweets, while during actual copulation, the female emits screams and wails. If a jaguarundi senses another, a stranger, nearby, it 'carks' sharply, probably to make contact and signify territory possession. During confrontation loud hisses, 'shshshshs' and sudden spits accompany crouching, body tensed, mouth wide open, and tail switching side to side.

- LOCAL COMMON NAMES
 Weasel-cat, Otter-cat; Native Amerindian terms include Ya'guarundi, Ya'waum'di; Portuguese-derived names include Gato-preto, Gato-vermelho, Gato-mourisco, Maracajá-preto, Eyra; Spanish dialect names include Tigrillo, Leoncillo, León brenero, Onzo, Gato colorado, Gato moro, Gato eyra; Mayan-derived names are Mbaracaya-eira, Gato cerban

- SCIENTIFIC NAME
 Herpailurus (formerly *Puma*) *yagouaroundi*

- SIZE
 Head-body 50–70cm (20–28in), tail 30–60cm (12–24in), weight 3–8kg (7–18lb), males slightly larger

- HABITATS
 Many, from hilly cloud forests and shrubby uplands to lowland scrub, grasslands, swamps and farmlands, although usually near water

- DIET
 All kinds of small animals, from insects, spiders and worms to fish, frogs, lizards, snakes, mammals such as rats, and especially birds

- CONSERVATION STATUS
 IUCN Least concern but decreasing (see key, page 9)

MULTI-COLOURED CATS

One of the jaguarundi's atypical cat features is a plain coat, with no spots or stripes. This is similar to its closest feline relative, the cougar (puma or mountain lion), *Puma concolor*, but unlike almost all other cat species. There are also three distinct jaguarundi colour forms, or morphs: pale reddish-yellow or chestnut, grizzled grey or grey-brown, and darker brownish-black. The first of these seems more common in drier, open areas, while the third is found in dense forest. However, all colour forms are seen in all suitable habitats.

▶ Snarling and grimacing to defy a threat, the jaguarundi shows its small head, short rounded ears, smallish close-set eyes, relatively long body, proportionally short legs, and plain fur. Its general shape resembles mammals called mustelids, such as stoats and weasels, leading to nicknames such as 'weasel-cat' and 'otter-cat'.

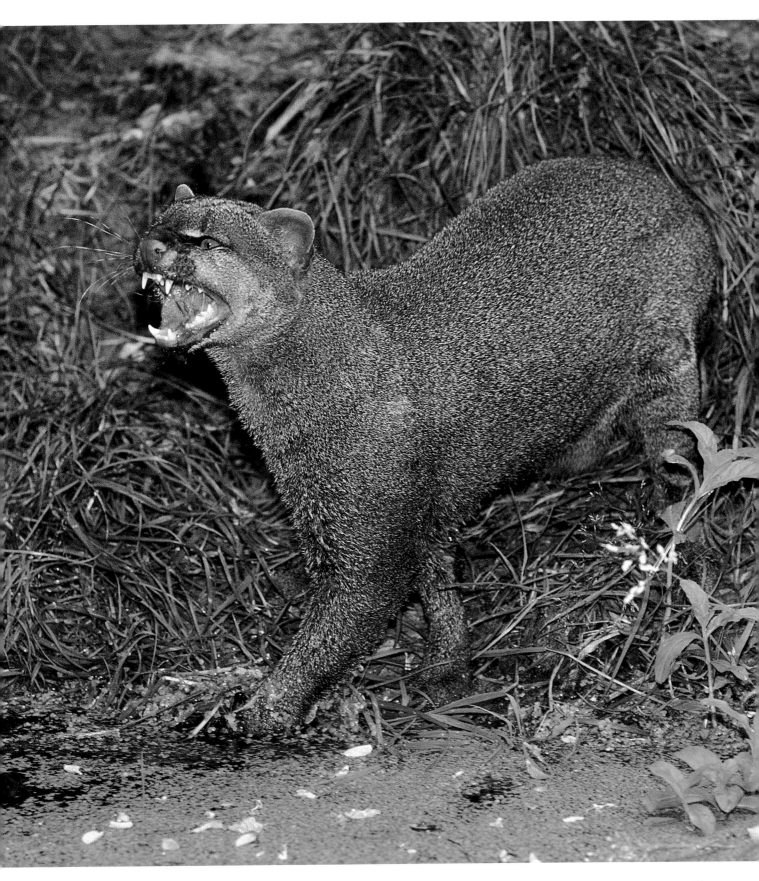

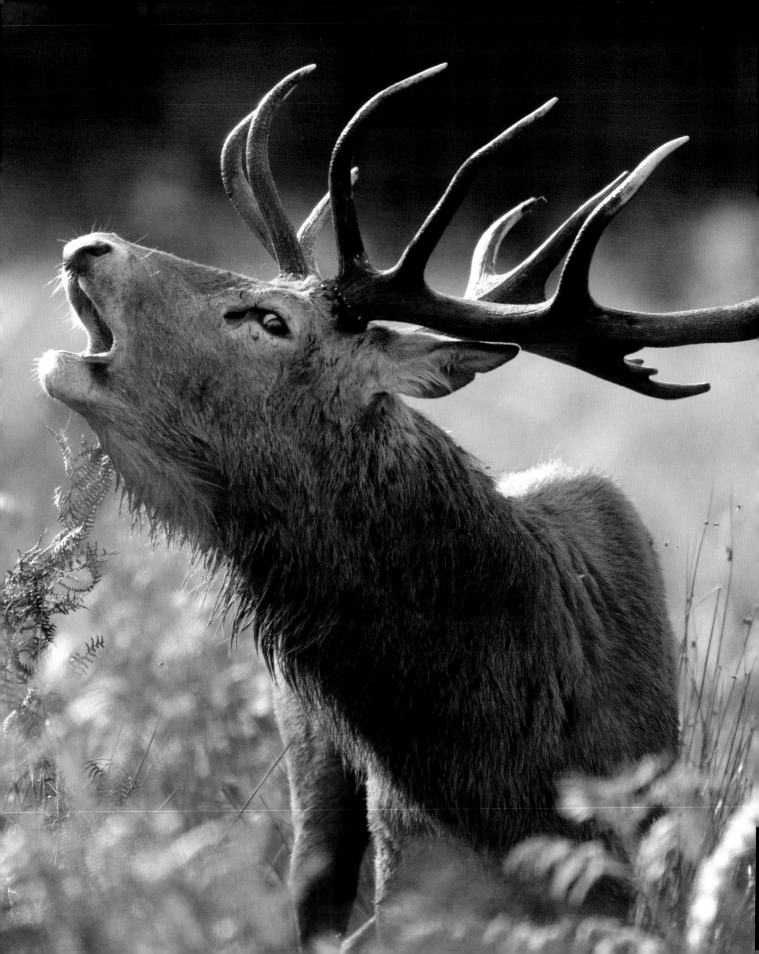

3
Europe

Lobster moth caterpillar

A MENAGERIAL AMALGAM

The lobster moth caterpillar has few similarities to other larvae. Instead it resembles, to human eyes, some sort of hotchpotch of shellfish such as lobster or crab, scorpion, dead leaf insect, praying mantis, and various other fanciful, even imaginary creatures. And its defence displays are also different. It doesn't show off eyespots or wave and protrude colourful body parts – though, like other caterpillars, it will rear up alarmingly when threatened. But exactly how its appearance and behaviour serve to protect itself and deter predators is much discussed among biologists.

Brown and speckled, well camouflaged against tree bark and plant backgrounds, the lobster moth is a relatively anonymous night-flyer of broad-leaved woodlands. The caterpillar or larva, however, is quite extraordinary. Anatomically it has a large, helmet-like head, three pairs of long flexible legs on its thoracic segments (the body sections just behind the head), camel-like humps on the next group of abdominal segments, then four pairs of 'false' limbs or prolegs, ending with a hugely enlarged terminal or anal segment with long extensions known as claspers. Few other lepidopteran (butterfly or moth) larvae look anything like it.

SHOWING OFF OR HIDING AWAY?
Naturalists describing the lobster caterpillar compare it to a whole menagerie of creatures. One explanation for the caterpillar's appearance concerns camouflage. Its un-caterpillar-like shape and outline, plus its shades-of-brown colours, may function to disguise it as a misshapen twig or dead leaf on the tree where it feeds. When approached, the sudden rearing of this apparently old, dead item, as the caterpillar spreads and waves its legs and claspers, is enough to discourage a potential enemy.

- LOCAL COMMON NAMES
 Lobster prominent

- SCIENTIFIC NAME
 Stauropus fagi

- SIZE
 Caterpillar length up to 75mm (3in), adult wingspan up to 75mm (3in)

- HABITATS
 Broad-leaved woodlands, parks

- DIET
 Caterpillar: leaves of beech, birch, oak, hazel, walnut, willow and others
 Adult: Probably nectar, soft buds and fruits

- CONSERVATION STATUS
 IUCN Not evaluated
 (see key, page 9)

FROM 'ANT' TO 'LOBSTER'
When the lobster moth caterpillar first hatches from its egg, as a first-stage or first-instar larva, it has a remarkable resemblance to a small, almost black ant or tiny spider. If molested, it waves its three long, spindly pairs of thoracic legs furiously, and wriggles and writhes in an animated display, similar to an angry ant. As the caterpillar grows and sheds its skin through further instars, usually up to five or six, it becomes more like the lobster-style design.

◀ Recently hatched out, this first instar (first larval stage) lobster moth caterpillar mimics an agitated black ant by waving its long thoracic legs.

▶ About the size of a human finger, the lobster moth caterpillar looks like a series of different creatures stuck together, from its praying mantis-style forelegs to its scorpion-like tail.

European tarantula

MULTI-STAGE DEFENCE STRATEGY

The name 'tarantula' refers to several kinds, or species, of spiders – in fact, more than a thousand. They are mostly large, hairy, and scary to some people. They live in warmer lands all around the world. The Mediterranean tarantula is found in southern and south-eastern Europe, the Middle East and North Africa. Many tarantulas have several types of display against threat, usually carried out in a set sequence: body waggle, hair kicks, frontal rearing, fang display, and ... bite!

The Mediterranean tarantula has a host of common names according to its neighbourhood, such as Cyprus tarantula, Middle East gold tarantula, and – due to its hairy appearance – black furry. Like many relatives in the tarantula group, when uneasy it shakes its rear end from side to side. If the problem persists, it may use its rear legs to loosen hairs from its main body and flick them around. The hairs are barbed and stick into skin, eyes and other sensitive surfaces.

READY TO ATTACK – OR RETREAT
The next stage is for the spider to rear up at the front (see also pages 16, 183). It raises and extends its front pair of legs and the 'feelers' or pedipalps next to them. Should the danger remain, it rears up higher to bare its long, sharp, downward-pointing chelicerae, or fangs. This action also displays the bright shades of red, pale reddish-pink or red-orange on the palp tips and the head underside, which contrast with the shiny black fangs and the dark head and body. The spider must then decide whether to strike and jab in venom, or race away at speed to hide. It may opt to lunge as though biting but in a non-venomous 'dry strike' to save its valuable chemical weapon.

DISTRIBUTION MAP

● *Lycosa tarantula*
● *Chaetopelma olivaceum*

- LOCAL COMMON NAMES
 Many, including those in the text left, also Israeli tarantula, Egyptian tarantula, Turkish tarantula, European black tarantula

- SCIENTIFIC NAME
 Chaetopelma olivaceum

- SIZE
 Head-body length, female 50mm (2in), male 20–25mm (⁴/₅–1in)

- HABITATS
 Widespread in woods, shrubland, arid scrub, parks, gardens, even buildings

- DIET
 Nocturnal beetles, cockroaches, and similar small creatures

- CONSERVATION STATUS
 IUCN Not evaluated
 (see key, page 9)

A FEARSOME FAMILY
The biggest of the tarantulas, family Theraphosidae, rejoice in names such as goliath tarantula and bird-eating tarantula. Perhaps the scariest name is the 'face-sized tarantula', *Poecilotheria rajaei*, only described for science as a distinct species in 2012. Apart from a few notable exceptions, most tarantula bites are not hugely venomous to humans. The bite of the Mediterranean tarantula, which is kept as an exotic pet, can be unpleasant, even painful, but rarely fatal.

◄ The tarantula wolf spider, *Lycosa tarantula*, from which the name 'tarantula' originates, is actually a member of a different family, the wolf spiders, Lycosidae. Legend states that its stinging bite makes people jump about in a way that resembles the energetic folk dances of Italy known as tarantellas.

► A fully reared-up Mediterranean tarantula exposes the reddish areas of its pedipalp tips and head underside. Its fangs are tilted forwards for show, rather than being folded back into furrows as usual.

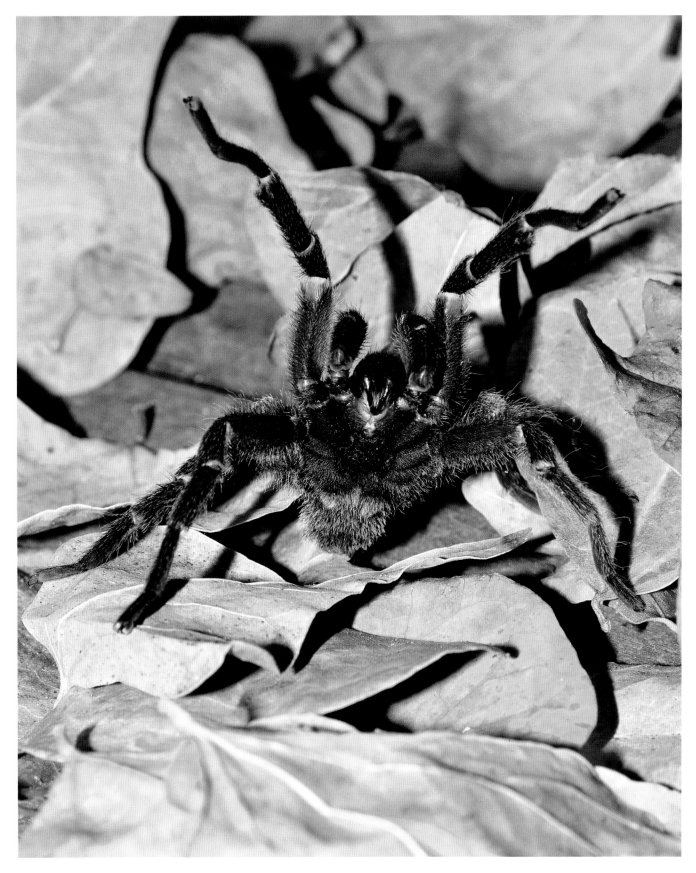

European wood scorpion

DANCING THE NIGHT AWAY

European scorpions include some very similar kinds that are difficult scientifically to identify and name. Many known generally as small wood scorpions belong to the genus (species group) *Euscorpius*. There have been numerous attempts, still ongoing, to unravel how many species there are, and which species lives where. Since many kinds are familiar in and around human habitation, their behaviours are well known, especially their 'scorpion dance' mating displays.

In terms of evolution and diversity, scorpions are a conservative group. Almost all of the 2,500 species are instantly recognizable as scorpions. They have similar anatomy, diet and habits. They are mostly nocturnal, secretive, hidden by day. They prowl cautiously at night for any small victim they can seize with their claw-like pincers, or chelae, with perhaps a jab of paralyzing venom from the stinger on the arched tail.

STING IN THE TAIL
Scorpions also have conservative displays, especially when courting and mating. A male who detects a suitable female sways and rocks his body, called 'juddering'. The two then touch pincers and begin to walk or even run, to and fro, sideways and around, in a 'scorpion dance'. Sometimes they stroke or brush together their tails; occasionally the male lightly stings the female to discourage her escape. They may also indulge in a 'scorpion kiss', touching their mouth areas together. The dance helps the pair to locate a suitable hard surface where the male can place his package of sperm, the spermatophore, for his partner to take into her body and use to fertilize her eggs.

DISTRIBUTION MAP

- ● *Euscorpius tergestinus*
- ● *Euscorpius italicus*

- **LOCAL COMMON NAMES**
Many and varied depending on region and features like body and tail colour, such as Italian scorpion, Yellow-tailed scorpion, Carpathian scorpion, Black-pincered scorpion; Scorpione di legno, Scorpione italiano (Italian); many other European language names

- **SCIENTIFIC NAME**
Several species of *Euscorpius* including *E. tergestinus*, *E. sicarnus*, *E. carpathicus*, *E. italicus*

- **SIZE**
Head-tail length excluding pincers 25–50mm (1–2in), depending on species

- **HABITATS**
Mostly warm but shaded, humid places including woodlands, leaf litter, rocky shrubland, stony scrub, old wood, also walls, ruins, around and inside buildings

- **DIET**
Small creatures such as flies, crickets, worms

- **CONSERVATION STATUS**
IUCN Not evaluated
(see key, page 9)

◄◄ Wood scorpions like this brown-backed euscorpius have very poor eyesight, although this does not affect their nocturnal outings. Males usually detect females by pheromones, or scents, and then raise pincers for their 'scorpion dance'.

◄ The dance involves gentle movements with pincers hardly touching, and also fierce grappling, here in Italian scorpions. Pincers locked, each partner jostles the other to gauge physical prowess and mating suitability.

COMPLEX SPECIES COMPLEX
Scorpiologists have long puzzled over the species of European small wood scorpions *Euscorpius* and their relationships. Some of these are species 'complexes' within *Euscorpius*, meaning a very closely related group that may be in the process of becoming separate species – or merging into one species. Physical appearances suggest between fifteen and twenty-five species of *Euscorpius*. However, modern analysis of genes and other body components could increase this number.

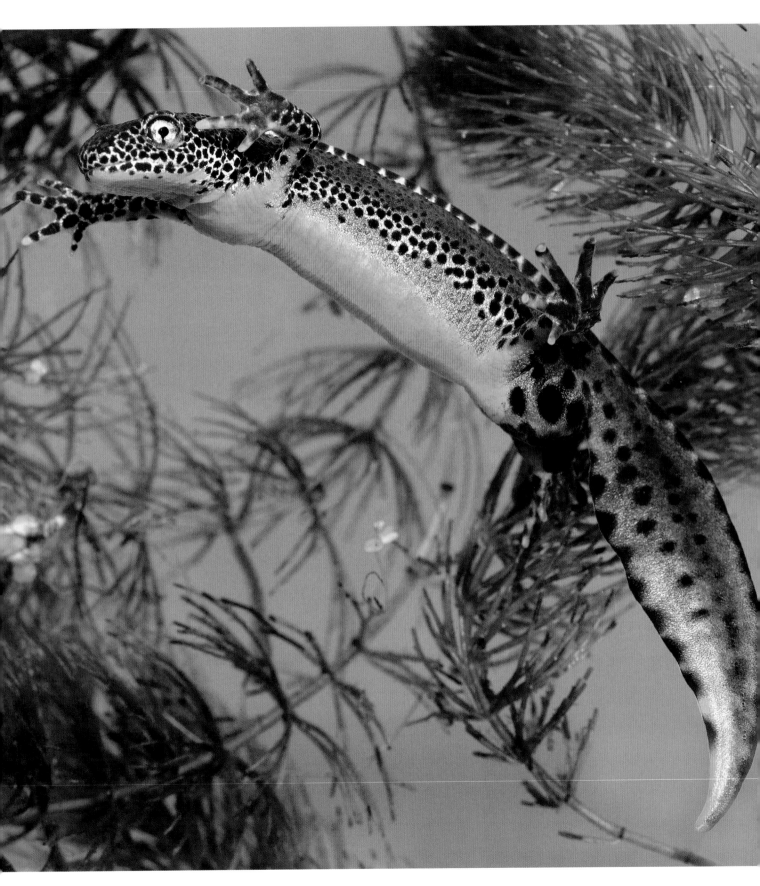

Alpine newt

HIGH-ALTITUDE COLOURFUL COURTSHIP

Unlike many amphibians, alpine newts cope with chilly slow streams and cold pools at high altitudes, as well as with warmer lowland habitats. They are often found above the tree line, in high scrub and mountain meadows. Of course, their water must not be frozen when the newts begin their spring courtship displays, which range from February or March at mild low altitudes, to post-snowmelt May or June at greater elevations.

Generations of naturalists and ethologists (animal behaviour specialists) have demarcated 'stages' in alpine newt courtship. Usually the male initiates proceedings with 'orientation' as he positions in front of a female. He may then 'tail-quiver', flicking his tail towards her, probably to swish his waterborne pheromone scents in her direction and gauge her reaction.

Then, in varied order, may come the 'creep' as the male moves away and the female follows. There is more 'tail-quiver' from both partners, and perhaps 'cloacal nuzzle' as one probes the other's genital opening with its nose. There may be a 'tail-fold' as the male pleats his tail like a concertina, also the 'distal lure' as he bends his tail at right angles to his body and waves its tip invitingly.

ULTIMATE GOAL

The male's ultimate aim is to expel a package of sperm, his spermatophore, onto the surface below, then lure the female over it so she can take it into her genital opening. For this he may use the 'brake' or 'block', when he positions at right angles just in front of her, so she is above the sperm package.

DISTRIBUTION MAP

- LOCAL COMMON NAMES
 Many regional English names such as Balkan alpine newt, Spanish alpine newt; Alpenmolch, Bergmolch (German); Triton alpestre (French); Tritone alpestre (Italian); Alpski pupek (Slovenian); Alpesi göte (Hungarian); Bergvattensalamander (Swedish)

- SCIENTIFIC NAME
 Ichthyosaura (formerly Triton, Triturus) alpestris

- SIZE
 Total length 75–125mm (3–5in) (females slightly larger)

- HABITATS
 Upland and lowland woods and forests, including high areas above the tree line, also parks and gardens, but always near water for breeding

- DIET
 All kinds of small creatures such as worms, slugs, insects, spiders, water-fleas, in water and on land

- CONSERVATION STATUS
 IUCN Least concern, but populations decreasing
 (see key, page 9)

◀ The male alpine newt's colours intensify when he enters breeding condition, especially the blue sheen along his flanks and the low black-and-yellow crest on his back.

▶ A female (in front) and male alpine newt move parallel, head to tail, as they manoeuvre during courtship.

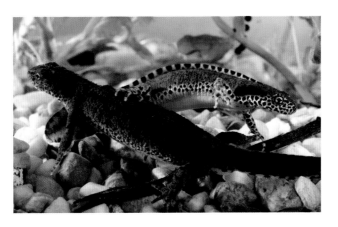

TRULY 'AMPHI-BIAN'

In most regions, alpine newts live on land for most of the year, during what is known as their terrestrial phase. They hide in moist, dark places by day and emerge to feed at dusk. In spring comes the aquatic phase as they move to water for courtship and egg-laying. The tadpoles develop in the water while the adults move back to land. This is why amphibians are so named, from *amphi-bios*, 'two kinds of life', in water and on land.

Fire-bellied toad

DANGER, TOAD IN FLAMES!

One of the strangest and most surprising defence displays is known by the term 'unken reflex'. Found mainly among amphibians, especially frogs, toads and salamanders, it involves several sudden movements, especially curving the body to reveal bright yellow, orange, or red parts, often with contrasting dark spots or patches. Coupled with muscle contortions, body bloated with air, hissing, poison oozing from neck glands, and stiff immobility, the result in a fire-bellied toad is hardly an appetizing sight, even for a hungry predator.

'Ünke' is a German term for toad, and the unken reflex is well known from various toads, in particular fire-bellied toads, *Bombina*. From above, and from the side when crouched low, they look unremarkable in camouflage-type natural colours of greens, browns and greys. The toad's secret weapon is its extremely gaudy underside – the chin and belly. These are brightly hued in red, yellow or orange, according to the species, with a random pattern of black or dark spots, swirls and patches. For example the European fire-bellied toad has red or reddish-orange and black.

PANOPLY OF DETERRENCE
The unken reflex causes the toad's back to arch into a C, exposing the underside in a sudden burst of contrasting colours. This is an example of the animal feature known as aposematic coloration (see page 6), warning of the creature's toxic skin and glands. The fire-bellied toad also gulps air and hisses to become bigger and more intimidating. The parotid glands, one each side of the neck, expel a toad's trademark foul-smelling and horrible-tasting poison fluid. And the stiff, motionless body adds to the off-putting effect.

DISTRIBUTION MAP

European fire-bellied toad
Bombina bombina

- LOCAL COMMON NAMES
Many common names according to species and region, for example, for *B. variegata*: Yellow-bellied toad; Gelbbauchunke (German); Sonneur à ventre jaune (French); Geelbuikvuurpad (Dutch); Gulbuget klokkefrø (Danish); Sapo de vientre amarillo (Spanish); Ululone a ventre giallo (Italian)

- SCIENTIFIC NAME
Six species in the genus *Bombina*, including Yellow-bellied toad *B. variegata*, European fire-bellied toad *B. bombina*, Oriental fire-bellied toad *B. orientalis*

- SIZE
Head-body length 30–70mm (1¹/₅–2⁴/₅in) depending on species (females are usually larger than males)

- HABITATS
Adaptable, in natural pools, streams, swamps, damp banks and undergrowth, moist woodlands, drier scrub, also see left, with water nearby for breeding

- DIET
Small creatures such as insects, spiders, worms, slugs, snails, also small shrimps and similar freshwater prey

- CONSERVATION STATUS
IUCN Least concern, although populations decreasing (see key, page 9)

ON THE MARCH
Frog and toad tadpoles tend to grow and develop faster in warmer water. The yellow-bellied toad takes advantage of this by laying its eggs in very small, even temporary bodies of water in seldom-disturbed farmland, earthworks, quarries, mining surrounds, ditches, gardens, even vehicle tyre-track puddles. Hopefully the tadpoles become toadlets and leave before the water dries. These toads have spread and maintained numbers even as their natural habitats are being dammed, filled in, cut down and generally destroyed.

▶ Unconcerned about threats, an Apennine yellow-bellied toad *Bombina pachypus* gulps air while incidentally exposing its vivid underside. The combination of flame-like yellows, oranges and reds, coupled with smoky-dark swirls and patches, inspired the 'fire-bellied' name.

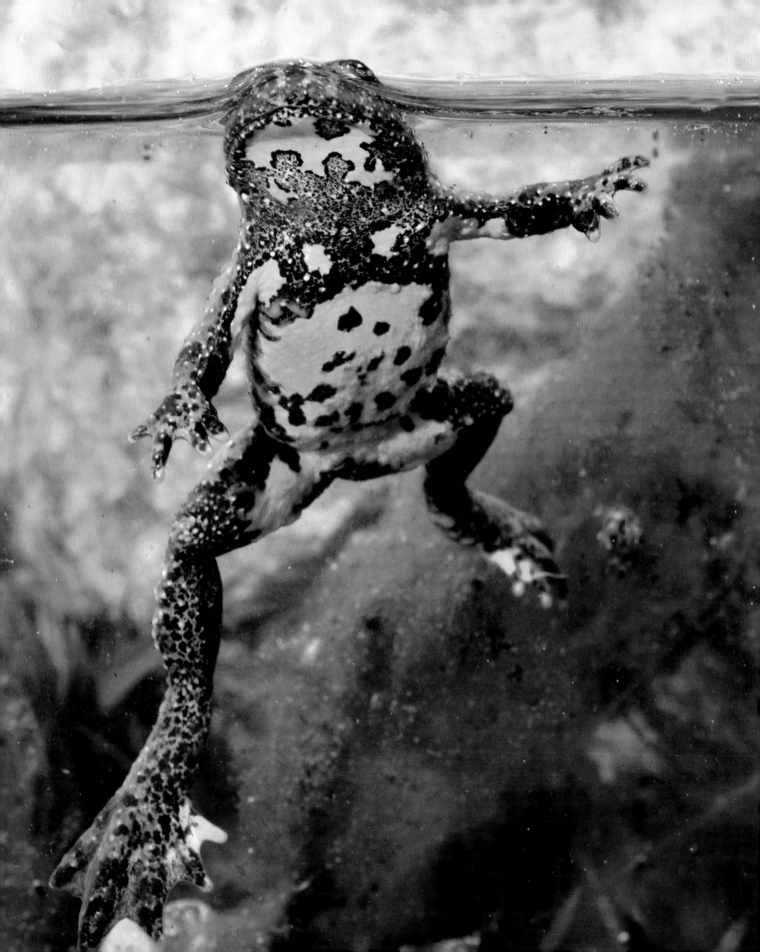

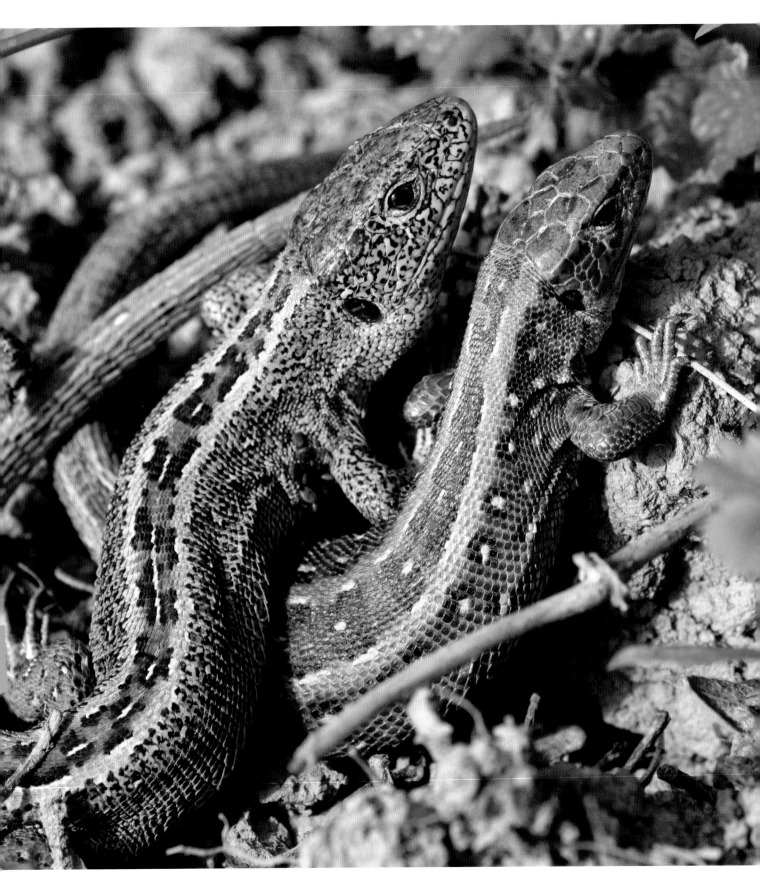

Sand lizard

GREEN FOR GO TO BREED

Sand lizards are smallish, quick, agile and adaptable. They prefer drier habitats, as suggested by their 'sand' name. For most of the year they bask and feed by day and are generally spaced apart from, and peaceful with, their sand lizard neighbours. However, this all changes in spring. Males boost their formerly subdued green-grey flanks to a much more vivid green, and they display with great energy to court females and see off rival males.

Sand lizard breeding begins in the warmth of spring. As males develop their glowing green flanks, each takes a prominent position on a mound, rock or log to display himself, and to monitor other males. If one comes too close, the two engage in confrontational posturing, which involves head-bobbing, lifting the body on all four legs, flipping over onto the back, curving the body to the side and swinging the tail.

Sometimes these rituals are not enough, and the two make physical contact. They try to bite and snap at each other's head, neck and belly, all at super-fast speed. Serious injuries occur but are rare. Usually, one male soon slinks away.

PERSUASION OR FORCE

Meanwhile, interested females move around the area, sizing up each male's size, health and greenness. If a pair show mutual interest, they circle each other. The female may crouch flat on the ground, and lift and wave her rear legs, as a readiness sign. Or the male may take the lead and grab the female in his mouth, pressing her down for the mating act.

DISTRIBUTION MAP

- LOCAL COMMON NAMES
Numerous local names around Europe such as Lagarto ágil (Spanish); Lézard des souches (French); Sila ķirzaka (Latvian); Zauneidechse (German)

- SCIENTIFIC NAME
Lacerta agilis

- SIZE
Total length 18–20cm (7–8in)

- HABITATS
Varied but mainly drier places such as open woods, fields, sandy heaths, rocky scrub, coasts, also well-drained transport verges, embankments, gardens

- DIET
Any small catchable creatures, from flies, grasshoppers, crickets, beetles and spiders to worms, snails, woodlice

- CONSERVATION STATUS
IUCN Least concern, although a European Protected Species (see key, page 9)

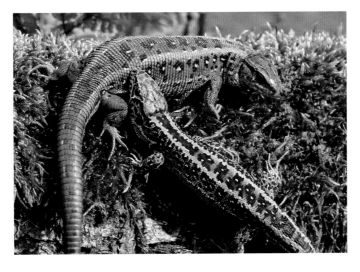

◄ The start of breeding varies from March in the south of the sand lizard's range, to May or even June in the north. After they mate, the brightly green-sided male may guard the female, staying close to her, to prevent other males getting in on the act.

► Sometimes the male sand lizard grabs a reluctant female and subdues her into mating.

PROTECTING HIS INVESTMENT

The actual mating of sand lizards usually takes just a few minutes. But the male may then escort his partner for hours, even a few days, in a behaviour known as mate-guarding. These lizards are polygynandrous, that is, either a male or female may mate with multiple individuals. The mate-guarding male is trying to ensure his partner's eggs are fertilized by his sperm, rather than the sperm of another, subsequent male.

Grass snake

'DEAD' SNAKE IN THE GRASS

One of Europe's most widely distributed, largest, and most common snakes is the grass snake. It is often chanced upon in parks, gardens and other human habitations – especially near water. It is an extremely proficient swimmer and its favourite preys include frogs, fish and other aquatic creatures. It is also, when under threat, one of the most adept animals at feigning death or 'playing dead', known as thanatosis, tonic immobility or 'playing possum' after the Virginia opossum (see page 35).

In a tight corner, the grass snake first becomes aggressively defensive. In characteristic snake fashion it puffs itself with air, hisses menacingly and rears up at the front. It may dart its head forward in a quick lunge. Often this is a warning and the snake does not make contact. If the action has to be repeated, it may well be only a quick prod with the snout, mouth closed. Biting a big opponent may well backfire since the grass snake does not wish to risk its main hunting weapons – its fangs – and also it has no venom.

SUDDEN COLLAPSE
Should these usual snake-type defence displays fail, the grass snake has another tactic. It unexpectedly writhes theatrically for a few seconds, then suddenly collapses in a heap, floppy, unresponsive, mouth open, tongue lolling. Presumably this confuses predators such as hawks, foxes and wildcats. While they consider their next move, the grass snake can revive and slither speedily to safety. Or it may deploy yet another tactic, as explained below.

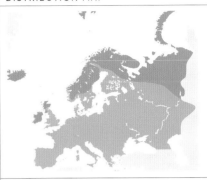

- LOCAL COMMON NAMES
 Water snake, Ringed snake, Common grass snake, European grass snake; many names across Europe such as Gemeine ringelnatter (German); Couleuvre à collier (French); Cobra-de-água-de-colar (Portuguese); Culebra de collar (Spanish); Suge gorbataduna (Basque); Serp de collaret (Catalan); Ringslang (Dutch); Biscia dal collare (Italian); Vanlig snok (Swedish); and lots more

- SCIENTIFIC NAME
 Natrix natrix

- SIZE
 Total length usually up to 100cm (40in), occasionally more

- HABITATS
 Open areas like scattered woodland, bushes, shrubs, fields, hedges, parks and gardens, usually near water

- DIET
 Mostly aquatic creatures such as frogs, toads, fish, worms, insects

- CONSERVATION STATUS
 IUCN Least concern (see key, page 9)

ONE MORE TACTIC
If the grass snake's pretend demise still does not repel a predator, the reptile has another manoeuvre. It makes a surprising and startling recovery and continues to thrash, writhe and lunge at the danger. It also expels its bowel wastes, oozes repulsive-smelling fluid from anal glands at the rear end, and dribbles blood from its mouth and nostrils. This makes the snake an even less attractive mouthful.

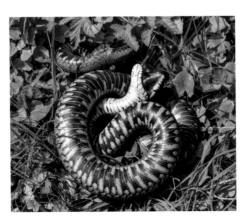

◀ A grass snake apparently in its 'death throes', coiled yet unmoving, gaping and perhaps defecating.

▶ Gaping mouth and limp, protruding tongue are all part of the grass snake's apparent expiry. However, should it be grabbed or even lightly touched, it springs back to life with even more forceful resistance.

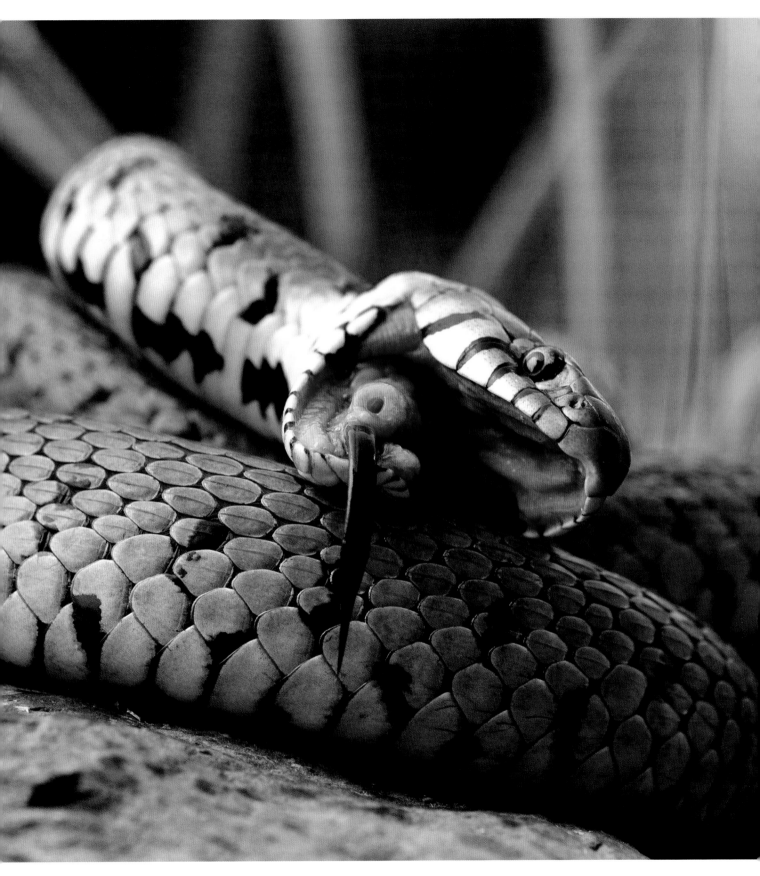

Great crested grebe

SHAKES, DIVES AND GIFT-GIVING

The complex, elaborate and lengthy courtship displays of the great crested grebe are some of the most observed, described and analyzed of any animal species. This is partly because they occur on open water and can be watched relatively easily by enthusiastic ornithologists and naturalists, who are often concealed in bird-watching hides (some of these floating on small boats) or secreted in bankside vegetation.

As soon as temperatures rise and wildlife begins its spring awakening, great crested grebes congregate on their open-water, vegetation-fringed locations, and begin to establish their breeding areas and to court mates. The grebes' displays are highly ritualized. That is, their actions are largely symbolic, stereotyped, and proceed in a predictable manner (see page 8).

A LENGTHY RITUAL
A potential pair come face to face, bills raised to show their white necks, crests of cocked head feathers, and erect tails. Bouts of side-to-side head-shaking alternate with simulated preening when they quickly bill-comb their back feathers. They also tilt their wings up, out and forwards, and dive with splashy, showy resurfacing.

Perhaps most famous is the grebes' 'weed dance' routine. One or both partners dive to gather a bill-full of water plants, come to the surface, swim and approach front-to-front, stretch up, shake heads and offer the weedy 'gift' to the other. All these rituals may continue through the breeding season to reinforce the pair bond.

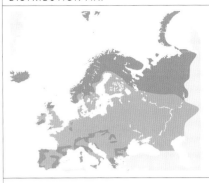

- LOCAL COMMON NAMES
 Many across their wide range, a small selection being Mergulhão-de-poupa (Portuguese); Somormujo lavanco (Spanish); Grèbe huppé (French); Haubentaucher (German); Toppet lappedykker (Danish); Svasso maggiore (Italian); Perkoz dwuczuby (Polish); Ausuotasis kragas (Lithuanian); Potápka roháč (Czech)

- SCIENTIFIC NAME
 Podiceps cristatus

- SIZE
 Bill-tail length 40–60cm (16–24in), wingspan 60–75cm (24–30in)

- HABITATS
 Fresh water with plenty of fringing vegetation for nest-building, such as lakes, reservoirs, very slow rivers, large canals, wetlands, lagoons

- DIET
 Water creatures, mainly fish, also amphibians, insects, shellfish, watersnails, worms

- CONSERVATION STATUS
 IUCN Least concern (see key, page 9)

PASSING OF THE SEASONS
As spring and summer proceed, great crested grebes defend their territories with much showy flapping and bill-darting at intruders of their kind. Their territory is based around the nest site but its size varies greatly, depending on nearby suitable nest places and food abundance. As the offspring begin to fend for themselves, the territorial system breaks down and the birds become more solitary.

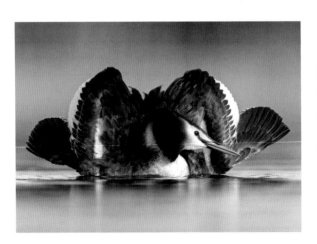

◄ A great crested grebe arches its wings and maintains an erect head crest, to demonstrate its healthy condition and readiness to breed.

► 'Weed dancing' great crested grebes rear up, feet paddling frantically, to present their offerings, known as nuptial gifts. The behaviour is ritualized, that is, symbolic as part of courtship. The birds do not actually eat the plants, indeed they are carnivorous.

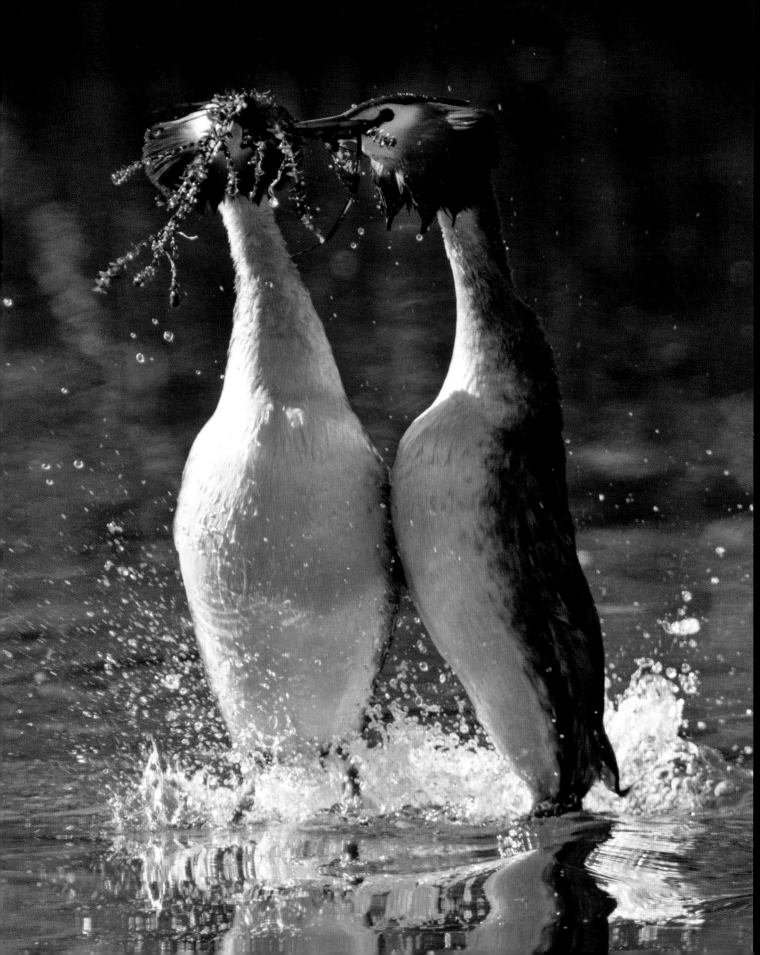

Avocet

FOLLOW ME, I'M INJURED ... NO I'M NOT

Distraction displays are chiefly to lure a predator or other threatening animal elsewhere, usually away from a nest, den or burrow with eggs or young. Wading birds like avocets are especially proficient at this trick. The general method is for the parent bird to pretend to be hurt, injured or sick, so that it appears an easy catch for the hunter, which follows as the bird leads it away from the nest. When the avocet decides the nest is far enough away and safe, it suddenly 'recovers' and flies off.

The distraction technique is employed by several kinds of animals, mainly birds and mammals. The avocet's nest, like those of other shorebirds, is exposed. It is not especially prominent, being a small gathering of surrounding natural vegetation such as leaves, stems, shoots and roots, in a scape or on a low mound.

LURED AWAY BY AN EASY MEAL
However, once a predator such as a fox, rat or gull spots the eggs or chicks, the parent goes into action. One technique is for the avocet to swoop and dive at the threat, squawking and flapping at speed. Or the bird poses as sick or injured, dragging one or both wings along the ground, flapping erratically, limping, and croaking in an agitated fashion. Diverted by this display, the marauder switches attention to what it perceives as 'easy meat'. The injury-feigning parent draws it farther off, to where it feels the predator will no longer remember or find the nest. Then, amazingly, the avocet is fully mended and makes a hasty escape.

- **LOCAL COMMON NAMES**
 Pied avocet, Black-capped avocet, Eurasian avocet; varied names according to region such as Bjúgnefja (Icelandic); Alfaiate (Portuguese); Bec d'alena comú (Catalan); Avoceta común (Spanish); Säbelschnäbler (German); Avocette élégante (French); Avocetta (Italian); Gulipán (Hungarian); Sabljarka (Serbian); Šabliarka modronohá (Slovak); Bontelsie (Afrikaans)

- **SCIENTIFIC NAME**
 Recurvirostra avosetta

- **SIZE**
 Bill-tail length 42–45cm (17–18in), wingspan 75–80cm (30–32in), standing height 45cm (18in)

- **HABITATS**
 Coasts, estuaries, mudflats, brackish lagoons, saltmarshes, tidal flats, also inland wetlands, damp grassland

- **DIET**
 Small creatures such as worms, shrimps, snails, insects

- **CONSERVATION STATUS**
 IUCN Least concern (see key, page 9)

◀ With one wing raised and one trailing along the ground, apparently broken, also legs bent as if injured, an avocet distracts a predator away from its nest.

▶ The avocet may limp and hobble for many metres, then it suddenly takes to the air.

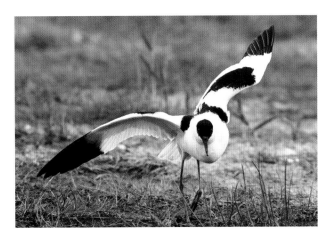

FAMOUS LOGO
The UK's Royal Society for the Protection of Birds, RSPB, is one of the world's foremost animal charities and conservation groups. Its official logo or symbol features the avocet. This was produced by eminent wildlife artist Robert Gillmor and adopted by the RSPB in 1955. As the bird is black and white, the logo works well for non-colour, black-and-white printing – similar to the panda of the World Wide Fund for Nature (World Wildlife Fund, WWF).

European bee-eater

FOOD FOR THE FAMILY

Few birds are mistaken for a bee-eater, with its rusty-red-brown crown, black- and blue-fringed eye-mask with white beneath, yellow throat, blue-turquoise chest and underside, and yellow-green-blue wings and tail. The remarkably long, slim, sharp bill is designed to catch the bird's predominant food of flying insects. This is key for the bee-eater's courtship, since the male spends much time hunting and then presenting his catches to the female, both before, during and after the period when the pair raise their young.

Many breeding birds share the workload. Usually, one sits on the eggs to keep them warm, called incubation, while the other gathers food for itself and brings some back for its mate. The female may do the incubation, while in other species, the two take turns.

Bee-eaters take this relationship a stage further. Even before nesting and egg-laying, the male catches and brings back gifts of food which he displays and then passes to the female. Often he offers larger, prized, showy items, like dragonflies, butterflies and hornets, while he himself eats smaller bees and flies. He also sings varied melodic tunes, and skips, hops and flaps along a favourite perch.

GROUP LIVING
Bee-eaters seldom live alone. A female and male pair for life, which might be more than five years. With others, they form relatively stable groups. Pairs nest near each other, in tunnels and burrows they peck and scratch in the earth, or take over from other creatures, along riverbanks, sandbanks and soft cliffs. They are co-operative birds and sometimes help each other to excavate nest burrows, incubate eggs and feed young.

EATING BEES
To avoid bee and wasp stings, a bee-eater swoops from a lookout perch to catch prey with its long, hard, sting-resistant bill. It then perches and rubs, thrashes and bashes the insect against a branch, twig, rock or similar hard surface, to remove the sting. During the breeding season one bee-eater may consume more than 200 bees daily.

▶ A male bee-eater gifts a dragonfly to his partner. This kind of presenting during courtship or pair-bond reinforcement is termed nuptial gifting.

▶▶ Although usually accommodating with group members, occasionally two bee-eaters squabble, for instance, over a nest burrow.

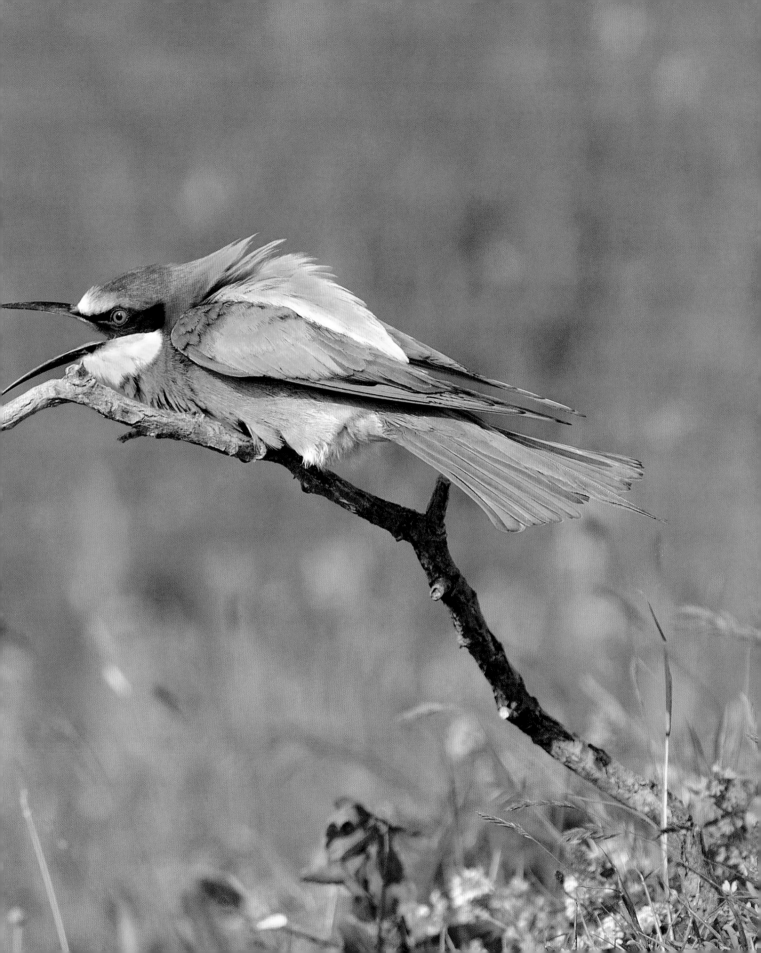

Mute swan

A BIRD BEST AVOIDED

During the spring–summer breeding season, a male mute swan aggressively defends his partner and their nest, eggs or chicks. His range of threat displays keeps away most animals, from smaller waterfowl like ducks to other swans, pets such as dogs, and also humans. He is sizeable, powerful and fierce, with a very strong pecking bite, bony spurs on the wings, and large feet with claw-tipped toes. He is not to be confronted.

Mute swans are not completely mute, although they are less vocal than other swans. They make soft dog-like barks and yaps, grunts, snorts and low whistles. The most common noise is a loud hiss with which the male, or cob, warns intruders to keep away. He also stretches his neck up and forwards. Swans are very territorial when breeding, and he keeps any danger away from the female, known as the pen, and nest. If the hiss does not work, he has no hesitation in attacking.

'BUSKING' AT THE DANGER
On the water, a defending cob half-raises and arches his wings over his back in a U-like shape, bends his neck to keep his head low, and paddles at great speed, surging towards the problem. This unmistakable behaviour is known as 'busking'. If the intruder remains, he has no hesitation in making it physical as he lunges forwards to peck, flap and scratch. On land, the cob runs at the threat, flapping and hissing loudly, again making thrusts and stabs with his beak.

DISTRIBUTION MAP

- **LOCAL COMMON NAMES**
 Numerous European language names such as Knölsvan (Swedish); Knopsvane (Danish); Höckerschwan (German); Cisne vulgar (Spanish); Cygne tuberculé (French); Cigno reale (Italian); Labud grbac (Serbian)

- **SCIENTIFIC NAME**
 Cygnus olor

- **SIZE**
 Bill-tail length 140–160cm (55–62in), wingspan 210–240cm (82–95in)

- **HABITATS**
 Any open water, from inland ponds, lakes and slow rivers to canals, reservoirs, lagoons, coasts, including water in towns and cities

- **DIET**
 Wide range of water plants plus some small aquatic animals, also farm crops, decorative plants in parks and gardens

- **CONSERVATION STATUS**
 IUCN Least concern
 (see key, page 9)

◄ A 'busking' male mute swan part-raises and arches his wings together over his back, bends his neck so his head is low, and powers through the water at great speed, as shown by the 'bow wave'.

► A male mute swan sees off another who has strayed into his breeding territory. If the two are evenly matched they can suffer serious injury.

ATTACKING ALL COMERS
A very aroused male mute swan may attack almost anything that moves in his territory. People, dogs, cats, other medium-sized and large birds – almost any creature is repelled. He might even attack rowing boats, canoes, kayaks and other small craft. Away from the breeding season, the swan and his partner may stay in their territory but be much less defensive, or they might gather with others of their kind to form roaming, feeding flocks.

Brown hare

NOT MAD BUT READY TO 'BOX'

Around much of Europe, a seasonal spring spectacle across open land is two hares, or maybe more, in frantic action. They run, chase, swerve, sometimes roll over or somersault, and occasionally rear up like tiny kangaroos to 'box' with their paws. Many myths surround these energetic displays, giving rise to sayings such as 'mad as a March hare'. The hares are not mad, nor do they only 'box' in March.

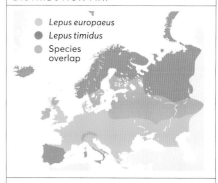

DISTRIBUTION MAP

○ Lepus europaeus
● Lepus timidus
○ Species overlap

Hares indulge in these chasing and boxing displays well into the summer. However, late winter and early spring, especially dawn and dusk in March, is when people notice them on farmland. This is when many crops have not yet grown; visibility later in spring reduces as the crops mature.

BATTLE OF THE SEXES

Displaying hares may seem to be playing or even, to our eyes, showing signs of madness and being out of control. Another common idea is that the participants are rival males, known as bucks or jacks, competing for dominance and the attentions of local females, called does or jills. This is occasionally the situation. But most commonly, the hares are a female, perhaps not yet ready to mate, rejecting the approaches of an over-enthusiastic male.

Also it is not only 'boxing' with the forepaws. The female also springs up and kicks out with her extremely powerful hind feet, aiming for the male's soft underbelly. After a few such bouts, usually he understands the message and leaves. But the female may then have to fend off another male, sometimes even two or three at once.

- **LOCAL COMMON NAMES**
 Common brown hare, Central European brown hare, Eurasian brown hare; Sorhare (Norwegian); Almindelig hare (Danish); Lièvre européen, Lièvre commun (French); Feldhase (German); Liebre común (Spanish); Lepre comune (Italian)

- **SCIENTIFIC NAME**
 Lepus europaeus

- **SIZE**
 Head-body length 65–75cm (26–30in), tail 7–10cm (3–4in), weight 3–5kg (6.6–11lb)

- **HABITATS**
 Open countryside including meadows, moors, farmland, shrubby grassland, hedgerows and scattered woodland

- **DIET**
 Grasses, herbs, farm crops, buds, twigs, shoots, bark and other plant material

- **CONSERVATION STATUS**
 IUCN Least concern (see key, page 9)

DOWNWARD TREND

Brown hares are not rare – yet. However, many populations across their extensive range are on a downward trend. A major cause is loss of habitat, with natural grasslands, scrub, shrub and woodland edge replaced by neatly tended and intensively cultivated farm fields separated by wire fencing. During the twentieth century, their UK numbers fell by more than 70%. Sadly hare shooting, and hunting with dogs, are still practised.

◀ There are about twenty-five species of hares worldwide. Mountain hares, Lepus timidus, occur across Northern Europe and North Asia, and in European mountains and uplands.

▶ Male and female brown hares, known by the traditional names of jack and jill, stand and trade blows. Usually it is the female, not yet ready or able to breed, repelling an eager male.

Red deer

ROARS, BELLOWS AND BOLVING

A fully grown red deer stag (male) is a majestic and extremely impressive sight – especially during the rut. This occurs when stags compete to impress, take over, and mate with a group of hinds (females), known as the stag's harem. In most of Europe, rutting is in the autumn. Open woods and countryside echo to the loud, low bellows and roars of displaying stags. There is also much posturing and action as they show off their size and power.

The red deer stag's audio display is not only to intimidate rivals. It also sends signals to nearby hinds. Due to the physical size of the head, throat and vocal area, the biggest, fittest males with the most stamina tend to roar at a lower pitch, more loudly, and more often, since roaring is strenuous. Females give these stags more attention, and are more likely to mate and stay with them. Such stags also keep their roar quality and clarity for longer. In 'lesser' stags the sounds gradually become broken, quieter and more like coughs.

WHEN ROARING FAILS
Should roaring or 'bolving' fail, stags may confront. They parallel walk, strutting side by side, stiff-legged. They break off occasionally to spray around their scent-laden urine. Another option is adorning – thrashing antlers among vegetation so they become decorated with leaves, twigs, ferns, stems and other matter. A further tactic is rolling in mud to increase a stag's threatening appearance. If all this fails, stags then clash antlers, push and shove in a trial of strength.

◄ Roaring, also known as bolving, is most common in the early morning and around dusk. However at the height of the rut it may continue through the day and night.

► Antlers decorated or 'adorned' with all manner of vegetation, a stag resumes its bolving (roaring and bellowing).

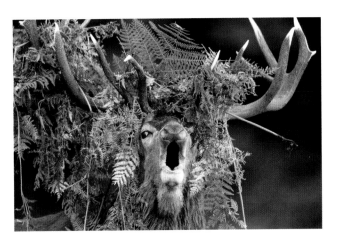

ANNUAL ANTLERS
Unlike the horns of cattle, goats, sheep, antelopes and gazelles, deer antlers are cast off and regrown each year. As the antlers enlarge they are covered by a soft, fleshy, nutrient-supplying layer called velvet. This is shed in time for the rut, leaving the antlers mature, tough and ready for action. Apart from reindeer and caribou (which are the same species), only male deer have antlers.

Iberian ibex

RUTTING AND BUTTING: CLASH OF HEADS

Like many members of the sheep-and-goat group, the caprids, Iberian ibex males clash fiercely for dominance and the ability to mate with females. Indeed, this is a general feature of the entire hoofed mammal category, the ungulates. The ibex's physical battles are preceded by displays of posing, showing off horns and hooves, snorting, coughing, head-tossing, stamping and similar behaviour.

Iberian ibex are social animals, but usually in single-sex groups. Males form loose congregations through most of the year, while females and their young are in tighter-knit herds. Like many of their fellow ungulates, when it is time for mating, males develop higher levels of the hormone testosterone and become much more antagonistic towards each other. The aim is to dominate other local males and gain mating rights to the female herd. As in deer (see previous page), this time is known as the rut and is usually in late autumn and early winter.

REAR UP, RAM DOWN

Some caprids back away from their male rivals and then charge, head-butting with tremendous sudden force and a loud bash or crack. Ibex tend to rear up on their hind legs and head-butt on the way down, crashing their horns and foreheads. Or they approach more slowly, align heads, then repeatedly thrust and push the opponent. Perhaps more sneakily, as one male moves away to prepare for the next assault, the other charges at his flank or rear.

DISTRIBUTION MAP

- LOCAL COMMON NAMES
 Iberian wild goat, Spanish wild goat, Spanish ibex; Cabra montés, Cabra salvatge, Cabra brava, Herx, Bucardo (Spanish and Portuguese)

- SCIENTIFIC NAME
 Capra pyrenaica

- SIZE
 Head-tail length 90–140cm (35–55in), males considerably larger than females; male horn length up to 90cm (36in), female 30cm (12in)

- HABITATS
 Upland and mountain forests and woods, usually with rocky cliffs, crags and outcrops

- DIET
 Leaves, shoots, stems, buds, fruits, nuts, twigs and other vegetation

- CONSERVATION STATUS
 IUCN Least concern
 (see key, page 9)

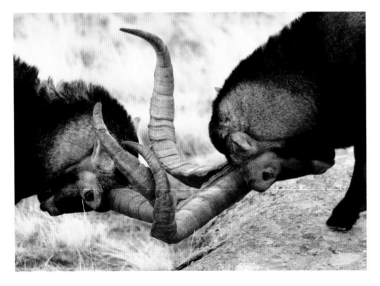

EXTINCT, CLONED, EXTINCT

Among various subspecies, or varieties, of the Iberian ibex was the Portuguese ibex, *C. p. lusitanica*, extinct by the end of the nineteenth century. Another was the Pyrenean ibex, *C. p. pyrenaica*, which died out mainly through hunting and competing domestic grazers. Tissue samples from the last individual, 'Celia', were used to try and clone this subspecies in the early 2000s. Only one youngster was born alive and it survived just a few minutes.

◀ Ibex rams 'fence' with their horns, swinging and wrenching the other's head sideways with violent power.

▶ Well fed, weighty and powerful after a summer's feasting, male ibex or rams rise on their rear legs to dive down and clash heads and horns.

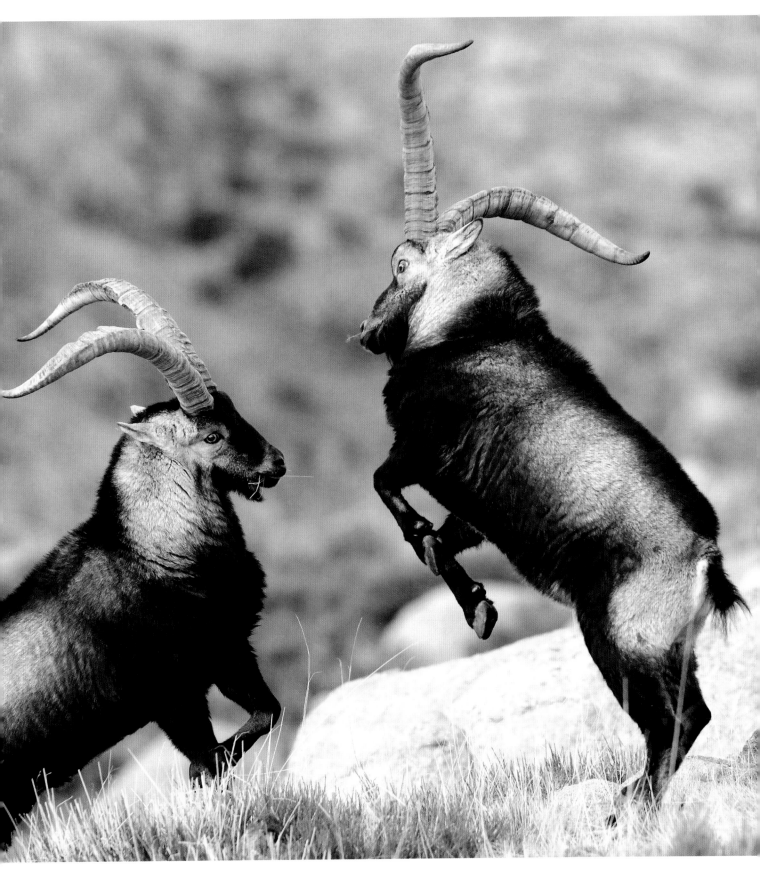

Grey seal

BUSY AT THE ROOKERY

Grey seals are highly adapted for life at sea, and spend more than two-thirds of their time on and under the waves. They are most conspicuous when they 'haul out' on land to rest, and also during the pupping and mating season, usually late autumn and early winter. This is a busy time at the rookery (breeding colony site). Cows (females) give birth and feed their pups (young), and soon after mate with bulls (males) who have been displaying, tussling and battling each other to gain female attention.

Display and rivalry among grey seal bulls are rather different from many other seal species, such as elephant seals (see page 237). Grey seal bulls do not compete to hold a patch of beach or shoreline. Neither do they clash to gain a high place in the dominance hierarchy. Their main aim is to attract, keep and defend a female group against other males. Those who attain the aim are known as tenured bulls.

The females usually return to their same rookery each year and form loose aggregations. But they are quite mobile, shifting along the beach or rocks from day to day, which means their tenured bull must go with them to keep other bulls at bay.

EXHAUSTING TENURE
A successful tenured bull may have mating rights over five, even ten females. But it is exhausting work. Other bulls challenge by croaking, roaring, rearing and trying to push and jostle with their chest. More serious fights may occur, with the seal's long, sharp teeth inflicting wounds, but this is relatively rare among grey seals.

- **LOCAL COMMON NAMES**
 Common grey seal, Atlantic grey seal, North Atlantic grey seal; Útselur (Icelandic); Halli (Finnish); Havert (Norwegian); Gråsäl (Swedish); Gråsæl (Danish); Pelēkais ronis (Latvian); Ilgasnukis ruonis (Lithuanian); Hallhüljes (Estonian); Grijze zeehond (Dutch); Kegelrobbe (German); Phoque gris (French)

- **SCIENTIFIC NAME**
 Halichoerus grypus

- **SIZE**
 Around European shores, average head-body length male 2–2.3m (6½–7½ft), female 1.6–1.9m (5¼–6¼ft); weights vary greatly with season and breeding condition but average males 220–240kg (485–530lb); females 140–160kg (310–350lb). Grey seals in the West Atlantic (Canada, US) are 15–25% larger

- **HABITATS**
 Coastal waters for most of the year, resting on beaches, sandbanks, rocks and small islands especially in the winter; shores of various kinds for breeding

- **DIET**
 Mostly fish, also squid, octopus, crabs, lobsters, occasionally seabirds, smaller seals, including its own species (cannibalism)

- **CONSERVATION STATUS**
 IUCN Least concern (see key, page 9)

◀ Much grey seal conflict is symbolic or ritual rather than truly physical. The bulls rear up, flap flippers, chest-heave, show off their powerful teeth, and make roars and bellows. Serious fighting is uncommon but can leave deep scars, especially around the neck.

BACK OUT TO SEA
Through summer and early autumn, hungrily feeding grey seals build up their fat reserves. A day or two after a female arrives on land she gives birth, then provides milk for her single pup for up to three weeks, living off her body fat. When the pup is weaned, she mates and returns to the sea, followed two or three weeks later by the pup, who also accumulated then used up its blubber reserves. As a tenured bull's females come and go, he may not be able to feed at sea for five or six weeks, so he also lives on his fat reserves.

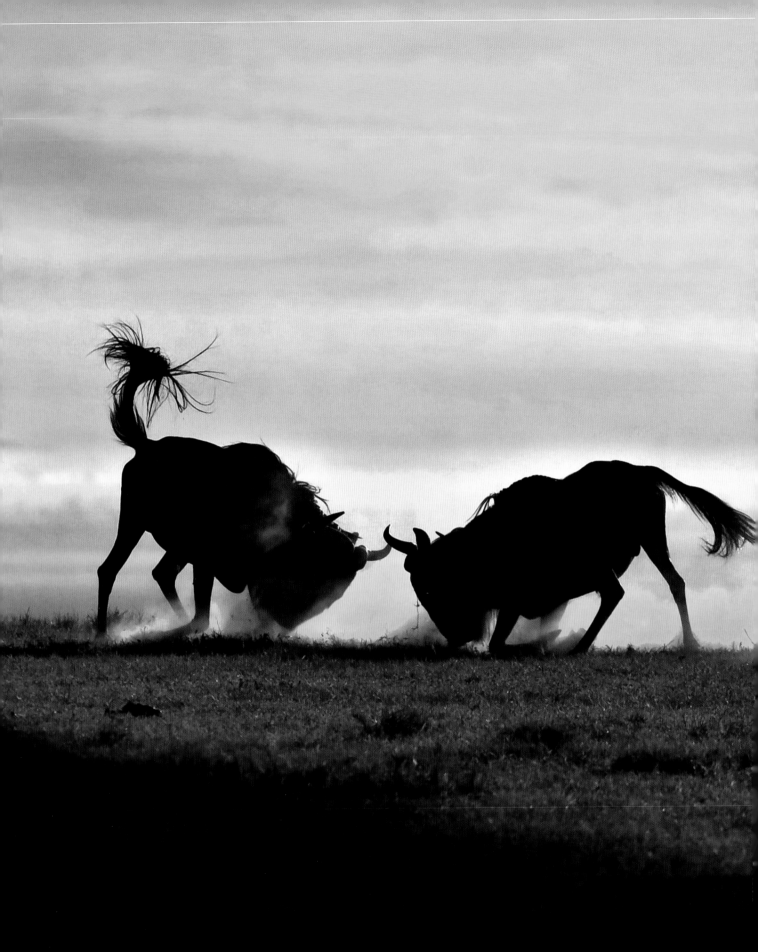

4

Africa

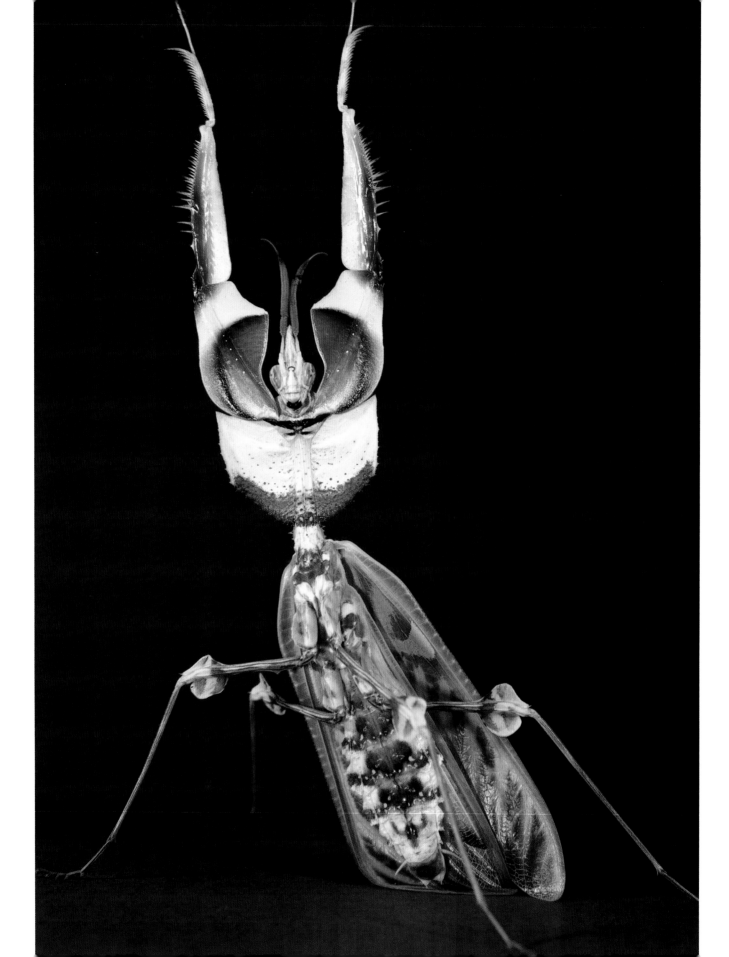

Devil's flower mantis

FLOWER TO TERROR IN AN INSTANT

One of the largest mantids, the devil's flower mantis is highly camouflaged within flowering vegetation. Posing innocently among flowers and leaves, it waits for any prey considered catchable. With a lightning strike, the mantis flashes out its jack-knife forelegs, impales the victim on their spines, and deploys its scissor-like mandible 'jaws' to decapitate and consume. But if under threat, and again in a flash, the mantis rears up in an amazing display of full-on intimidation that startles creatures many times its size.

A view of a relaxed devil's flower mantis, quietly waiting for prey with limbs folded, is unremarkable. In its younger or larval life stages, called nymphs, the upper sides are generally brown like a dead leaf. The adult is more green, and has other shades such as pink and cream, like a living leaf. Or rather, leaves – since from above and the side, flaps on its thorax (mid-body section) and legs, plus the chevron-like pattern on its abdomen (rear-body section), all in shades of green, merge with the general jumble of surrounding foliage and flowers.

FLARED FLAPS
Like most mantids, the devil's flower can adopt its startle display in a fraction of a second. It rears up, head and neck held high, and front legs extended up and slightly out with their flaps flared open. The now-exposed undersides of these parts form an astounding display of shades: white, cream, red, green, blue, turquoise, purple and black. Coupled with the mantis's size – and as many creatures know, its ferociously spiked front legs – this is indeed an off-putting sight known as a deimatic ('frightening') display.

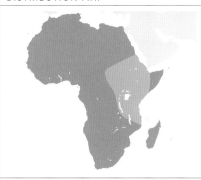
◀ With forelegs up and flaps opened out, the devil's defensive display is sudden and startling. The staring eyes watch intently for increasing threat.

▶ The young stages or nymphs of the devil's flower mantis have a camouflage mimicking old brown leaves. About seven or eight moults are needed to become adult.

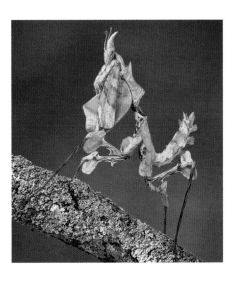

A VERY DIFFICULT 'PET'
The devil flower mantis's great size – bigger than a human hand – and amazing colour scheme make it a sought-after exotic pet. However its care is extremely tricky, even for experienced keepers. Many captives quickly die, especially if stressed by being repeatedly stimulated to 'show off' their startle display. The trade in gathering their eggs and all growth stages from the wild puts this species at increasing risk.

Rainbow or Painted milkweed locust (grasshopper)

POISON TRANSFER FROM FOOD TO FLESH

Rainbow, painted, gaudy, milkweed, bush, blue, green, leprous, not to mention locust or grasshopper – insects of the genus (species group) *Phymateus* have many names in English and in African languages. Most kinds eat poisonous plants like milkweeds, nightshades, and bushman's poison tree or poison plum. The insects are not harmed and transfer the toxins into their bodies, becoming poisonous themselves – which they advertise with colourful body and wing patterns, along with wing-rattling, chirping and hissing.

The twelve or so *Phymateus* species are known as both grasshoppers and locusts. The latter is a group within the former. Certain environmental conditions – usually optimum food and weather – trigger gregarious behaviour in locusts (but not most other grasshoppers). The wingless young locusts, termed nymphs or hoppers, gather in marching bands that walk, jump and hop from place to place, devouring vegetation. The winged adults do the same, but fly rather than jump to new feeding places.

ADVERT FOR DISTASTEFUL TOXICITY
Phymateus locusts munch through toxic plants that would harm or kill many other creatures, including people. The locusts are immune, and they appropriate or sequester the harmful substances into their own flesh and body fluids. The locust's bright, contrasting warning coloration, especially on the wings, and (on some species) the body too, tell other creatures to beware. This well-known tactic of cautionary colours and warning patterns is known as aposematism (see page 6). To emphasize its distasteful unpalatability, the locust may spread its wings in a flash of bright hues, chirp and hiss loudly, and kick out with its strong rear legs.

DISTRIBUTION MAP

- LOCAL COMMON NAMES
 Painted locust/grasshopper, Milkweed locust/grasshopper, Rainbow locust/grasshopper, Gaudy locust/grasshopper; Tumateus (local Madagascan name)

- SCIENTIFIC NAME
 Several species of *Phymateus* including *P. saxosus, P. aegrotus, P. viridipes*

- SIZE
 Head-body length in females up to 75mm (3in), males up to 50mm (2in), depending on species

- HABITATS
 Woods, bush, shrub, grasslands

- DIET
 Most species eat toxic plants (see below)

- CONSERVATION STATUS
 IUCN Not evaluated (see key, page 9)

CHEMICAL DEFENCES

Phymateus locusts 'steal' their poisons from a range of plants, depending on the insect species and its distribution. The plants include milkweeds, nightshades, and the bush *Acokanthera oppositifolia*, commonly known as bushman's poison, Hottentot's poison bush or poison plum. On Madagascar, these milkweed locusts 'steal' some of their toxins from very poisonous plants known as pervillaea dogbanes, which are endemic to the island.

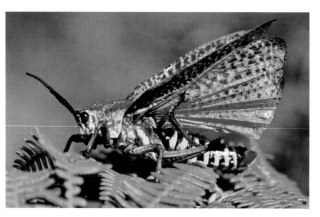

◄ A milkweed or rainbow locust flashes its brilliantly coloured wings for added effect.

► The showy colours of a male (smaller) and female Madagascan milkweed locust, *P. saxosus madagascariensis*, also known as the giant painted locust (or grasshopper), advertise their poisonous flesh.

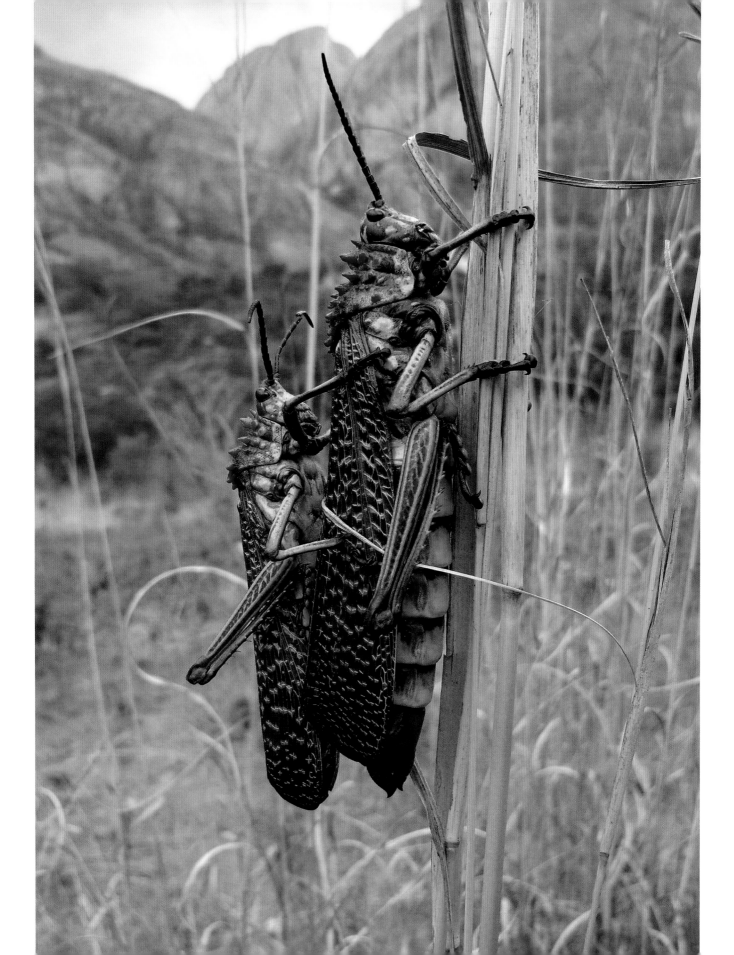

Flap-necked chameleon

MODIFIED FOR MOODS AND INTENTION

The lizards known as chameleons are sometimes called 'masters of disguise'. True, they have a considerable ability to change hues and shades of their basic colour, such as green or brown, and to some extent, to alter this base colour. But chameleon colours, coupled with body postures and movements, also fulfil many other functions. They may indicate mood and intention, warn away a breeding rival, attract a mate, or repel a threat such as a snake, hawk or cat.

Two flange-like areas of skin known as occipital flaps give this lizard its name. One is on each side of the rear head, extending from the enlarged, helmet-like bony part of the upper skull, known as the casque. The flaps usually lie flat, barely noticed, against the upper neck. They may resemble ear flaps, but a reptile's ears are simple eardrums, tympanic membranes, behind the eyes. These lie flat among the scales and may be coloured like them, with no protruding parts like the ear flaps, or pinnae, of mammal ears.

INTIMIDATING RESISTANCE

When the flap-necked chameleon is moved to defence, several changes occur in a second or two. The flaps swing forward like miniature elephant ears and may tilt upwards. The chameleon's legs tense, the mouth opens, its body inflates with air, and it hisses loudly. Another flap in the throat-chin area, the gular pouch, extends down and forwards, often revealing bold contrasting colours. The chameleon's overall shades may darken as it sways in an intimidating manner, side to side, and also forwards and backwards.

DISTRIBUTION MAP

• LOCAL COMMON NAMES
Common flap-necked chameleon, African flap-necked chameleon; Unwabu endlebeni (Zulu)

• SCIENTIFIC NAME
Chamaeleo dilepis

• SIZE
Total length females 35cm (14in), males slightly smaller

• HABITATS
Wide range from forest, bush and grassland to suburban parks and gardens

• DIET
Insects, especially grasshoppers and beetles, also spiders and similar small creatures

• CONSERVATION STATUS
IUCN Least concern (see key, page 9)

POPULAR AND ADAPTABLE

The flap-necked chameleon is relatively common, with a wide range of habitats, environmental conditions and foods. This adaptability, plus its peaceable temperament, and its bizarre and unmistakable – to some people, charming – appearance have made it a popular exotic pet. However the spread of urbanization, farming, mining and other habitat loss in sub-Saharan Africa, plus regular flap-neck deaths on roads, means its range is shrinking and some populations are now in danger.

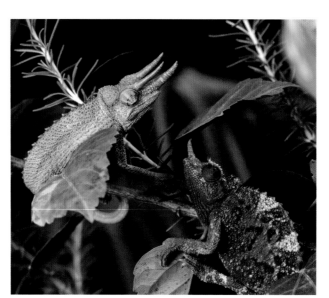

◀ Jackson's or three-horned chameleons, *Trioceros jacksonii*, court with less energetic forms of their full-scale defence display, and the male (left) also changes colour rapidly.

▶ Colourful gular pouch extended, mouth wide to show small but sharp teeth, and neck flaps at the ready, a flap-necked chameleon prepares to repel danger.

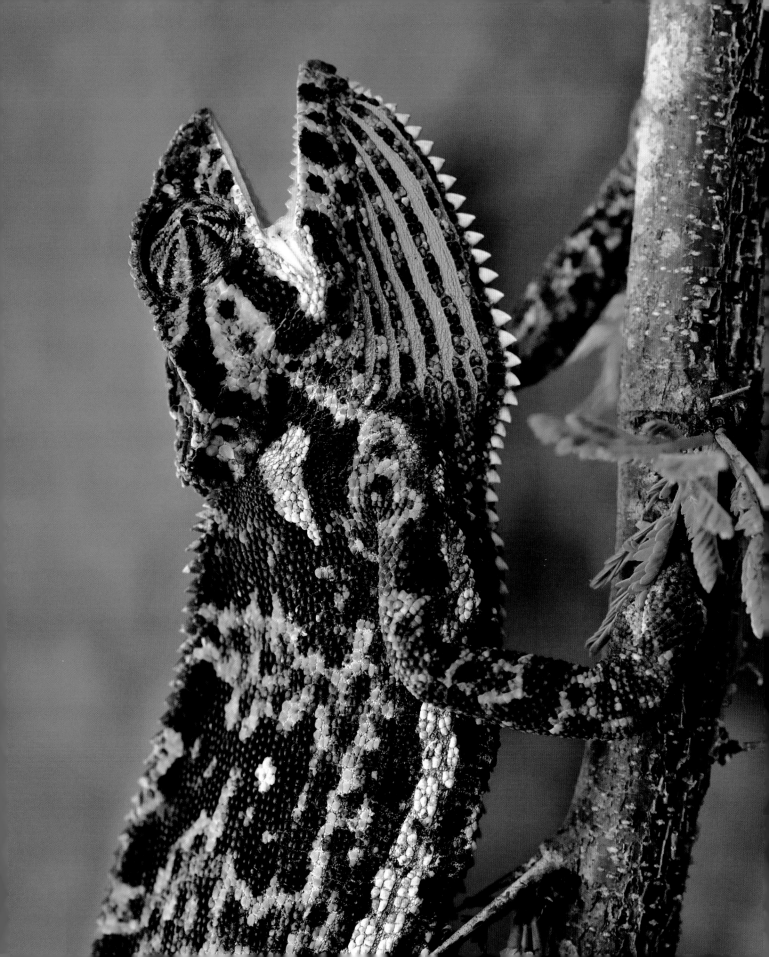

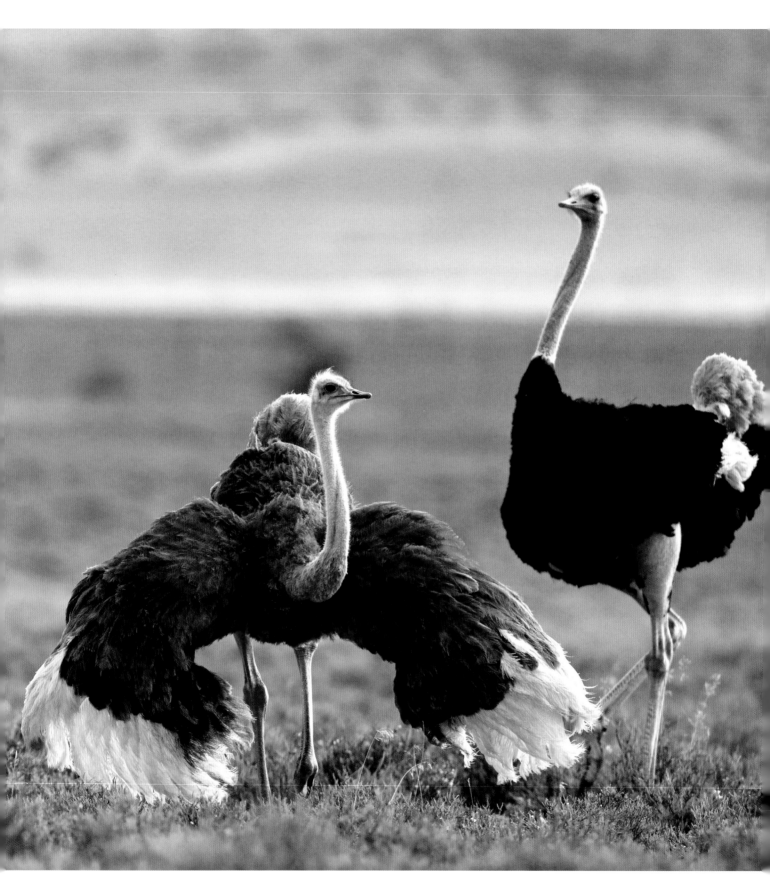

Ostrich

FLAPPING BUT NOT FLIGHT

Famous worldwide as the tallest, heaviest and generally biggest of all birds, ostriches have size on their side. Their very strong, flexible necks and robust beaks, plus their even stronger, longer legs armed with clawed toes, and their amazing running speed and endurance, mean they are seldom a target for local predators. So the primary reason for ostrich displays relates to courtship, mating and chick rearing.

Courting time among ostriches involves spectacular performances. As breeding begins, each cock (male) attempts to gather a group or harem of hens (females), as many as seven or eight. He struts, uses his neck muscles to make loud booms, and hisses and dashes at rival cocks who approach his territory.

FLOWING PLUMAGE

Turning his attention to the hens, the cock fluffs and waves his wings at one of them, alternating left and right wing actions in an enthusiastic 'dance'. The wing's bones and muscles are much reduced and of course incapable of flight. But their adornments of long, flowing, wafting plumes, in contrasting black and white, make a remarkable sight.

After some brief but symbolic feeding, the cock flaps energetically, and pecks and claws the ground, indicating a nest site. The hen spreads and droops her wings and trots around him, as he twists and shakes his head on its elongated, bendy neck. If all is satisfactory, the two mate. The cock repeats this with others in his harem. He then fashions a communal nest scrape where all of his mated hens lay their eggs.

- **LOCAL COMMON NAMES**
 Common ostrich; Volstruis (Afrikaans); Mhou (Shona); Mbuni (Swahili); Intshe (Zulu)

- **SCIENTIFIC NAME**
 Struthio camelus

- **SIZE**
 Males occasionally exceed 2.5m (8ft 2in) in height and 130kg (285lb) in weight, females average 10–20% smaller

- **HABITATS**
 Chiefly open areas such as savanna grasslands, scattered woodland, semi-arid bush and shrub

- **DIET**
 Almost any plant material including leaves, buds, fruits, stems, also occasional insects, small reptiles and other little creatures, and carrion

- **CONSERVATION STATUS**
 IUCN Least concern but decreasing in some areas
 (see key, page 9)

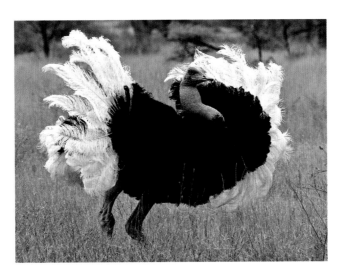

◀ A cock ostrich stands tall, wings folded, while a hen from his harem (small flock) encircles him with wings lowered, indicating she is receptive and ready to mate.

▶ The displaying cock's spread wings reveal their extravagant plumage, while he nods, and curves, stretches and twists his neck in a rhythmic courtship dance.

A BIG INVADER

Ostriches were – and in some places, still are – farmed in enclosures for meat, eggs, hides and decorative feathers. Being large and powerful, with natural instincts to roam widely, in some places they have escaped their confines to establish feral populations. In Australia from the 1970s, ostriches absconding from farms have managed to live wild in a few areas, although their long-term survival is questionable.

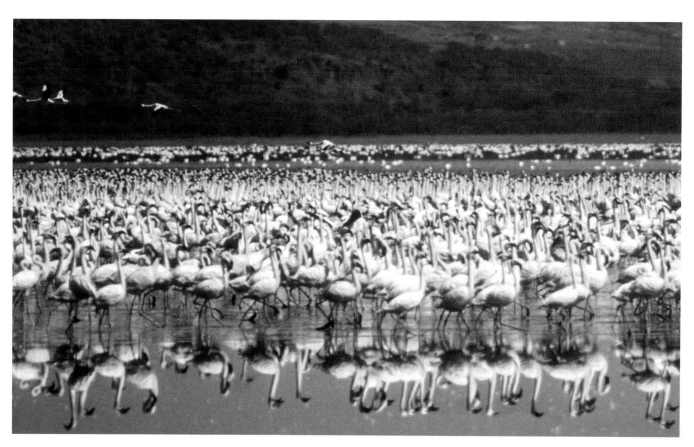

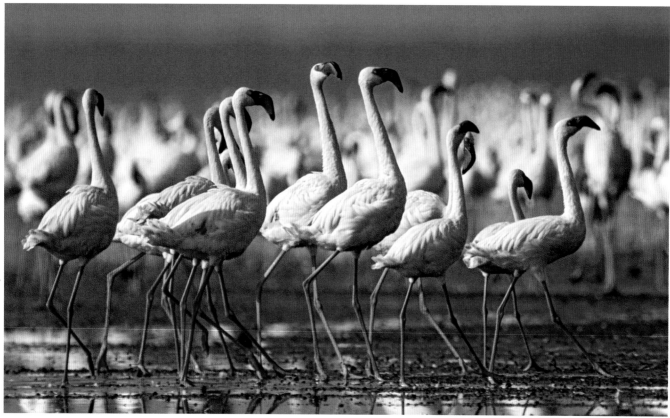

Lesser flamingo

MARCHING ON PARADE

Specialized habitat and nutrition mean lesser flamingos rely on very salty or saline water for their foods – which are similarly specialized microscopic plant-like organisms, filtered out by the birds' delicate, sieve-like bills. Extremely social, these flamingos feed, court, breed, warn of danger, and travel in great flocks. There is much ongoing communal interaction and communication by way of visual postures, displays, scents, and also strident honks, soft murmurs and many other sounds.

A huge gathering of lesser flamingos marching to and fro, heads swivelling, necks bent then straight, wings spread then folded, may seem random and disorganized. However, these birds are deploying a wide variety of visual, auditory and olfactory signals as they watch each other, receive messages and meanings, and pass information through the crowd.

Courtship behaviour can occur through the year, although in the breeding season – which varies, depending on factors such as rainfall – the actions become more frequent, more extravagant and more urgent. Males stride along in unison and move their heads from side to side in a swinging motion known as 'head-flagging', all the while honking like geese. The marches are highly coordinated as the birds suddenly all change direction.

SALUTES AND GREETINGS
As a female's attention increases, a nearby male may lower his head in the 'broken neck' gesture, and add wing movements resembling human arms raised in greeting and saluting. This brandishes flashes of colour from his wing feathers. He may then approach the interested-looking female; if he is successful, she responds with head bobbing and wing flapping.

◀◀ Each lesser flamingo monitors those around, a collective tactic that has advantages of 'safety in numbers' as many eyes scan for danger.

◀ Rather than one individual displaying in isolation, with no others for comparison, the flamingos' synchronized parades and dances allow each female to assess the performances of the males around in relation to each other and choose the best mate.

ORDER AMID CHAOS
A vast flock of flamingos busy with daily activities, such as feeding and displaying, may look chaotic. However, dedicated 'flamingologists' have managed to identify much interactive display. For example, an abruptly straightened, stretched-high neck, rather than the usual graceful S-curve, can indicate potential danger, such as from a nearby eagle, vulture, hyaena or jackal. The signal spreads in seconds, putting the entire flock on high alert.

Grey crowned crane

A STYLISH PERFORMER

Away from the breeding season – which varies with rainfall and other conditions – grey crowned cranes are social birds. They travel, feed and roost in loose flocks of twenty to one hundred or more. However each mated pair stays close together. They bow, preen each other, and generally interact to maintain their mutual bond. As reproduction approaches, each pair is more territorial around its nest site, and their displays become more lengthy and elaborate.

Tall and 'classy', a grey crowned crane pair in full courtship mode put on a sophisticated show. This nuptial dance is a performance with many moves and segments, of varying lengths and sequences. Core elements include hops, strides, sprints, jumps, head bobs and bowing, leg-kicks, and wing spreading and flapping. The main accompanying vocalizations are powerful booms produced using the expandable throat or gular pouch (in the neck, beneath the red patch of feathers), and emitted with the head craned forwards and down at shoulder level.

IMPROVISED PRESENTATION
Either male or female may initiate the courting display, by walking alongside the other and beginning some small-scale head-bowing which the partner reciprocates. Either may progress the sequence, for example, from head bowing to wing flapping. Likewise, either partner may finish the session, usually by looking around in case of threat or by meandering off to feed. Sometimes other adults and even young grey crowned cranes join in, but with less energy and at a respectful distance from the two main dancers.

DISTRIBUTION MAP

- LOCAL COMMON NAMES
Multiple English variations such as Golden crested/crowned crane, Blue-necked crane, Royal crane, African/East African/South African crowned/crested crane, Crested crane; Korongo taji (Swahili); Mahem, Bloukraanvoël (Afrikaans)

- SCIENTIFIC NAME
Balearica regulorum

- SIZE
Height up to 100cm (40in), wingspan up to 200cm (80in)

- HABITATS
Mostly savanna grasslands, also marshes, farmland, usually with lakes, rivers or other water nearby for feeding and nesting

- DIET
Varied, from seeds, leaves, fruits and other plant matter to worms, insects, frogs, small lizards and other creatures

- CONSERVATION STATUS
IUCN Endangered
(see key, page 9)

NATIONAL BIRD
In 1962 Uganda adopted a new national bird and displayed it on the new national flag. The flag has three sets of horizontal stripes – from the top, black, yellow and red, repeated. At the centre is a white disc with a grey crowned crane, chosen for its beauty, elegance and mostly peaceable disposition. With some artistic licence, the three colours of the flag can be said to represent the crane's head and crest.

▶ A pair of grey crowned cranes reaffirm their partnership with a complex sequence of dancing, head bobs and wing flaps. 'Grey' refers to the bird's neck and upper body; the crown or crest is golden, gold-silver or straw-coloured.

Fischer's lovebird

AFFECTION AND DEVOTION

Small but bold, also vocal and demonstrative, Fischer's lovebirds are restricted to a relatively small region of East Africa. Like the other eight or so species in the lovebird genus (species group) *Agapornis*, a female and male form a close, long-lasting bond. They keep each other's company as much as possible, and exchange what we interpret as physical affection, loving behaviour and devotion. They even exhibit, when separated, what might be termed 'mourning'.

Anthropomorphism involves transferring human feelings, emotions and behaviours onto non-human objects – including animals. Whether lovebirds are truly 'in love', in the sense that many humans would understand, is a massive and ongoing debate. However these small members of the parrot family do pair bond extremely closely and for life.

KISS, VOMIT

Among the lovebirds' mutually intimate habits are perching close to each other, preening each other's feathers and exchanging food items, as well as pecking gently at each other's bills, in what might be a bird version of 'kissing'.

To initiate pairing, a male approaches the female, bobs his head up and down, edges to and fro, makes soft cheeps and peeps, and gauges the female's reaction. If she responds, the two begin to reinforce their bond with much mutual activity. However, one aspect of their display which is not so easily interpreted as human 'love' is when the male provides a 'gift' to the female of part-digested food from his stomach. He donates this by inter-oral regurgitation – that is, vomiting into her mouth.

- LOCAL COMMON NAMES
Fischer's dwarf parrot, Red-headed dwarf parrot; Pfirsichköpfchen (German); Inséparable de Fischer (Spanish); Fischeragapornis (Dutch); Cherero machungwa (Swahili); Rooikopdwergpapegaai (Afrikaans)

- SCIENTIFIC NAME
Agapornis fischeri

- SIZE
Bill-tail length up to 15cm (6in), wingspan up to 12cm (5in)

- HABITATS
Mostly drier, open places above 1,000m (3,300ft) such as scattered woodland, scrub, savanna, farmland, parks

- DIET
Most kinds of plant material, from bark and hard seeds to soft fruits, berries, buds and flowers, plus occasional small insects and similar creatures

- CONSERVATION STATUS
IUCN Near threatened, many populations decreasing (see key, page 9)

◀ Fischer's lovebirds spend much time mutually preening and bill-nibbling, which helps to reinforce their reputation, from a human perspective, of 'loving devotion'.

LOVEBIRDS AS PETS
Fischer's and other species of lovebirds are regularly kept by bird enthusiasts. However, capture from the wild has enormous effects on their natural populations. Statistics suggest that in the 1980s, Fischer's lovebird was one of the world's top five most wild-captured and traded bird species. Legal protection in parts of its very limited geographic range, plus the status of Near Threatened as a species at risk, will hopefully halt this trend.

Pin-tailed whydah

THE TRAILING TAIL TALE

In his full breeding plumage, the male pin-tailed whydah sports tail feathers that are twice as long as his head and body. He shows them off in a magnificent courting display as he flitters, hovers and flaps in mid-air, just in front of his hopeful future partner. The male's 'butterfly dance' demonstrates his health and survival abilities. Even with such an ungainly, un-aerodynamic tail, he manages to fly, feed and flatter the female, allowing her to assess his suitability.

A male pin-tailed whydah courts a female, and if successful, the pair mate – but that is not the end of the process. This species is far from monogamous. The male attracts more females into his territory and courts them in the same way. Meanwhile the female may also move on and mate with other males.

THE HOVER DANCE DISPLAY
The male pin-tailed whydah spends much time hover-dancing in front of females, his amazing tail streamers (trailing feathers) waving in the breeze and in the downdraft from his flapping wings.

The enormity of the male's tail compared to his body is probably an example of the evolutionary process known as sexual selection (see page 8). This describes how, up to a point, 'bigger is better' for an anatomical feature that attracts the opposite sex, before it becomes too much of a hindrance to survival. Away from the breeding season, the male pin-tail moults to look very similar to the female, including a more normally proportioned tail.

The origin of the name 'pin-tailed' whydah is unclear. A leading explanation is that the long tail feathers were pinned onto the hats of human widows for their spouses' funerals. The feathers, being black but also graceful and elegant, were especially appropriate to show off the widow's social status and the wealth she had inherited.

BROOD PARASITISM
In Europe, the common cuckoo is a familiar brood parasite. The female lays her eggs in other birds' nests, to be raised by the nest's owners. Whydahs are similar, but with three main variations. One, the pin-tailed whydah female is not especially 'host specific', that is, she can lay in a range of host nests, mostly waxbills and similar finches. Two, the female adds two or three eggs to the existing clutch, rather than the cuckoo's one. Three, again unlike the cuckoo, when the whydah chicks hatch they do not eject the host's eggs or chicks from the nest.

▶ A male pin-tail whydah flutters and flits for a female – a display designed to show his extraordinary tail feathers to maximum effect. After the summer breeding season, his nuptial plumage is shed and he looks much more like the female, although he retains his red-pink bill.

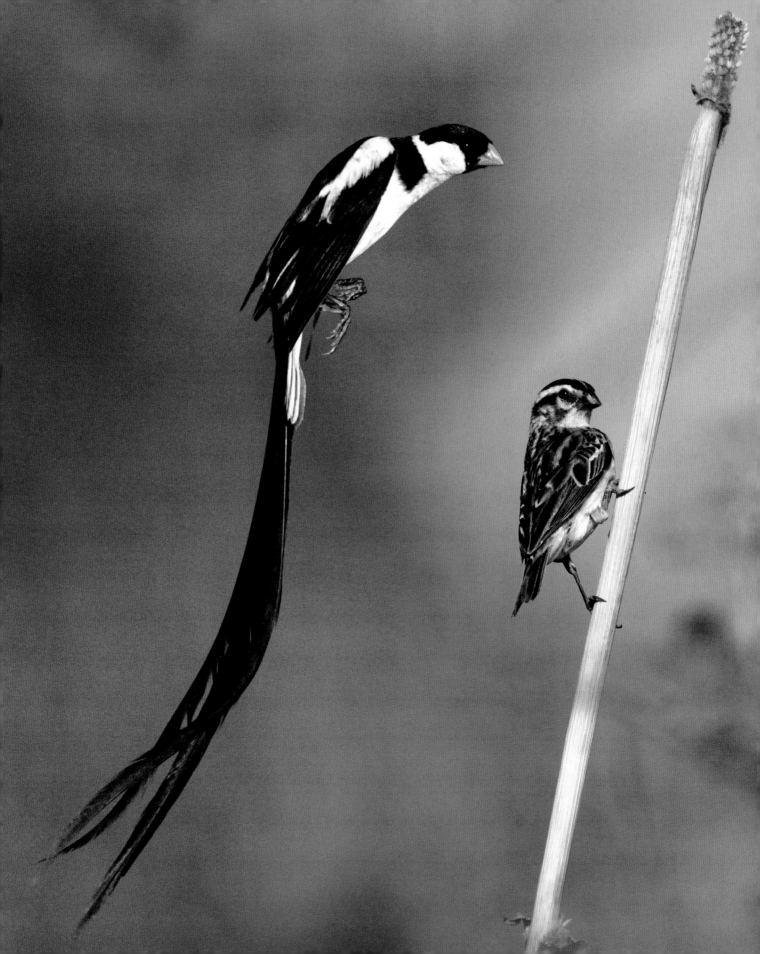

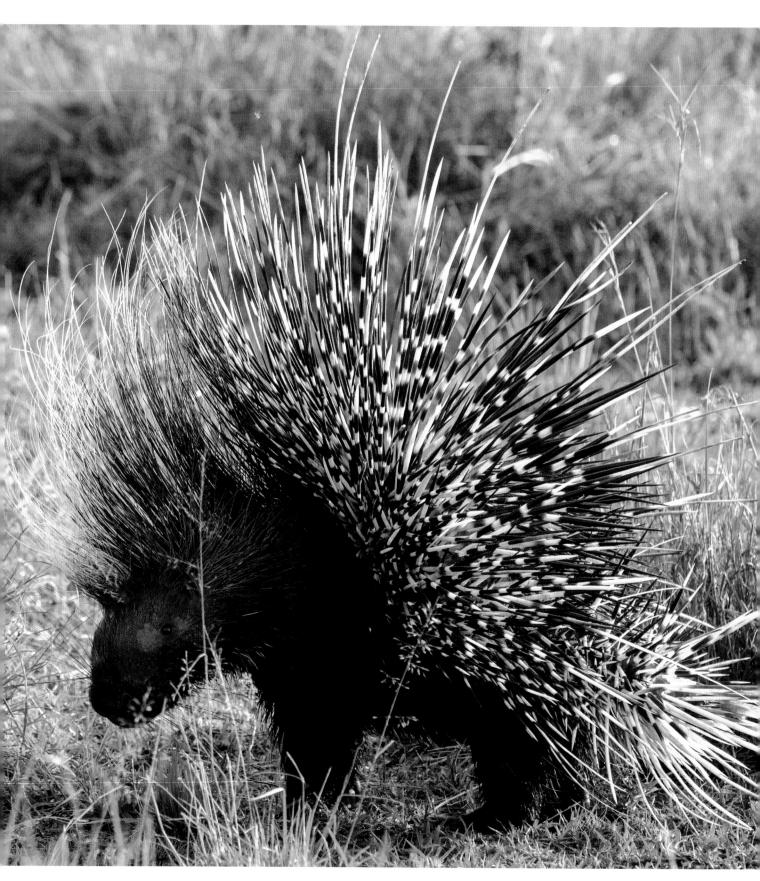

African porcupine

QUILLS AT THE READY

An unconcerned porcupine, strolling on the lookout for food, appears a very different creature from a porcupine faced with danger. The spines or quills normally lie flat along the upper surfaces of the head, neck and body. But as soon as the porcupine senses a threat, the quills raise and tilt upright into a spiny covering. The creature also trembles its body and tail to rattle the hollow quills, stamps loudly, and angles sideways to the attacker, to present the longest, strongest elements of its thorny defence.

Three species of porcupines inhabit various parts of Africa. They have similar habits, diets, breeding systems – and defensive behaviours. Nocturnal, they stay in their burrows or dens by day, and even on brightly moonlit nights. When foraging in the darkness, experienced predators well acquainted with the quills – from lions, leopards, hyaenas and jackals, to owls, and big lizards and snakes – avoid any confrontation. A predator tackling a porcupine usually tries to flip the animal over to expose its softer, less protected underbelly. But the porcupine puts up a spirited resistance.

REARGUARD ACTION
After the general defence described above, in a second the porcupine may turn its rear to the attacker and rush backwards. The sharp, stiff quills along the back, rump and tail, some as long as 40 centimetres (16 inches), are loosely attached to their owner and have tiny barbs at their tips. They easily detach on contact with the predator to embed in its flesh, causing not only pain but risk of infection.

African brush-tailed porcupine
Atherurus africanus

- LOCAL COMMON NAMES
 English names vary with the species, see below. Also for most porcupines: !Noab (Namara); Nungu (Swahili, Shona); Ystervark (Afrikaans); Jart, Xaddee, Qunfis (Ethiopian dialects); Kotoko (Akan)

- SCIENTIFIC NAME
 African species include the Crested porcupine, *Hystrix cristata*, Cape porcupine *H. africaeaustralis*, and African brush-tailed porcupine, *Atherurus africanus*

- SIZE
 Larger species head-body length up to 80cm (31in), weight 25kg (55lb)

- HABITATS
 Mostly forests, shrubland, bush and scrub

- DIET
 Plants, from juicy buds, shoot and fruits to underground parts like roots, bulbs and corms, including farm crops, also some worms, insects, small mammals, and carrion

- CONSERVATION STATUS
 IUCN Most species are Least concern (see key, page 9)

◄ A crested porcupine stands its ground, quills raised to show their contrasting coloured rings. The quills are hairs modified through evolution to be hollow, long, sharp, stiff and erectable.

► In relaxed manner, the porcupine spines lay flat, pointing rearwards.

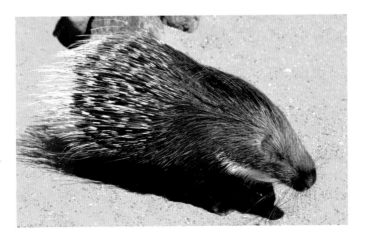

PRIZED BUSHMEAT
Despite their spiky armour, and like pangolins (see page 140), most kinds of porcupines are easy meat for people with spears and guns. The flesh is said to be very tasty and adaptable for varied recipes. Coupled with revenge killings for farm crops, this has led to a thriving trade in porcupine bushmeat. The fame of its distinctive flavour has spread far, to restaurants across Europe and Asia. Despite this, African species are not regarded as being in immediate danger.

Gelada

SCOWLS AND GRIMACES GALORE

The gelada is sometimes called the gelada baboon. However it is not a member of the 'true' baboon group, *Papio*, although it is a close cousin. A distressed, threatened or angry gelada is, like its baboon relatives, an extremely formidable opponent. It is muscular, fast and agile. It is well equipped with powerful, nail-bearing fingers and toes, and four fearsome, fang-like canine teeth, the upper two being especially outsized. All these features are employed during the gelada's visual and vocal displays. Hyaenas, leopards, even lions tend to steer away and move on.

Like most monkeys, geladas are social, dwelling in groups and using a wide range of communications, especially dozens of types of vocalized 'chatter'. A striking display is the open-mouthed combination of yawn, snarl and pout. The animal opens its jaws wide to display its fearful teeth, and curls its top lip upwards and inside out onto the nostrils to reveal the startling pink inner lip lining, gums and tongue.

A possible addition is to retract the forehead skin to raise the eyebrows and widen the eyes, showing the pale skin around them. Also the gelada may thrust its chest forwards, highlighting the furless, hourglass-shaped or triangular skin patch in the centre.

NO PLACE TO HIDE
This gelada's facial threat expression is useful in various situations, from sorting out dominance and submission within the group hierarchy, to warning a predator that the gelada will defend itself with great determination. This is especially important since gelada habitat is mostly treeless, grassy highlands where, unlike in most monkey habitats, it cannot escape into the branches.

DISTRIBUTION MAP

- LOCAL COMMON NAMES
 Gelada baboon (see text), Gelada monkey, Bleeding-heart baboon, Lion baboon/monkey; Tschelada (local Ethiopian dialect)

- SCIENTIFIC NAME
 Theropithecus gelada

- SIZE
 Male head-body length up to 75cm (30in), tail up to 50cm (20in), weight may exceed 20kg (44lb), females 30–40% smaller

- HABITATS
 High plateau grasslands, shrub, open woodlands, rocky outcrops, cliffs

- DIET
 Chiefly all parts of grasses including leaves (blades), stems, roots, flowerheads, seeds, also shoots, leaves and fruits of other plants

- CONSERVATION STATUS
 IUCN Least concern, but populations fragmenting and decreasing (see key, page 9)

A SPECIALIZED HABITAT
Geladas are extremely specialized monkeys. They dwell in limited areas among the grassy uplands and highlands of Ethiopia, north-east Africa, at altitudes of up to 4,500m (14,750ft). The great majority of their diet is grasses. Their dextrous hands pluck grass leaves and stems with surprising speed and delicacy. The much enlarged, pointed canine teeth play almost no role in chewing; they are for display and defence.

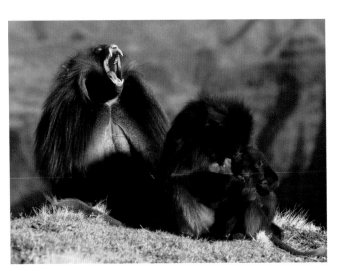

◄ The thick, fluffy ruff or mane of the gelada gives its alternative name of lion baboon. Here a male displays to protect one of 'his' females and their youngster.

► A male gelada 'yawns' to show off his vampire-like upper canine teeth and the vivid pink inner lining of the curled-up top lip.

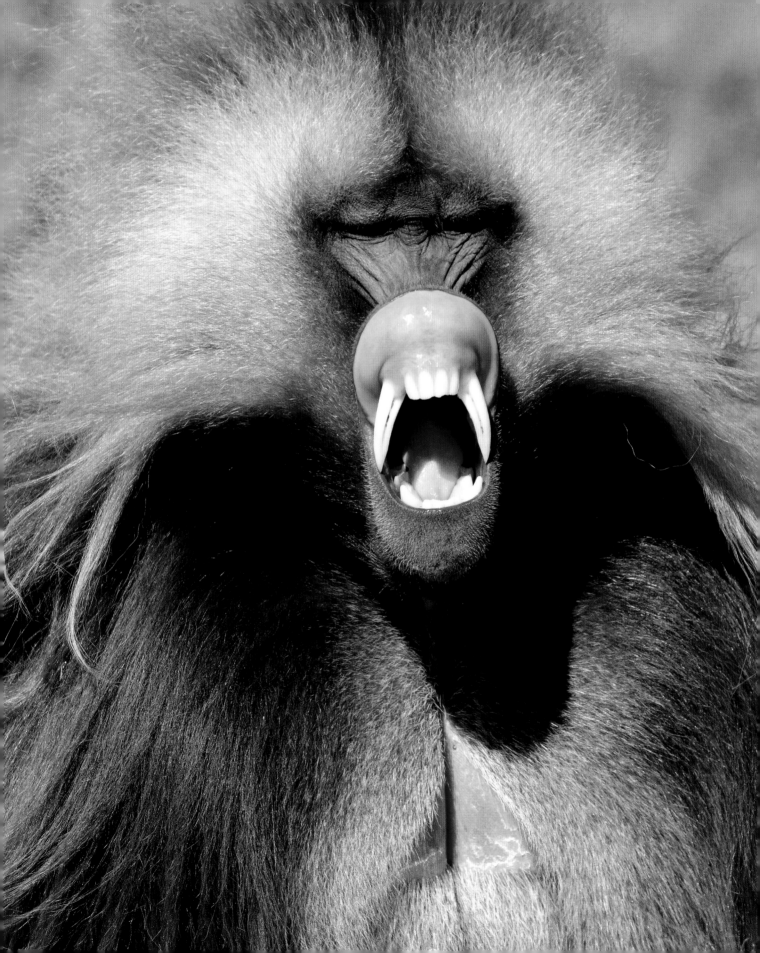

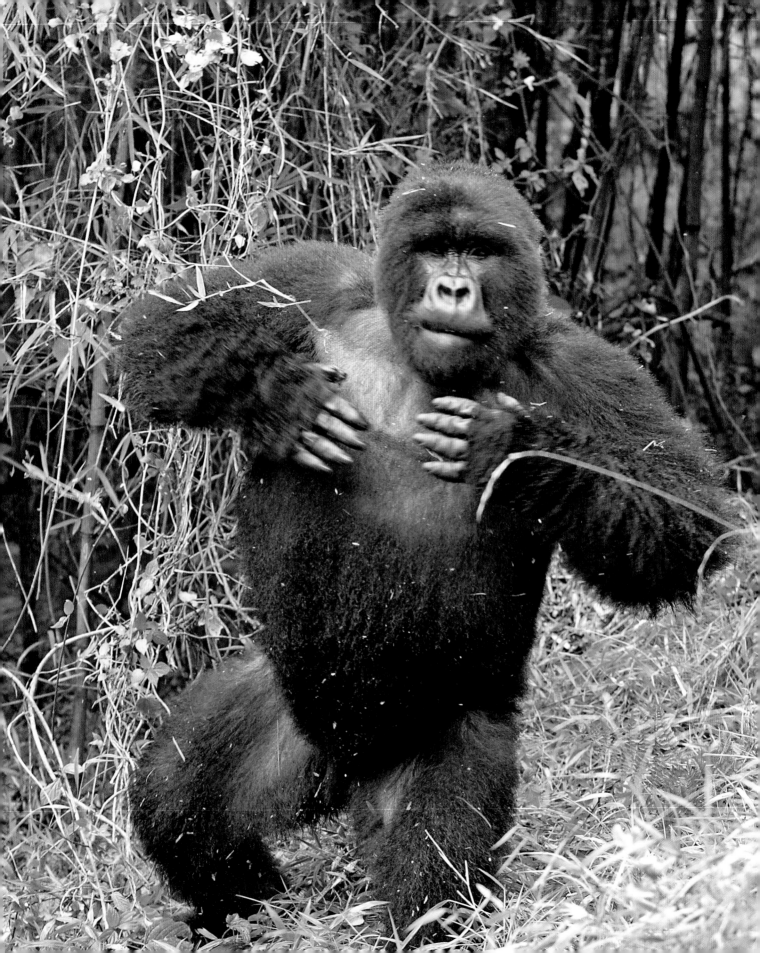

Mountain gorilla

READY WITH A RITUAL

A mature, dominant male gorilla, or 'silverback', beating his chest at a perceived threat, is one of nature's unforgettable sights. He may be defending his troop against a rival male gorilla ready to challenge, or seeing off a predator, or warning intruders such as other big primates – including ourselves. However, chest-beating is only one element in his series of highly forceful, rapid warning actions known as the gorilla communication ritual.

Rituals or ritualized behaviours are sets of stereotyped actions that usually follow the same set order, and which are symbolic, that is, removed from their original survival purpose (see page 8). For example, some courtship rituals involve a 'gift' of food for the partner, but this food is not eaten.

NINE-ELEMENT RITUAL
Primatologists have unravelled nine main elements in the gorilla communication ritual, although individuals have their own variations. Typically the series begins with 'hooo-ooo-ooo' hooting that gradually speeds up. Next is gathering vegetation as if to feed but then discarding it, then jumping up and down bipedally (on two legs). Then comes more vegetation gathering, this time to hurl around the vicinity, and the famous chest-beating with cupped hands.

Sixth is kicking out with one leg, followed by running sideways on all fours. The penultimate element is usually tearing and thrashing vegetation in an ever more violent manner. Finally the gorilla bashes and thumps the ground with the palms of the hands. By now, most threats have receded. If not, the gorilla may undertake a full-on charge.

- LOCAL COMMON NAMES
 Gorille (French, spoken in parts of their range); Gorila (Spanish); Igorila (Xhosa); 'Grill', 'greeya', 'greel' and many other local dialect variations

- SCIENTIFIC NAME
 Western gorilla *Gorilla gorilla* (subspecies Western lowland gorilla *G. g. gorilla*, Cross River gorilla *G. g. diehli*) Eastern gorilla *Gorilla beringei* (subspecies Lowland, Eastern Lowland or Grauer's gorilla *G. b. graueri*, Mountain gorilla *G. b. beringei*)

- SIZE
 Male standing height up to 190cm (74in), weight may exceed 200kg (440lb), females 30–40% smaller

- HABITATS
 Rainforests and woodlands, from lowlands to mountains above 4,000m (13,120ft) depending on subspecies

- DIET
 Most plant matter including leaves, stems, shoots, flowers, also bark, fruits, roots, occasionally insects and similar small creatures

- CONSERVATION STATUS
 IUCN Both species Critically endangered (see key, page 9)

◀ A male mountain gorilla reaches the chest-beating or 'pec-pounding' stage of his ritualized communication. It is about halfway through the nine elements of the full threat display.

▶ As fellow great apes, humans relate to many expressions and actions of gorillas and chimpanzees. However, some mislead us. What might look like a grin or laugh is often teeth bared to warn against danger.

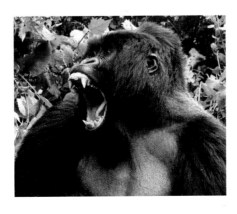

'HEAR HOW BIG I AM'
Bigger drums make deeper booms than smaller ones. In the same way, a larger gorilla produces deeper, lower-frequency thudding sounds when chest-beating, compared to a smaller individual. This is because the chest and lungs have a larger volume and they vibrate and resonate at a slower rate. Researchers have determined that chest-beating is a way rival males literally size each other up by sound, as they decide whether to initiate a challenge.

Blue wildebeest

STAMPING, SNORTING, SHOVING, SPARRING

Breeding times for blue wildebeest depend partly on local climate, with rainfall triggering grass growth that will provide food for the herds and their new youngsters. Onset of rain is the time that males, or bulls, come into reproductive condition. They gather at display areas, known as leks, and tussle and compete in various ways. The winners claim a territory and as many females, or cows, as they can attract and retain.

Wildebeest have nomadic phases. Huge herds famously follow the rains which encourage fresh grazing, sometimes trekking hundreds of kilometres to find new lush greenery. The main breeding time is about two to four weeks following first rainfall, usually between April and June.

STOOP TO CONQUER
Bulls establish their positions in the male hierarchy as they claim their territory, bellow, snort and stamp to impress rivals. When two bulls feel they are evenly matched, they become more physical. A typical manoeuvre is to face each other at close quarters, drop down onto bended front knees, tip the head down to lower the horns onto the ground where they gore the earth, then clash heads front-on in a show of shoving power.

Successful bulls are kept exceptionally busy attracting, mating with, and defending a territory with its small group or harem of cows. They must repel a relentlessly ongoing procession of challengers who hope to lure away cows sneakily. However cows also tend to wander between male territories and mate with each of the holders.

DISTRIBUTION MAP

- LOCAL COMMON NAMES
 White-bearded wildebeest / gnu, Brindled wildebeest / gnu, Common wildebeest / gnu; Blouwildebees (Afrikaans); Gaob (Nama); Ngongoni (Shona, Siswati); Nyumbu (Swahili); Nkhonhoni, Inkonkoni (Xhosa, Zulu); Khongoini (Venda); Kgôkông (Sepedi, Setswana/Tswana)

- SCIENTIFIC NAME
 Connochaetes taurinus

- SIZE
 Male head-body length up to 2.5m (8ft), shoulder height up to 1.5m (5ft), weight up to 300kg (660lb), females 15–20% smaller

- HABITATS
 Chiefly savanna grassland, open scrub and shrub, scattered woodlands

- DIET
 Grasses and foliage from shrubs, bushes, trees

- CONSERVATION STATUS
 IUCN Least concern
 (see key, page 9)

WILDEBEEST RANCHING
Especially in the southernmost parts of their range, blue wildebeest are being kept on vast private areas. The landowners monitor the herds that are, in effect, living wild but also available as 'harvest' for the game meat industry. A specialized product is the dried, preserved meat called biltong. In this way the species is becoming a valuable, and supposedly sustainable, component of the local farming and livestock economy.

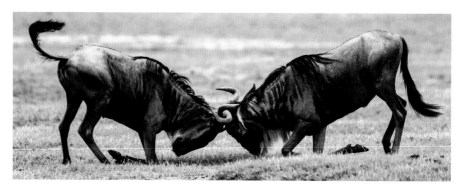

▲ A classic wildebeest rutting display is to drop onto bended front legs and begin a head-to-head, horn-to-horn shoving competition.

▶ Two blue wildebeest bulls square up, heads down and furrowing the ground, in their combat of strength and stamina.

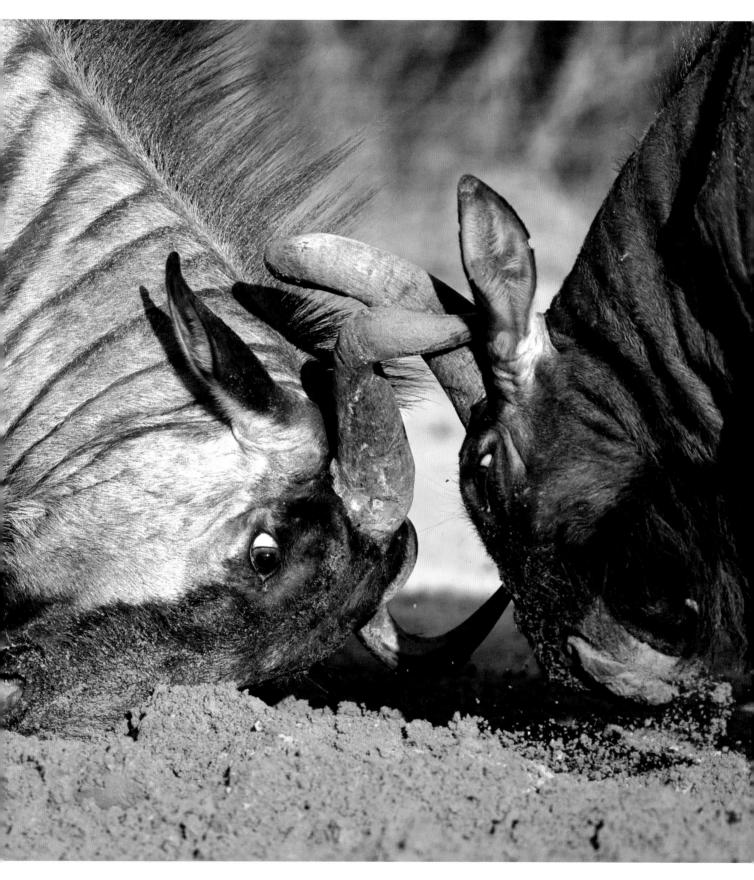

Springbok

A SPRING IN THE STEP

Springboks certainly spring, in the sense of leaping, jumping or prancing. They display with amazingly high bounces or bounds, but stiffly straight-legged, without bending the limbs, also with head down and back arched. It is as though the ground is a trampoline. Sometimes the springbok travels forwards in the air, sometimes sideways. It may change direction, or it may touch down where it took off. This behaviour looks joyous and celebratory – but it has a serious side.

This small antelope's name, 'springbok' (occasionally 'springbuk'), describes its display as a springing, prancing buck, stag or similar hoofed mammal. The strange-looking action is known as 'pronking', from the Afrikaans *pronk*, 'prance, show off, make a show, strut'. Another name is 'stotting', from various European terms for 'bounce, push, jolt, thrust'.

WHY THE SPRING?
The chief explanation for a springbok's pronking is that the animal is showing off its fitness, health and vigour to possible predators in the vicinity. It's a signal that says: 'Look how agile and athletic I am. There's no point in trying to catch me. Don't even bother.' Possible springbok predators are numerous and include lions, leopards, cheetahs, hyaenas, jackals and wild dogs. As well as signalling its fitness, the jump lifts the animal above long grass for a good view of its surroundings.

Springboks are among the most flamboyant pronkers, but related ungulate (hoofed mammal) species also display in this way. They include several other African antelopes and gazelles, and pronghorn and certain deer species in North America.

- LOCAL COMMON NAMES
 Springbuk, Springbukk (Afrikaans and related languages); Insephe (Zulu); Tshepe (Tswana)

- SCIENTIFIC NAME
 Antidorcas marsupialis

- SIZE
 Head-body length 150–180cm (58–70in), shoulder height 80–85cm (31–33in), weight 30–40kg (66–88lb)

- HABITATS
 Open places such as grassland, scattered woodland, farmland, floodplains

- DIET
 Grasses, stems, buds, leaves, flowers, fruits and other plant material

- CONSERVATION STATUS
 IUCN Least concern (see key, page 9)

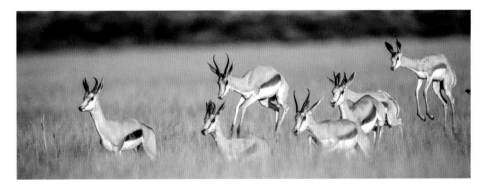

◄ A springbok's leap can propel it vertically upwards to 3 metres (10 feet) in the air.

▲ In a springbok herd, some members rest while others feed and some remain on lookout. An individual who detects a predator starts to spring up high. Within a second or two herd members are leaping or pronking at great speed in all directions – making it tricky for the predator to pick out a single victim.

THE SPRINGING BUCK
The name springbok derives from Afrikaans terms *spring*, 'jump, leap' (as in English), which in turn comes from Middle Dutch *springen*; and *bok*, an antelope, goat, deer or similar hoofed creature or 'buck'. If its pronking display fails and a predator chases, the springbok – which is one of the fastest of all land animals – races away at more than 80 kilometres (50 miles) per hour.

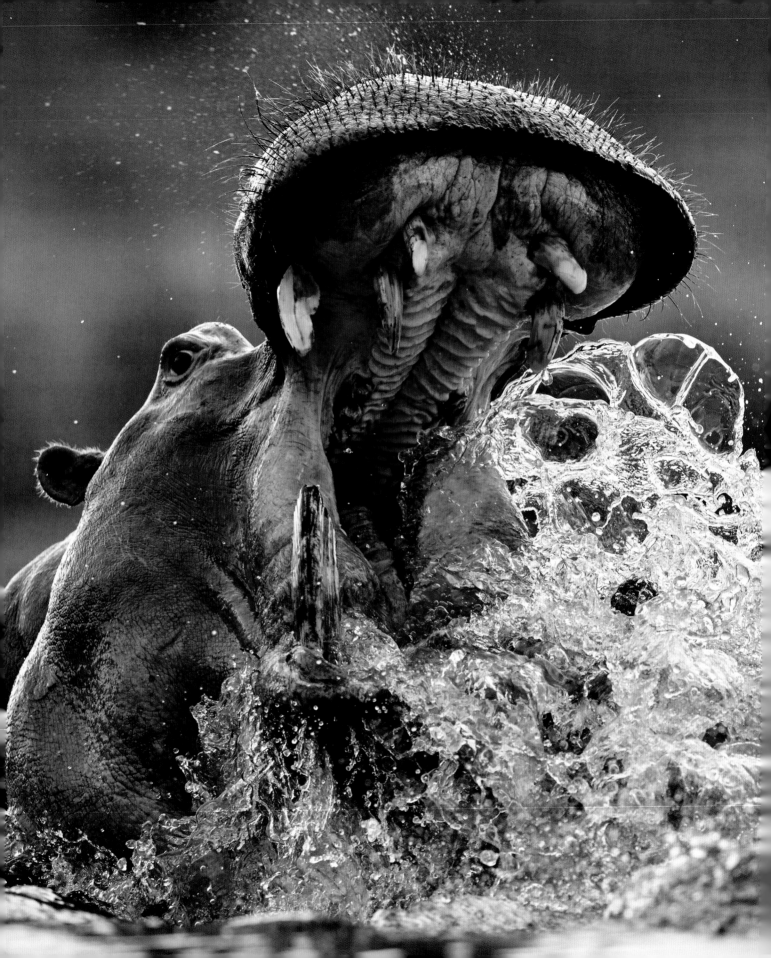

Hippopotamus

MASSIVE AND UNPREDICTABLE

A bull (male) common or river hippo in aggressive mood is exceptionally dangerous. He may produce a variety of sounds, from quiet wheezes rising to loud honks and roars, as he flicks his ears and tail. His threatening behaviour increases as he opens and closes his mouth slightly. Next stage is to open wide – and this is the largest mouth of any land animal. The jaw hinge joints are set far back on the skull, allowing a vast gape approaching 180° to expose his massive lower tusks. He may then charge – and almost no other creature would stand its ground.

Hippos seem peaceable as they relax in water during the daytime. But they can rouse within seconds. The threat may be a stranger hippo or other large animal in the area – including humans, and even watercraft and land vehicles. Another provocation is something coming between a cow (female) and her calf. However these giants, which vie with rhinos as the second-largest land animals, are unpredictable and sometimes aggressive for no obvious reason.

DUNG SHOWERING
A successful bull or 'beachmaster' rules a territory of a few hundred yards of river or lakeshore. He fiercely protects his group or harem of cows, sometimes numbering 50-plus. One of his displays is dung-showering or muck-spreading. He stands in the shallows or on the bank, and as he defecates, his small tail flicks side to side, to shred and spread his emerging excretions over a large area, which symbolically proclaims his possession.

The bull's most serious responses are reserved for another male who challenges his territory. The two fight, gape, slash and jab with their lower tusks, which may reach 50 centimetres (20 inches) in length. Serious wounds and even death may occur.

DISTRIBUTION MAP

- LOCAL COMMON NAMES
 Common hippo/hippopotamus, River hippo/hippopotamus; Seekoei (Afrikaans); Kubu (Tswana); Mvubu (Zulu, Siswati); !Khaos (Nama); Kiboko (Swahili); Mvuu (Shona)

- SCIENTIFIC NAME
 Hippopotamus amphibius

- SIZE
 Male head-body length up to 4m (13ft), shoulder height up to 1.5m (5ft), weight may exceed 2,500kg (5,510lb), females are slightly smaller

- HABITATS
 Lakes, rivers, swamps, floodplains and other wetlands with suitable plant food nearby

- DIET
 Shoots, grasses, reeds, sedges and similar low vegetation

- CONSERVATION STATUS
 IUCN Vulnerable
 (see key, page 9)

◄ A hippo's 'yawn' displays the lower tusks, which are the elongated, forward-projecting lower incisors and the even longer, upward-pointing canine teeth.

► Two hippos begin a sparring match as they gape, prod and jab with their enormous mouths and teeth. Between males, the usual reason is the entitlement to a territory and so mating privileges with females.

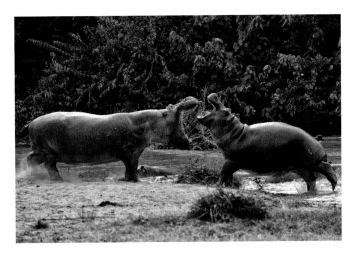

STAY WELL CLEAR
The hippopotamus is often regarded as the most dangerous animal in Africa, causing more people to die than, for example, lions. In fact, far more deadly are mosquitoes that spread numerous diseases. A long way behind are snakes such as puff adders, and humans who pursue wars, deliberate starvation and other atrocities. Next come hippos, responsible for between 500 and 3,000 human deaths each year – about the same as estimates for Nile crocodiles.

African pangolin

CURLED AND ROLLED AGAINST ADVERSARY

Pangolins, like porcupines (see previous 129), have evolved a protective armour from the usual mammalian hairy coat. A pangolin's hairs are bunched in groups and 'glued' into large, flat, overlapping plates, similar to the scales of some reptiles. This appearance has led to the pangolin's nicknames of 'animal pinecone' and 'scaly anteater'. Its main defence is to curl into a ball, but it also has further actions and displays to ward off a threat.

Most pangolin species – four in Africa, four in Asia – are nocturnal and feed chiefly on ants, hence the name 'scaly anteater', although they are not especially close relatives of the 'true' anteaters in the Americas.

A TOUGH TARGET
Pangolins sleep by day, usually in a tunnel or similar den, and forage under darkness for food. They locate nests and prey mainly by smell, and lick up their tiny victims into the toothless mouth with fast flicking movements of the long, slim, sticky tongue.

A worried pangolin's main reaction is to curl into a ball. (The name 'pangolin' is derived from a traditional Malay term meaning 'roll' or 'curl'.) The action shields its underside, which has no scales, and wraps the long, wide tail around the head. In this ball-like position, the toughened scales are tilted outwards slightly to expose their sharp edges. The pangolin may also spray a foul fluid from glands at its rear end, rather like a skunk. And its strong, sharp claws, designed to rip into ants' nests, are formidable attack weapons.

- **LOCAL COMMON NAMES**
 'Scaly anteater', see also common names in English below; iMfinyezi (Zulu); Thagadu (Sependi, Pedi); Hambakubvu, Haka (Shona); Kgaga (Sotho, Tswana); Ietermagôg, Ystermagôg (Afrikaans); xiKhwarhu (Tsonga)

- **SCIENTIFIC NAME**
 African species comprise Giant or Giant ground pangolin *Smutsia gigantea*, Ground or Temminck's pangolin *S. temminckii*, Long-tailed or Black-bellied pangolin *Phataginus tetradactyla*, Tree or White-belled pangolin *P. tricuspis*

- **SIZE**
 Example size for Ground pangolin: total length up to 120cm (47in), weight up to 12kg (26lb)

- **HABITATS**
 Adaptable, from dry scrub, sandy veldt and grassy shrubland to moist woodlands, forests and floodplains

- **DIET**
 Mostly ants (up to 90%) and termites, occasionally beetles, spiders and other small invertebrates

- **CONSERVATION STATUS**
 IUCN Giant pangolin Endangered, Ground pangolin Vulnerable, Long-tailed pangolin Vulnerable, Tree pangolin Endangered (see key, page 9)

TRAGICALLY TASTY
Pangolins face a terrible and uncertain future. All eight species across Africa and Asia are hugely poached, trafficked and traded, against all manner of wildlife laws and regulations. They are prized in Chinese and Vietnamese cuisine. Their scales and bones are ground into powders for traditional medicines that modern medical science views as at best unproven, at worst useless.

▶ The pangolin's large, wide, flattened tail, with its overlapping, hard, sharp-edged scales, furnishes excellent protection against most predators.

▶▶ Pangolins roam widely for food. The tongue flicks out to a length of up to 40cm (16in).

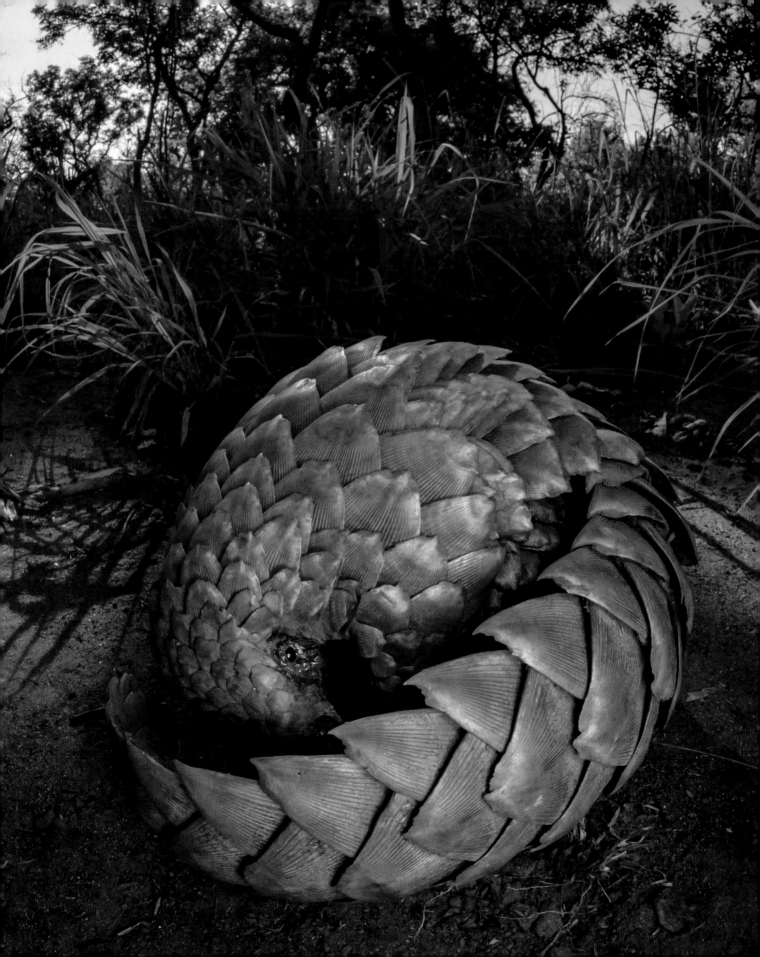

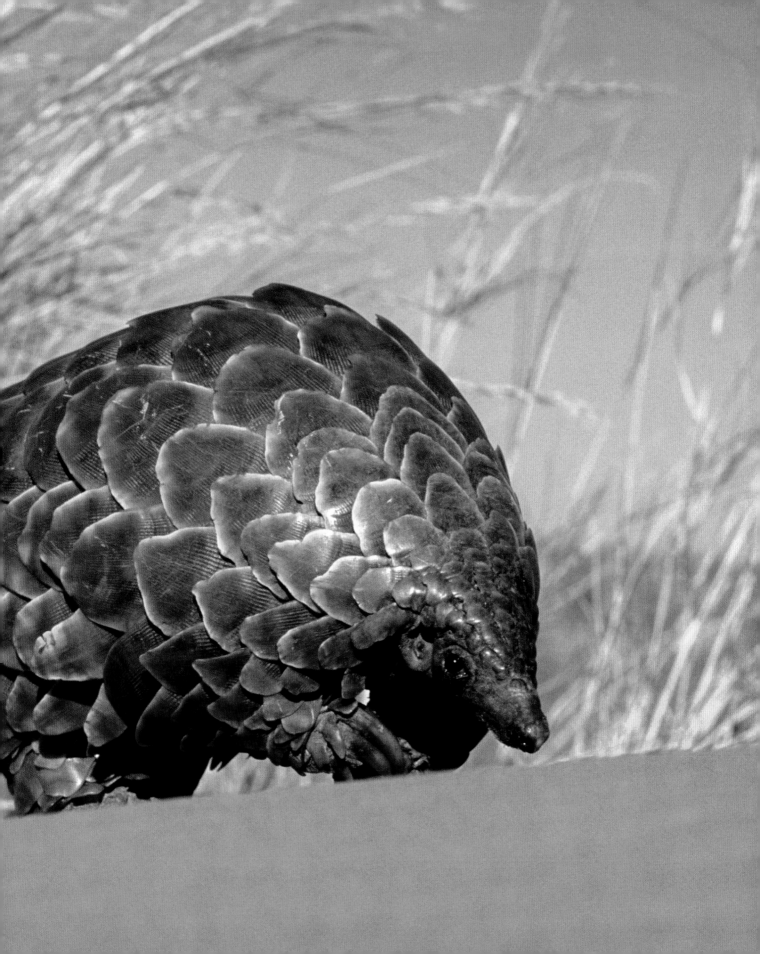

African lion

ICONIC ROAR OF THE BUSH

Lions are the only social, group-dwelling cats (although cheetahs sometimes form small partnerships called coalitions). The group or pride is run by senior lionesses (females) and includes younger females, various offspring, and a few males. In general, lionesses hunt and care for the cubs, while males patrol and defend the pride's area or territory – and sleep for 20-plus hours daily. Complex, varied visual and vocal displays, especially roars and facial expressions, are central to pride life and also pride defence.

The iconic sound of the African bush, and one of the most distinctive of any animal vocalizations, is the lion's roar. In the quiet of a still night it may carry for more than 8 kilometres (5 miles).

ROARING FOR TERRITORY

The loudest, fiercest and most resolute roars are usually a male announcing his pride's presence and position, to advise other lions and their prides to keep away. Often there are several roars in succession, the first few being deepest and longest, followed by shorter, less strident roars that tail away.

Another reason to roar is when an individual becomes separated from its pride – especially when there is a menace about, such as a pack of hyaenas. This noise is less aggressive and less urgent. It is often answered by a nearby pride member who produces a roar that dwindles into a low growl. The separated individual then answers and follows the repeated exchanges to rejoin the group. Within the pride, many other sounds serve for communication, from snarls and growls when disputing social standing, to purrs, puff-like exhalations and miaows when expressing pleasure and friendship.

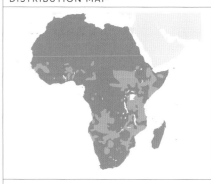
FLEHMEN RESPONSE

A wide array of mammals display the facial expression known as the flehmen response or flehmen grimace. In lions this consists of an open mouth, a raised or curled upper lip that exposes the teeth, a wrinkled or screwed-up nose, and closed eyes. The action draws scent-carrying air into the nose and over the sensory vomeronasal or Jacobson's organ (see page 36). It is usually employed to sniff other pride members, especially when assessing readiness to mate.

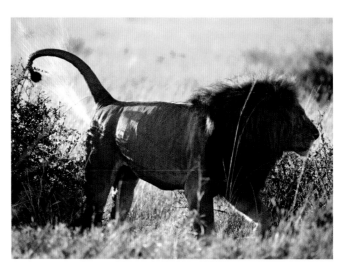

◄ Scents are important in marking out territory. Lions spray their urine onto bushes, tree trunks, rocks and other items, and the smell lingers for days.

► A male African lion emits a full-throated roar in defence of his pride's territory. His considerable canine teeth are also displayed.

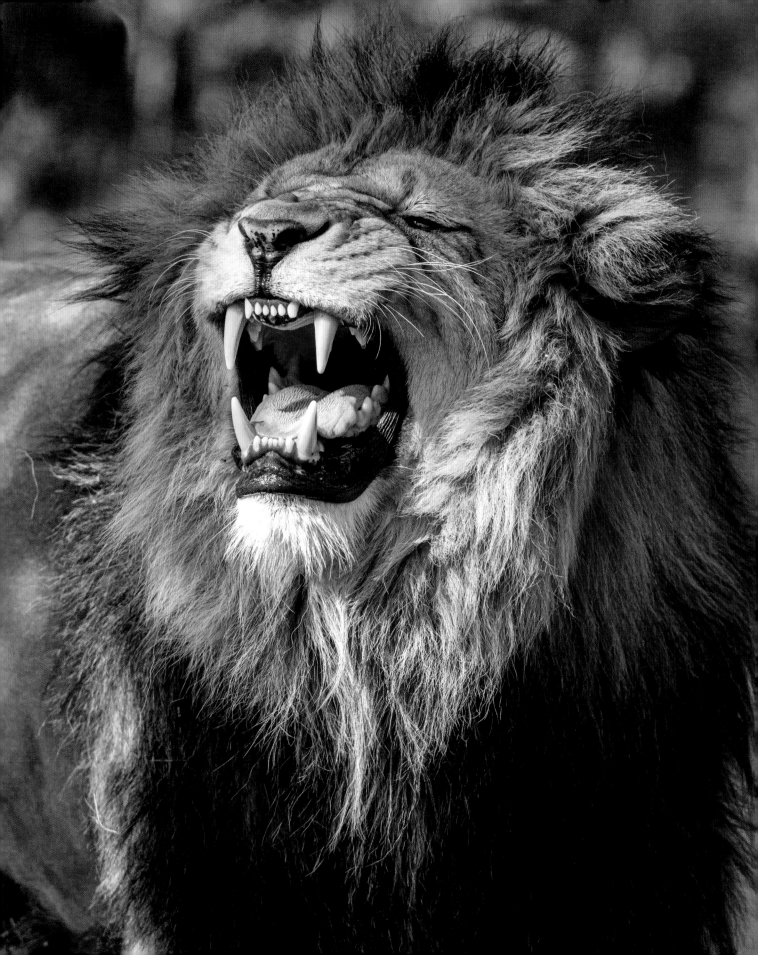

African savanna (bush) elephant

THE PLANET'S BIGGEST EARS – AND TEETH

A record-breaker in many ways, the African savanna elephant uses its size and power in some of the animal kingdom's most awesome displays. This elephant is the world's most massive land animal, with the world's biggest ears, and also its tusks are the world's largest teeth. When aroused or threatened, it puts on one of the greatest and most heart-stopping shows in nature – as people who happen to get in the way, and experience its full might, know only too well.

Usually the male or bull African savanna elephant shows most aggression at breeding time. Mature bulls abandon their loose social groups and become more solitary. They track the herds, each composed of cows (females) and their young, with an older and extremely knowledgeable cow, the matriarch, as herd leader.

EARS OUT, TUSKS FORWARD
In aggressive mode, the elephant faces its adversary, stands tall, and spreads and flaps its huge ears. It nods, shakes and jerks its head to wave around the tusks and trunk,

foot-scrapes to raise a dust cloud, and rumbles, roars and trumpets loudly. If not satisfied, the elephant may trot a short distance forwards as a warning, then a full-on charge with tusks to the fore. A bull in 'musth', with extremely raised levels of the male hormone testosterone, is much more likely to this aggression and charge.

A bull may also direct his aggression at predators such as lions and hyaenas, and even at vehicles, humans and any other large moving objects. Cows react with similar displays if their calves are at risk.

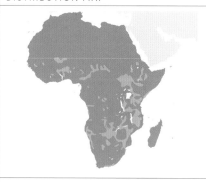

- **LOCAL COMMON NAMES**
 African bush elephant, African elephant; Olifant (Afrikaans); !Khoab (Namara); Nzou, Zhou (Shona); Ndovu, Ndhlovu (Swahili)

- **SCIENTIFIC NAME**
 Loxodonta africana

- **SIZE**
 Male head-body length (excluding tusks and tail) up to 4m (13ft), shoulder height up to 3.4m (11ft), weight 5–6 tonnes (5–6 tons); females on average 30–40% smaller

- **HABITATS**
 Varied and regularly on the move, from arid scrub and dry savanna grasslands to woods, open forests, rainforests, wetlands, coasts, farmland

- **DIET**
 Most plant material, from leaves and fruits to twigs, bark, roots

- **CONSERVATION STATUS**
 IUCN Endangered, populations fragmenting and decreasing (see key, page 9)

GRAVE DANGER
The African savanna or bush elephant is one of three elephant species. The others are the African forest elephant, *Loxodonta cyclotis*, and the Asian ('Indian') elephant, *Elephas maximus*. The two African species were regarded as one until the 2010s. All three species are gravely threatened. The African forest elephant is listed as Critically endangered and possibly just a decade or two away from extinction in the wild.

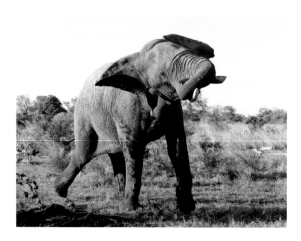

◀ Repeated head flourishing, with trunk and ears waving wildly, make an aroused elephant's threat unmistakeable.

▶ An African savanna female guarding her young has no hesitation in violently warning any threat, with spread ears and head-shaking. She is only too ready to charge.

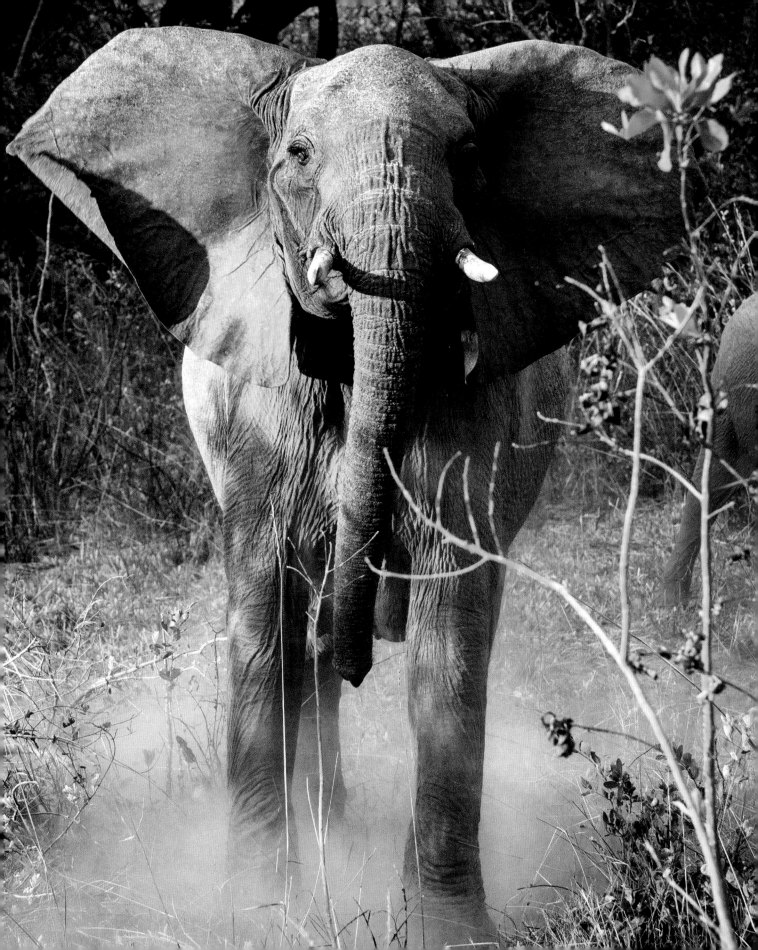

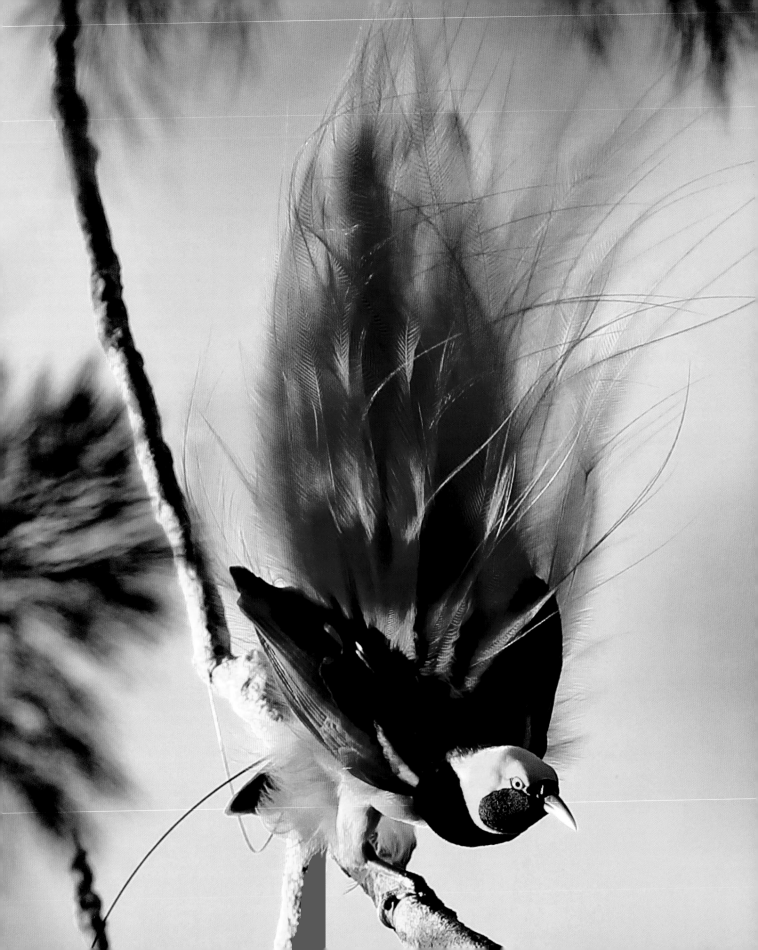

5
Asia

Stalk-eyed fly

FLIES' EYES ON LONG STALKS

Some of the most bizarre-looking insects – indeed, of all animals – are stalk-eyed flies. Also called hammerhead flies, they have extraordinary heads with a long sideway extension or stalk on each side, bearing the antenna (feeler) and eye at the end. In most of the 100-plus species, these stalks are much longer in males than females. When competing for females, males go head-to-head and begin a 'dance' which, at its most basic, compares the distance between their eyes.

DISTRIBUTION MAP

family Diopsidae

- LOCAL COMMON NAMES
 Eyed fly, Hammerhead fly, Antler fly (a name also applied to other kinds of flies), Diopsid fly

- SCIENTIFIC NAME
 More than 100 species in the family Diopsidae, including genera (species groups) *Centrioncus*, *Cyrtodiopsis*, *Diasemopsis*, *Diopsis*, *Eosiopsis*, *Pseudodiopsis*, *Sphyracephala*, *Teleopsis*

- SIZE
 Larger species total length up to 12mm (1/2in), 'eyespan' may exceed 15mm (3/5in)

- HABITATS
 Mostly warm, damp vegetation along rivers, by lakes, wetlands, moist woods and forests

- DIET
 Decaying plant matter, fungi, algal and bacterial growths

- CONSERVATION STATUS
 IUCN Not assessed (see key, page 9)

Most stalk-eyed flies could sit easily on a human fingernail. Yet they have all the display behaviours, tactics and moves of much more massive creatures, such as rutting deer and head-butting bison.

Stalk-eyed flies are widespread across Southern and South-East Asia, with some in Africa and a few in Europe. At breeding time, spring and summer, local flies gather at a traditional display site or lek, where males perform and females assess. Males sway and show off their head adornments, jump, fast-step and flail their wings. Often the male with the widest 'eyespan' wins. This is an excellent example of the evolutionary tendency known as sexual selection (see page 8).

GLADIATORS IN MINIATURE
If the contest is more evenly matched, males head-butt, poke, back off, advance again, head-joust and spar at each other. They may also kick out with their forelegs, whack with their wings, and swing their eyestalks like clubs. These extremely physical and sometimes vicious gladiatorial encounters are all carried out within an arena the size of an average credit card.

NOT AN UNCOMMON TRAIT
Stalk-eyes are 'true' flies, Diptera, with one pair of wings, rather than two pairs like most other insects. Dipterans number more than 200,000 known species, with many more still undescribed. The stalk-eyes' close cousins include ensign flies, rust flies, fruitflies and houseflies. Entomologists (insect experts) consider that stalked eyes have arisen separately in at least eight fly groups, each evolving independently from its own non-stalked ancestors. The Diopsidae are the most extreme group with proportionally the widest eyespans.

▶ Two stalk-eyed males of the genus *Cyrtodiopsis* go head to head. The seeing parts of their eyes are three-quarters spherical, giving them all-round vision. The upper fly has his legs spread, ready for kick-boxing.

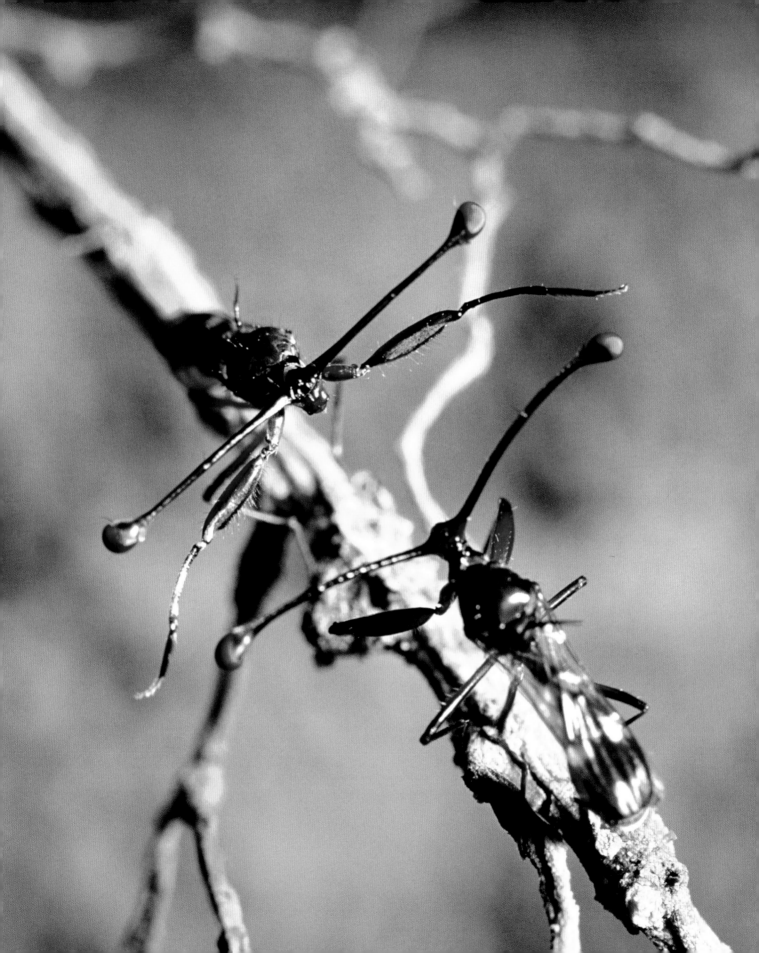

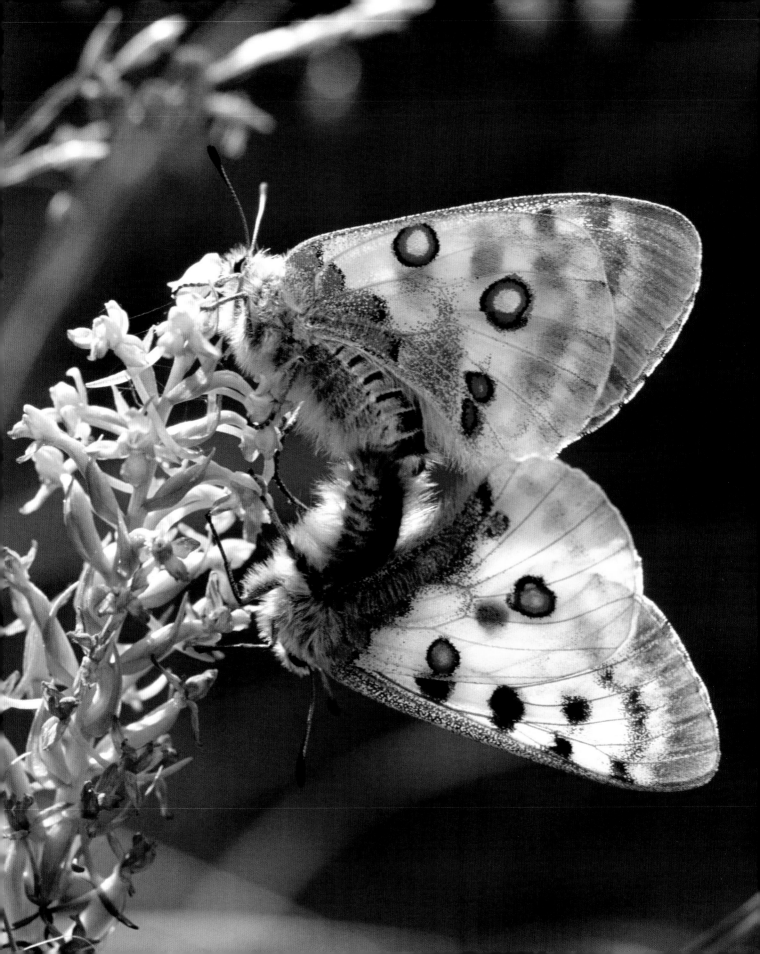

Apollo

VIVID DANCE IN THE MOUNTAIN BREEZE

A medium-large, powerful butterfly with strong flight and striking coloration, the apollo frequents mountains and uplands. Being adapted to the fast, swirling winds of altitude, it is impressive in the air, with strong, regular wingbeats along a direct fly path. Its courtship display is also more straightforward and less 'fluttery' than those of many of its lowland relatives, although similar in the basics. However, it is what happens after mating that distinguishes the apollo from many other butterflies.

Apollo butterflies vary considerably across their vast range. The wing pattern of a pale background, five dark forewing patches, and two hindwing red or orange spots, is common throughout. Geographically, however, the forewing spots vary in size and darkness, from black to grey or brown. The hindwing spots may be intense red, orange or yellow-pink. The background varies from pure white to cream or misty grey, and the wings may be semi-transparent.

DEFINITELY THE FATHER
These bright colours flash vividly as a courting pair flap around each other in rapid flight with great aerobatic skill, or the male dances for the perched female. While coupling, the male exudes a lump of gel-like fluid known as a mating plug, sperm cap or copulation plug, or sphragis, onto the female's rear end. This sets into a tough barrier that prevents her from receiving sperm from other males, so ensuring the current mate is the father of the next generation.

The mating or copulation plug is a widespread tactic among animals, including butterflies, moths, bees and other insects, spiders and scorpions, some reptiles, also mammals including marsupials, rodents and primates. It is a less arduous tactic than mate-guarding (see pages 89,164).

- LOCAL COMMON NAMES
Parnassian, Crimson-ringed butterfly, Mountain apollo; Apollofjäril (Swedish); Apollofalter (German); Papillon apollon (French); Farfalla apollo (Italian)

- SCIENTIFIC NAME
Parnassius apollo

- SIZE
Female head-body length 35mm (1 2/5in), wingspan up to 90mm (3 1/2in), male slightly smaller

- HABITATS
Mountains, rocky uplands, hills, cliffs, alpine meadows and grasslands, usually above 500m (1,640ft), across most of Central Asia and Europe

- DIET
Caterpillars: stonecrops *Sedum*, house leeks and similar plants
Adults: nectar, pollen

- CONSERVATION STATUS
IUCN Least concern, but populations severely fragmented and many declining (see key, page 9)

◀ An apollo pair prepare to mate on a fragrant orchid, their spots and patches showing through semi-transparent wings.

▶ The apollo's sturdy body and large, powerful wings make its courtship a purposeful and impressive sight.

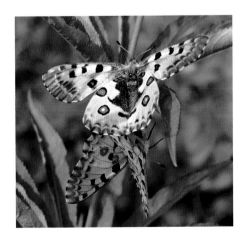

A FADING RELIC
Apollo butterflies are regarded as a 'relic species' from the last great ice age. As glaciers and ice sheets retreated, the butterflies established populations in different mountain and upland regions, separated by lowlands. Members of each population, breeding among themselves, began to evolve their own appearance and traits. There are more than fifty named apollo varieties or subspecies. But many are under threat from habitat loss, over-gathering by obsessive insect collectors, also climate change and diseases from air pollution.

Betta

WARRIOR FISH WITH FANCY FINS

Few fish are as famous as the betta, sometimes called the Siamese fighting fish, pla kat or pla kud. The scientific name is *Betta splendens*. *Betta* is derived from a Malay term for 'warrior, fighter', while *splendens* celebrates the male's splendidly flamboyant appearance. He 'flares' his gill covers or opercula, spreads and shimmers his flowing fins and tail, and twists and turns in the water to attract a female – or repel another male.

DISTRIBUTION MAP

- **LOCAL COMMON NAMES**
Fighting fish, Siamese fighting fish;
Pla kud, Plar kut, Pla kat, other dialect
names (mostly Thai/Malay); Belaga,
Sepilai (Malay); Cá lia thia (Vietnamese);
Trey kroem phloek (Khmer/Cambodian)

- **SCIENTIFIC NAME**
Betta splendens

- **SIZE**
Total length up to 8cm (2 ¾in)

- **HABITATS**
Still or slow shallow water with much
vegetation, such as rice paddies,
swamps, pools, lagoons, even with
pollution and low oxygen content

- **DIET**
Small freshwater creatures such as
shrimps, water-fleas, insects, worms,
also some plant matter

- **CONSERVATION STATUS**
IUCN Vulnerable (in the wild)
(see key, page 9)

In the wild in South-East Asia, bettas have much more muted coloration and less elaborate finnage than their aquarium-bred counterparts. After building a surface nest of bubbles, a male approaches a nearby female and begins his elaborate routine. He fans, waves and generally shows off his fins, flaps or flutters his gill covers, and puffs up his body as he swirls and writhes in an elaborate nuptial dance.

If the female is interested, her colour darkens and develops stripes or bars, and she swims near the nest with fins folded. The two display and dance, touching and nudging.

The male rubs and wraps around the female, positions her on her side or upside down near the nest, and encourages her to release eggs in batches. He fertilizes these and places them in the nest.

MALE-MALE ENCOUNTERS
In the wild, male-male encounters involve much displaying but are usually brief, as one contestant soon withdraws. This 'fighting' trait has been enhanced by selective breeding in captivity (see below). Hence the term Siamese fighting fish – Siam being the former name for Thailand.

BETTA BETTING BANNED
Bettas have probably been captive-bred for centuries, both for appearance and aggression. Traditions developed for staging male-male battles, with much betting on the outcome and celebrating the victor. Such fighting is now banned in many countries, but bettas are still the staple of a massive global aquarist trade. Enthusiasts rear and selectively breed varieties for new colours, fin shapes, adornments and display abilities.

▶ There are now dozens of betta varieties, with intense colours and ever more elaborate fins and tails.

▶▶ Bettas spread their fins, puff up and generally try to look bigger and more impressive for several reasons, including courtship, dealing with rival males, and defence against predators.

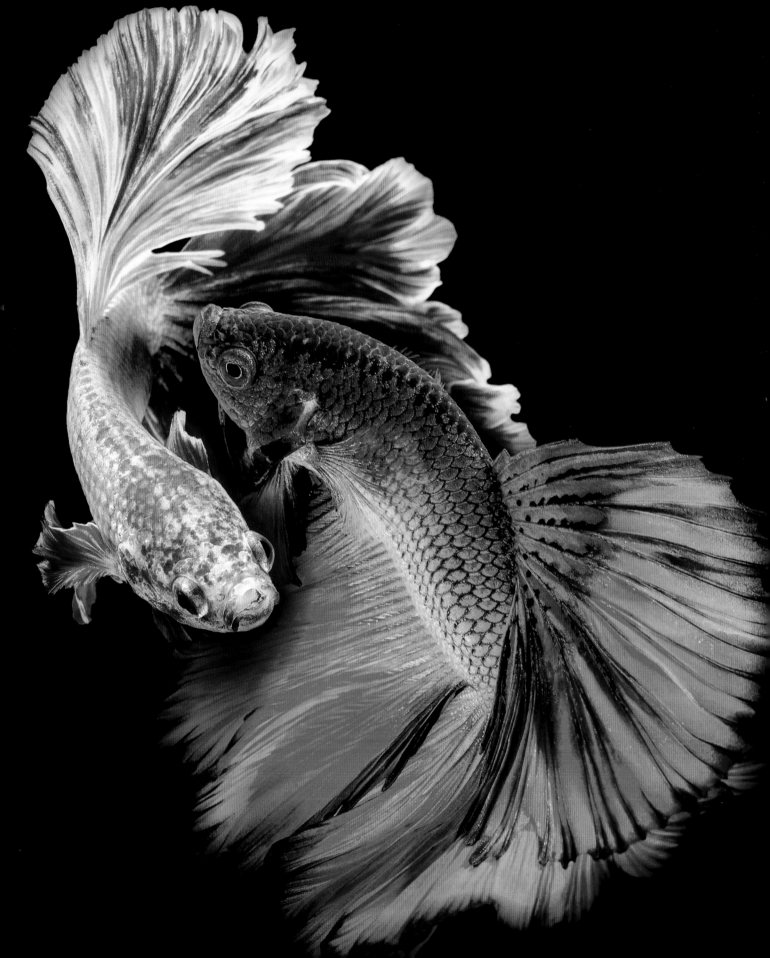

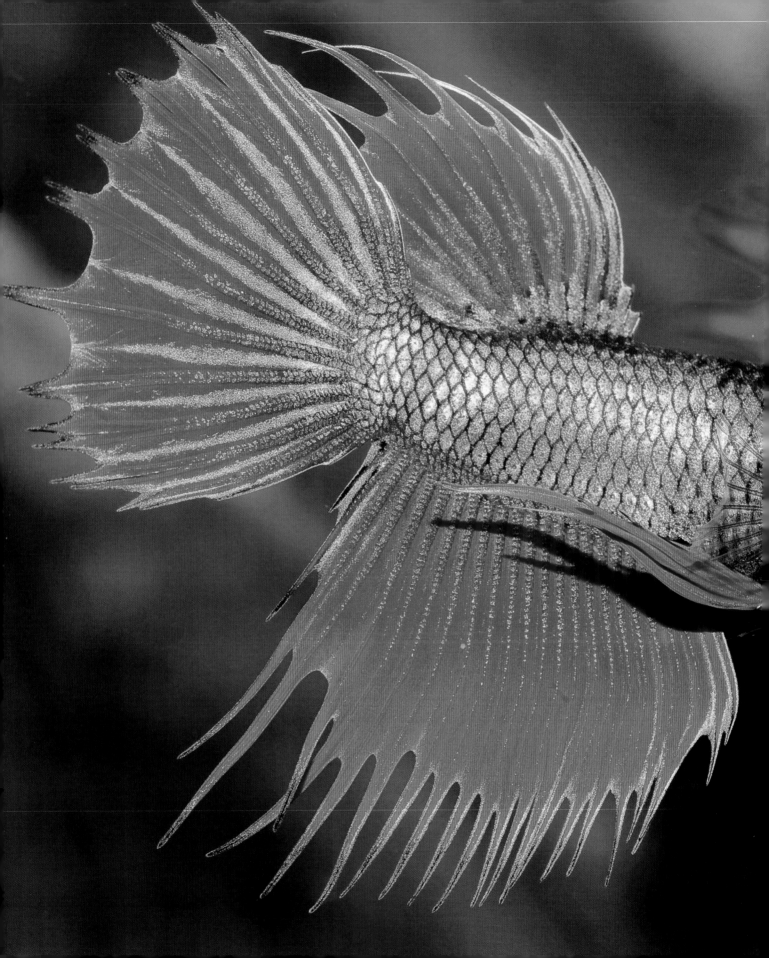

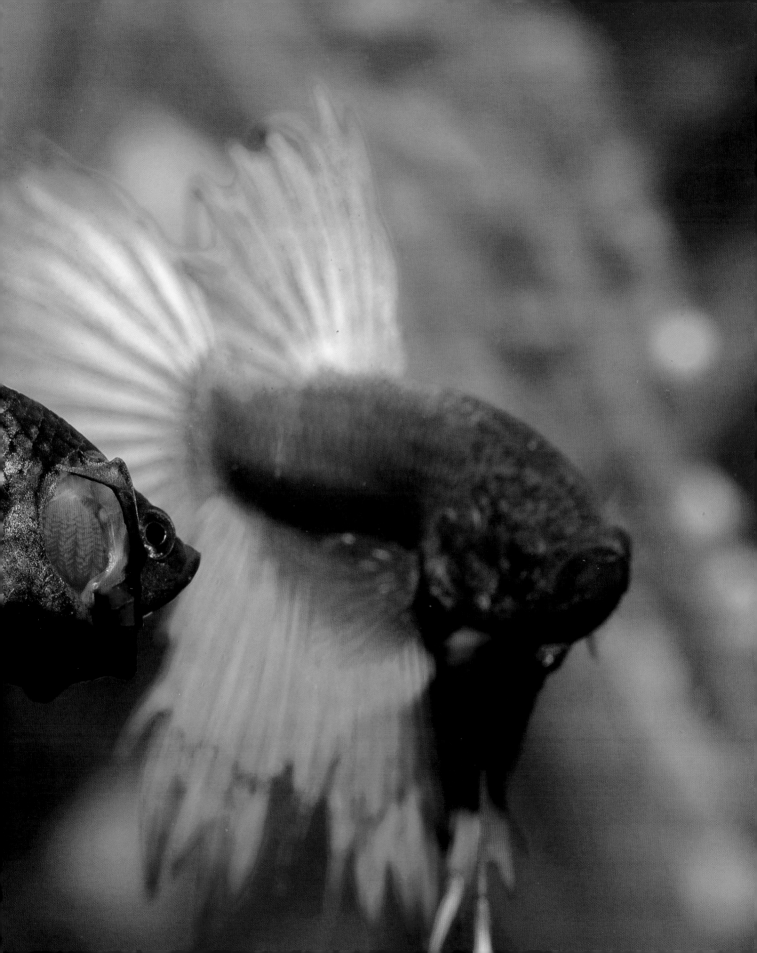

Kottigehar frog

HIGH-KICKING COURTSHIP

Many frogs croak, cheep, chirp, peep and ribbit – especially males in the breeding season, calling for female attention. The Kottigehar frog is no exception. Unlike most others, however, he also puts on an impressive visual display known as 'foot-flagging'. He stretches out one long, strong rear leg to the side, toe-spreads to reveal the webbed foot skin, swings the leg rearwards and back to his body, then repeats on the other side. This waving, kicking, left-right leg 'dance' aims to catch the eye of a mate.

The Kottigehar frog is named after one region of its very restricted geographic range in the Western Ghats of south-west India. Its specialized habitats include fast upland streams, which are noisy places in which to make cheeps and croaks heard.

FOOT-FLAGGING, CHIN-BALLOONING
The male Kottigehar's subdued vocalization resembles a warbler or similar bird, often written 'kee-ke-kirik' or 'keeri-keerik'. But his high-kicking, foot-flagging dance, alternately displaying the bright toe-webbing skin of each foot, is like twin lights flashing on and off in the dense vegetation. Also noticeable is his bright white vocal (chin) sac as it rapidly inflates then deflates when he calls.

Once a Kottigehar pair come together, they continue like many of their frog cousins. The male positions on the female's back and grips her tightly in a hold known as amplexus. She kicks a scrape in the stream bed and lays her eggs within. He fertilizes them, then she covers them for their early development into newly-hatched tadpoles.

DISTRIBUTION MAP

family Micrixalidae

- LOCAL COMMON NAMES
Dancing frog, Kottigehar dancing frog, Kottigehar torrent frog, Kottigehar bubble-nest frog, Kottigehar bush frog, also Naraina's, Swami's, Rao's or Ramaswami's bush/swamp/dancing/bubble-nest frog

- SCIENTIFIC NAME
More than twenty species in the genus *Micrixalus*, including Kottigehar frog *M. kottigeharensis*, Beautiful dancing frog *M. adonis*

- SIZE
Most species female head-body length 25–30mm (2–2 1/2in), males slightly smaller

- HABITATS
Most species prefer rainforest, wetlands, rivers, streams, usually with fast currents, also ponds, swamps, rice paddies

- DIET
Flies, worms, small aquatic creatures

- CONSERVATION STATUS
IUCN Kottigehar frog Critically endangered, most other species Vulnerable or Endangered (see key, page 9)

ON THE 'EDGE'
'EDGE' species are Evolutionarily Distinct and Globally Endangered, and the Kottigehar frog is one of them. EDGE creatures are specially chosen for their unique history, often evolving on their own for millions of years with no close relations, and for their urgent plight of being under great threat, especially in a very restricted geographical area. The Kottigehar frog is included in the Top 100 EDGE Amphibians.

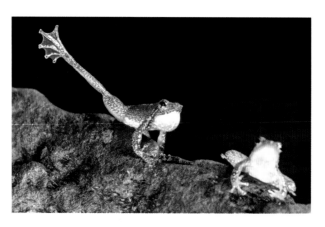

◀ A male Kottigehar frog high-kicks to make an impression on a nearby female. Their toes have wide adhering pads to grip the slippery wet rocks and plants of their fast-stream homes.

▶ A male 'foot-flags' while calling with his white inflated chin or vocal sac. The display is used for territorial purposes as well as courtship.

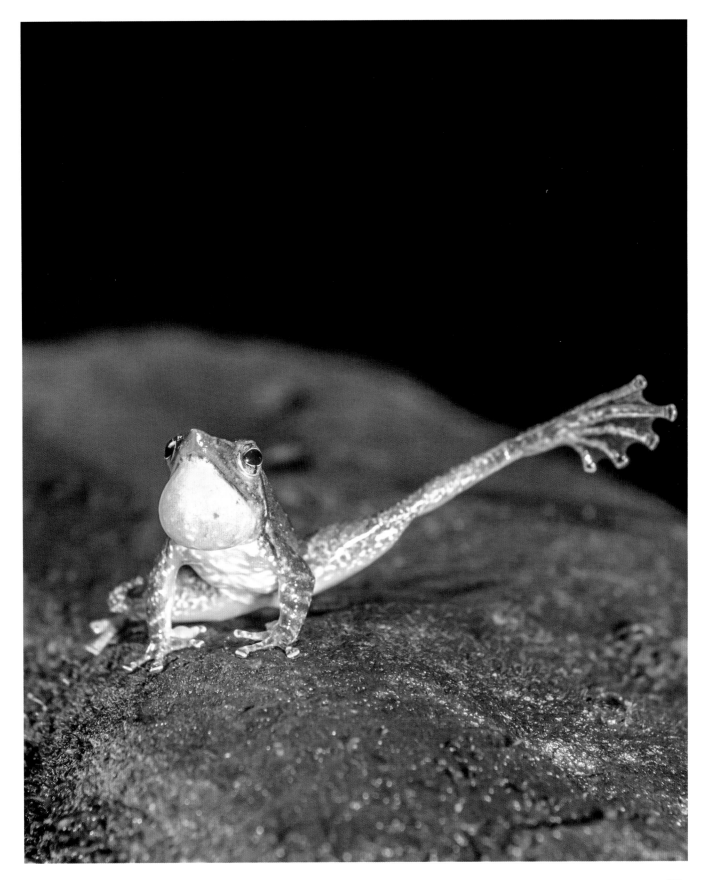

Pondichéry fan-throated lizard

FULL-THROATED DISPLAY

Small, slim, agile and rapid, the fan-throated lizards Sitana are a busy group from Southern Asia. There are about fifteen to twenty species. The one that scientifically established the group was the Pondichéry fan-throat, officially named in 1829. Their great feature is the male's relatively huge (given his size) underside skin flap. It folds out, fan-like, from the middle front lower jaw and chin along the throat to the chest. It is his bright, sometimes glaring and garish indicator that he is ready to defend his territorial patch against other males, while attempting to lure females.

The fan-throat lizard's chin/throat/chest flap of skin is known as the dewlap. It is not unique to this lizard group, being present in other lizards, including anoles (see page 52), and also in birds and certain other animals. A lizard's dewlap is a useful compromise between the animal remaining camouflaged and unnoticed most of the time when it is folded, then suddenly displaying brightly.

FOLDAWAY FLAG
The elastic dewlap skin folds and retracts neatly under the chin and front chest when not in use. When the male is stimulated by another male challenge, or by the potential to breed, it is extended by long, slim throat bones on the chin underside that swivel down and forwards. This unfurling can happen many times in quick succession, flashing the male's mating intentions to females in the area.

The male also bobs and dips his head, hops from side to side on all fours, perhaps stands up and hops on his two rear legs, and even twirls his tail – all the better to communicate his fitness and well-being to a future mate.

DISTRIBUTION MAP

- LOCAL COMMON NAMES
 Pondichéry fan-necked lizard, Pondichéry sitana; Sitane de Pondichéry (French); Sinhala, Theli katussa (local dialects)

- SCIENTIFIC NAME
 Sitana ponticeriana

- SIZE
 Most species head-tail length 10cm (4in), largest up to 17cm (5in)

- HABITATS
 Adaptable but mainly open areas, from rocky hills through woods and scrub to farmland, suburbs, coasts, holiday resorts

- DIET
 Small creatures such as insects, spiders, worms, also occasional seeds, fruits and other plant food

- CONSERVATION STATUS
 IUCN *S. ponticeriana* Least concern, although some *Sitana* species are Vulnerable, Endangered, even Critically endangered such as the Dark sitana, *S. fusca* (see key, page 9)

SEPARATELY SIMILAR
Convergent evolution is when different kinds of animal or plants come to resemble each other in certain features, because they have adapted though evolution to similar conditions, habitats or needs. The dewlaps of male anole and fan-throated lizards are a case in point. They have evolved, not from the same common ancestor, but independently in each lizard group. They are a convenient way of enhancing appearance for tasks such as defending territory and appealing to females.

▶ Fran-throat dewlap colour is hugely variable, from mainly white or cream with faint colours, to intense blues and reds with an 'embroidery' texture, as here in this Pondichéry male. Note his bipedal (on-two-legs) stance and the possible distraction of the tiny spider on his nose.

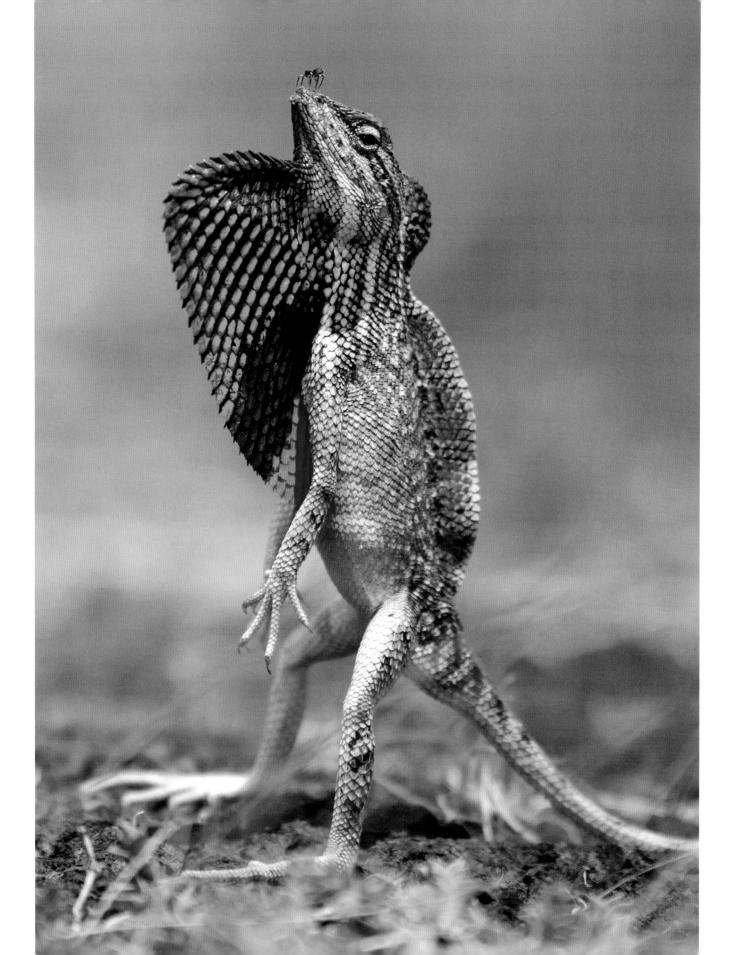

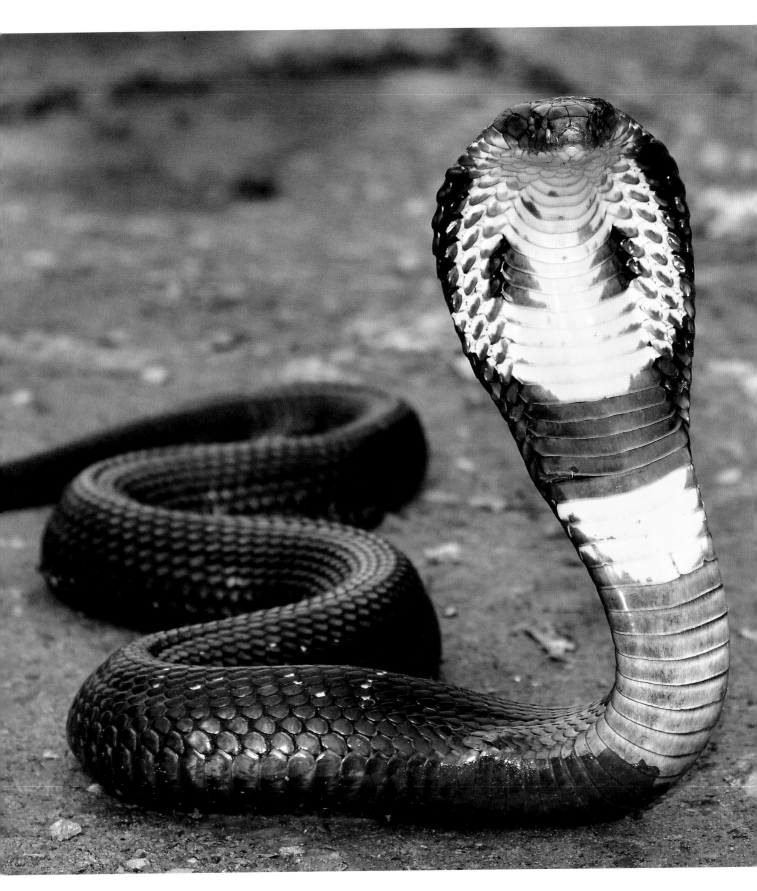

King cobra

HOODED AND DEADLY

One of nature's best-known threat displays is a cobra rearing up, front of the body raised, head horizontal, beady eyes following the danger, and the hallmark neck hood spread or 'flared'. For added effect the cobra may open wide to display its deadly fangs, also puff and hiss loudly. The king cobra is especially impressive, being the largest of the forty-plus species of snakes known as cobras – and also a hunter of its kin.

The king cobra is the world's longest venomous snake. It is muscular, agile and speedy. When it rears, it can hold up more than one-third of its body, bringing its gaze eye-to-eye with a not-too-tall human. The king cobra can also hold this pose while sliding or shuffling along and even when making rapid, wriggle-like leaps.

SHY AND NON-CONFRONTATIONAL
The cobra's spread hood is a sure warning sign that the snake is ready to defend itself, and its rearing frees the head to strike in any direction.

Its hiss (a widespread threat signal among animals, see page 9), can be deep, like a dog's growl. However, the king cobra is generally shy and usually tries to avoid confrontation by slithering away.

The king cobra's scientific name *Ophiophagus* means 'snake-eater'. Indeed, its dietary mainstay is other snakes, venomous or not. It spends much time draped among tree branches and foliage, quietly waiting for a suitable meal to slide by. It also swims well and may hunt on the forest floor or along streams and pools.

DISTRIBUTION MAP

- **LOCAL COMMON NAMES**
 Hamadryad (traditional local name, also former scientific name)

- **SCIENTIFIC NAME**
 Ophiophagus hannah

- **SIZE**
 Male total length occasionally exceeds 5m (16 ½ft), weight 12kg (26lb), females 15–30% smaller

- **HABITATS**
 Warm, humid forests, woods, thickets, wetlands, farmland, plantations, less common in dry habitats

- **DIET**
 Chiefly other snakes, both non-venomous and venomous, including its own kind (cannibalism), also lizards, birds, small rodents such as rats

- **CONSERVATION STATUS**
 IUCN Vulnerable
 (see key, page 9)

◄ The cobra's hood makes the snake appear larger. It also has two dark 'eyespots' that contrast with the lighter cream or pale yellow of the throat.

▶ With the longest tongue of any snake, and fangs perhaps 15 millimetres (³/₅ inch) in length, the king cobra puts on a serious threat display. (The projecting opening in the lower mouth is the glottis, leading to the windpipe.)

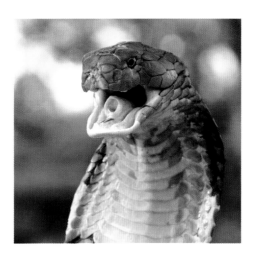

HOW THE HOOD WORKS
The distinctive cobra hood consists of loose, elastic skin held out by extensions of the rib bones in the neck region. To study how it works, scientists implanted miniature electrodes into a cobra's neck – with the snake under anaesthetic, of course – to record muscle activity. About eight sets of muscles are involved to 'erect' the ribs out and sideways, to keep the skin taut, and to support and spread the tension along the whole row of ribs.

Goldeneye

NECK-ACHING ARCH-BACK

Often called the common goldeneye, this duck is an inhabitant of the inland waters and forests of the far north during its spring-summer breeding season. In autumn most populations migrate south to overwinter around coasts and non-frozen lakes and rivers. In mid to late winter, the individuals in a flock begin to take an interest in those of the opposite sex. This is when the males perform their striking displays, including manoeuvres such as the contorted 'head-throw-kick'.

While still at their winter site, male goldeneyes gather to persuade females. About three to five males cluster around a prospective mate and begin their ritualized 'dances', which have more than a dozen distinct phases or elements.

THE BENT NECK MANOEUVRE
Among the more remarkable courting tactics is the head-throw-kick. In one version the male prods and thrusts his head and neck forwards, then arches the neck up and back so that his head tips over backwards and the top of the head touches his rump; meanwhile he tilts his body back and then forwards, and kicks the water surface with his feet. Along the way he utters cheep-like 'pee-eent' calls. If the female responds with similar behaviour, the two become a pair.

At the breeding ground, the female chooses a nest site while the male establishes and defends her (known as mate-guarding), the nest site and a small territory around. Mating can be physical too. The male mounts the female who is virtually underwater, and pecks and pulls at her plumage. When she lays their eggs, he ceases his territoriality.

DISTRIBUTION MAP

- LOCAL COMMON NAMES
Common goldeneye, Whistler; Pato chillón, Porrón osculado (Spanish); Garrot à oeil d'or (French); Telkkä (Finnish); Nynorsk, Kvinand (Norwegian); Knipa (Swedish); Hvinand (Danish); Schellente (German); Gągoł (Polish); Hojiro-gamo (Japanese)

- SCIENTIFIC NAME
Bucephala clangula

- SIZE
Total length up to 50cm (20in), weight up to 1kg (2⅕ lb), wingspan 75–85cm (30–34in)

- HABITATS
Summer breeding around forested inland waters of the far north, migrating south to inland and also coastal areas for winter

- DIET
Aquatic creatures such as fish, shrimps and other crustaceans, shellfish, insects, some seeds and plant material

- CONSERVATION STATUS
IUCN Least concern
(see key, page 9)

DUCKS IN TREE HOLES
The goldeneye is a cavity nester, that is, it makes its nest in the hole of a forest tree. A duck's bill is not designed for such excavation, so the goldeneye makes use of old woodpecker holes, or natural cavities formed where, for example, a branch breaks from the trunk. A spin-off from this behaviour means goldeneyes take readily to nest boxes that have been suitably prepared and sited, allowing much closer study of the species by ornithologists (bird experts).

◄ Once a female goldeneye settles on a male suitor, the two remain as a pair for the season. However, long-term bonds over several seasons are thought to be uncommon.

► The male's speciality move is to throw his head so far back that its top touches his rump. At the same time he rocks his body, tilting down then up, while surface-splashing with his feet.

Great argus

MANY-EYED ENTERTAINER

One of the world's most famous animal displays is the amazing shaking and shimmering of the peacock's (male peafowl's) tail. A very close bird relative with an arguably even more spectacular courtship display is the great argus (greater argus or argus pheasant). His lavish wing and tail feathers fan out to form a most astonishing sight as he stamps, stomps and looms over his would-be partner.

On most days, the cock (male) great argus treads quietly around the forest floor, searching for almost anything edible. His long wing and tail feathers trail behind like a cloak or train. But it is all change at breeding time. The cock prepares carefully by fastidiously clearing a patch of forest floor of leaves and twigs for his performance area, or lek. He then calls loudly, '(k)-oohw-WOOW', to advertise his presence to hens (females).

HIDDEN HEAD

If one or more hens approach, the cock commences. His wings suddenly fan out and forwards on either side into an almost complete bowl shape, bearing the patterns of hundreds of ocelli or eye-spots. His head nestles in the middle, peering at the female's reaction. His tail plumes, especially the two particularly elongated central ones, also erect, fan out and angle forwards. He struts and stamps, emphasizing his prowess as a fine and fit father. If a hen consents, the two mate.

Then, as in many species where the male is amazingly elaborate, the hen moves off, and she alone nests and raises the chicks.

DISTRIBUTION MAP

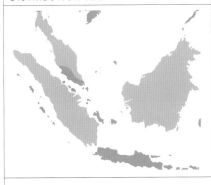

- LOCAL COMMON NAMES
Greater argus, Argus pheasant, Phoenix bird; Kuang raya, Burung keruai, Burung kuang raya, Burung kuau rimba (Malay, Indonesian); Nók wâa (Thai); Seiran (Japanese)

- SCIENTIFIC NAME
Argusianus argus

- SIZE
Male bill-tail length up to 200cm (78in), including tail of up to 100cm (39in), wingspan 90–100cm (35–39in), weight 2–2.5kg (4.4–5.5lb), female smaller

- HABITATS
Warm to hot forests and woodlands

- DIET
Omnivore, consuming seeds, fruits, blossom, also insects, worms, slugs and other small creatures

- CONSERVATION STATUS
IUCN Vulnerable
(see key, page 9)

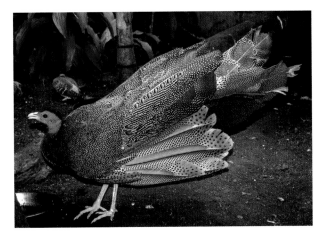

◄ The male great argus's head is almost hidden at the centre of the funnel-like wing surrounds, as the multi-eyed feathers shake and shimmer. His two central tail plumes show above at the rear.

► The female also has elongated wing and tail feathers, but not as lengthy and trailing as the male's, and with fewer eyespots.

WHY 'ARGUS'?

In Greek mythology, Argus (Argos), 'watchful guardian', was a giant with many eyes, often said to number one hundred. He was also called Argus Panoptes, 'Argus the all-seeing'. While some of his eyes slept, others were open, looking all around. When he was finally slain, his eyes were immortalized in the tail of the peacock. The great argus has even more, and more distinct, eye-spots, hence its suitably apt common and scientific names.

Lesser bird of paradise

UNFORGETTABLE AUDITIONS

Close cousins of crows, rooks and ravens (corvids), the birds of paradise could hardly be more different in appearance and behaviour. There are about forty-four species. In most, the males have some of the most colourful, extravagant plumage and courting behaviour in the entire bird world.

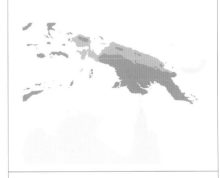

The lesser bird of paradise is a medium-sized family member. The male's yellow head and upper back contrast with his light blue bill, shiny green throat, chestnut-brown body and wings, flowing yellow and white flank plumes, and long tail feathers reduced to central shafts as thin brown 'wires'. As in most paradise species, the female is much plainer.

AN OUTSTANDING SHOW
Lesser bird of paradise males display at a traditional site, the lek – usually one tree. Ten or more congregate, watched by females and juveniles. Each male has his own dance sequence that includes spreading his wings down and forwards, erecting and tilting his flank plumes over his back, hopping, head-bobbing, side-stepping, leaning forwards, and hanging inverted with plumes and wings extended. It is a spectacular show. The biggest, dominant males usually occupy the centre of the lek area and mate with most females.

- LOCAL COMMON NAMES
 Paradisier petit-émeraude (French);
 Kleine paradijsvogel (Dutch);
 Cenderawasih kuning-kecil,
 Cendrawasih kecil, Burung kuning
 (Malay, Indonesian)

- SCIENTIFIC NAME
 Paradisaea minor

- SIZE
 Overall length 30–35cm (12–14in)
 excluding tail 'wires', wingspan 60cm
 (24in), weight 250–320g (9-11oz)

- HABITATS
 Dense lowland and hilly rainforests,
 also certain kinds of agricultural land,
 plantations

- DIET
 Mostly fruits, flowers and other plant
 matter, also insects, spiders and small
 creatures

- CONSERVATION STATUS
 IUCN Least concern
 (see key, page 9)

BIRDS FROM 'PARADISE'
Bird of paradise males make full use of their ornamentation as they indulge in energetic, complex and acrobatic dancing and cavorting, incorporating almost every known move, from slight hops and head-bobs to sweeping pirouettes, somersaults and swinging upside down. In the eighteenth and nineteenth centuries, when the first preserved bodies, skins and feathers reached naturalists in Europe, they were believed to originate in some kind of 'perfect paradise' of the most wonderful, almost unearthly animals and plants.

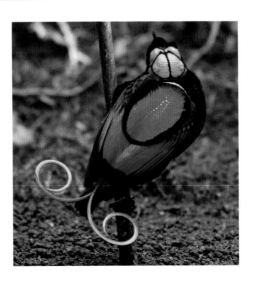

◀ The male Wilson's bird of paradise, *Cicinnurus respublica* (formerly *Diphyllodes respublica*), is one of the smaller species. However, he has the greatest variety of multihued coloration, including the two reflective, glittering, violet tail plumes.

▶ The male lesser bird of paradise's display fully exploits his bright colours and fluent plumage.

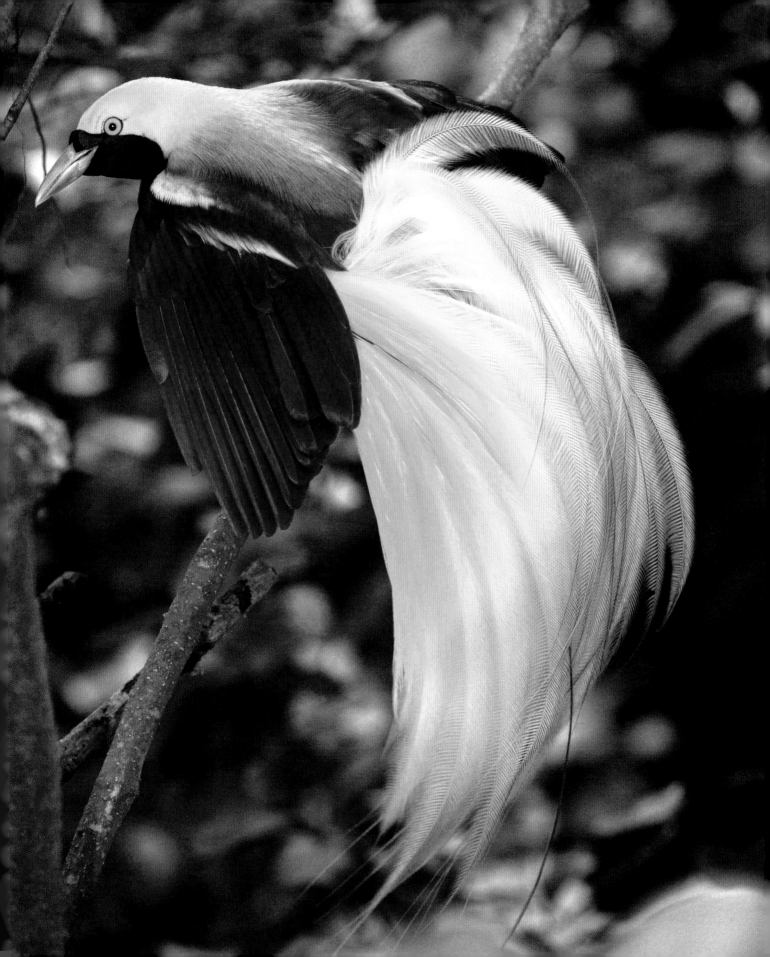

Indian grey mongoose

IMPORTANT! TACTICS, STAMINA, TIMING

Astonishingly fast-reacting and agile, the Indian grey mongoose is famed as a 'snake killer'. Sadly, people still forcibly make a mongoose and a cobra (or similar venomous snake) confront each other for so-called 'entertainment'. Such displays are thankfully fading. But it is true that in the wild, the Indian grey and other mongooses hunt snakes as food. The mongoose has specialized tactics and a well-practised routine to ensure a win, or at least, survival.

There are about thirty-four different kinds or species of mongooses, or herpestids, spread across Asia and Africa. The Indian grey is one of the larger. Like most others, it is highly adaptable in habitats and diets, preying on an extensive variety of usually smaller creatures.

When a hungry mongoose meets a cobra or similar, it begins its threatening 'dance', leaping and bouncing around the snake. It also erects its thick fur to help protect against snake bite. Teeth bared, it dashes in, fakes a lunge and bite, leaps away, and changes its angle of attack, all at amazing speed.

This elicits repeated strikes as the snake bites at empty air, tiring each time.

IN FOR THE KILL
As the reptile fatigues, the mongoose selects the precise moment to land a fast, fierce nip on the snake's head or neck. It then dances around again to repeat the process. Even if the snake does manage to bite, the mongoose has a special immunity to its venom and is usually unharmed (see below). Eventually the snake, exhausted and wounded, succumbs to the mongoose's skull-crushing bite.

- LOCAL COMMON NAMES
 Asian mongoose, Indian mongoose, Grey mongoose, Common grey mongoose; this species and various similar mongooses have many local names across Asia such as Newla, Maṅgūs (Hindi); Beji (Bengali, east India, Bangladesh); Muṅgūs (Marathi, west-central India); Mungisa (Telugu, east-central India); Mungisi, Munguli (Kannada, south-west India); Mweyba (Burmese); Phang-phxan (Thai)

- SCIENTIFIC NAME
 Urva edwardsii (formerly *Herpestes edwardsii*)

- SIZE
 Total length 80–90cm (31–35in), about half of which is tail, weight 1–1.5kg (2.2–3.3lb)

- HABITATS
 Many, from forests and woods to bush, scrub, shrubby grasslands, farmland, coasts, around human settlements, even in urban centres, also kept as semi-tame 'pets'

- DIET
 Extremely varied, including small creatures such as insects, frogs, lizards, snakes, birds and mammals like rats and mice, also fruits, seeds and other plant matter

- CONSERVATION STATUS
 IUCN Least concern
 (see key, page 9)

HOW THE IMMUNITY WORKS
Most snake venoms are neurotoxins, interfering with nerve signals that control functions such as heartbeat, breathing and muscle movements. Snake venom molecules (particles) work by attaching to specialized nerve-ending structures termed acetylcholine receptors and blocking their workings. The mongoose's receptors have a slightly different structure from most mammals, so the snake's venom molecules cannot attach to them or disrupt their functions.

▶ Thick, stiff hairs erect, a mongoose approaches a cobra and begins its display and lengthy tactics to wear down the snake's stamina. Some mongoose hunts last more than an hour before the snake starts to tire and lose its reaction speed.

Yunnan snub-nosed monkey

GRIN, GRIMACE, GROWL

This large monkey has a variety of common names, mostly relating to its lack of nose bones (see panel, right). It is an unusual monkey in many ways, with an extremely high-altitude habitat of conifer and mixed forests, thick fur to cope with the cold there, and a winter diet dominated by lichens (hardly digested by most mammals). More usual among monkeys is its multi-purpose threat displays of curling back the lips to expose the teeth, especially the long, fang-like, fierce-looking canines, either with jaws clamped together or gaping wide open.

Like its fellow five snub-nosed species, the Yunnan accompanies its 'grimace-grin' with other actions. These include tensed body and limbs, arched back, swishing the long tail, and perhaps hands held out to show sharp-nailed fingers. Associated sounds incorporate screeches, growls, chatters, hisses and in particular, a loud, strident braying.

MULTI-PURPOSE DISPLAY
The Yunnan snub-nosed shows aggression for a number of reasons. Among males, these include challenging each other for a small group of females, or harem. In the wider troop is the need to establish dominance among other males with their harems. Another trigger is stranger monkeys in the area, including other snub-nosed bands and also rhesus macaques. A less extreme version, the 'grunt bared-teeth display', is the male's response to a female lying prostrate, stretched on the ground, glancing sideways at him, as a mating invitation.

Feeding in trees and also on the ground, both males and females display against predators that include leopards, dholes (Asian wild dogs), wolves, golden cats, and birds such as buzzards, eagles and hawks.

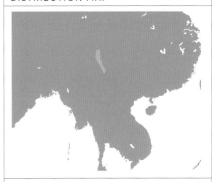
- LOCAL COMMON NAMES
 Black-and-white snub-nosed monkey, Black snub-nosed monkey (a name also used for a closely related species), Yunnan golden-haired monkey; Hei bai yang bi hou (Chinese); Baiyao, Baip hhod (local Bai language); Zha mi pu zha (Lisu)

- SCIENTIFIC NAME
 Rhinopithecus bieti

- SIZE
 Male head–body length 75–85cm (29–33in), tail 60–80cm (23–31in), weight 12–15kg (26–33lb), females about two-thirds this size

- HABITATS
 Conifer, mixed and deciduous forests on mountains and hills at altitudes up to 4,500m (14,750ft)

- DIET
 Winter: mainly lichens, also bark, twigs, leaves including bamboos
 Summer: buds, flowers, seeds, fruits, leaves

- CONSERVATION STATUS
 IUCN Endangered
 (see key, page 9)

◄ The snub-nosed 'grin-grimace' showcases the four long canine teeth. It is a common signal during the breeding season when inter-male competition is especially intense.

► In some circumstances, usually more serious, the mouth is open rather than closed. Lack of nose bones means an absent nasal protuberance.

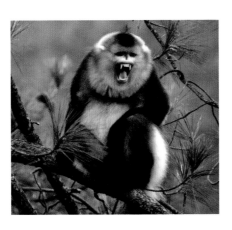

'BACK FROM THE DEAD'
The Yunnan snub-nosed monkey was described scientifically in 1897. With no further reports over the following decades, it was believed extinct. Then in 1960 eight fresh skins from Yunnan showed the species was still around. National Chinese reserves were established for this and other snub-noses, plus many other rare species. In 2003 several of these reserves were incorporated as the Three Parallel Rivers of Yunnan World Heritage Site.

Orangutan

CALL OF THE BOSS MALE

The three species of orangutans are among the most charismatic, intelligent and threatened of all the world's creatures. Unlike the other great apes – gorillas, chimps and humans – they are mainly solitary, apart from a mother with her offspring, and a courting-mating pair for a short time. Visually, adult interactions are limited and relatively simple. Much more common and varied are vocal communications. Probably the most striking of these is the powerfully impressive, far-carrying 'long call' of the mature male.

From about twelve years of age, an adult male orang is ready to 'flange'. He develops wide cheek flaps or flanges, an extended throat pouch, and long hair – all signs that he is sexually mature and ready to mate. The main signal for his presence through the forest is his long call.

A typical long call commences with softer bark- and grunt-like sounds. These increase in volume into a pulsing series of extended roars that mix bellowing, yelling, shouting and booming, and which carry many hundreds of metres through the forest. The call then tails away into bubbling grumbles and groans. The whole event usually lasts between one and two minutes.

ONLY ONE BOSS

The long call has two main purposes. It announces to females in the vicinity that here is a mature flanged male, ready to court and mate. The long call also tells nearby immature, unflanged males that there is only one 'boss' in the area. Hearing the call seems to suppress any further physiological development of these junior males. Some may remain unflanged, and therefore non-breeding, for many years.

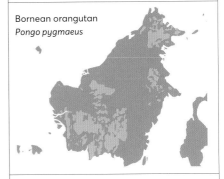

DISTRIBUTION MAP

Bornean orangutan
Pongo pygmaeus

• LOCAL COMMON NAMES
Original Malay (possibly part Indonesian) name *orang* 'human, person, man', *hutan* 'forest'; Uraŋutan (old Javanese); various forms in many languages such as Orang utan, Orang-utan, Orangutang, Ourang-outang, Orang hutan

• SCIENTIFIC NAME
Three species of genus *Pongo*: Bornean orangutan *P. pygmaeus*, Sumatran orangutan *P. abelii*, Tapanuli orangutan *P. tapanuliensis*

• SIZE
Male standing height 130–145cm (51–57in), weight 65–85kg (143–187lb), females about 30–40% smaller

• HABITATS
Tropical rainforests especially near water

• DIET
Mainly fruits, also leaves, stems, buds, flowers, occasionally insects and small amphibians, lizards, birds, mammals

• CONSERVATION STATUS
IUCN All three species Critically endangered
(see key, page 9)

MORE VOCAL SIGNALS

Orangs have a series of quieter sounds reserved for casual social interaction. Two males considering a challenge may emit a more rapid, simpler version of the long call named the 'fast call'. An agitated orang 'kiss-squeaks' by inhaling air through pursed lips. The growling, guttural 'rolling call' intimidates another orang. The very human 'raspberry-blowing' may accompany nest-building or a mother caring for her youngster.

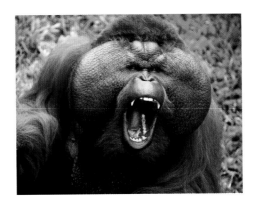

◀ Possibly the orang's cheek flanges – here in the Bornean species – act as a directional 'loudhailer' for his vocals. He calls in the direction he is travelling, thereby informing other orangs along the route.

▶ A 'flanged' (mature) male orang prepares to call across the rainforest. His call's volume and pitch indicate his position and his size.

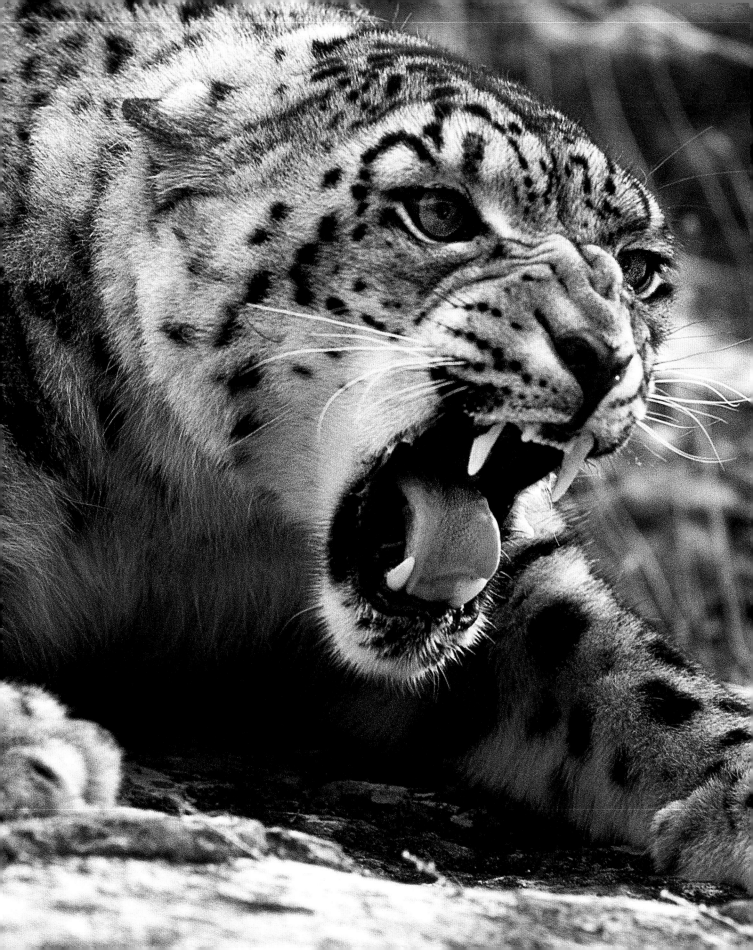

Snow leopard

RAREFIED HABITAT, RARE ENCOUNTERS

The snow leopard inhabits the high, cold, rocky mountains of Central Asia, where life is sparse and scattered. Its main prey of wild sheep, goats and similar medium-sized mammals eke out a living from the scarce, shrubby vegetation. The snow leopard roams widely in search of food, through a home range that can exceed 1,000 square kilometres (390 square miles). Meeting another snow leopard is a rare occurrence, and each cat's conduct depends on sex and season.

The snow leopard's threat display is familiar from most of the cat family, like the bobcat and lion (see pages 41, 144) – and our pet moggies. Jaws gape to reveal teeth, lips curl back for the same reason, nose wrinkles, eyes narrow, ears flatten, posture crouches, legs tense, the usually sheathed claws expose, tail switches side-to-side but occasionally holds out, fur erects; and all of this is complemented by sounds such as snarls, growls and hisses. This basic suite of actions prepares the snow leopard for action: to leap or pounce at the target, to feint as a sideways distraction allowing time to reassess, or to jump, turn tail in mid-air and flee.

A RARE DISPLAY
For the snow leopard, this defence-threat display is a rarity. Male may threaten male when they meet on their lonely wanderings and one strays into the other's home range, which has been marked by the occupier's urine, droppings and scent-rubbings. A less ferocious version of the display is used by male and female when they meet to consider mating, the breeding season being late winter, January to March.

DISTRIBUTION MAP

- LOCAL COMMON NAMES
Ounce; Xuĕbào (Chinese); Him tendua (Sanskrit, Hindi); Barfanī chīta (Hindi, Urdu); Ilbirs (Kyrgyz); Bars, Barys (Kazakh); Irves (Mongolian)

- SCIENTIFIC NAME
Panthera uncia

- SIZE
Head–body length 100–120cm (40–47in), tail 80–100cm (31–40in), weight 40–60kg (88–132lb), females usually slightly smaller

- HABITATS
Rocky mountains, cliffs, crags, uplands, alpine meadows, scrub and hills, usually between 1,000 and 6,000m (3,300 and 20,000ft)

- DIET
Mammals, from the size of mice and voles to wild sheep and goats larger than itself

- CONSERVATION STATUS
IUCN Vulnerable
(see key, page 9)

◄ Given their demanding habitat and huge roaming areas, a snow leopard face-off is a rare occurrence, as here with a male-male meeting.

► A male and female (the former usually being larger) nuzzle and scent-mark in readiness for mating.

CATS IN TROUBLE
The snow leopard's closest cousin is the tiger, then leopard, lion and jaguar. All these big cat populations are declining. Recent surveys estimate 4,000–6,000 snow leopards in the wild, with 600-plus in officially recognized zoos and wildlife parks. Most captive centres follow programmes to raise awareness of the snow leopards' plight, conduct research, match individuals to ensure breeding and genetic diversity, and reintroduce the species to suitable habitats.

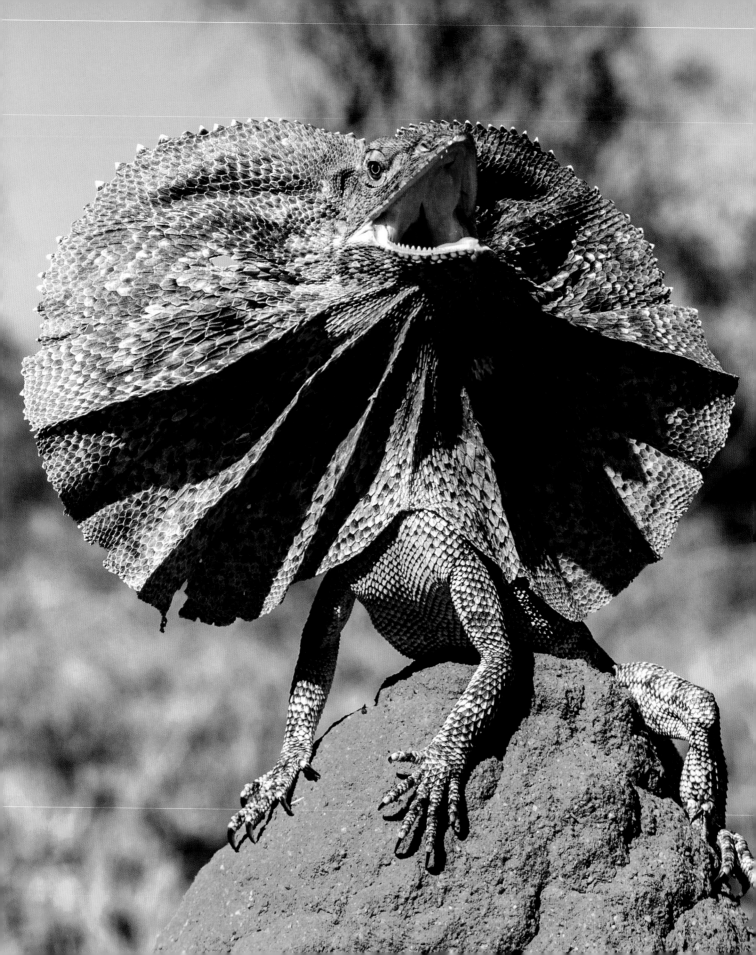

6
Australasia

Mountain katydid

LAST-SECOND FRIGHT

The startle or deimatic ('frightening') display of the mountain katydid is indeed sudden and disconcerting. In normal pose, resting or feeding, the insect is ideally camouflaged by a motley collection of splodged, mottled browns and creams. Under threat, it abruptly raises its wings to expose its main body, or abdomen. This is bedecked with unexpectedly bright and contrasting bands of crimson, black and blue, as the katydid arches and shakes itself to repel the molester.

Katydids, along with grasshoppers, crickets and locusts, are orthopteran, 'straight winged'. The mountain katydid (also called the mountain bush cricket) is a thumb-sized species with long antennae, robust body and strong legs. Both sexes have wings, but in the female these are hardened for body protection, and she is flightless.

TOUCH IS THE TRIGGER
It might seem sensible that the katydid's startle display should be deployed when its eyes, antennae and other senses detect the approach of a predator, such as a lizard or carnivorous mammal. Scientific experiments, however,

reveal that the display is only activated by tactile stimuli – that is, when the insect is actually touched.

This might seem too late. But the katydid is strong, thick-skinned, kicks powerfully, has a nasty bite – and as its food plants (including ragwort and fireweed) are toxic to many creatures, its flesh is distasteful, even poisonous. So the glowing coloured bands serve both to alarm the molester and act as warning or aposematic colours (see page 6). The katydid's overall package of startling flashed colours and patterns, tough body casing, distastefulness, kicks and nips means that in many cases it is not devoured.

- **LOCAL COMMON NAMES**
 Mountain bush cricket, Mountain grasshopper

- **SCIENTIFIC NAME**
 Acripeza reticulata

- **SIZE**
 Head-body length 5cm (2in), males slightly longer and slimmer

- **HABITATS**
 Mountains and hills, in woodlands, heaths, scrub and grasslands, also some lowland woods

- **DIET**
 Plants, in particular, herbs such as ragworts and fireweeds from which the insect assimilates distasteful toxins

- **CONSERVATION STATUS**
 IUCN Not evaluated
 (see key, page 9)

UNEXPECTED FINDING
Biologists who tested the mountain katydid's deimatic response used both captive insects and observations in the wild. A predator first detects, then identifies, approaches, subjugates and consumes the victim. Most defence displays occur relatively early, during the approach stage, or even as a pre-emptive manoeuvre if the prey detects the predator first. Displaying when the predator has actually arrived and is trying physically to tackle the victim was an unexpected discovery for the katydid.

◄ Crawling slowly about its daily business, the mountain katydid (here a female) blends well with soils, dry leaves, old stems and other debris.

► The slightest touch triggers the agonistic 'abdomen reveal' display. This is focused on the main body, or abdomen, rather than the wings as in species such as the peacock katydid (see page 47).

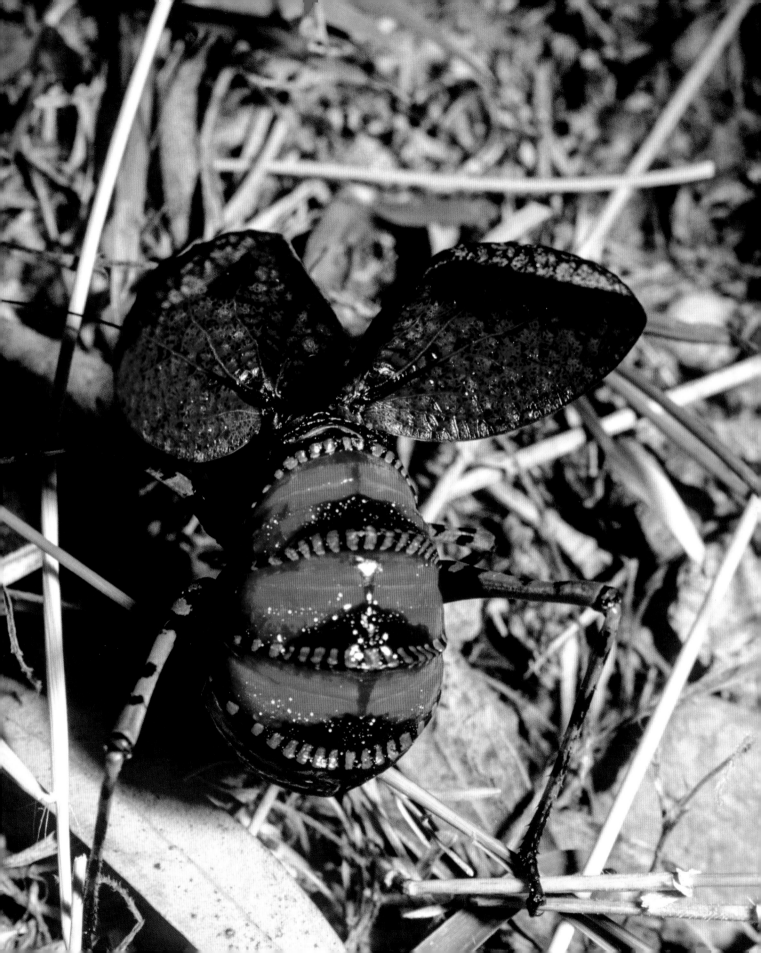

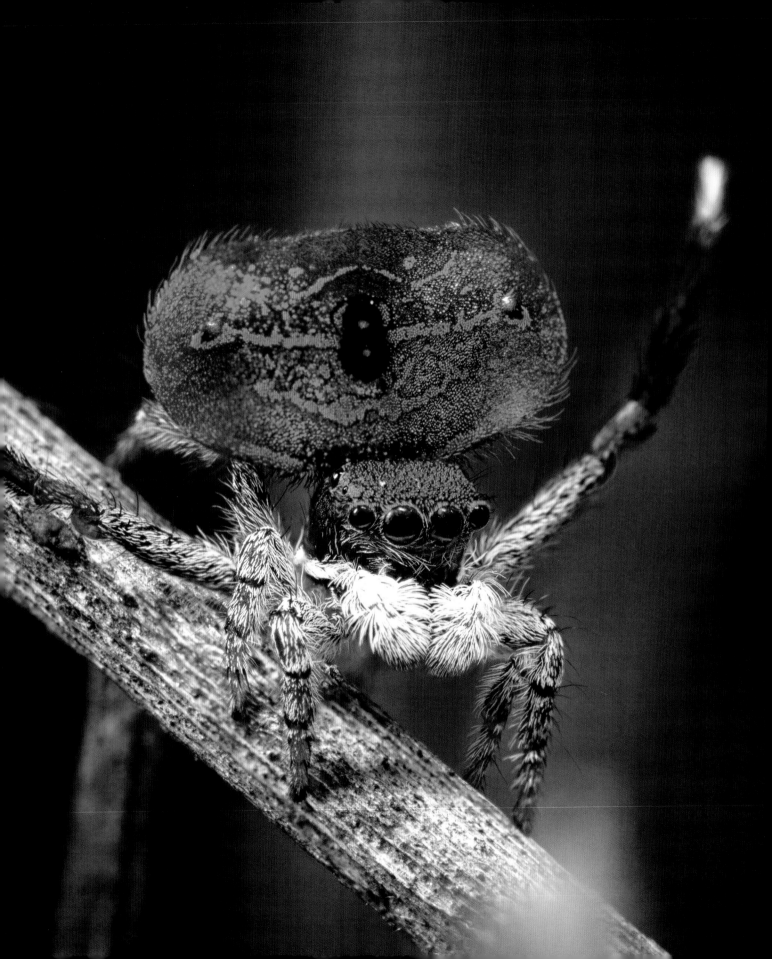

Peacock jumping spider

DIMINUTIVE BUT DEDICATED SHOW-OFF

'Peacock' is commonly applied to creatures that show off by erecting or spreading large, impressive, many-coloured body parts, particularly for courtship, as in the famous bird of that name. The male peacock spider does this, but in miniature, since he is not much larger than a rice grain. Even so, he puts on an impressive performance of dancing and displaying to attract a mate.

DISTRIBUTION MAP

- LOCAL COMMON NAMES
 Peacock spider, Peacock salticid

- SCIENTIFIC NAME
 Seventy-plus species in the genus (species group) *Maratus*, including Waspish peacock spider *M. vespa*, White-banded house jumper *M. griseus*, Prószyski's peacock spider *M. proszynskii*

- SIZE
 Largest species reach head-body length of 5–6mm ($\frac{1}{5}$–$\frac{1}{4}$in)

- HABITATS
 Varied, but most species prefer drier conditions in woods, shrub, heaths, grasslands, farmland, parks, gardens, dunes

- DIET
 Very small invertebrates including tiny flies, beetles, other spiders

- CONSERVATION STATUS
 IUCN Least concern (see key, page 9)

There are more than seventy-five kinds, or species, of peacock jumping spider. The male's colourful flaps and fringes, whose shapes, patterns and shimmering hues vary among the species, are part of the opisthosoma (abdomen). This is a spider's bulbous rear 'body' behind the front part, the prosoma (cephalothorax) that consists of the head and legs.

A LUMINOUS PERFORMANCE
The male stands on a prominent object such as a twig, stone or stem, and gesticulates animatedly with the third of his four pairs of legs. When a female approaches, he taps his standing surface to produce vibrations telling her of his mating intentions.

If the female comes nearer, the male spider raises and flattens his opisthosoma and its flaps and fringes. This highlights their previously concealed, brilliantly glowing colours and patterns. He continues to sway his whole body, flourish his flaps and fringes, and wave his third legs vigorously. The female may arrive to mate, or lose interest and wander away. But if she has recently mated, she may rush at the male and attempt to eat him, a behaviour not unknown among spiders, known as sexual cannibalism.

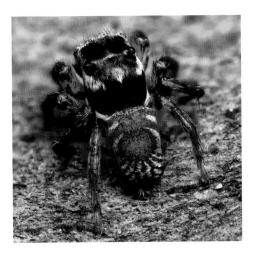

◀ A female's view of a displaying male peacock jumping spider shows his dazzling body, his third pair of legs gesturing in exaggerated fashion, and his row of four larger frontal eyes (of eight) watching for her response.

▶ Almost all species of *Maratus*, like this one from Queensland, are found in Australia.

PIGMENTS AND NANOSCALES

The glowing, almost electric-shining colours of peacock spiders are produced in two main ways. One is by means of coloured particles, pigments, as in many other creatures. The spider's are mainly white, pink and red. The other method is arrays of ridged, grooved and corrugated nanostructures on the spider's scale-like body hairs. These are so small, they split white light into its many rainbow-like colours, and selectively scatter, absorb or reflect these (see also next page).

Blue-ringed octopus

BEWARE THE BLUE GLOW

With a body hardly larger than a golf ball, and tentacles hardly as long as human fingers, a blue-ringed octopus could easily sit on an outstretched human hand. However this would be a most extreme folly. The blue-ringed octopus, or 'BRO', is among the world's deadliest animals. One individual has enough venom to kill more than twenty people. The signal that the octopus is ready to bite is in its rings.

The four blue-ringed octopus species have similar habits. Mostly they hide in their lairs or dens, in crevices, caves and nooks in the shallows. They are sometimes encountered unexpectedly in tidal rock pools and shore lagoons by people exploring the coast, since the BRO can change its colour for camouflage against various backgrounds. This is achieved by changing the shape, size and density of pigment-containing cells or cell groups termed chromatophores (see pages 210, 213).

SUDDEN TRANSFORMATION
The BRO has keen senses, especially sight, and tactile receptors that detect water currents from nearby movement. A threat triggers rapid transformation. Within a second, the fifty or more previously dull skin circles or rings glow and flash bright blue, as though activated by an electric switch.

The change is achieved by stimulating iridophores, which are chromatophores containing crystals whose surfaces have ridges and other nanoscale structures. The structures interfere with white light, splitting it into colours that can either be absorbed or scattered so they 'disappear', or be reflected for an eerily glistening iridescent effect (see also previous page).

DISTRIBUTION MAP

genus *Hapalochlaena*

- LOCAL COMMON NAMES
 'Bluey', 'BRO'; Poulpe à anneaux bleus, Poulpe bleu (French); Kugita (Filipino); Pulpo anillado mayor (Spanish)

- SCIENTIFIC NAME
 Four species in the genus (species group) *Hapalochlaena*, including Greater blue-ringed octopus *H. lunulata*, Blue-lined octopus *H. fasciata*

- SIZE
 Greater blue-ringed octopus with arms spread up to 20cm (8in) across

- HABITATS
 Tropical reefs, rock pools, sandy coves, rubble-strewn sea beds and similar coastal zones, usually in water less than 40m (130ft) deep

- DIET
 Small shrimps, prawns, crabs, fish, worms and similar creatures

- CONSERVATION STATUS
 IUCN Least concern
 (see key, page 9)

THE FINAL ACT
Like other octopuses, the blue-ringed is semelparous: it breeds just once and then dies. After a mother octopus has mated and laid her eggs, she no longer eats. Yet she remains with her brood, guarding and caressing the eggs as she gradually starves. She may survive to see her babies hatch, but that is usually her final deed. Researchers have traced this behaviour to hormone-like substances produced by a structure between the eyes, the optic gland.

▶ The BRO's gleaming, pulsing blue rings are highlighted by black surrounds that heighten contrast, a form of warning or aposematic coloration. Although small, the octopus can bite at speed to deliver of one of the world's deadliest venoms.

▶▶ Larger, darker patches around the black-edged blue rings enhance the contrast even further.

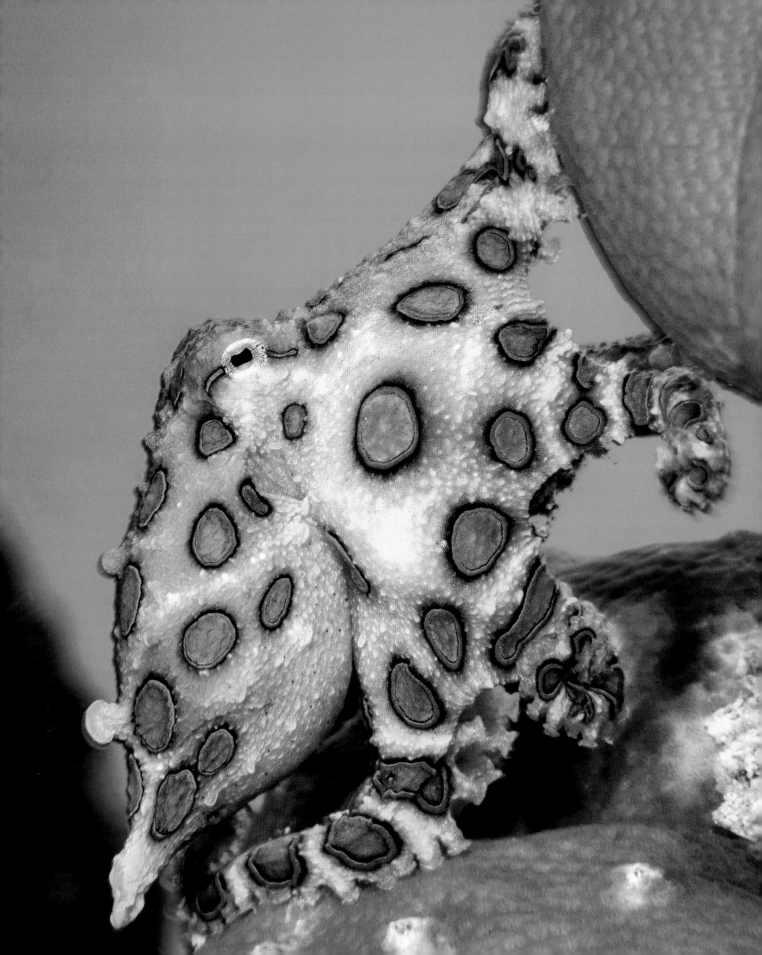

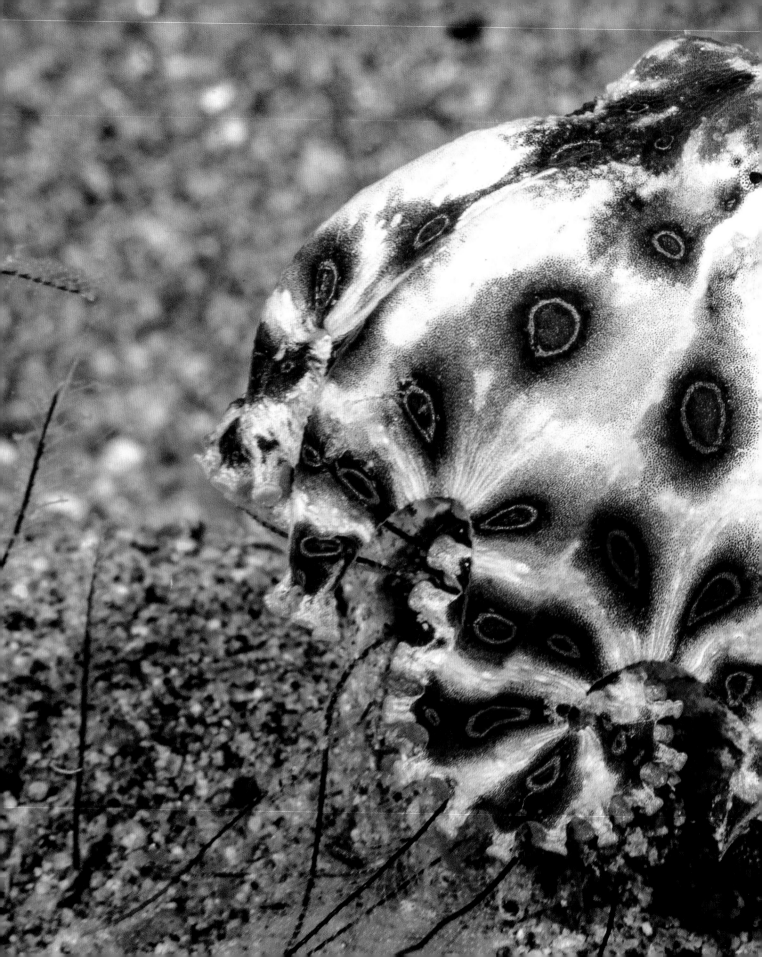

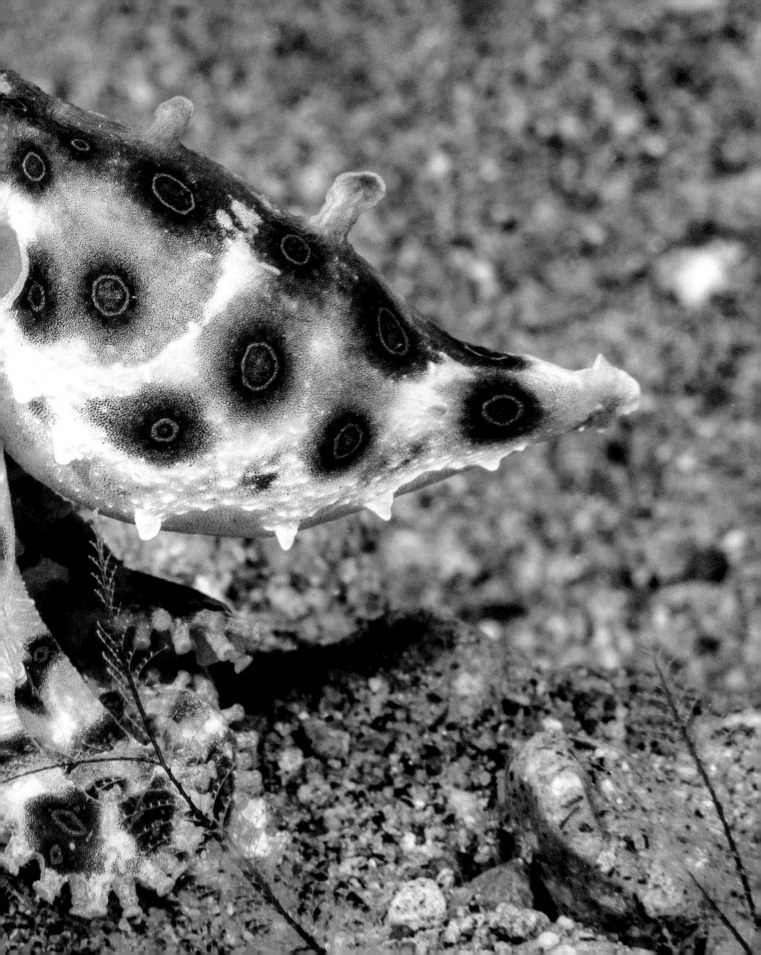

Cane (marine) toad

UNWELCOME INVADER

One of the world's most infamous creatures, the cane or marine toad is an unwitting victim of human attempts at 'biological control'. From 1935 it was introduced to north-east Australia to 'control', that is, eat, cane beetles damaging the rapid spread of sugarcane fields. The toads ate the beetles, but much more besides. They spread from plantations to devastate local insects and other small wildlife. In a double hit, native predators unfamiliar with the toad and its defence display tried to eat it, unaware of the deadly poisons in its skin.

The amphibian group of frogs, toads, salamanders and newts share a general defensive performance. They swallow air to puff up the vocal sac in the throat and other flexible body parts, and straighten their legs to look taller. This increases the creature's apparent size. Accompanying sounds include hissing (a widespread threat noise), perhaps also spitting and flicking out the long tongue. Some species also feign expiration or even flip over in apparent death throes (see page 86).

The cane toad is an expert in this general amphibian defensive scheme. It also exudes thick, pale poison fluid, bufotoxin, from the parotid gland just behind each eye.

NOT DETERRED, NOT IMMUNE

However many local predators are not deterred by the toad's show. These include quolls (native cats), lizards, snakes, birds of prey, and also pet and feral cats and dogs. Since the toad is a relative newcomer, many native predators have not evolved natural immunity to its toxins. The result is an ongoing ecological disaster across north and north-east Australia.

DISTRIBUTION MAP

- LOCAL COMMON NAMES
 Cane toad, Marine toad, South American toad, Giant toad, Giant marine toad, Neotropical toad, Dominican toad, 'Bufo', 'Spring chicken' (local Caribbean and Central American nickname), Dechedch (Palauan, malay-Polynesian)

- SCIENTIFIC NAME
 Rhinella marina (formerly *Bufo marinus*)

- SIZE
 Head-body length up to 20cm (8in), weight 50–100g (2–4oz)

- HABITATS
 Woods and forests, also bush and shrubland, coasts, needing suitable fresh water for breeding

- DIET
 Wide-ranging, from worms and insects to small shellfish, fish, amphibians, reptiles, birds and mammals (including bats), also scavenger on discarded human food

- CONSERVATION STATUS
 IUCN Least concern; regarded as one of the world's Top 100 (that is, worst 100) Invasive Alien Species (see key, page 9)

PERVASIVE INVADER

A century before its introduction to Australia, the cane toad was brought from its native range – South and Central America and a few Caribbean islands – to more Caribbean locations. Then during the 1930s–40s to Florida USA, and East and South-East Asia including Papua New Guinea, Philippines, Japan, and east as far as Hawaii. These originally well-meaning but under-researched introductions for biological control have substantially damaged many local ecosystems. Various strategies to control the toads have mostly been ineffective so far.

▶ Considerably larger than a human fist, the cane toad is strong and tough. Its defence posture, with body inflated and raised on straight legs, makes it appear more intimidating.

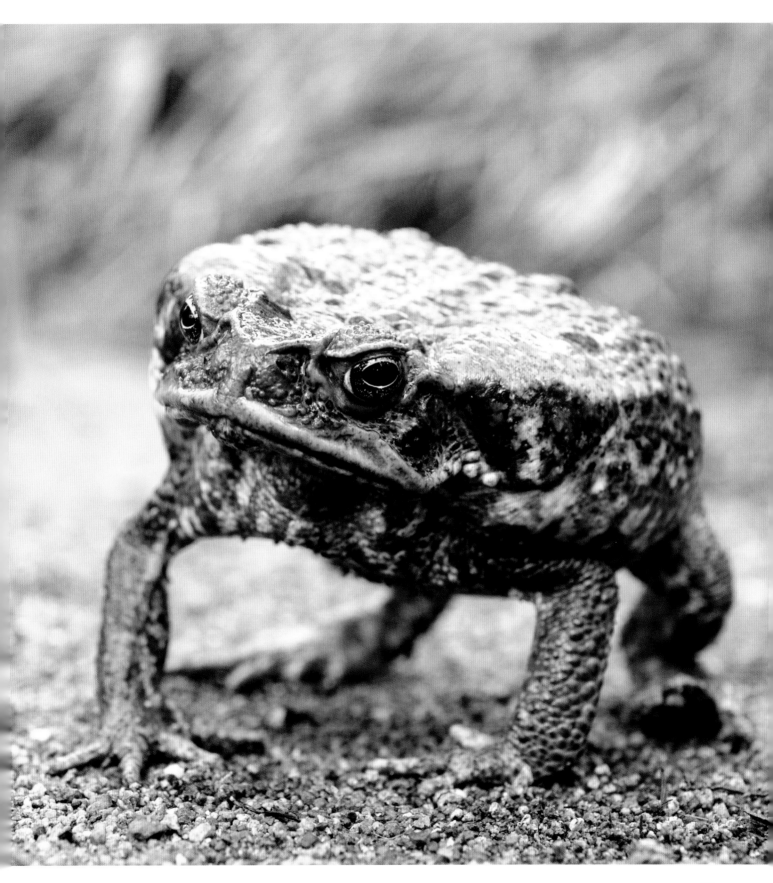

Shingleback (Blue-tongued) skink

LIFE-SAVING POKED-OUT TONGUE

One of about eight species of blue-tongued skink, the shingleback is a big, strong, robust lizard. It has a large head, wide mouth, short but powerful legs, and a stubby, stumpy tail, hence one of its many common names, 'bobtail'. This reptile's major deterrent – along with confrontational actions, postures, hisses and growls – is to open wide and thrust forward its bright blue tongue.

Shinglebacks are named from their overlapping, rough-edged, thick, bony, protruding scales, like shingles (tiles) on a building roof. These offer considerable protection against a predatory bite. In blue-tongues generally, the vivid tongue colour contrasts with the bright, shiny pinks and reds of the mouth lining. The mouth's width and gape are also menacing, seeming almost larger than the head itself.

As the lizard faces a threat, it gapes its jaws and protrudes its tongue, in a rapid action which makes some attackers recoil and reconsider the confrontation. The blue-tongue can also puff up or flatten its body, and squat down or raise itself, to augment the display.

BLUE IS THE COLOUR
A shingleback adopts its defensive show for two chief purposes. One is to chase away others of its species from its territory. These lizards are slow-moving and rarely roam far, since their diet is wide-ranging and they can usually find enough sustenance in a smallish area, but they do protect their patch against other shinglebacks. The other purpose is anti-predator, against larger lizards and snakes, dingoes, and big birds of prey.

DISTRIBUTION MAP

- LOCAL COMMON NAMES
 Bobtail lizard/skink, Boggi, Sleepy lizard/skink, Stumpy-tail lizard/skink, Two-headed skink/lizard, Pinecone lizard/skink, 'Bluey'; some of these names are applied to other *Tiliqua* species

- SCIENTIFIC NAME
 Tiliqua rugosa, also several other species of *Tiliqua* including Indonesian blue-tongued skink/shingleback *T. gigas*, Adelaide pygmy blue-tongued skink *T. adelaidensis*

- SIZE
 Head-body length up to 40cm (16in), tail 10–12cm (4–5in)

- HABITATS
 Many but mainly dry, from woods to bush, shrubby grasslands, heaths, dunes

- DIET
 Wide-ranging, including many small creatures, plant material such as seeds, fruits and blossom, also carrion and human refuse

- CONSERVATION STATUS
 IUCN Least concern
 (see key, page 9)

TWO HEADS – OR TAILS?
One of the shingleback's colloquial names is 'two-headed' skink or lizard. This refers to the similarity in size and shape of its head and tail, known as cephalo-caudal mimicry. It is a design shaped by evolution in varied creatures, from moths to birds. The usual explanation is that a predator which customarily assaults the head may, in the hurry and confusion of an attack, target the tail instead. The lizard can then escape with less serious injuries.

▶ In its aggressive pose, the shingleback's startling blue tongue stands out luridly against the fleshy mouth lining. Note that this individual has turned to face the danger, but left its head-mimicking tail nearest the threat.

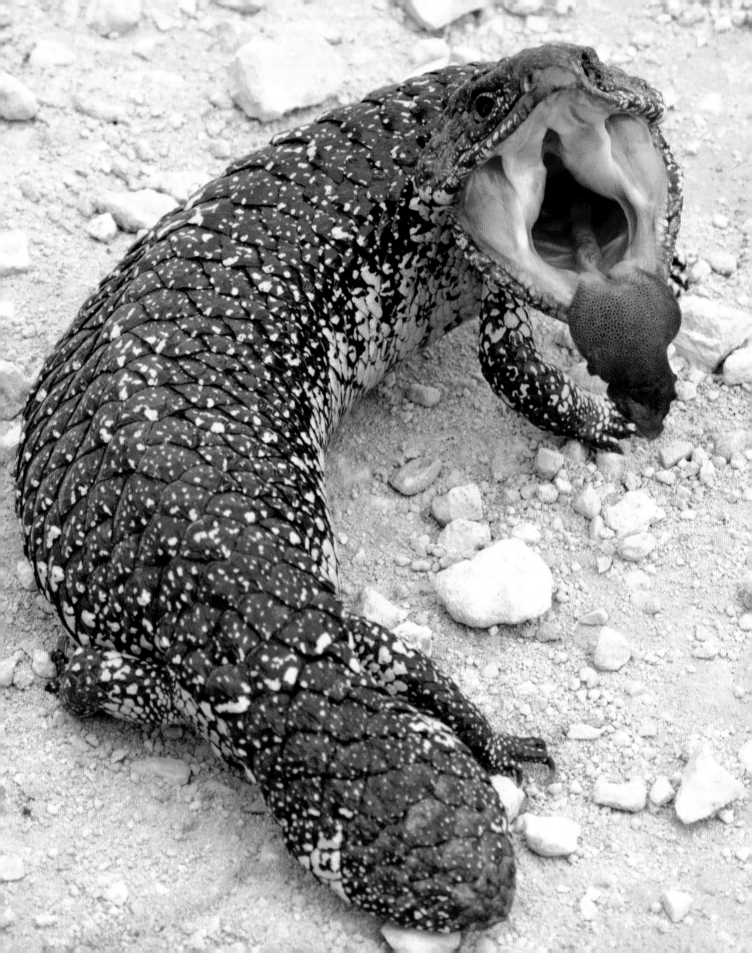

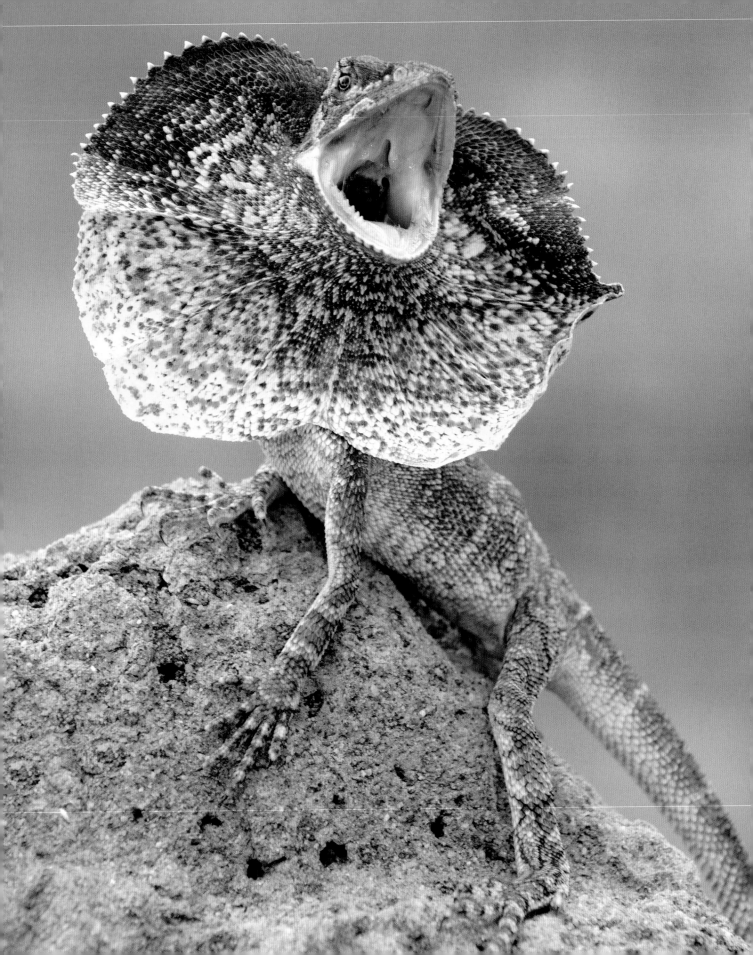

Frilled lizard

SUDDEN, STARTLING RUFF ERECTION

Reptiles use various expanded parts of their bodies for display, such as throat flaps, splayed toes and colourful tails. Relative to its body size, the frilled lizard (frilled dragon) has perhaps the largest showing-off surface of any reptile. At the slightest problem, the wide, ruff-like frill of skin around its neck almost instantly fans out. Coupled with a gaping mouth, hisses and animated 'dancing', by the time a predator recovers from the alarming sight the lizard has usually fled.

The frilled lizard is something of an evolutionary oddity. Its closest relations – which are not that close – are bearded, water and forest dragons in the group Amphibolurinae. When on the ground, 'frilly's' first line of defence is to race away almost upright on its rear legs to the nearest tree; the species is mostly arboreal. Or it may sneak under vegetation and become completely still, hoping to remain unnoticed.

GRAPHIC COLORATION
If these tactics fail, the frilled lizard swings around to face the aggressor and flicks open its wide neck flap or ruff. This is brightly coloured in complex graphic patterns of reds, oranges and yellows, with scattered dark spots, and is a sizeable scary sight compared to its relatively smaller owner. The lizard may also stand erect, lift and swish its tail, hop from foot to foot, leap about, hiss, and in particular, open its mouth expansively, so the pink and yellow lining and rows of small yet sharp teeth contrast with the frill. The sudden changes in the lizard's appearance and behaviour aim to surprise the assailant and buy a precious few seconds to escape.

- LOCAL COMMON NAMES
'Frilly', Frilled dragon, Frill-necked monitor/lizard/dragon, Frilled agama, Ruff-necked dragon/lizard, Cloaked dragon/lizard; Leliyn (local Jawoyn aboriginal language); Kragenechse (German)

- SCIENTIFIC NAME
Chlamydosaurus kingii

- SIZE
Male head-body length up to 40cm (16in), tail similar length, female slightly smaller

- HABITATS
Woodlands, forests, bush with trees

- DIET
Mostly arboreal (tree-dwelling) insects, spiders, small reptiles, birds, mammals

- CONSERVATION STATUS
IUCN Least concern
(see key, page 9)

◀ 'Frilly's' startle or deimatic display resembles the abrupt opening of an unexpectedly colourful, garish umbrella. Long, slim, spine-like rods of cartilage worked by throat muscles hold out the stretchy skin.

▶ In relaxed mode, the frilled lizard's neck ruff hangs loosely over the shoulders and front body. This slim, agile reptile can also race away at remarkable speed and easily dart up a nearby tree.

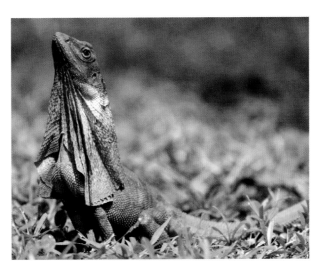

JAW EXTENSIONS
The loose, elastic skin of the frill is usually contracted neatly along the shoulders and sides of the body, resembling a shawl or cape, with its colours hidden. To fan the frill, the lizard opens its jaws wide and contracts muscles in its chin and throat area. These cause several long, slim rods of cartilage (gristle) called ceratobranchials and ceratohyals, associated with the jaw, to swing out and up. Like the ribs of an umbrella, these supporting rods stretch the frill skin and spread it outwards, forwards and upwards.

Superb lyrebird

MIMIC SUPREME

One of the world's premier display artists, the male superb lyrebird couples his vivid, vigorous, tail-highlighting visual performance with some of the most varied songs, calls and sounds in the entire bird world. Oddly, the closest cousins of the two lyrebird species – the other being Albert's lyrebird – could hardly be more different. They are scrub-birds: also Australian but small, shy, and anonymous in their drab camouflaged plumage.

The lyrebird is named from its two long, outer, gently S-shaped tail plumes that recall the harp-like musical instrument, the lyre. The male or cock usually claims a patch of forest as his territory. Here he clears several areas and builds mounds of scraped-together loose soil, twigs, leaves and other debris. He chases away rival males with great passion, and he also stages his spectacular show for nearby females. He spreads or fans out sideways his long tail feathers, shakes them noisily, flaps his wings, cranes his head and neck forwards, hops, stamps and struts.

SONG AND DANCE ROUTINE
The male accompanies each section of his visual display with an amazing range of vocalizations. These include his own 'personalized' version of the typical lyrebird refrains such as clicks, whistles and shrill tweets. But he also copies or mimics the calls and songs of many other birds, as well as sounds from varied other animals, and even noises from mechanical devices such as vehicle engines and chainsaws. Up to three-quarters of his vocal repertoire is borrowed from these other sources.

- **LOCAL COMMON NAMES**
 Superior lyrebird; Weringerong, Bull'n-bull'n, Woorayl (local Aboriginal languages); Ménure superbe (French); Graurücken-leierschwanz (German)

- **SCIENTIFIC NAME**
 Menura novaehollandiae

- **SIZE**
 Male bill to rear body up to 100cm (39in), plus tail of up to 75cm (29in); female 10–20% smaller with reduced tail

- **HABITATS**
 Forests and woods, usually rainforests or moist woods

- **DIET**
 Insects, worms and similar small invertebrates, also some seeds, fruits and other plant matter

- **CONSERVATION STATUS**
 IUCN Least concern (see key, page 9)

EXPERT MIMIC
Lyrebirds are famed for their vocal mimicry. Not only do they copy other birds, such as the raucous laughter of kookaburras and the chiming dings of bellbirds. They also impersonate human conversation and non-natural sounds, from aircraft, helicopters and trucks to engines, alarms, drills, hammers and saws. It seems females are attracted to males with the widest, most precise range of copycat vocalizations, an example of the evolutionary trait known as sexual selection (see page 8).

▶▶ A male fans his tail to show the two brown-buff outer feathers, the lyrates, and the delicate, lace-like tracery of the fourteen feathers between, as he vocalizes with amazingly skilled mimicry.

▶ During his performance, and also after mating, the male lyrebird may present his rear to the female and stalk slowly towards her.

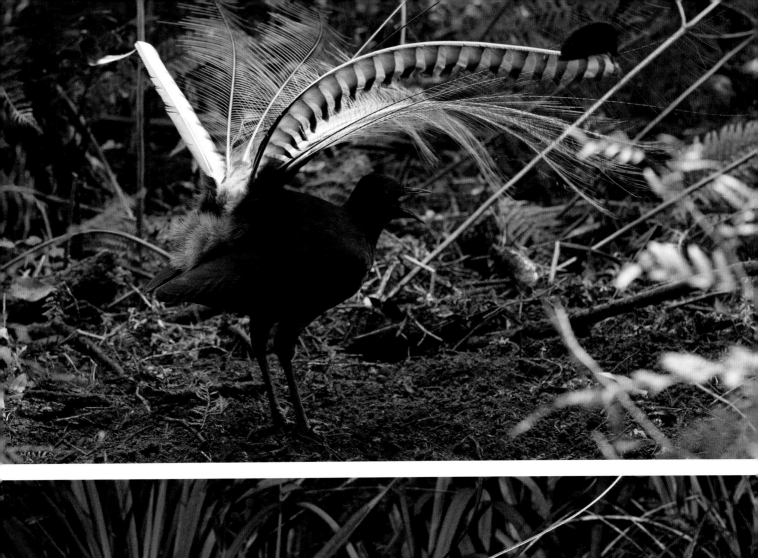
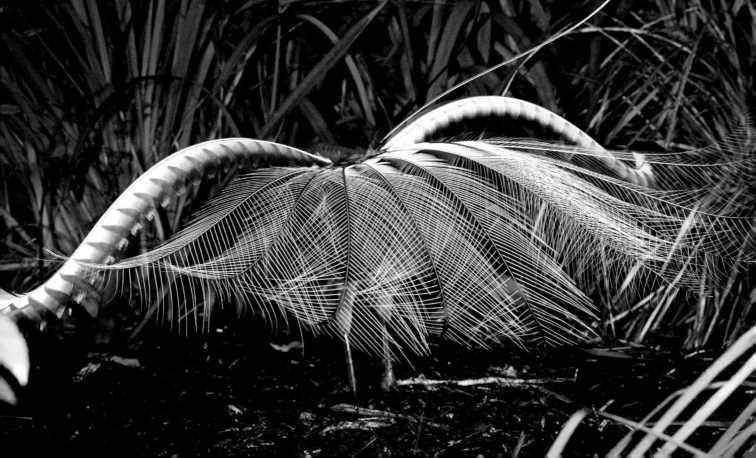

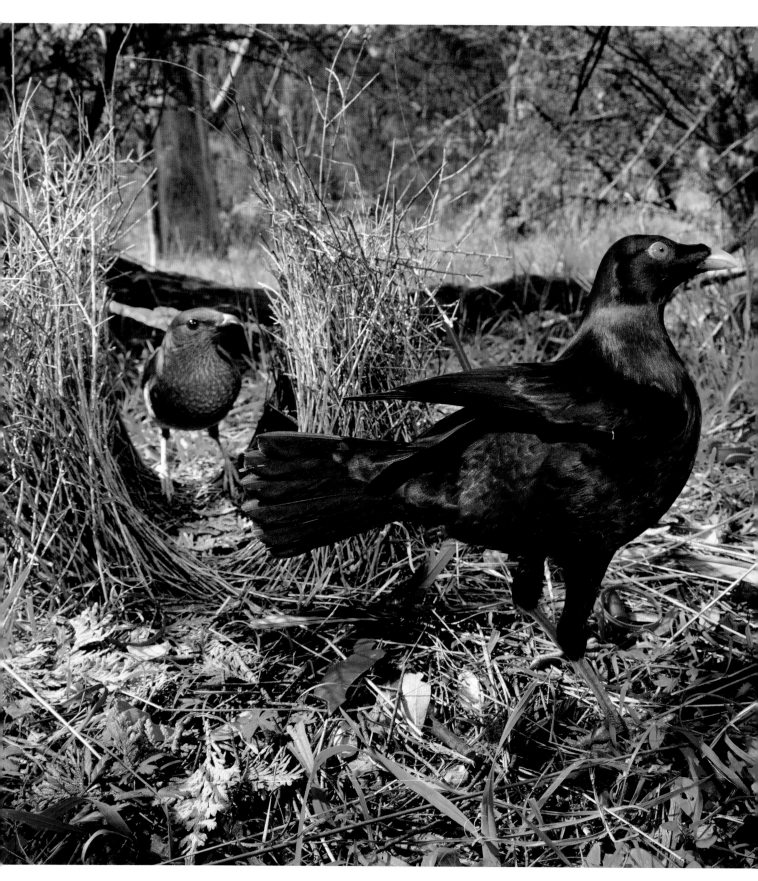

Satin bowerbird

LEADING ANIMAL ARCHITECT

Various birds are renowned for skilfully building large, complex nests. The male satin bowerbird is not, since nesting and chick-rearing are exclusively female tasks. But he does construct a 'bower' – a distinctive and specialized creation designed to entice the female into courtship and mating. The bower is composed mainly of twigs, grasses, shoots and stems, and adorned with all manner of brightly coloured decorative items which often match his striking, glossy, blue-black plumage.

Female and younger male satin bowerbirds look very different to the gleaming, silky, deeply-hued mature male. They are greenish with small, pale scallop markings on the chin and chest, and greenish-brown wings. Only when males reach about five years of age do they moult towards the adult plumage, which fully develops by age seven.

ENTICING AVENUE
The male busily assembles forest floor material into an edifice with a U-shaped channel or avenue through the centre. He then collects brightly coloured items and scatters them on and around this bower. Feathers, flowers, berries, stones, shells and all manner of similar natural objects are utilized. Depending on where he lives, he may also gather discarded litter like straws, plastic wrappings, bottle tops, ballpoint pen caps and similar trinkets.

As the male ages, he develops a preference for more blue items, perhaps to complement his blue-back sheen. He also hops and dances in an energetic manner which resembles his defensive display against predators. Females visit a selection of bowers and choose a male based on his bower construction, decoration and dancing ability.

DISTRIBUTION MAP

- LOCAL COMMON NAMES
 Satin bird; Jirguluhm, Wamban, Guda-balumbaa, Warrgandala, Lo-Ritj (Aboriginal languages and dialects); Pergolero satinado (Spanish)

- SCIENTIFIC NAME
 Ptilonorhynchus violaceus

- SIZE
 Bill-tail length 30–35cm (12–14in)

- HABITATS
 Predominantly moist or wet forests, woodlands and thick, shrubby bush

- DIET
 Fruits, seeds, blossom, leaves, other plant material, occasionally insects and similar small creatures

- CONSERVATION STATUS
 IUCN Least concern (see key, page 9)

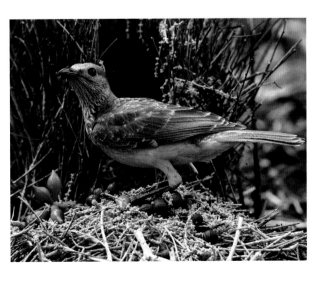

◄ This male satin bowerbird has gathered a selection of bright blue litter items such as plastic seals and wrappers. A female has arrived in the central avenue to assess both the male and his construction skills.

▶ The fawn-breasted bowerbird or tervinya, *Chlamydera cerviniventris*, is found in New Guinea and the far north-east of Australia. Like the satin species it builds an avenue-type bower but its preferred decorative colours are shades of green.

EXTENDED ATTRACTION
There are about twenty-eight species of bowerbirds in Australia and Papua New Guinea. Their close relations are birds of paradise. The latter are highly colourful, decorative and animated, but only with their own bodies. Bowerbirds have extended the male's display from his physical body, plumage and movements to the accessory feature of the bower. Each species fashions its own design of bower, resembling, for example, a dome, teepee, a carpet of shiny leaves, even a 'maypole' version around a sapling trunk.

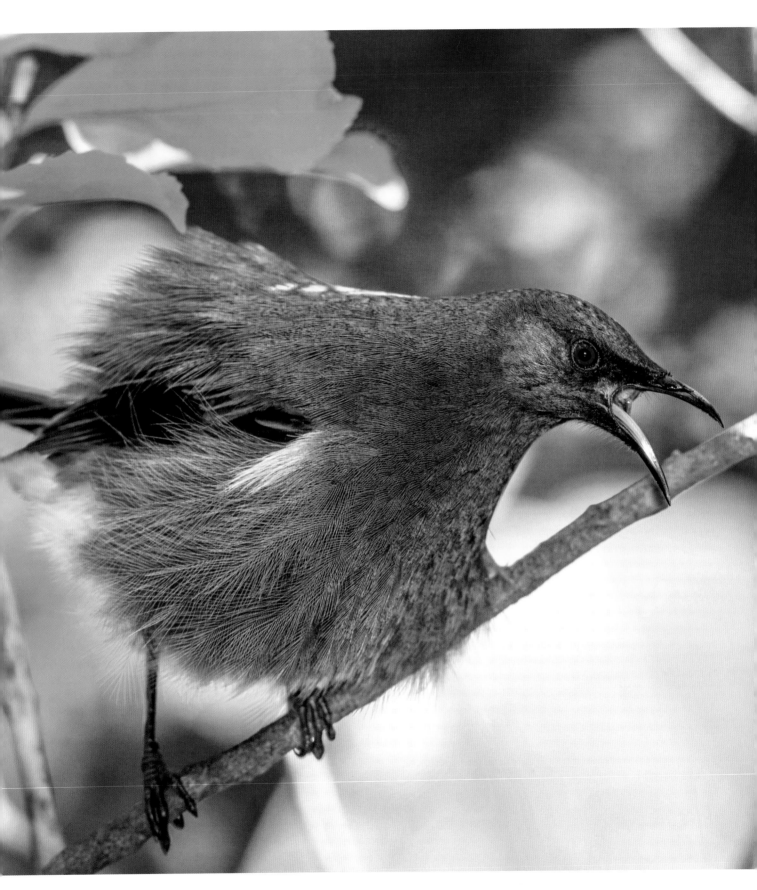

New Zealand bellbird (Korimako)

FAMILIAR FOREST CHIMES

Across much of New Zealand, an iconic element of the avian dawn chorus is the chiming song of the native bellbird (korimako or makomako). It usually occurs when several bellbirds gather in an area. Their flute-like ringing, generally three chimes in a row, informs of their whereabouts. During the breeding season, these birds become fiercely territorial nest-guarders, with the male, in particular, putting on an aggressive 'puff' display accompanied by harsh, staccato, rattling 'yeng-yeng' or 'k'heg k'heng'.

New Zealand bellbirds pair from about September and establish a nest site they have probably used for several years. The nest is a loose affair of twigs, stems and grasses with a soft lining of feathers, mosses and slender stems, in thick vegetation or tree foliage. The female incubates the eggs, usually three or four, then both parents feed the chicks.

READY FOR COMBAT

During this time the male bellbird is especially confrontational with any intruders into the territory, and particularly near the nest. He fluffs up and out his fine-vaned yellow-green chest and body feathers, calls loudly, faces the aggressor, and darts and jabs forward his head and bill, ready to fight. The female has been observed to feign injury, and fall flapping from the nest in an ungainly manner onto lower branches or the ground, as she tries to lure away a marauder.

With European arrivals, predators of bellbird eggs, chicks and even adults became much more numerous, including rats, cats, stoats and weasels. The species' numbers declined drastically, but in recent decades they have adapted to changed habitats and are now becoming widespread again.

- **LOCAL COMMON NAMES**
 Anthornis bellbird; Korimako, Makomako, Titimako, Rearea (various Māori languages); Méliphage carillonneur (French); Maoribelhoningvogel (Dutch); Miodożer szmaragdowy (Polish); Nyu-ji-randomitsusui (Japanese)

- **SCIENTIFIC NAME**
 Anthornis melanura

- **SIZE**
 Bill-tail length 18–23cm (7–9in), males slightly larger

- **HABITATS**
 Woods, forests, thick scrub, also certain kinds of farmland, tree plantations, parks, gardens

- **DIET**
 Omnivore, in summer predominantly nectar, plus fruits, berries, blossom, buds, in winter some insects and similar small invertebrates

- **CONSERVATION STATUS**
 IUCN Least concern (see key, page 9)

◄ The male bellbird is distinguished by the purple sheen on his cheeks and chin. When singing he arches his back, thrusts his head forwards, and raises his plumage to resemble a combined cloak and apron.

► A young bellbird, tongue extended, practises its repertoire as it begins to establish its own area.

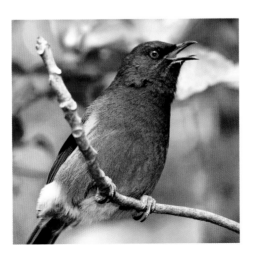

MUSICAL WELCOME

Early European visitors to visit New Zealand were most struck by the flute-like chiming calls of bellbirds, which were very different to bird songs back at home. On the 1770 voyage of Captain James Cook and crew in the *Endeavour*, at Queen Charlotte Sound the expedition naturalist Joseph Banks wrote: '[Bellbirds] made, perhaps, the most melodious wild music I have ever heard, almost imitating small bells, but with the most tunable silver imaginable...'

Eastern grey kangaroo

FIGHT FOR ALPHA STATUS

The eastern grey male is a powerful, well-muscled animal standing as tall as an adult human. These kangaroos live in loose social groups called mobs, numbering from three or four to more than a dozen. A typical mob has one dominant or alpha male – the 'boomer', 'boss man' or 'old man' who assumes mating rights; also a few junior males, and several females with young. Mob members regularly come and go... and this is when the 'old man' may have to display and fight to hold his position.

Far from colourful show-offs, Eastern grey kangaroos are drab, generally relaxed and mostly peaceable. But when breeding time approaches in spring, the dominant male in each mob must exert his authority in order to be first choice as father for the females. One of the mob's junior males may decide it is time to challenge, or a maturing male may arrive from elsewhere.

BOXING AND KICK-BOXING
A challenge involves the two males squaring up to assess each other's size, strength and agility. If neither backs away, the physical contest begins.

Males have a variety of moves. They punch, box or spar with their front long-clawed paws. They may lean back on the tail and kick out or kick-box with one huge clawed rear foot, or even both feet simultaneously, perhaps while hanging onto the opponent's neck with their arms. They also spit, bite and slap the other's face with their front paws, while all the time rocking rearwards and holding the head back to avoid injury. Occasionally serious wounds result. One or even both contestants may retreat; in the latter case, another male may move in and assume alpha status.

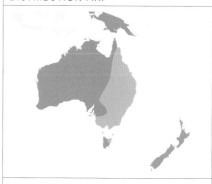

DISTRIBUTION MAP

- **LOCAL COMMON NAMES**
 Great grey Kangaroo, Scrub kangaroo, Forester; Iyirrbir, Iyirrpir, Kucha (regional Aboriginal names); Gangarru (Aboriginal name also applied to similar animals); Kangourou géant (original French name)

- **SCIENTIFIC NAME**
 Macropus giganteus

- **SIZE**
 Large male: head-body length 1.4m (4 2/3 ft), tail 1m (3 1/4 ft), standing height 1.8m (6ft), weight up to 70kg (154lb); females about 20–30% smaller

- **HABITATS**
 Very adaptable, from dry scrub, grassy bush and semi-desert to woods, forests

- **DIET**
 Plants, mainly grasses and low vegetation, some fungi

- **CONSERVATION STATUS**
 IUCN Least concern
 (see key, page 9)

EAST MEETS WEST
The second-largest marsupial after the red kangaroo, the eastern grey ranges along the eastern third of Australia, including Tasmania. Its close cousin the Western grey lives along the southern quarter of the continent. The two were recognized as distinct species in 1817: after studying captive Western individuals in the Ménagerie du Jardin des Plantes in Paris, France, zoologist Anselme Gaëtan Desmarest formally distinguished and named the Western species as *Macropus fuliginosus*, the Eastern species having been named in 1790.

▶ Forepaw prods, slaps and punches, and the trademark double-kickbox with both rear feet, are some of the manoeuvres males employ to establish dominance. Both sexes also use these fighting tactics against their very few predators, mainly dingoes and humans.

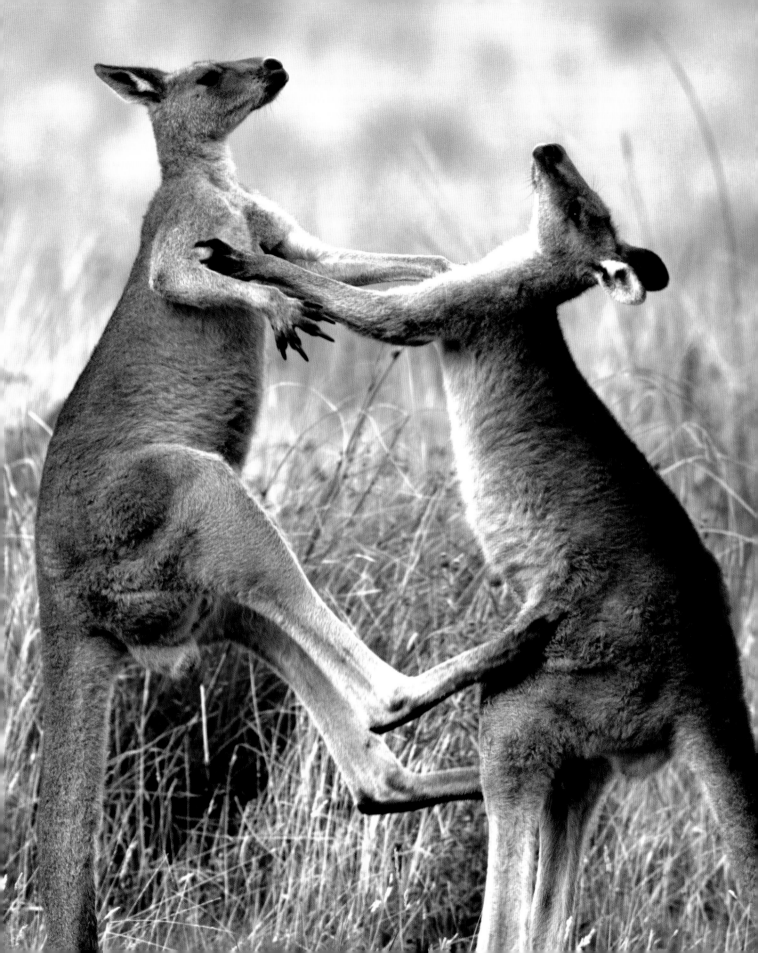

Grey-headed flying fox

AIRBORNE ANGRY MOB

Airborne mobbing is a well-known behaviour among birds and also bats. Many individuals rush near to, dash past, dive at, and generally harass a flying predator, usually a raptor (bird of prey) such as a hawk, falcon or eagle, or large owl. Grey-headed flying foxes may show this behaviour if such an aggressor approaches their daytime resting place. And their mobbing numbers may be in the hundreds, even thousands.

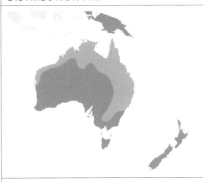

DISTRIBUTION MAP

Grey-headed flying foxes rest or roost during daylight in locations known as camps. These are usually groups of large trees in traditional places that have been in use for decades. At breeding time, a male and the females he has attracted claim, scent-mark and defend a territory, that is, a length of branch. This ensures the males with their harems are spaced out.

At dusk the bats begin to emerge from their camp and fly off in order to forage during darkness. They may travel more than 50 kilometres (30 miles) to a rich food source. Females with young usually leave the camp first, followed by youngsters able to fly, then bachelor males without partners, and finally higher-status males.

REDUCED CHANCE OF SUCCESS
However, the presence of an avian predator can delay their emergence. If the predator approaches the camp, many bats suddenly take to the air and rush at it, mobbing and calling with a variety of shrieks, squeals and screeches. The predator's chance of surprise attack by suddenly snatching a bat, either from its branch or as it takes off, or perhaps trying to single out one victim from the rushing, whirring confusion of mobbers, are drastically reduced. It usually leaves the area.

- **LOCAL COMMON NAMES**
 Grey-headed fruit bat; Zorro volador de cabeza gris (Spanish)

- **SCIENTIFIC NAME**
 Pteropus poliocephalus

- **SIZE**
 Head-body length 25–30cm (10–12in), wingspan up to 100cm (39in), weight 700–800g (25–28oz)

- **HABITATS**
 Forests, woodlands, wetlands, coastal mangroves, fruit and farm plantations, parks and urban landscapes

- **DIET**
 Nectar, pollen, flowers, fruits, leaves, some insects and similar invertebrates

- **CONSERVATION STATUS**
 IUCN Vulnerable, numbers decreasing (see key, page 9)

IN NEED OF CONSERVATION
Grey-headed flying foxes were once numerous and widespread, with populations in millions. Recent surveys suggest there are now fewer than half a million, and losses continue. The bats' camp sites are reduced due to habitat change, and near human habitation are perceived as a noise, hygiene and disease risk. They are unwelcome in orchards and plantations. Increased risks of drought, heatwaves and wildfires due to climate change are further perils. Recent legislation aims to protect the bats and some of their camp locations.

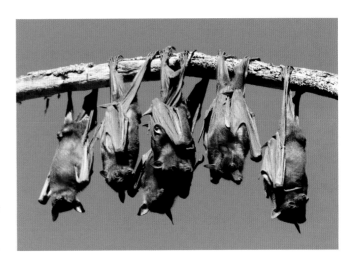

◄ Usually resting at their roosts during daylight, flying foxes take to the air in mass numbers to mob a winged hunter such as a sea eagle.

► Roosting bats gather together more closely out of the breeding season.

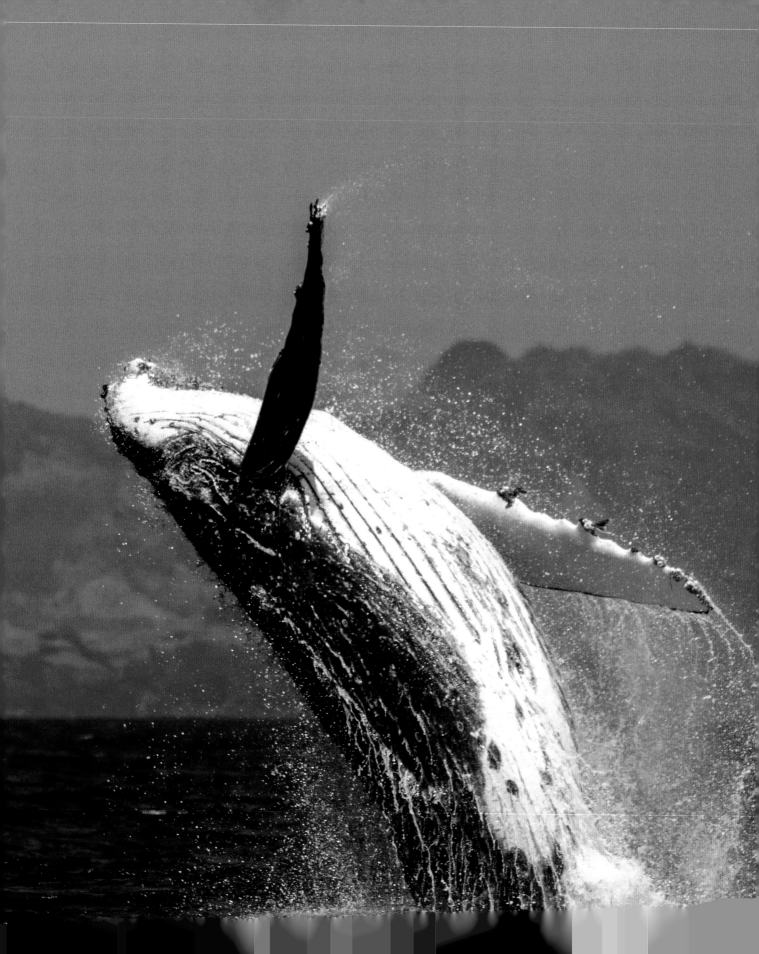

7

Islands, Seas and Oceans

Strawberry seaslug

A MUTUAL MATING OF GIVE AND TAKE

Land slugs are a generally dull group, well camouflaged as they silently slime around woods and similar habitats, scraping up plant material with their rasp-like radulas (tongues). Seaslugs are very different. There are few more vivid examples in nature of such dazzlingly bright warning, or aposematic, coloration. The entire creature is a living, slithering display of distasteful, poisonous, even deadly flesh, containing toxins absorbed and concentrated from its food.

Seaslugs, also called nudibranchs, are marine equivalents of terrestrial slugs and snails, although they belong to a different group within the main slug-and-snail assemblage, the gastropods. Like most of their relations, seaslugs are hermaphrodites. Each individual possesses both sets of breeding parts, with a duct-like female genital opening or vagina and an extending, phallus-shaped male penis.

TWO-WAY MATES

Seaslug mating is a two-way affair. Each inserts its penis into the other's vagina. But before this are identity checks where each individual makes sure the other belongs to the same species. This is partly by means of waterborne scent chemicals emanating from the seaslug's body and detected by the other individual's rhinophores, which resemble tentacles on the head end. The two may also circle each other, then slime against each other in a tactile embrace. In some species each touches and prods the other with its penis. If the partner responds with the same move, the mating pair seem as if they are in a penis-fencing 'swordfight'.

- LOCAL COMMON NAMES
 Neon seaslug, Golden seaslug/nudibranch; 'Nudey' (nickname for the general nudibranch group) Erdbeerschnecke, Neonsternschnecke (German)

- SCIENTIFIC NAME
 Gymnodoris aurita

- SIZE
 Occasionally exceeds 10cm (4in)

- HABITATS
 Reefs, seabed rubble, rocky shallows

- DIET
 Mostly small animal life such as sponges, coral animals, anemones, sea-squirts, worms, shellfish

- CONSERVATION STATUS
 IUCN Not assessed
 (see key, page 9)

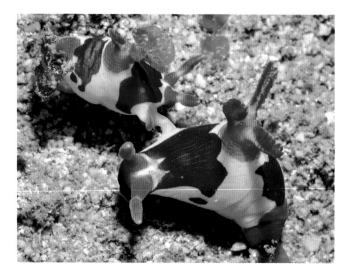

DISPOSABLE ORGAN

A recent discovery shows that the red-and-white seaslug, *Chromodoris (Goniobranchus) reticulata*, has an added twist to an already remarkable mating system. About 10–15 minutes after a pair's mutual penis insertion, the penis of each individual detaches, is discarded, and floats away. The pair separate, having exchanged sperm. Yet some 24 hours later each has regrown its penis and is ready to breed again, as a reconstituted, female-and-male hermaphroditic individual.

◄ Two Chamberlain's seaslugs, *Nembrotha chamberlaini*, prepare to phallus-fence and mate, the female genital aperture being on the right side of the body. The pale red head protrusions are sensory rhinophores.

► Strawberry seaslugs engage in reciprocal mating, each passing male sperm into the other's female genital opening. The large flower-like frills on the back are gills to obtain oxygen from sea water.

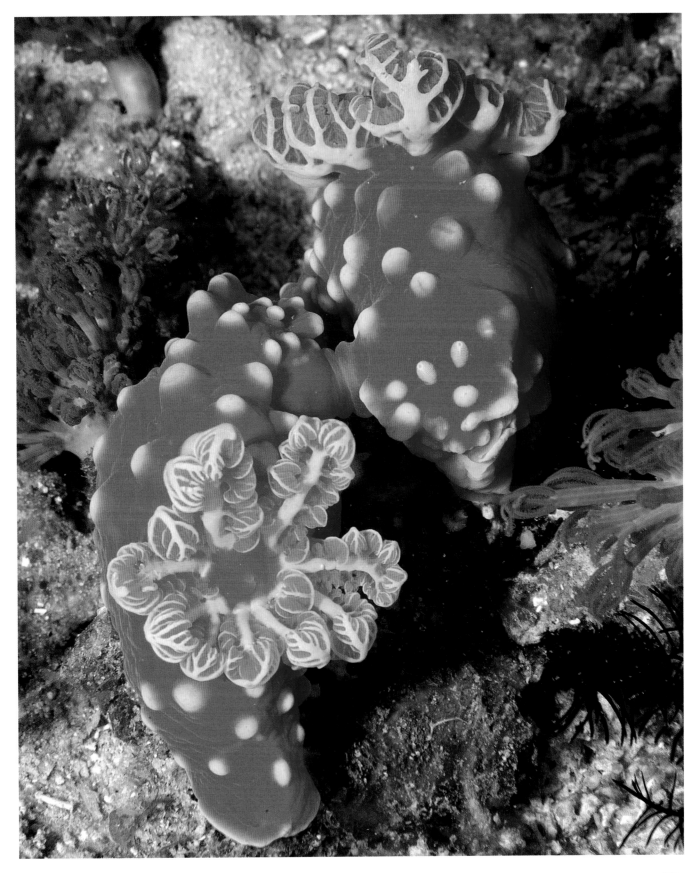

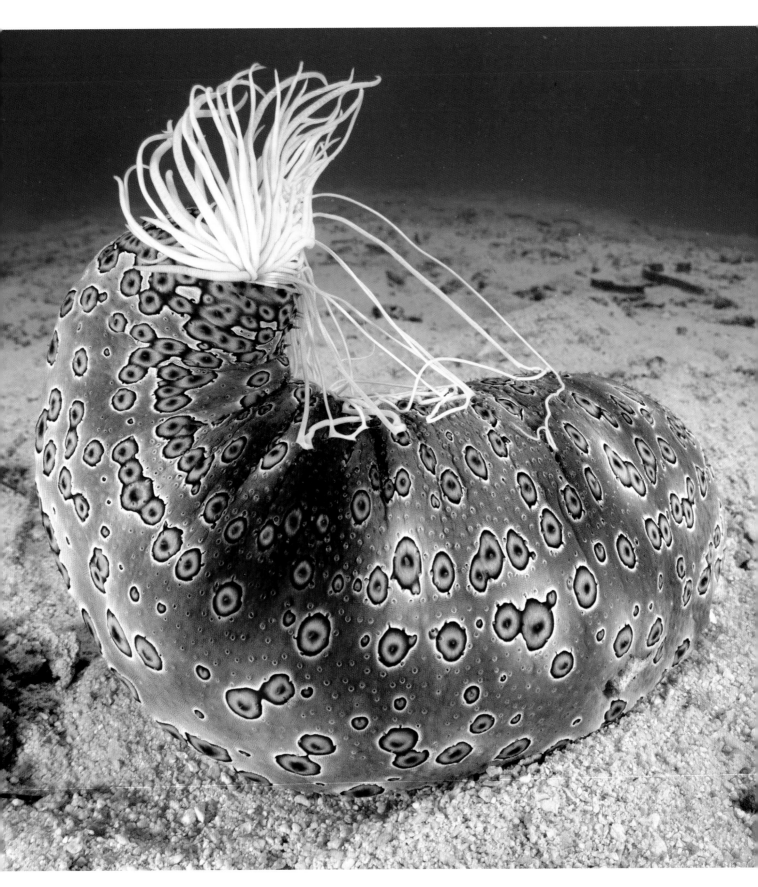

Leopard sea cucumber

UNPLEASANT DETERRENT

Sea cucumbers resemble inoffensive sausages as they crawl along the seabed on waving rows of small, flexible, finger-like tube feet. The tentacles around the mouth gather debris, sand and mud into the mouth, then the digestive system extracts any edible, nutritional bits and pieces, similar to the ecological role of earthworms. But a molested sea cucumber is very able to defend itself – by ejecting and displaying a horrible mass of exceptionally sticky, string-like, toxin-coated tubes from its rear end.

The sea cucumber's gut tube at its rear end widens into a chamber, the cloaca, into which the reproductive parts also open. The cloaca then opens to the outside through a closeable aperture, the anus. Uniquely in sea cucumbers, also attached to the cloaca is a pair of branching structures called respiratory trees. Rather like internal gills, these absorb oxygen from sea water that flows in and out. Again uniquely in sea cucumbers, associated with the left respiratory tree is a bundled mass of threads known as Cuvierian tubules. These are the creature's secret weapon.

EJECTED THREADS

When threatened, the sea cucumber tenses its body to eject the tubules through its anus, and perhaps also through a special, easily 'torn' opening from the cloaca through the body wall directly to the outside. The ejected tubules quickly absorb water and expand in length twenty times or more. Their incredibly adhesive surfaces, which also bear toxins known as holothurins, stick to and wrap around anything nearby in a stubborn tangle. Most predators who experience this defence learn in the future to leave such animals well alone.

- LOCAL COMMON NAMES
 Spotted fish/sea cucumber, Leopard fish/sea cucumber, Tiger fish/sea cucumber, Ocellated sea cucumber; Ñoät da traên, Sâm Vàng (Vietnamese); Balat, Matang itik (Filipino dialects); Nool attai (Indian languages); various names are applied to sea cucumbers harvested for food, such as Trepang, Teripang, Balate, Namako, Bêche-de-mer

- SCIENTIFIC NAME
 Bohadschia argus

- SIZE
 Length up to 60cm (24in)

- HABITATS
 Shallow reefs, lagoons, estuaries, sandy and rubble-strewn seabeds, rarely below 50m (160ft)

- DIET
 Edible particles in sand, silt, mud

- CONSERVATION STATUS
 IUCN Least concern
 (see key, page 9)

◄ A leopard sea cucumber squirts a mass of sticky, mucous, filamentous threads known as Cuvierian tubules out of its anus. The animal's pattern of spots are a warning to predators that the threads can easily ensnare and also poison them.

▶ The defensive filaments of this aureolated sea cucumber, *Holothuria sanctori*, are ready to entangle, irritate and perhaps exterminate an enemy. The bright body pattern is a warning to aggressors.

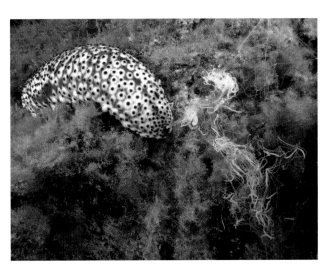

FISHY GUESTS

Sea cucumbers and their relatives in the echinoderm group, starfish and sea urchins, are sometimes hosts to a small fish living inside them. One species is the star pearlfish, *Carapus mourlani*. It enters the body cavity of the sea cucumber through the anus and shelters within by day. At night it emerges to feed on smaller fish, worms and shellfish, then retreats into its host again. The pearlfish is very slim but may be half the length of its host.

Big blue octopus

FLEXIBLE STALKER OF THE REEF

Most octopuses are carnivores, hunting prey such as shellfish and fish. And most of them do this during darkness. The 'big blue', though, is out and about in daylight, stalking prey usually during the early morning and early evening, hence its common name of day octopus. It is a fast, agile, shape-shifting, colour-changing adversary. When two individuals meet for mating purposes, or to establish territorial dominance, or even for one to eat the other (cannibalism), all kinds of displays and actions can ensue.

Like many of its cephalopod cousins, such as squid and cuttlefish (see next page), the big blue octopus can change its appearance from very pale all over, to almost plain black, to virtually any pattern and shade between. Darker camouflage colours tend to predominate as the octopus stalks among the reef shadows, using its keen eyesight to spot likely prey. When two big blues meet, they tend to pulse in lighter hues, depending on their mood and intentions.

PASSING CLOUDS

One of the big blue's particular visual displays is known as the 'passing cloud'. Its skin colour cells, chromatophores, change in an instant to make several vague, dusky, irregular, cloud-like shapes pass across its head and main body and out towards the arms. The shape and darkness of the 'clouds' is enhanced by their pale edges (as in 'every cloud has a silver lining').

The passing cloud display often occurs as a form of moving shadow camouflage when the octopus sees a possible meal, such as a crab. The colour and movement may lull the victim into not spotting the danger. The octopus then overpowers its prey and toxic saliva from its bite renders the crab helpless.

A DANGEROUS GAME

Like certain spiders, praying mantids and other animals, the male big blue octopus may fall victim to sexual cannibalism. After a pair mate, if the female is much larger and also hungry, she may consider the male a convenient meal. In one sense this helps to further the species. The male will die naturally anyway soon after mating. The female gains a large nutritious meal to help her lay and guard her eggs – although she also dies naturally after that, and may never see her hatched young (see page 184).

▶▶ Two octopuses confront each other, intertwine arms and test the other's strength. It may be a dispute over a hunting area, or concerning sole ownership of a nearby desirable den or lair for hiding and resting.

▶ A larger female octopus (left) examines the smaller male (right), possibly as a prelude to mating. Her small eyes are in the topmost head ridges, with her main body opening and yellow funnel or siphon just below, which squirts out water for movement.

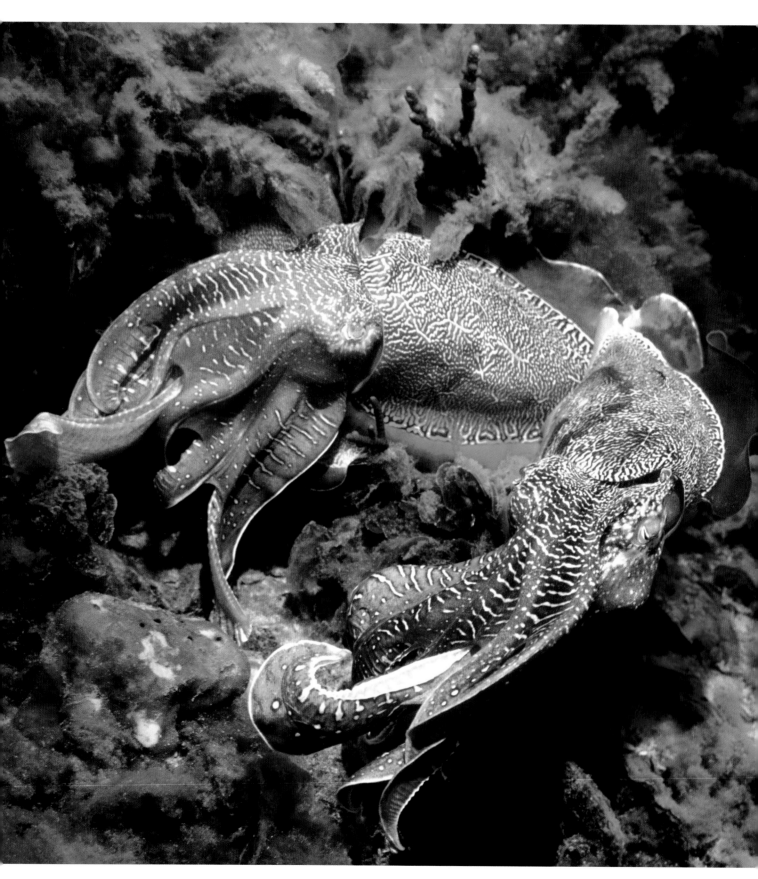

Giant cuttlefish

EVER-CHANGING EXHIBITION

It's often said that not only do two cuttlefish of the same species never look the same, but that a single individual never looks the same from one minute or even second to the next. For a multitude of reasons, including camouflage, angry self-defence, dominance disputes and mating desirability, these supreme quick-change artists drastically change their appearance in three main ways: skin colour and pattern, skin and flesh textures and undulations, and overall body shape.

Like octopuses and squid, cuttlefish belong to the mollusc group known as cephalopods, 'head-feet'. At the head end, arranged around the mouth, are eight shorter arms, and also two longer prey-grabbing tentacles, although these are usually withdrawn and shrouded by the arms. The giant cuttlefish is well named, being usually described as the largest of the whole cuttle group.

A cephalopod's remarkable ability to change colour is based on skin chromatophores and iridophores, as described below (see also page 210). Cuttlefish and octopuses also have microscopic structures called leucophores that brightly reflect whatever light shines onto them, providing contrast with the other two systems.

PUCKERED UP
Giant cuttlefish pulse and flash their colours to intimidate rivals and attract mates. Two males may have colour competitions to see which can produce the fastest, most dazzling effects. They can also pucker and crease their skin into lumps, ridges and furrows, using muscles that contract certain patches of skin and also push and redistribute body fluids beneath it.

DISTRIBUTION MAP

- LOCAL COMMON NAMES
 Giant Australian cuttlefish; Sepia gigante australiana (Spanish); Seiche géante australienne (French , French Polynesian)

- SCIENTIFIC NAME
 Sepia apama

- SIZE
 Head and mantle (main body) length may exceed 50cm (20in), weight 10kg (22lb) or more

- HABITATS
 Head and mantle (main body) length may exceed 50cm (20in), weight 10kg (22lb) or more

- DIET
 Fish, shrimps, crabs and other shellfish, occasionally smaller cuttlefish and squid

- CONSERVATION STATUS
 IUCN Near threatened
 (see key, page 9)

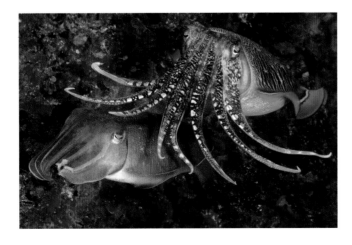

◄ Giant cuttlefish congregate in certain areas to breed, especially Spencer Gulf in South Australia, which is now a specially protected marine reserve. Males parade their extraordinary quick-fire hues and patterns to gain dominance.

► A dominant male pharaoh cuttlefish, *Sepia pharaonis*, prepares to mate with a female. Competition can be intense, with more than ten males to each female in some breeding localities.

QUICK-CHANGE SYSTEM
The cephalopod chromatophore is a microscopic bag or sac of pigments with mini-muscles arranged radially around it, like the spokes of a bicycle wheel. Nerve signals make the muscles shorten, which stretches the pigment sac over a larger area so that its colour is more visible. When expanded, which can happen in a fraction of a second, a pigment sac may reach one millimetre across. Combinations of different pigment colours produces a vast visual range, rather like the red, green and blue pixels of a TV screen.

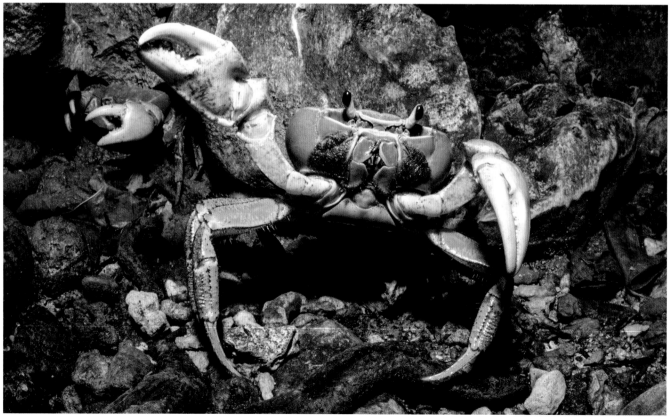

Blue crab

PINCERS AT THE READY

Most crabs have a similar defensive display – and that is a lot of crabs, since the group contains more than 7,000 species. The main action is for the crab to rear up by tilting its head and front body upwards, and hold out and wave its pincers in a threatening manner, ready to grab, seize, pinch and crush any danger. The blue crab is one of the most familiar exponents of this confrontation, partly because of its spread around the world, and partly due to its tastiness.

As well as self defence against their many predators, crabs also employ their pincer show in aggressive or agonistic situations. Reasons include inter-male skirmishes when trying to gain access to females, also when defending a rich food source against others, and when fighting over the best burrows, crevices or similar dens where they can rest in safety. Certain crab species compete remotely by simply waving pincers at each other from a distance. Others, including the blue crab, are more direct and readily go straight into hand-to-hand, or pincer-to-pincer combat.

DECLINING NUMBERS

A crab's pincer-based resistance is deployed regularly against a long list of predators that include various sharks, eels, stingrays and other fish, marine turtles, birds such as herons, seals and sea lions – and humans. As with many other marine species, blue crab populations, and consequently fishery catches, have decreased rapidly in many regions. This is especially evident along North American Atlantic coasts, due to over-exploitation, water pollution and general environmental degradation.

DISTRIBUTION MAP

- LOCAL COMMON NAMES
Atlantic blue crab, Common blue crab, Bluepoint, Chesapeake blue crab, Cirrique and similar regional names; Mavi yengeç, Çalpara (Turkish); Blåkrabbe, Blå svømmekrabbe (Danish); Cangrejo azul (Spanish)

- SCIENTIFIC NAME
Callinectes sapidus

- SIZE
Shell width up to 25cm (10in)

- HABITATS
Varied, from rocks and reefs to mud and sand, especially bays, estuaries and even fresh water, rarely below 30m (100ft)

- DIET
Wide-ranging, including fish, shellfish, seasnails, worms, plant matter, general debris and scavenged items, carrion

- CONSERVATION STATUS
IUCN Not assessed
(see key, page 9)

◄◄ A blue crab's pincers can easily give a person a painful nip. This female is presenting her main weapons while also sidling into the water.

◄ The Christmas Island blue crab, *Discoplax celeste*, was recognized as a distinct species within the *Discoplax* group in 2012. These are land crabs that frequent streams, pools, swamps, waterfalls and similar areas with fresh water.

WORLD TRAVELLER

From its original range along the east coasts of North, Central and South America, the adaptable and ecologically flexible blue crab has spread across the Atlantic to Europe, Africa and even as far as Australia. Some of these journeys were probably made by very young, small, larval stages of the crab in sea water that was either taken on or released as ship ballast – weight to keep a vessel stable. Some introductions may have been deliberate, to set up crab fisheries in new zones.

Thorny seahorse

DAILY DANCE CUSTOMS

The forty-plus species of seahorses have remarkable courtship and mating acts. When a pair come together, they begin a long sequence of manoeuvres that tell each other whether the prospective partner is suitable mate material. Many of these actions are ritualized, that is, carried out in a stereotyped way as a set sequence, as though rehearsed many times (see page 8).

Seahorse courtship begins when a pair come close together and their curly tails wrap closely around the same support such as a seaweed stem. Their colours brighten and their bodies shake and quiver, as they repeatedly face each other and then turn away. This usually happens at around daybreak.

Next is the 'pointing' phase. The female leans and stretches forwards to point her mouth at the male, as he leans back and again his body shakes and vibrates. After a pause, the female again takes up her pointing posture. The male may then respond and do the same.

ROCKING SEAHORSES

The pair may rock to and fro, female forwards and male back, then vice versa, either face to face or side by side, colours glowing. They still grip their support. Then they let go, rise upwards in the water and perhaps drop down again. Finally on one of these ascents the two at last mate (engage in the sexual act); then the usual female and male roles reverse (see below).

- LOCAL COMMON NAMES
 Spiny seahorse; Ibara-Tatsu (Japanese); Cá ngựa gai dài (Vietnamese); Kuda Laut Duri, Korek Telinga (Malay); Kabayo-kabayohan (Filipino vernacular)

- SCIENTIFIC NAME
 Hippocampus histrix

- SIZE
 Total length (height) up to 20cm (8in)

- HABITATS
 Beds of seagrass and seaweeds, weedy reefs, usually at depths between 10m and 50m (33ft and 165ft)

- DIET
 Tiny animals, especially the young or larval stages of fish, shellfish

- CONSERVATION STATUS
 IUCN Vulnerable
 (see key, page 9)

WHEN FATHER IS MOTHER
Breeding seahorses adopt role reversal. The female uses her egg-laying outlet, the ovipositor, to place her eggs – perhaps numbering more than 1,000 – into a pocket-like brood pouch on the male's lower front. He releases sperm to fertilize them. The pouch then partly seals and its walls provide nutrients for egg development. The male is, in effect, pregnant. Several weeks later he convulses his body, and baby seahorses squirt out into the ocean to fend for themselves.

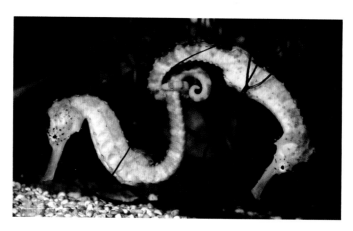

► Thorny seahorse courtship involves several stages of a swaying, quivering 'dance' as their coloration alternately brightens and fades. Their prehensile tails grip the same support or holdfast.

▲ Tiger-tail seahorses, *Hippocampus comes*, link tails as they cavort, lean and twirl. Sadly, like many seahorse species, they face multiple threats, including capture and drying for so-called traditional 'medicines' which are scientifically unproven.

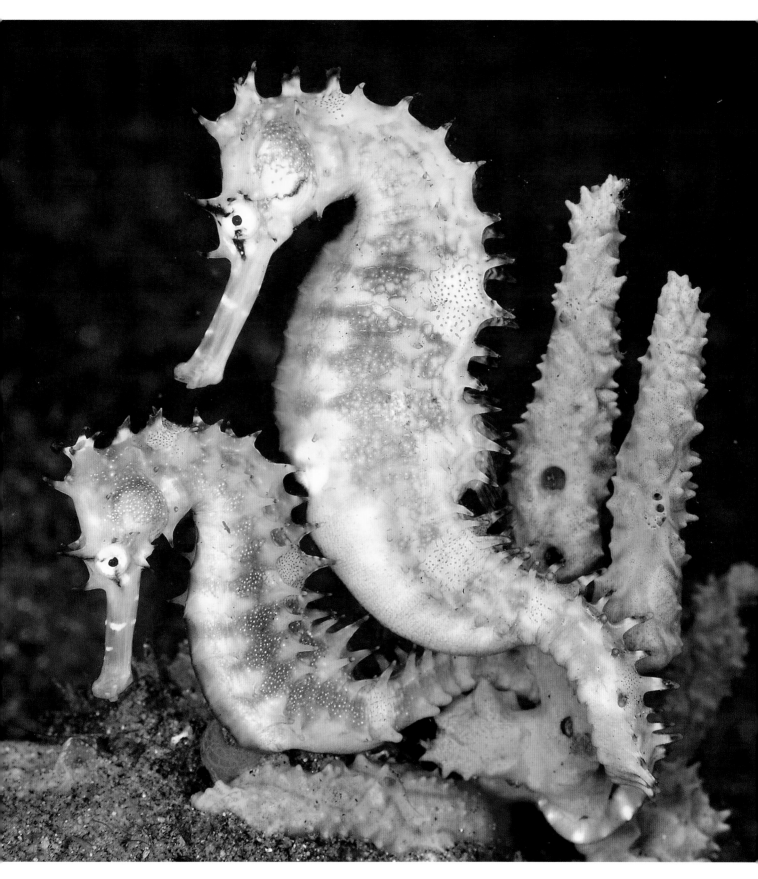

Mandarin fish

'HUMMINGBIRDS' OF THE REEF

Mandarin fish live life at a slow pace and in a low place. They are bottom-dwelling and spend much of the day in dens among the reefs, rocks and rubble of a calm lagoon, emerging at night to feed on small creatures. When foraging, they do not so much swim as crawl along the seabed on enlarged, fan-shaped pelvic fins (the pair below the central body). But for display purposes they rise a metre or two above the bottom, as the males compete with each other, or a male and female undertake a spawning swim.

Mandarin fish are bedecked in dazzling colours arranged in complex patterns of spots, stripes, swirls and almost every other imaginable shape. This all-over permanent display is an example of warning or aposematic coloration. The fish's skin produces thick mucus or slime that contains toxins harmful to the mandarin's predators and other enemies. Once a predator comes into contact with the repellent taste and poison of the mucus, it is very unlikely to repeat the encounter.

SHOW-OFF SPINES
Male mandarins are larger than females and have a tall spine at the front of the dorsal fin on the back. This is erected as a feature during their show of intense rivalry with other males, since in many regions males outnumber females by perhaps ten to one.

The action begins soon after dusk. Males emerge from their hidey-holes, spread fins, parade, bump and shove each other, and perhaps nip or bite their competitors. Often the bigger males are most successful. If a watching female selects one, she and he will rise a metre or so above the bottom, closely side by side, and quiver briefly as they release eggs and sperm into the water.

DISTRIBUTION MAP

- LOCAL COMMON NAMES
 Mandarin dragonet/goby, Striped mandarin/dragonet, Red or green dragonet (depending on variety); Nangka-tangka, Talangka, Bunog (Filipino dialects); Nishiki-teguri (Japanese); Bebaji batik (Malay)

- SCIENTIFIC NAME
 Synchiropus splendidus

- SIZE
 Male length up to 7.5cm (3in), females slightly smaller

- HABITATS
 Coral reefs, rocky and rubble sea beds, lagoons, rarely deeper than 20m (65ft)

- DIET
 Very small creatures such as shrimps and other crustaceans, coral polyps, worms, eggs

- CONSERVATION STATUS
 IUCN Least concern
 (see key, page 9)

SCALES AND JAWS
Mandarin fish are unusual in several ways. Like catfish and a few other groups, they lack scales. They rely on their warning colours and covering of thick, distasteful mucus to combat would-be predators. They also have two sets of jaws: the usual ones in the mouth to seize prey, and powerful, ridged pharyngeal jaws in the throat area. The latter crack and crush shells and other hard coverings of food items, allowing the fish to eat a varied diet.

◀ A pair of mandarin fish prepare to undertake their spawning swim, which lasts only a few seconds. The female releases up to 200 eggs each time.

▶ Two challenging males display their amazing colours and fanned-out fins, with a tall spine at the front of the dorsal fin (on the back behind the head).

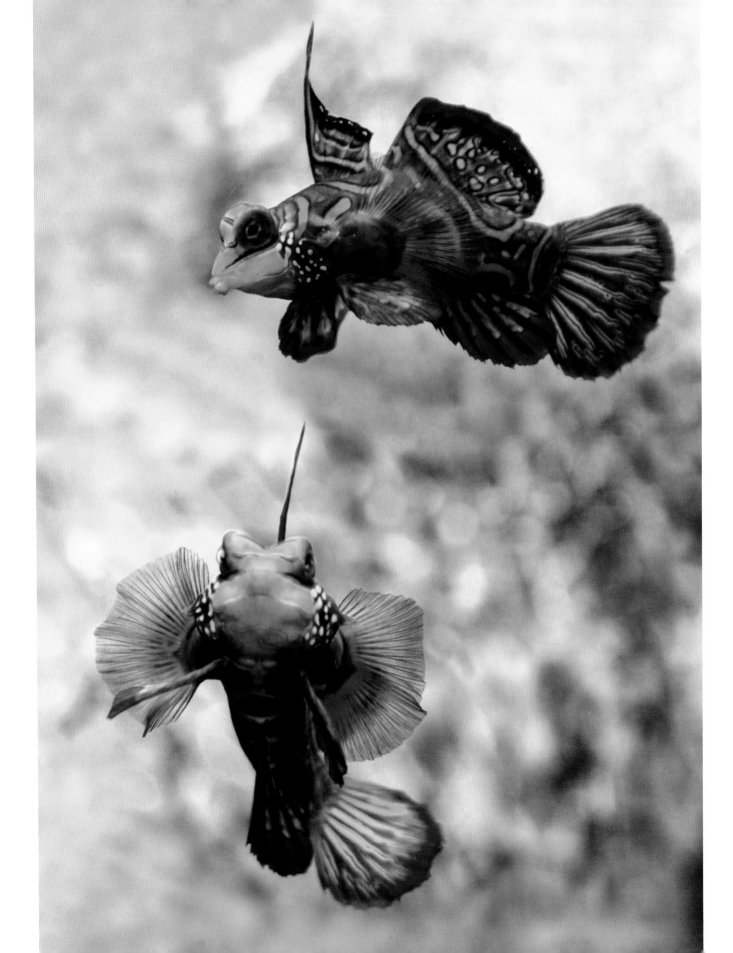

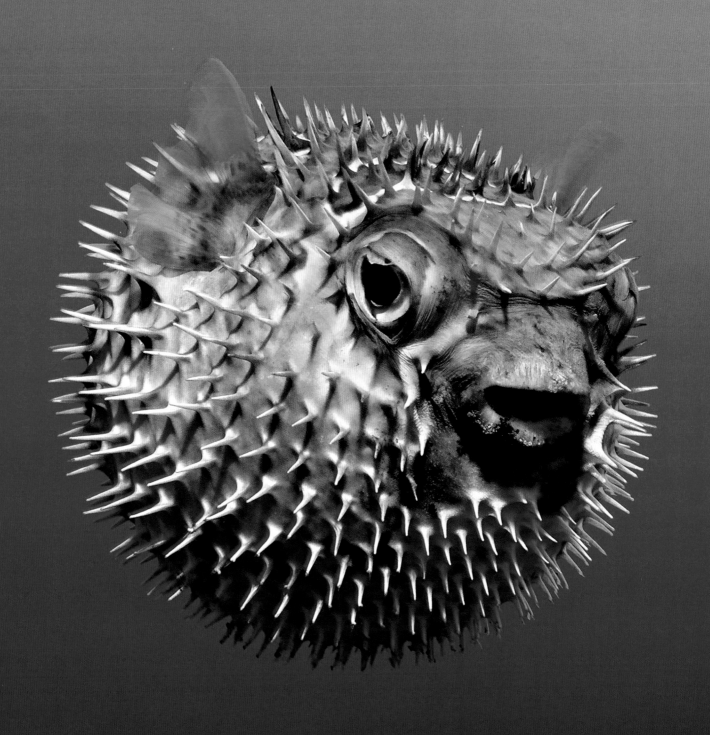

Porcupine fish

SHARP SPIKY SPHERE

Named after the spiky, spiny mammals known as porcupines, porcupine fish have a similar self-defence system. Their tactic is to swallow water when in water, or air when in air, to make their bodies balloon out. This helps to erect their strong, sharp spines so that these point outwards. Very few predators attempt to bite and swallow such a large, spiky, thorny mouthful.

'True' porcupine fish belong to the genus (species group) *Diodon*. The five kinds include the long-spined, black-blotched and slender-spined species. Among their many common names are balloonfish and pufferfish (but see also right).

Diodon porcupine fish have several specialized adaptations to achieve their spiky show. The stomach is very elastic and stretchy, as is the skin. As soon as the fish begins to swallow, the stomach enlarges and presses on the organs around, which cope with the stress, slide and redistribute, and pass the pressure to the expandable skin. In some species the fish swells to three times its normal body volume.

NO EASY ACCESS

The spines of the porcupine fish, which are modified scales, usually lie almost flat against the skin, pointing towards the tail. As the skin stretches, it pulls on the spine bases, which have a tripod-like shape, and tilts each spine upwards at right angles to its surrounding patch of skin. In this way the inflated, globular body is covered with sharp points facing straight outwards. There is no easy way to bite or attack this defence system.

DISTRIBUTION MAP

Black-masked porcupine fish
Diodon liturosus

- **LOCAL COMMON NAMES**
 Many general names including blowfish, balloonfish; names for the various species include Cá nóc nhiêm (Vietnamese); Pez eriso (Spanish); Peixe-ouriço-de-cista (Portuguese); Tauta (Samoan); Hitozura-harisenbon (Japanese); Poisson porc-épic (French)

- **SCIENTIFIC NAME**
 Five species in the genus *Diodon* including Long-spined or Freckled porcupine fish *D. holocanthus*, Black-blotched or Black-masked or Short-spined porcupine fish *D. liturosus*

- **SIZE**
 Length of a typical species *D. liturosus* 60cm (24in)

- **HABITATS**
 Varied, mostly tropical and subtropical, from reefs and lagoons to the open ocean

- **DIET**
 Shellfish, smaller fish, starfish, sea urchins, crabs and similar small creatures

- **CONSERVATION STATUS**
 IUCN Least concern
 (see key, page 9)

◀ A black-masked porcupine fish displays its thorny covering of erected spines sticking out from its inflated, ball-shaped body.

▶ Usually the spines lay against the body, pointing rearwards, as in this long-spined or freckled porcupine fish.

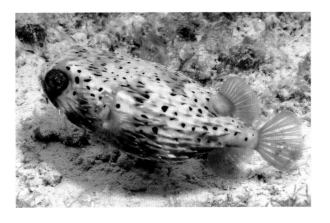

DEADLY PUFFERS

The name 'pufferfish' is applied to several groups of fish that swell or puff up their bodies. Perhaps most famous, or infamous, are the tetraodontids. They have shorter spines than porcupine fish and a different mechanism for deploying them. They are also among the most toxic, deadly creatures on Earth. Their poisons affect most other fish and also many other animals, with one individual containing enough toxin to kill more than twenty humans.

Blue-streaked cleaner wrasse

A VISIT TO THE CLEANERS

Survival in nature doesn't just involve countering predators and other enemies. Some creatures that are very different have helpful relationships which benefit all partners. This is termed mutualism. A fascinating example is the interaction between small fish called cleaners and larger fish who are their clients or customers. The blue-streaked cleaner is one of the most studied. With its distinctive appearance and display 'dance', it is safe from a client that could easily devour it in one gulp.

Cleaner fish are so called since they 'clean' their clients by removing their troublesome parasites, diseased and dead tissue, and general debris, which the cleaner eats. The cleaner benefits by having a meal, and the client is rid of pests and irritations. This happens at regular, often-used localities known as cleaning stations, usually in the sheltered shallow water of a coral reef. Here the cleaner fish dances and displays to attract customers.

STRIPED PERFORMER

The blue-streaked cleaner is clearly recognizable by the black side-stripe that widens from the snout to cover much of the tail, in contrast to the vivid blue of the rest of the body. The wrasse also 'dances' by tilting its rear up and down, tail spread. It may even do headstands and tailstands, then rise and sink, while rippling its fins and gently bending its body.

The client fish approaches the familiar station, recognizes the cleaner and adopts a stationary pose, mouth open and gill covers flared out. The cleaner then feeds by gently pecking and nipping at the client's skin, inside the mouth, and in amongst the gill filaments.

DISTRIBUTION MAP

- LOCAL COMMON NAMES
 Common cleaner wrasse, Bridled beauty, Gadfly fish; Bola i bulewa (Fijian); Dokter biasa, Bayan (Malay); Bunak, Mameng, Labayan (Filipino languages); Mtsoungafi (Comorian)

- SCIENTIFIC NAME
 Labroides dimidiatus

- SIZE
 Length 10cm (4in)

- HABITATS
 Reefs and rocky shallows, lagoons, tidal pools

- DIET
 Small parasites on larger fish, such as copepods, isopods and similar so-called 'fish lice' and 'fish fleas', also some free-swimming prey

- CONSERVATION STATUS
 IUCN Least concern
 (see key, page 9)

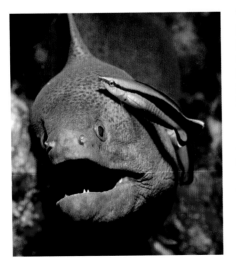

TRUE OR FALSE CLEANER FISH?

Several species of the wrasse group (Labridae) have the cleaner lifestyle. So do members of the goby family (Gobiidae), such as the neon blue goby, *Elacatinus oceanops*. However, there are also imposters. The false cleaner fish, *Aspidontus taeniatus*, a type of blenny (Blenniidae), looks very similar to the blue-streaked cleaner wrasse and even mimics its dance. This may fool a client fish, allowing the false cleaner to nip off pieces of its flesh and fins, rather than remove parasites.

◄ The yellow-margined or leopard moray, *Gymnothorax flavimarginatus*, is a strong, fierce eel that may exceed two metres (almost seven feet) in length. But it waits patiently and peacefully as it is cleaned.

► A blue-streaked cleaner services a customer perhaps a hundred times its size, a yellow-banded sweetlips, *Plectorhinchus lineatus*. This cleaner is attending to pests and parasites on the lips and mouth interior.

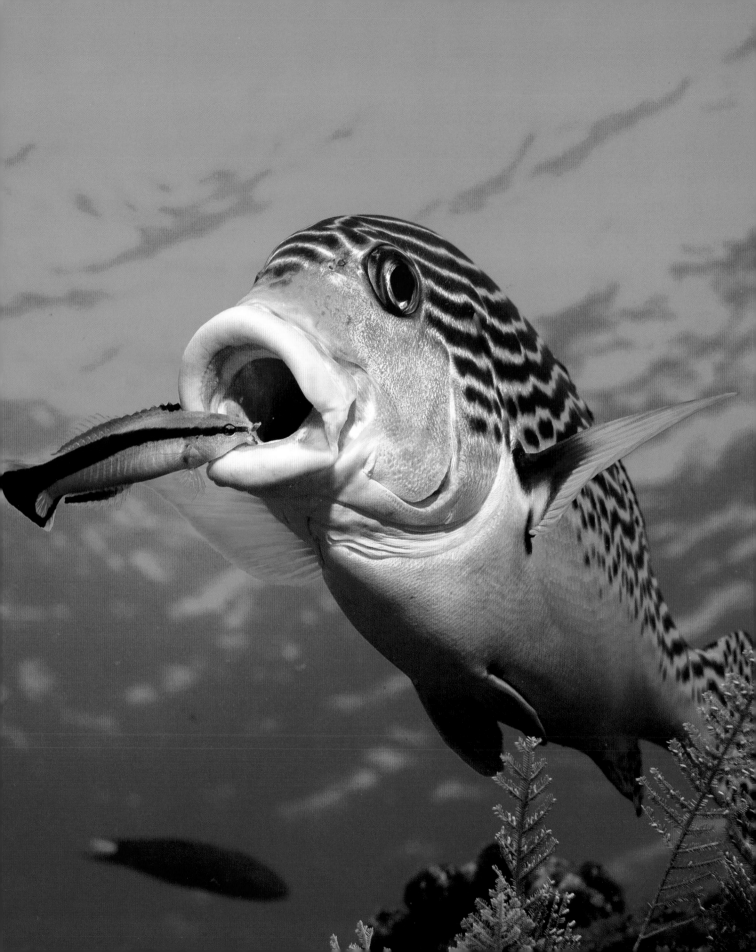

Gentoo penguin

THE IMPORTANCE OF STONES

The third largest of approximately twenty penguin species, all flightless, gentoos can be noisy birds. They communicate through a wide variety of squawks, bellows, trumpets, hisses and other sounds. And, though apparently compact, relatively inflexible birds, they display visually with a surprising and enthusiastic range of body postures, head positions, wing actions and tramping, stamping feet.

Most gentoos pair for the breeding season, from about June to November. They are colonial birds, and males hiss, flap and point their bills at each other to gain a favourable flat, safe nest site. Nests usually end up being one or two metres (three to six feet) apart. The male then advertises by pointing his bill vertically and making a loud bellowing call. If an interested female approaches, the two bow at each other and make soft trumpeting sounds.

KEY TO SUCCESS
Successful nesting depends on the main materials used – stones and pebbles. These can be as big as human fists. The male gathers a selection of perhaps several hundred to form the bowl-like nest, and he guards them carefully. If he becomes distracted, a nearby rival may grab one of them. Stone-stealing is a serious matter and males confront fiercely over their ownership.

Both male and female protect their nest territory and their stones by making bill-jabbing motions and hissing at intruders. They also strengthen their pair bond by rubbing together their faces and bills, and by bringing back extra stones from their feeding trips in the sea, when the recipient partner bows in 'thanks'.

DISTRIBUTION MAP

● Primary range

- LOCAL COMMON NAMES
 Gentoo, 'Johnny' penguin (former nickname)

- SCIENTIFIC NAME
 Gymnothorax flavimarginatus

- SIZE
 Standing height up to 80cm (31in), weight may exceed 8kg (18lb)

- HABITATS
 Subpolar and polar shorelines, less commonly edges of bergs, ice shelves and pack ice

- DIET
 Fish, crustaceans such as krill and shrimps, small squid and octopuses

- CONSERVATION STATUS
 IUCN Least concern
 (see key, page 9)

◀ As one gentoo partner returns from foraging at sea, it may bring a stone as a nuptial gift to reinforce both the pair bond and the nest structure.

▶▶ A mated pair of gentoos maintain their relationship by bill pointing and face rubbing. The bowl-shaped nest is lined with smaller pebbles, bits of vegetation and feathers.

SPEEDY SWIMMERS
Penguins are often regarded as awkward and ungainly movers on land, with a limited range of gaits. By contrast, in the sea they are fast and graceful swimmers, able to turn in a split second as they chase fish such as Antarctic icefish and rock cod. Underwater they are the speediest of all penguin species, having been timed at more than 35 kilometres (22 miles) per hour. However their dives are fairly short, two to three minutes and to perhaps 50 metres (165 feet) in depth.

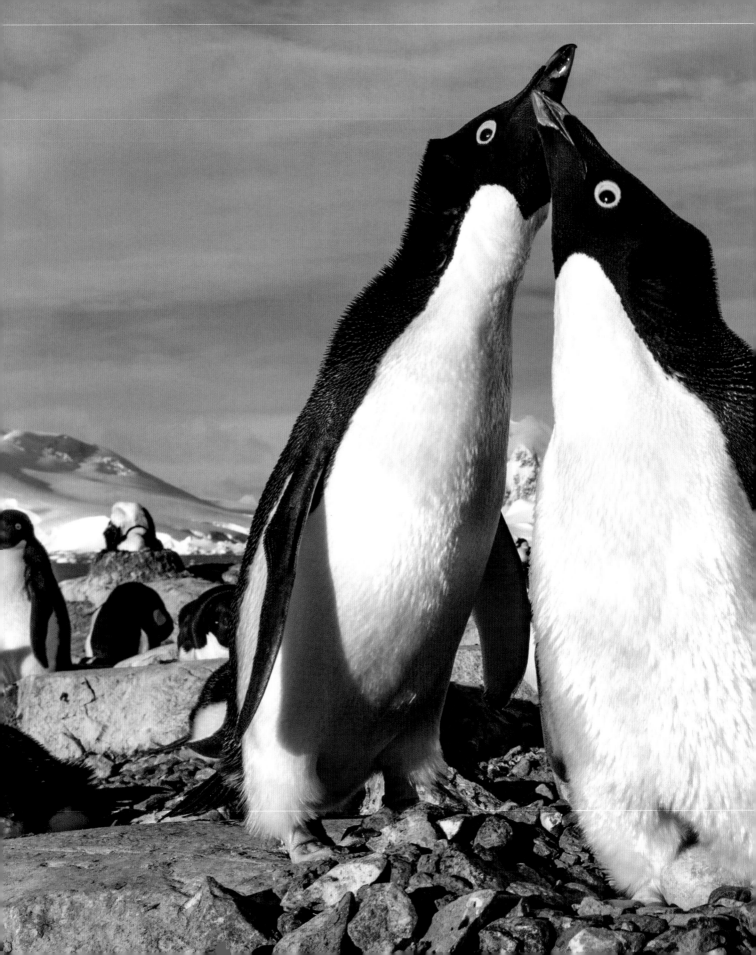

Magnificent frigatebird

RED-THROATED RITUAL

The magnificent frigatebird spends much of its life soaring vast distances across the open ocean, riding even hurricane-force winds with such great skill that it hardly needs to flap. However as breeding time beckons, around December, these birds gather along traditional coastal nesting sites. Here the males display to females by inflating their huge throat sacs, or gular pouches, coloured vivid red for extra effect.

Female frigatebirds collect around the main display area and monitor the proceedings. The most impressive males with the biggest, most colourful pouch action are desired. The male takes in air and his sac enlarges like a bright red balloon, often much larger than his head which peeks out from behind. To highlight the display, the male may spread, stretch and shake his wings, and lean back on his rear body and tail, with head and bill pointing skywards, to thrust the pouch forward for maximum visibility.

DRUMMING FOR SUCCESS
Added to this spectacle are sound effects. The bird taps, drums, clacks, claps and rattles his upper and lower bill against the stretched-tight gular skin, where the noises resonate and amplify as though he is playing percussion instruments. Studies show that males who drum at lower frequencies tend to mate more often. The pitch is related to the pouch size, with deeper sounds indicating a larger pouch and so a bigger, stronger owner. This reinforces the visible display of pouch size.

DISTRIBUTION MAP

- LOCAL COMMON NAMES
 Man-o'-War bird; Ave fragata, Fragata magnífica, Rabihorcado grande (Spanish); Tesourão, Rabiforcado, Alcatraz, Fragata-magnífica (Portuguese); Frégate superbe (French)

- SCIENTIFIC NAME
 Fregata magnificens

- SIZE
 Female bill-tail length up to 110cm (43in), wingspan approaching 255cm (100in), male slightly smaller

- HABITATS
 Open ocean, breeding along tropical and subtropical coastlines with trees and bushes such as mangroves

- DIET
 Fish, crabs and other crustaceans, squid, jellyfish, also opportunistic items such as waste from fishing boats, edible human garbage

- CONSERVATION STATUS
 IUCN Least concern
 (see key, page 9)

PIRATES OF THE HIGH SEAS
Like some skuas and jaegers, frigatebirds gain food by a technique known as kleptoparasitism – stealing food from another. This has led to one of their common names, Man-o'-War bird. Often, in mid-air, they harass and pester other birds, such as terns, gannets and boobies, even pecking them or grabbing their feathers. The victim bird drops any food it is carrying, or disgorges (vomits up) swallowed food, and the frigatebird aerobatically dives to intercept and catch the falling meal.

◀ A frigatebird pair perch in the branches. Here the nest is built. Both incubate the single egg, but the male has much less involvement in feeding the chick and may even leave soon after it hatches.

▶ In full flow, a male magnificent frigatebird spreads his wings and looks upwards to present and emphasize his brightly hued, balloon-like gular pouch.

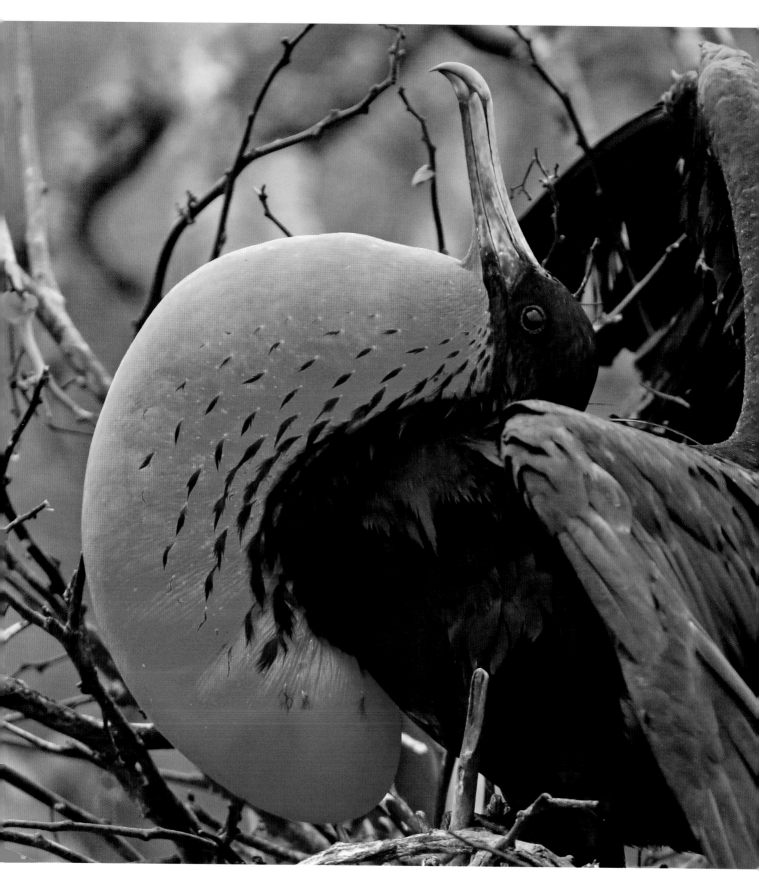

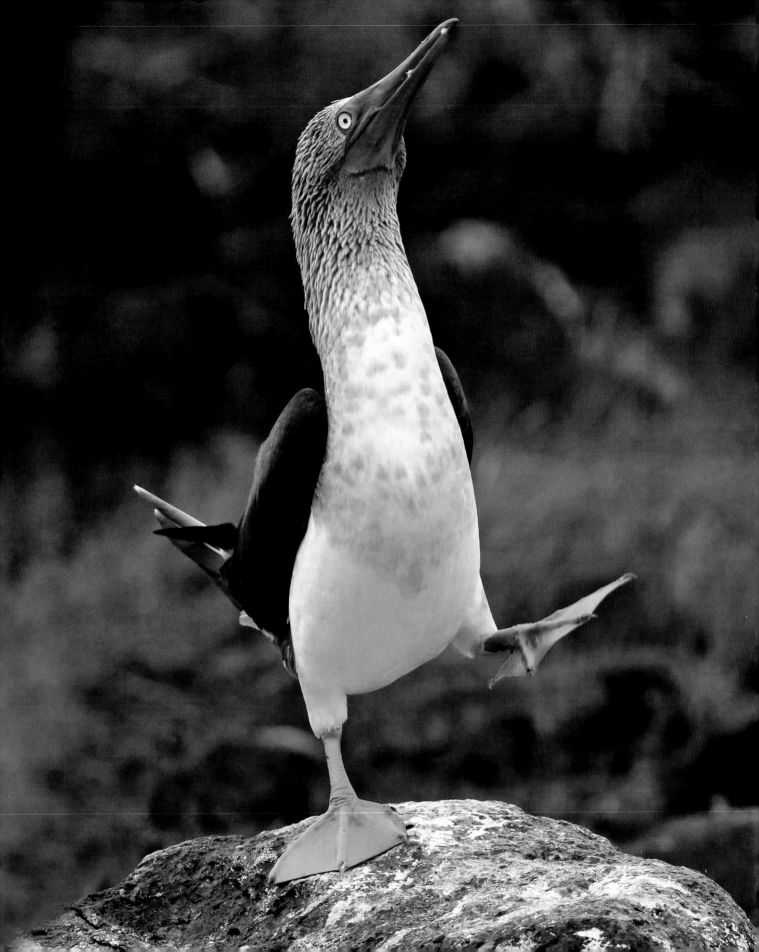

Blue-footed booby

VARIED SHADES OF BLUE

Animals perform colourful, striking displays with varied parts of their bodies. However, not many use their feet. Being a seabird, the blue-footed booby's feet are large and webbed for paddling and swimming. They are also extremely blue. The shade and brightness of the blue hue varies among individuals and also in the same bird over time. It is an important indicator of health, age and fertility.

At their breeding colonies, male boobies begin their courtship rituals. In the main sequence a male parades and struts, lifting each blue foot up and forward in turn, in a slow, extravagant, mid-kicking action. He also bows and skypoints, stretching his neck and head up with the bill vertical. Added actions are wing-spreading, tail-raising, a mechanical-sounding whistle, and proffering nest materials as a nuptial offering to an interested female. She responds with skypointing, spread wings and a mirrored set of foot movements. She may also lower her head to tuck under her wing.

USEFUL COLOUR INDICATOR

Scientific research has revealed links between the blueness of a male booby's feet and his fitness and condition. The blueness comes from carotenoid pigments in the bird's food. Lighter, brighter blues indicate a younger, well-fed male in prime condition. Shortage of food and lengthening years tend to make the blues duller and darker. The individual male has no behavioural or conscious control over foot appearance and so it works as what biologists call an 'honest signal', one which cannot be faked, and which reflects to monitoring females his health and potential as a father.

◄ The booby's exaggerated foot-raising displays its colour, allowing females to make informed choices about a mate. If the male's foot colour dulls, the female may lose interest.

► A courting pair exchange movements and actions. The left one skypoints with wings raised and spread while the one on the right indulges in the characteristic slow-motion, one-foot-at-a-time 'dance'.

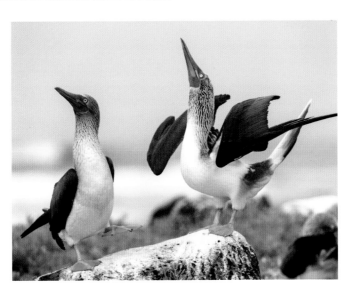

BLUE FOR WARMTH

Blue-footed booby feet have a plentiful blood supply and so are quite warm. However brood patches – bare areas of skin on the body underside that most birds use to incubate their eggs – are absent. So the booby perches the eggs on its feet for the warmth that encourages development. The hatched chicks also sit on the feet, as the parents bring them regurgitated fish and other food. Observations show the chicks of male parents with brighter blue feet develop faster.

Humpback whale

NATURE'S BIGGEST DISPLAYERS

Despite the humpback being one of the most enormous, most famous and most studied creatures on our planet, much of its behaviour, display and activity remains a mystery. Most familiar are its surface exploits since these are readily visible to human observers, yet their purposes are much debated. Marine scientists are also still discovering and interpreting the species' underwater endeavours – especially their astonishing range of songs.

The humpback's surface actions include breaching, lobtailing and flipper slapping. A breach is a leap from the water where at least half the body – and sometimes the entire animal – emerges into the air, crashing back through the surface, often on its back or side. In doing this, an animal might be sending signals to other whales about its health and fitness, issuing a dominance challenge, showing off (as a breeding male), swishing parasites off its skin, or stunning nearby fish for prey. It is possible that breaching has different uses in different situations and seasons.

SLAPS AND SMACKS

In lobtailing or tail-slapping, the humpback faces downwards, lifts its tail into the air and arches its rear body to smack the flukes (tail fins) against the surface. Again this may be some form of communication, or a way of frightening nearby small fish into a tight shoal which the whale can then exploit as food. Flipper or pectoral slapping involves the humpback lying on its side at the surface and crashing its huge front flipper or pectoral limb – 'arm' – onto the water. Explanations are similar, ranging from parasite removal to group communication or a feeding technique.

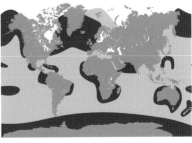
- LOCAL COMMON NAMES
 Baleine à bosse, Mégaptère (French); Hnúfubakur, Skeljúngur (Icelandic); Stor rorhval, Knölval (Norwegian); Langarmvinvisch (Dutch); Gorbatyi kit (Russian); Boggelwalvis (Afrikaans); Zato kujira (Japanese)

- SCIENTIFIC NAME
 Megaptera novaeangliae

- SIZE
 Female length may exceed 15m (49ft), weight 40 tonnes (44 tons), male slightly smaller

- HABITATS
 All oceans and most seas, migrating in spring from tropics to polar regions and back in autumn

- DIET
 Wide-ranging, including krill and similar crustaceans, fish, squid and similar creatures, depending on season and location

- CONSERVATION STATUS
 IUCN Least concern
 (see key, page 9)

SONGS OF THE HUMPBACK

The male humpback's spooky, eerie moans, groans, squeals, clicks, whistles and hums travel kilometres (miles) underwater. Rather like our music, their songs can be highly structured, with units building into phrases which combine into themes. Some whales sing for a few minutes, others for hours. Like their physical displays, humpback songs could have different motives and information depending on place and time, probably to do with feeding and breeding.

◄ Tail movements include smacking the surface loudly with the flukes, or exposing them as the whale upends and heads downwards to feed.

► A giant leap brings 40-plus tonnes (tons) of humpback clear of the water, to crash back and generate hugely impressive spray and sound. The noises can be heard hundreds of metres (yards) away.

Hooded seal

TWO BALLOONS BETTER THAN ONE

The 'hood' of the hooded seal is the male's two-lobed elastic bag or sac of blackish skin on the forehead, connected to the nasal system. This usually hangs limply between the eyes onto the nose, but it can be blown up like a balloon for various displays. Males also have a much more visually striking red sac that is usually hidden inside the nose, but which is protruded through the left nostril and inflated, again for display. This double-balloon headgear is a unique set-up in the animal kingdom.

As the male hooded seal matures, from about four years of age, his two inflatables begin to develop. On the forehead area is the stretchy black bladder or 'hood', usually drooping as far down as the nostrils. When pumped up with air from inside the nose, it expands into two compartments, front and rear, that almost cover his face and upper head.

FROM INSIDE TO OUTSIDE
Once the hood is inflated, the male can then close his right nostril and blow air against the flexible septum, which is the internal partition or dividing membrane between the left and right nose cavities. The extremely elastic, bright reddish-pink septum bulges, extrudes through the left nostril and balloons out, complementing the dark hood above it.

Both hood and septum can be used to challenge rival males and attract females for breeding. They are also acoustic devices. As they are pumped up and deflated, and also when vibrated and shaken, they send sound signals; this works in air and water. The signals serve various purposes, including warning other seals to stay away as the individual defends a plentiful food source.

- LOCAL COMMON NAMES
 Bladdernose seal, Balloon-nosed seal; Natsersuaq (Greenlandic); Blöðuselur (Icelandic); Klappus (Faroese); Klappmyss (Norwegian); Klapmyds (Danish); Phoque à capuchon (French); Foca capuchina (Spanish)

- SCIENTIFIC NAME
 Cystophora cristata

- SIZE
 Male head-body length may exceed 3m (10ft), weight up to 400kg (880lb), females 20–40% smaller

- HABITATS
 Breeding on coasts, usually icy, of seas and oceans, but otherwise mostly at sea

- DIET
 Fish, octopuses, squid, also krill and similar crustaceans

- CONSERVATION STATUS
 IUCN Vulnerable
 (see key, page 9)

FAST SWIMMER, DEEP DIVER
Hooded seals are among the larger seal species, and they are proficient swimmers and divers. Some underwater foraging trips last more than 40 minutes and descend to 1,000 metres (3,300 feet). Away from breeding time, individuals are mainly solitary and spend well over two-thirds of their time diving for prey. The acoustic signals from the hood and septum may serve to tell other seals to stay clear of a food-rich area the seal has found.

▶▶ Male hooded seals show off their inflatable headgear when confronting each other and persuading females at mating time.

▶ A close-up of the head shows the two compartments of the dark hood, here with the rear one larger. Extruded through the nostril is the air-filled, colourful nasal septum membrane. Just behind it, and below the hood, is the seal's left eye.

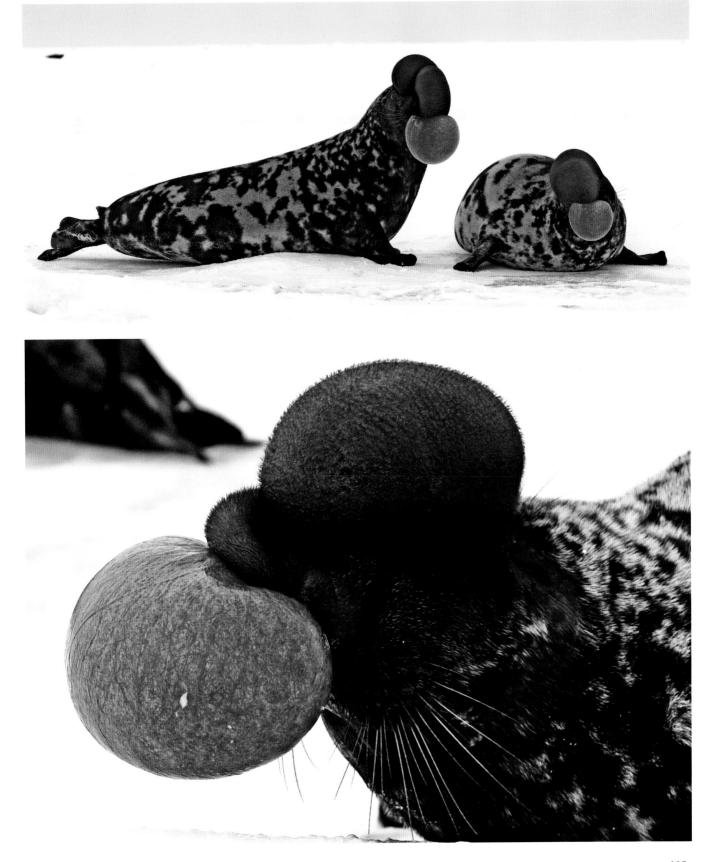

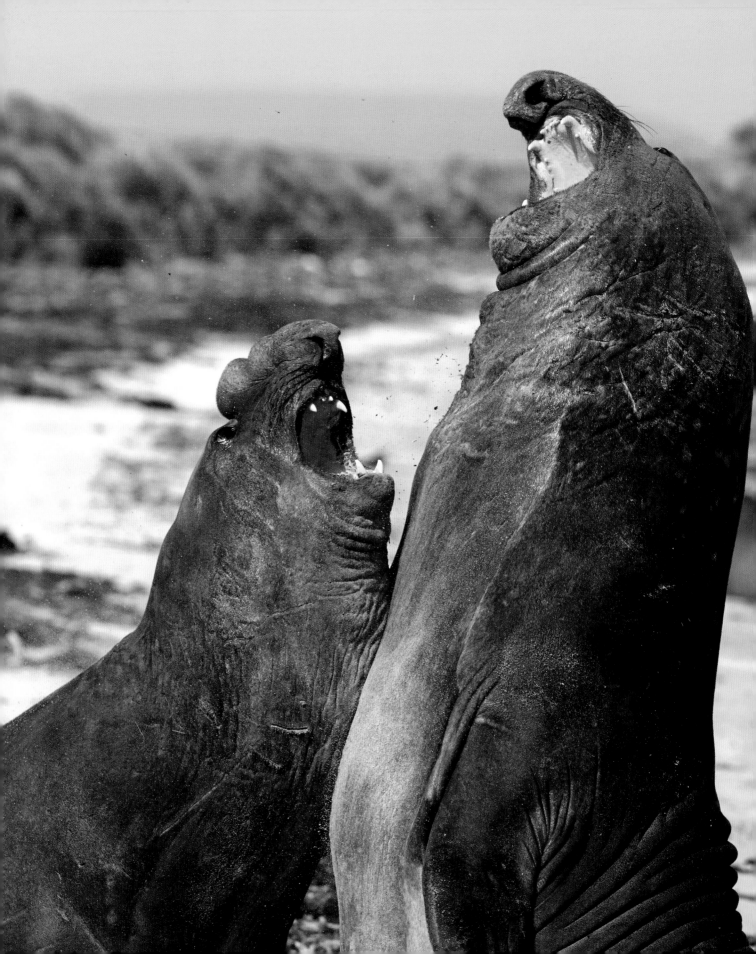

Elephant seal

TITANIC BEACH BATTLES

The two species of elephant seals were named from the male's long, overhanging snout or proboscis, reminiscent of the (admittedly much longer) elephant's trunk. There could also have been a size aspect to the naming, since a large, mature, well-fed Southern elephant seal – the slightly larger of the two species – would rival many real elephants in bulk. When ready to reproduce, these enormous mounds of flesh and blubber have some of the planet's most gigantic physical battles.

As the mating season looms, male or bull elephant seals pitch up at their traditional breeding beaches, some of which have been used for centuries, perhaps millennia. Here they begin their displays and battles. They confront adversaries, rear up, shake and blow up their noses, bellow and shuffle about the beach. This can be dangerous since also there may be females, or cows, who have just given birth, and their pups (young) can be crushed by the lumbering, clashing males.

MASTER OF THE BEACH
Fights can become bloody as the bulls ram chests and aim bites at each other's neck, head and proboscis. A bigger, heavier male may wrestle his opponent to the ground, crushing home his advantage. The winning alpha bull becomes a 'beachmaster', claims a territory, and gathers a group or harem of twenty, thirty, or even more cows with whom he mates.

The alpha may be assisted by a 'sidekick' beta male, who helps to repel other males from the harem. In return, the beta may be able surreptitiously to achieve his own matings while the alpha is busy elsewhere. This tactic, found in group dwellers from insects to deer, is nicknamed the 'sneaker male' ploy.

● Southern elephant seal
○ Northern elephant seal

● **LOCAL COMMON NAMES**
Sea elephant; Eléphant de mer (French); Foca elephante, Elefante marino (Spanish); Zeeolifant (Dutch)

● **SCIENTIFIC NAME**
Two species in the genus *Mirounga*: Northern elephant seal *M. angustirostris*, Southern elephant seal *M. leonina*

● **SIZE**
Southern male head-body length up to 6m (20ft), weight 4,000kg (8,800lb), females less than half this size; Northern males and females respectively about 30% smaller

● **HABITATS**
Beaches when breeding, otherwise sea-going or resting on bergs, pack ice, ice shelves

● **DIET**
Squid, fish, similar sea creatures

● **CONSERVATION STATUS**
IUCN Both species Least concern (see key, page 9)

◄ Bull elephant seals can weigh several tonnes (tons). The thickened, tough skin on the chest, known as the chest shield, is used to shove, push and ram rivals and as protection against bites.

DELAYED IMPLANTATION
After a cow elephant seal mates, there is a pause as the fertilized egg enters four months of 'suspended animation' in the uterus (womb). It then implants, settling into the uterus lining so it can develop. This is in effect when pregnancy starts. Seven months later – almost one year after mating – the pup is born, then the mother mates again. This delayed implantation synchronizes birth and mating into one short time. It is common in seals, sea lions and many other highly seasonal creatures.

Index

(Page numbers in **bold** refer to main named entries)

Picture credits

This book would not have been possible without the astonishing skill, perseverance and often bravery of photographers who faced up to so many animals with threatening displays. Our grateful thanks to all of them.

1 Thierry GRUN / Alamy Stock Photo; 2 Sushil Chikane / Alamy Stock Photo; 4 cbpix / Alamy Stock Photo; 6 Norma Jean Gargasz / Alamy Stock Photo; 7 Aditya "Dicky" Singh / Alamy Stock Photo; 8 Blue Planet Archive / Alamy Stock Photo; 9 Imagebroker / Alamy Stock Photo; 10-11 Wolfgang Kaehler / Alamy Stock Photo; 12 Daybreak Imagery / Alamy Stock Photo; 13 Daybreak Imagery / Alamy Stock Photo; 14 Rick & Nora Bowers / Alamy Stock Photo; 15 Sari O'Neal / Alamy Stock Photo; 16 FLPA / Alamy Stock Photo; 17 Alan Tunnicliffe / Alamy Stock Photo; 18 Mark Conlin / Alamy Stock Photo; 19 2020 Joe Belanger/Shutterstock; 20 Imagebroker / Alamy Stock Photo; 21 Rolf Nussbaumer Photography / Alamy Stock Photo; 22 Maria Dryfhout / Alamy Stock Photo; 24-25 Nature Picture Library / Alamy Stock Photo; 26 Ray Wilson / Alamy Stock Photo; 27 David Hoffmann / Alamy Stock Photo; 28 Nature Picture Library / Alamy Stock Photo; 29 Kerry Hargrove / Alamy Stock Photo; 30 Yellow-Crowned Night-Heron Bird / Alamy Stock Photo; 31 georgesanker.com / Alamy Stock Photo; 32 Danita Delimont / Alamy Stock Photo; 34 Minden Pictures / Alamy Stock Photo; 35 Bruce MacQueen / Alamy Stock Photo; 37 mauritius images GmbH / Alamy Stock Photo; 38 Imagebroker / Alamy Stock Photo; 39 Papilio / Alamy Stock Photo; 40 JUAN CARLOS MUNOZ / Alamy Stock Photo; 41 Val Duncan/Kenebec Images / Alamy Stock Photo; 42 All Canada Photos / Alamy Stock Photo; 44 BIOSPHOTO / Alamy Stock Photo; 45 EyeEm / Alamy Stock Photo; 46 Minden Pictures / Alamy Stock Photo; 48 Dirk Ercken / Alamy Stock Photo; 49 Chris Mattison / Alamy Stock Photo; 50 Giedrius Stakauskas / Alamy Stock Photo; 51 BIOSPHOTO / Alamy Stock Photo; 52 Nature Picture Library / Alamy Stock Photo; 53 Ivan Kuzmin / Alamy Stock Photo; 54 Hemis / Alamy Stock Photo; 57 agefotostock / Alamy Stock Photo; 58 Ernie Janes / Alamy Stock Photo; 59 Hemis / Alamy Stock Photo; 60a Nature Picture Library / Alamy Stock Photo; 60b imageBROKER / Alamy Stock Photo; 62 Minden Pictures / Alamy Stock Photo; 63 Octavio Campos Salles / Alamy Stock Photo; 64 imageBROKER / Alamy Stock Photo; 65 imageBROKER / Alamy Stock Photo; 66 Bill Gozansky / Alamy Stock Photo; 67 Minden Pictures / Alamy Stock Photo; 68 Linda Kennedy / Alamy Stock Photo; 69 Amazon-Images MBSI / Alamy Stock Photo; 71 blickwinkel / Alamy Stock Photo; 72-73 Minden Pictures / Alamy Stock Photo; 75 Imagebroker / Alamy Stock Photo; 76 Sarah Weston / Alamy Stock Photo; 78 Nature Picture Library / Alamy Stock Photo; 79 Nature Photographers Ltd / Alamy Stock Photo; 80 agefotostock / Alamy Stock Photo; 81 PhotoStock-Israel / Alamy Stock Photo; 82a blickwinkel / Alamy Stock Photo; 82b blickwinkel / Alamy Stock Photo; 84 Minden Pictures / Alamy Stock Photo; 85 Imagebroker / Alamy Stock Photo; 87 blickwinkel / Alamy Stock Photo; 88 FLPA / Alamy Stock Photo; 89 Imagebroker / Alamy Stock Photo; 90 blickwinkel / Alamy Stock Photo; 91 blickwinkel / Alamy Stock Photo; 92 Nature Picture Library / Alamy Stock Photo; 93 David Tipling Photo Library / Alamy Stock Photo; 94 David Tipling Photo Library / Alamy Stock Photo; 95 FLPA / Alamy Stock Photo; 97 imageBROKER / Alamy Stock Photo; 98-99 Malcolm Schuyl / Alamy Stock Photo; 100 robin chittenden / Alamy Stock Photo; 101 Arterra Picture Library / Alamy Stock Photo; 102 Nature Picture Library / Alamy Stock Photo; 103 Walker / Alamy Stock Photo; 104 blickwinkel / Alamy Stock Photo; 105 Mark Smith / Alamy Stock Photo:; 106 Marcos G Meider / Alamy Stock Photo; 107 Paolo Manzi / Alamy Stock Photo; 108 imageBROKER / Alamy Stock Photo; 110 Boyd Norton / Alamy Stock Photo; 112 Evan Bowen-Jones / Alamy Stock Photo; 113 Cathy Keifer/Shutterstock; 114 Nature Picture Library / Alamy Stock Photo; 115 Sabena Jane Blackbird / Alamy Stock Photo; 116 RZ_Images / Alamy Stock Photo; 117 Minden Pictures / Alamy Stock Photo; 118 blickwinkel / Alamy Stock Photo; 119 gerard lacz / Alamy Stock Photo; 120a Images of Africa Photobank / Alamy Stock Photo; 120b AGAMI Photo Agency / Alamy Stock Photo; 123 Imagebroker / Alamy Stock Photo; 124 Imagebroker / Alamy Stock Photo; 127 Nature Photographers Ltd / Alamy Stock Photo; 128 Cindy Hopkins / Alamy Stock Photo; 129 Susie Kearley / Alamy Stock Photo; 130 Gallo Images / Alamy Stock Photo; 131 BIOSPHOTO / Alamy Stock Photo; 132 Philip Mugridge / Alamy Stock Photo; 133 Nature Picture Library / Alamy Stock Photo; 134 Danita Delimont / Alamy Stock Photo; 135 AfriPics.com / Alamy Stock Photo; 136 Johan Swanepoel / Alamy Stock Photo; 137 Zoonar GmbH / Alamy Stock Photo; 138 robertharding / Alamy Stock Photo; 139 Tierfotoagentur / Alamy Stock Photo; 141 Nature Picture Library / Alamy Stock Photo; 142-143 imageBROKER / Alamy Stock Photo; 144 Images of Africa Photobank / Alamy Stock Photo; 145 Petr Ganaj / Alamy Stock Photo; 146 Papilio / Alamy Stock Photo; 147 Sergey Uryadnikov / Alamy Stock Photo; 148 Neil Bowman / Alamy Stock Photo; 151 Phil Savoie / www.naturepl.com; 152 Mike Read / Alamy Stock Photo; 153 Nature Picture Library / Alamy Stock Photo; 155 Kidsada Manchinda / Alamy Stock Photo; 156-157 blickwinkel / Alamy Stock Photo; 158 Yashpal Rathore / www.naturepl.com; 159 Yashpal Rathore / www.naturepl.com; 161 HIRA PUNJABI / Alamy Stock Photo; 162 Skynavin/Shutterstock; 163 ccarbill/Shutterstock; 164 Design Pics Inc / Alamy Stock Photo; 165 Victor Tyakht / Alamy Stock Photo; 166 Juan Carlos Munoz / www.naturepl.com; 167 Nancybelle Gonzaga Villarroya / ngonzagavillarroya©2019 / www.gettyimages.com; 168 Gabbro / Alamy Stock Photo; 169 blickwinkel / Alamy Stock Photo; 171 EyeEm / Alamy Stock Photo; 172 blickwinkel / Alamy Stock Photo; 173 blickwinkel / Alamy Stock Photo; 174 Panther Media GmbH / Alamy Stock Photo; 175 Cyril Ruoso / www.naturepl.com; 176 Imagebroker / Alamy Stock Photo; 177 Tierfotoagentur / Alamy Stock Photo; 178 Ken Griffiths / Alamy Stock Photo; 180 Premaphotos / Alamy Stock Photo; 181 Premaphotos / Alamy Stock Photo; 182 Paul Harrison / Alamy Stock Photo; 183 BIOSPHOTO / Alamy Stock Photo; 185 Nature Picture Library / Alamy Stock Photo; 186-187 Blue Planet Archive / Alamy Stock Photo; 189 Bert Willaert / www.naturepl.com; 191 Stephanie Jackson - Australian wildlife collection / Alamy Stock Photo; 192 Dave Watts / Alamy Stock Photo; 193 Top-Pics TBK / Alamy Stock Photo; 195a Minden / www.naturepl.com; 195b Dave Watts / www.naturepl.com; 196 Avalon.red / Alamy Stock Photo; 197 Minden Pictures / Alamy Stock Photo; 198 Nature Picture Library / Alamy Stock Photo; 199 Max Allen / Alamy Stock Photo; 201 blickwinkel / Alamy Stock Photo; 202 Nature Picture Library / Alamy Stock Photo; 203 Genevieve Vallee / Alamy Stock Photo; 204 Blue Planet Archive / Alamy Stock Photo; 206 Blue Planet Archive / Alamy Stock Photo; 207 Helmut Corneli / Alamy Stock Photo; 208 Ethan Daniels / Alamy Stock Photo; 209 BIOSPHOTO / Alamy Stock Photo; 211a Nature Picture Library / Alamy Stock Photo; 211b Doug Perrine / Alamy Stock Photo; 212 Steve Bloom Images / Alamy Stock Photo; 213 WaterFrame / Alamy Stock Photo; 214a Natalia Kuzmina / Alamy Stock Photo; 214b WaterFrame / Alamy Stock Photo; 216 Minden / www.naturepl.com; 217 Pascal Kobeh / www.naturepl.com; 218 Martin Strmiska / Alamy Stock Photo; 219 Panther Media GmbH / Alamy Stock Photo; 220 Helmut Corneli / Alamy Stock Photo; 221 Daniel Lamborn / Alamy Stock Photo; 222 WaterFrame / Alamy Stock Photo; 223 Helmut Corneli / Alamy Stock Photo; 224 Luis Leamus / Alamy Stock Photo; 226-227 WorldFoto / Alamy Stock Photo; 228 Olga Kolos / Alamy Stock Photo; 229 AGAMI Photo Agency / Alamy Stock Photo; 230 AGAMI Photo Agency / Alamy Stock Photo; 231 Nature Picture Library / Alamy Stock Photo; 232 Design Pics Inc / Alamy Stock Photo; 233 Maria Hoffman / Alamy Stock Photo; 235a WILDLIFE GmbH / Alamy Stock Photo; 235b Sylvain Cordier / www.naturepl.com; 236 Jeremy Richards / Alamy Stock Photo.